for Lisa

PASSAGE
a work record

Irving Penn

PASSAGE
a work record

with the collaboration of Alexandra Arrowsmith and Nicola Majocchi

Introduction by
Alexander Liberman

Produced by Nicholas Callaway

Alfred A. Knopf
Callaway

New York 1991

An American Modern

by Alexander Liberman

1941. I had been in the U.S. less than a year. I was beginning at *Vogue* when Penn, then art director at Saks Fifth Avenue, replacing the famous Brodovitch, called and offered me his job. He wanted to go to Mexico and paint. I did not accept, but what an interesting presence. Here was a young American who seemed unspoiled by European mannerisms or culture. I remember he wore sneakers and no tie. I was struck by his directness and a curious unworldliness, a clarity of purpose, and a freedom of decision. He was dropping a great job to risk the life of an artist. I felt a rapport. After his year away, I called him and asked if he would come and work with me as an associate in the *Vogue* Art Department.

He showed me the contacts of photographs he had taken while traveling across the U.S. and Mexico. They confirmed my instinct that here was a mind, and an eye that knew what it wanted to see. This, I still believe, is the essence of an original photographer.

We worked together. Penn did layouts—simple, direct, classical, and modern in their economy—no tricky design. Then one day, searching for a photographer to take a certain cover I said, "Why don't you take it?" This was our beginning.

In those days the *Vogue* studio, organized by Condé Nast to ensure a visual exclusivity and originality for its magazines, offered wonderful possibilities for creative photographic experimentation. Each selected photographer was given his own studio, a salary, plus all technical means and assistance. In exchange he was always on call and would execute any assignment he was given.

Penn immediately plunged into the vital question of inventing "his" light, a key to a personal statement different from the accepted unreality of the fashion photography of the period : overburdened backgrounds, theatrical lighting. Penn reacted by creating luminous tents in which objects and, later, models acquired a clear stillness. These images were so new, so divorced from the current imaginative traditions that they were a revelation. I sensed that we were in the presence of a major new vision, with infinite possibilities for growth and discovery.

Penn's first published works, revealing his struggle for absolute perfection and visual impact, were a striking portent of coming change. A Penn photograph "stood out." And created strong reactions pro and con.

The legendary editor, Edna Woolman Chase, who was always on the alert for any *lèse majesté* to her *Vogue*, said to me after looking at one of Penn's first great still-life covers, "Alex, if you want a still life, why don't you use a great still-life photographer?" For the first few years, Penn and I were thought of as dangerous destroyers of good manners in a world of ladies in status hats and white gloves. But so clear was Penn's concept, he could move without great convolutions from still life, to fashion, to portraits, to the world outside.

We had a lot of pages awaiting material in those days. *Vogue* was a bimonthly till 1972. There was a thirst for new visual sensations to feed those growing modern monsters, magazines. They devoured pages and pages with their ravenous appetite. In the overall composition of a fashion magazine there is a certain sameness of subject matter, so visual variety has to be introduced. The art director plays the role of a showman. He has to visually balance the "acts" so that each group of pictures separates itself from its neighbors. The showman becomes an orchestra leader, and uses each talent at his disposal to maximum effect. A photographer needs to be published, I feel, so that the quantitative accumulation of his repeated images creates recognition. Photography benefits from the drama of the printed reproduction, the excitement of bleed layouts. The enrichment of typography creates a new vitality. The variety of visions creates a whole: the magazine. Readers are intrigued and buy it; enjoy it or dislike it.

Penn and the key editors at *Vogue* were conscious of the very special and historic time in which they were living. The early forties was a period of violent change, with war and the Holocaust as staggering tragedies. During the war there was a sense of a new beginning in cultural New York, a tabula rasa of the past and even the dreadful present. Assigned to photograph the great innovators, Penn became aware of the daring intellectual presences of a Duchamp, of a Cage, of an Ernst, and so many others.

For his portraits, just as he had needed "his" light, Penn invented "his" space. A corner was built of painted wallboard, the subject wedged into its central focal point—each body compressed, altered by the claustrophobic concept, each willing to fit into the concept in his or her way—creating originality of stance. The face alone stood out, unrestricted and luminous, giving an immediate reading of character. There was an important additional detail—a small torn-off piece of carpet lay in the foreground. Penn once said that he hoped through the rough weave and hanging threads to give a grittiness, a texture, an impasto to the portrait: to break through the limitations of celluloid slickness to create a rougher image. But beyond this, the corner series had a meaning in time. These were existential pictures, the torn rug a memento mori at the feet of the great of the world, who were alone, cornered, as if in Sartre's claustrophobic *No Exit*. In these pictures Penn was in harmony with the tormenting isolation of Beckett: All this in the chic *Vogue* of the forties.

At the same time, there was a curious convergence between Penn's new vision and the great American ready-to-wear revolution. With war in Europe and the Pacific and "U.S.A. fashion on its own," *Vogue* proclaimed a new era. New young American designers, forced to simplify by war shortages, gave Penn visual purity in practical clothes designed for the now active woman. American fashion and the liberated American woman had found their photographer. Penn gave drama and glamour to women's everyday activities. I believe that his repeated images and *Vogue* support helped create a real impact and change of behavior.

Later there was a moment when, like Picasso or de Kooning, Penn assaulted "eternal woman" in his series of nudes. Seldom has the camera been used with such violence to achieve with the body of a young modern woman a prehistoric crudeness. Here Penn fought against feeling trapped by seduction. Maybe he was reacting to the routine flow of his fashion assignments, but I believe the presence of the most attractive women is a source to him of energy, generating erotic warmth and delight.

Sometimes he even allows himself to indulge in extravaganzas of original, daring fashion. These rare moments of breaking away from austerity are glorious adventurous trips into the realms of ultimate seduction. Superb ornamentation, striking cut, the fashion designers' play with a woman's body stimulate Penn's eager search for the exacerbating recording of extremes.

In his self-imposed noble purpose, Penn looks at women with, again, an American man's vision—there are no titillating frills or cute poses. His women are friends and partners in a sexual charade. He married a unique beauty of our time, Lisa Fonssagrives, and his portrayal of her is a testimony to an awe-inspiring respect and admiration for womanhood.

His demand for authenticity is obsessive. We once thought of photographing the instant of fall of a tray loaded with glasses. He insisted that only the finest Baccarat crystal would be right, so dozens and dozens of the most expensive glasses were used in recording the right moment of spill and break.

Penn is not easy to work with. The most difficult moments of our collaboration involved getting through his very special resistances and hesitations in taking a picture. All proposals had to go through a protective sieve, an inner filtration to correspond to the standard he sets for his work. He still eliminates models and clothes and corrects styling until he feels the rapport necessary for the result he wishes to achieve. This matching of the imagined possibility of the suggested subject with his vision was a wrenching experience for both of us. Penn seldom squanders his intensity. He has built in his parameters: in the studio, strobes in fixed positions regardless of subject; on trips, natural daylight. These are the absolute unifiers.

Some of his best portraits are a link with the marvels of daguerreotype in the slow absorption by the model of the surrounding daylight. There is a repose, a constant stillness that confers

monumentality on his capture of the transitory—from the noble serenity of a young African nude to the operatic gestures of Peruvian urchins. Penn was willing to scan the world. He actually traveled to New Guinea, Spain, France, Cameroon, Dahomey, Cuzco, Japan, Nepal, China, Crete, London, Scotland, Italy, Sweden, Portugal, and Czechoslovakia. He was able to unify the diversity with his cleansing American vision . . . an "innocent" but sophisticated tourist. Maybe there was in his eagerness to face it all, the whole world, a pioneer spirit's need for adventure, open-eyed and fearless : the good camera always searching for new documentation of life's exaggerations.

Photography needs to be dramatized more than any other medium. The world is inundated with images that seem to blur gray in our minds. For a picture to strike memory, it has to have an unusual, unique, inherent secret—a visual signature. Penn is always graphic. The structure of the picture, the pose, has the excitement of lettering in a cubist composition. He accentuates. An instinctive grasping for design dominates his pictures. After years of working and arguing, I knew that I could trust Penn on any assignment. I knew that whatever the subject, he would "Americanize" it. In my mind that meant make it modern, see it with the eyes of the New World. We could look long and hard at Nadar's or Atget's work and bravely launch a modern version. Penn's "Petits Métiers" are a glorious achievement, a record of working human beings in now legendary images. Penn has empathy for the simple and the humble. He shows his inner tenderness in his images of a child's innocence.

What I call Penn's American instincts made him go for the essentials. A Penn photograph has an immediacy, an impact, and communicates a clear signal of what it is about. The now bad word *advertising* in its true sense of communicating, displaying meaning, comes to mind. Penn displays. He uses contrasts of light to imprint the spectator's mind : deep, black shadows, luminous highlights. In our epoch there is no patience for Rembrandt's modulated chiaroscuro. We need the black-and-white lightning of *Guernica*.

Many serious creative beings know that there is enrichment and discovery through destruction, and Penn is no wide-eyed innocent. He can use cruelty, the outrage of caricature, to draw out the essential contrasts within any subject. When he photographs, he seldom gives a varied choice of images. He sees things one way and gambles all on this obsessive, incisive vision. He multiplies small variations within a unique whole. He stares through the frame of the camera, imposing a relentless gaze that draws out the smallest quirks of seduction or the revealing grotesque that lies masked in the human species. He is on his guard against Beauty and in the process discovers a universal appeal.

To me, after all these years, he is still affectionately, but with a humorous intonation, respectfully, "Mister Penn" to his rejoinder, "Yes, Mister Liberman." In working together a slightly

satirical, amusing comment would ease the draining tension of endless prolonged discussions. To publish a picture was a vital decision. He or I would question choice, use, layout. To reduce a great number of splendid images to a few was and is a fateful test. Days and nights were often filled with doubt and regret—even remorse—for the wasted unseen.

Some of the final images in this book are of Penn's own paintings. In these he reverts to his original drive. Another great, Cartier-Bresson, has also gone back to painting. What is this obsessive, lingering power in painting, of man's hand imposing its particular trace, translating an inner vision, as opposed to photography's imprinting of the real world outside? There is an incantational magic, a celebration, a uniqueness in painting. The possibility of reaching for the sublime through seeing and executing awkwardly one's own essence; the manual clumsiness; a reward of feeling. Photography has also its reward, but it is of a different essence. Photography ensnares and fixes. Its quality is in its recording of moments freezing history, and in the complex play of light. A photographic print has a distance, a necessarily cool surface. Detachment is built into the process. The mechanical manipulation of images, the modernity of no-hands electronics, the ability to repeat and reprint, allow creative imagemaking to reach an ever-widening public.

There is another Penn behind the camera. Deep in him is a sense of life's graver meaning. After all the fashion, after all the glory, he wants to record the transitory, the passing, the imminence of death. He prefers to photograph inert matter—lifeless shop-window dummies, signs signaling through the bustle of streets—and the encroachment of decay: flowers wilting, fruit rotting, garbage, the trashy discards of civilizations, skulls, and, finally, the ultimate sadness of all vanity. This is a leitmotif in much of his work and in his "Vanitas" series where a skull's eye sockets gaze sightlessly at the transit of *gloria mundi*. As I look through this book, reliving much of our rich work together—and a great deal of the best without me—I am struck by the diversity and by the incredible attempt of this man to embrace all creation. The range of experience seems to me like the moving focus of a unique, implacable, all-seeing eye disturbing and moving us in its passionate roving over life's meaning, shaking our preset expected experience of existence.

At art school the first two years: drawing in charcoal from the plaster cast, then from live models, sketching pacing tigers at the zoo, learning the materials of painting in watercolor and oils. When the time came finally to choose one major instructor, for me there was no question: Alexey Brodovitch.

Brodovitch called his class Design Laboratory. Mary Fullerton, his young assistant, directed day-to-day assignments. Brodovitch himself would come to class Saturday mornings, bringing us the flavor of professional New York, especially of Harper's Bazaar *where he was art director. He was for me both teacher and heroic figure. The artists he spoke about and collaborated with became our idols: Cassandre, Man Ray, Hoyningen-Huene.*

As student and as beginning professional Brodovitch encouraged what he found of interest in my earliest work and asked me to work with him as helper and collaborator. He first invited me to spend two school vacations as his assistant at Harper's Bazaar, *then encouraged me to work with him on some of his personal design projects, eventually a major one.*

Looking back, I see those two summers at Harper's Bazaar *as pointing the direction my work would take. At* Bazaar *I first met the strange world of fashion. There were daily contacts with major artists. The morning mail brought packages from Europe: drawings by Cocteau, Bérard, Jean Hugo. Visitors to the office were* Bazaar *contributors: Dali, Noguchi, Vertès, Blumenfeld, Lindner. Among the young editors was the astonishing Diana Vreeland.*

Sometimes I was asked by Brodovitch to make drawings for the magazine, small decorative refinements, initial letters, or space fillers at the end of articles. I learned to draw shoes, making stylized sketches in pencil on cameo paper. With this new skill I earned enough to buy my first camera, a Rolleiflex. On weekends I would wander the streets of New York taking camera notes, more to remember what I saw than with serious photographic intent. Occasionally even these tentative photographs were printed in Bazaar *as illustrations.*

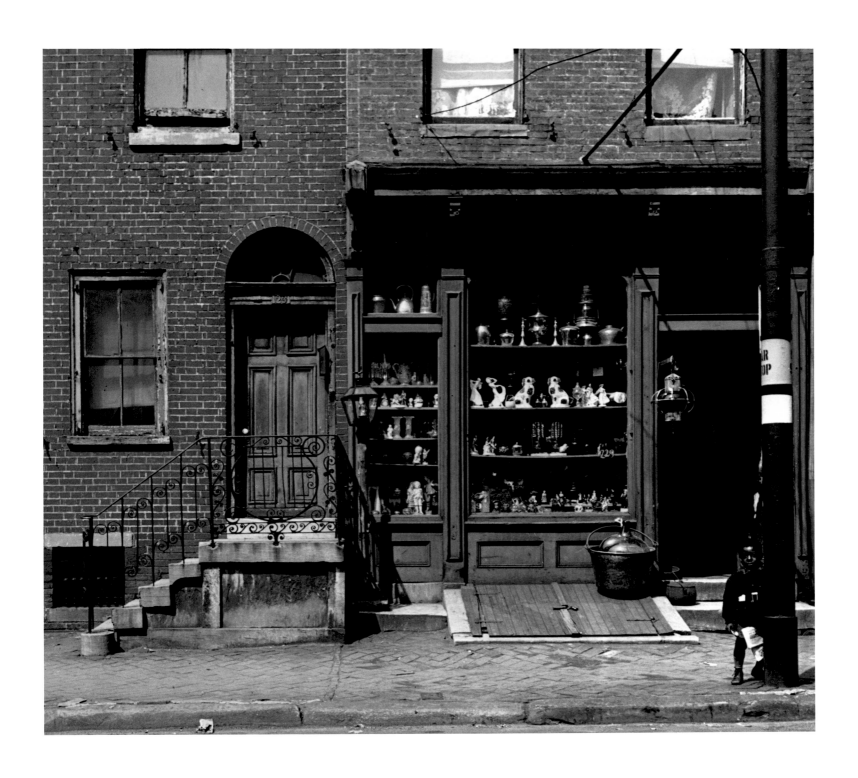

Antique Shop, Philadelphia, 1938.

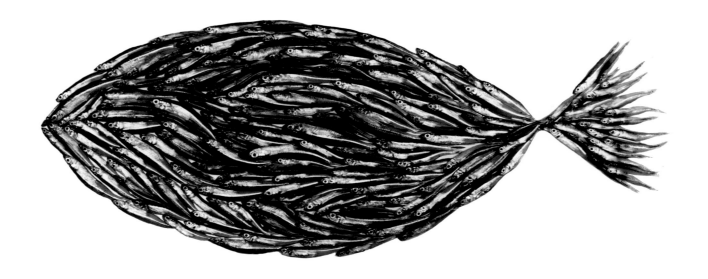

Fish Made of Fish, New York, 1939.

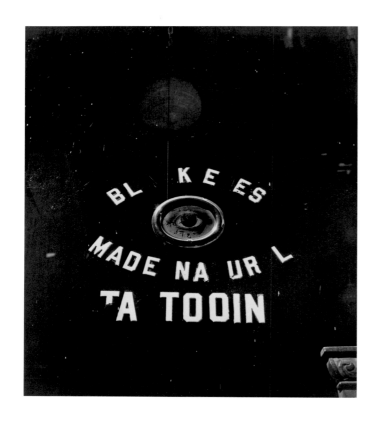

Tatooin, New York, 1939.

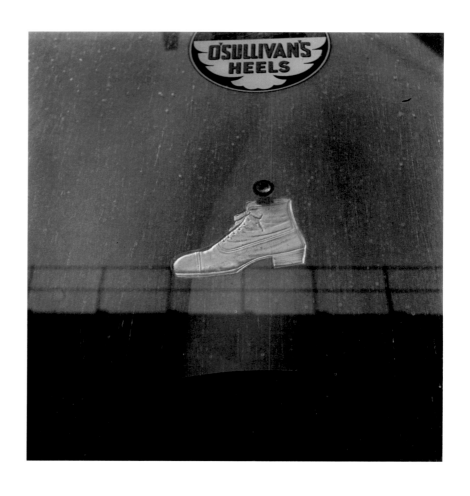

O'Sullivan's Heels, New York, 1939.

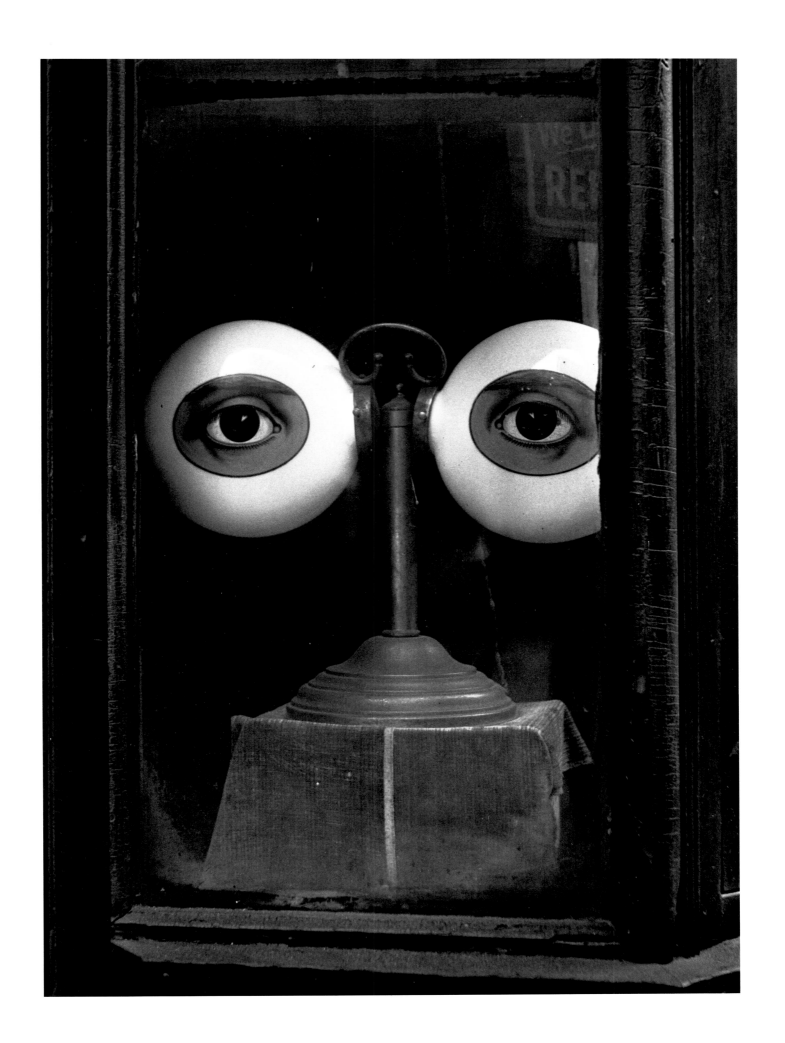

Optician's Shop Window, New York, 1939.

Shoe Repair Shop Window, American South, 1941.

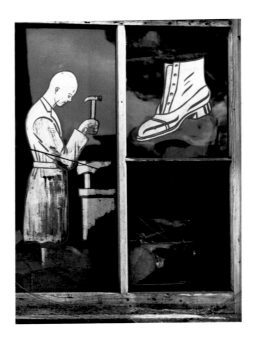

In 1941, after two years design-
ing advertising at Saks Fifth
Avenue (the first year as
Brodovitch's assistant, the
second year working alone),
I very much wanted a change of
work. I had for a time been
making sketches for paintings
I wanted to do, and I longed to
wander in strange places without
the discipline professional work
demanded. Europe was at war.
Mexico seemed a possible alter-
native, accessible and within my
limited means.

In leaving my job I felt the
obligation to find someone to
replace me. Brodovitch spoke
to me of a young man who had
just come from Paris and sug-
gested that we meet. It was at
this time that my life and
Alexander Liberman's crossed.
I found him the remarkable per-
son he is, of course much too
evolved for the job under con-
sideration. I told him so. We
shook hands and parted. I left
for Mexico to paint; he stayed to
become the brilliant art director
of Vogue. A year or so later it
was he who hired me to assist
him, beginning for me many
happy and productive years.

Making my way to Mexico
I wandered slowly through the
American South, going by train
in short trips from one town to
another, drawn especially to the
black neighborhoods. I found
the simple lettered and painted
communications on the fronts of
stores and buildings poignant
and touching. Some of these
I was able to record on film.

I found pleasure, too, in
watching groups of young men,
as chance composed them,
lounging in front of barber shops
and shoeshine parlors. The
camera in my hands did not
seem to intrude.

Funeral Home, American South, 1941.

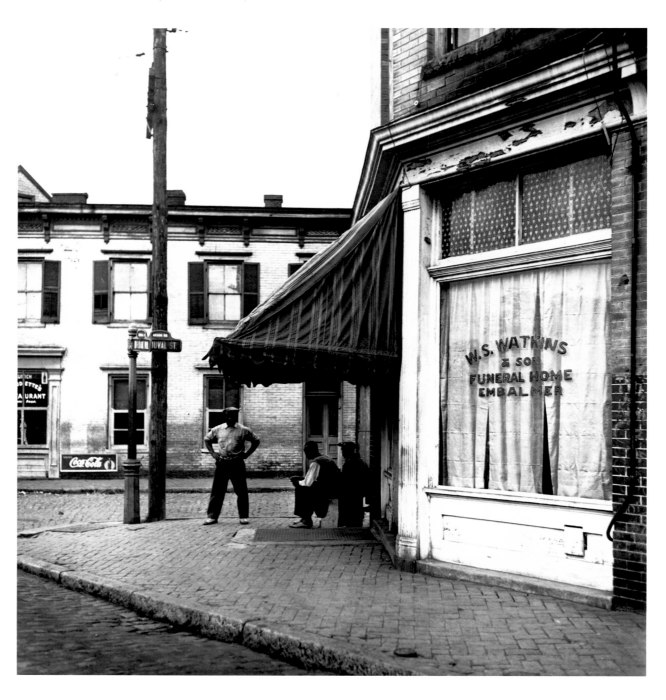

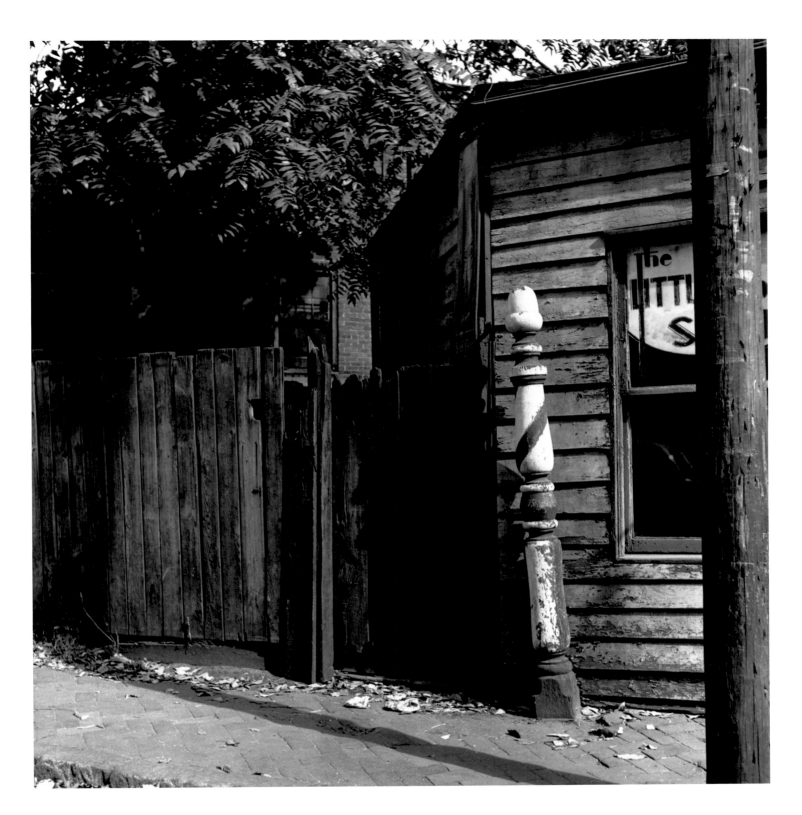

Barber Pole, American South, 1941.

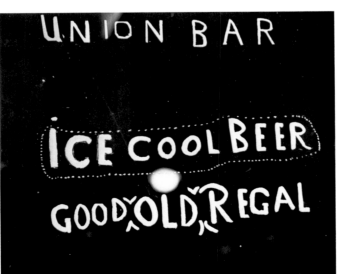

Union Bar Window, American South, 1941.

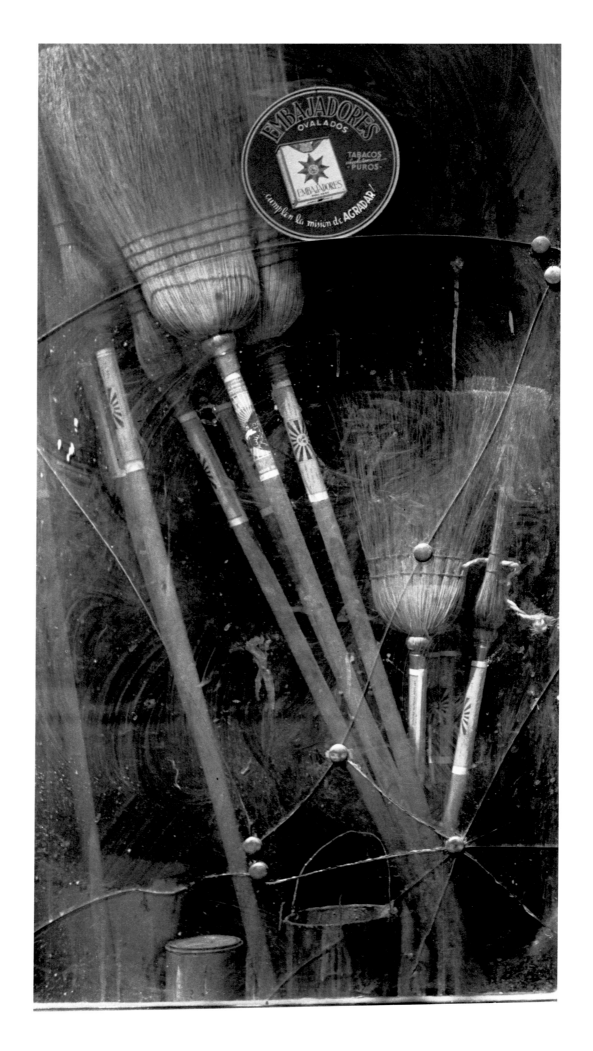

Shop Window, Mexico, 1942.

Pulquería Decoration, Mexico, 1942.

Haste, Mexico, 1942.

Just arrived in Rome, intoxicated with Italy, a figure I saw coming down the Spanish Steps was de Chirico carrying a shopping bag of vegetables! I knew him instantly, without doubt. I rushed up and embraced him. He must have thought me crazy. To me he was the heroic de Chirico; to him I was a total stranger, probably demented. Still, he was moved and said come home and have lunch with us. For two days he showed me his Rome, and hungry for attention he posed and postured for my camera: "Here I am with laurel on my head as conqueror!"

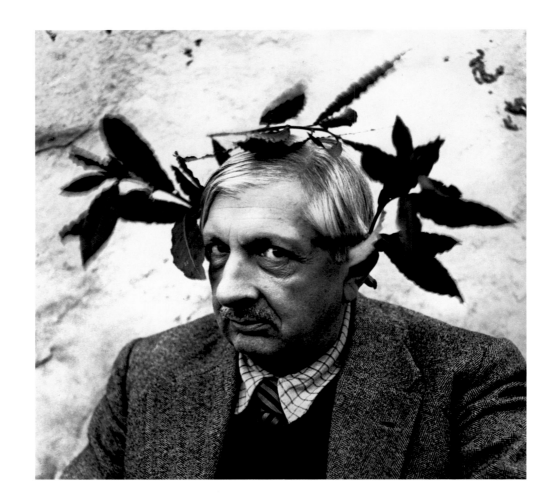

Giorgio de Chirico, Rome, 1944.

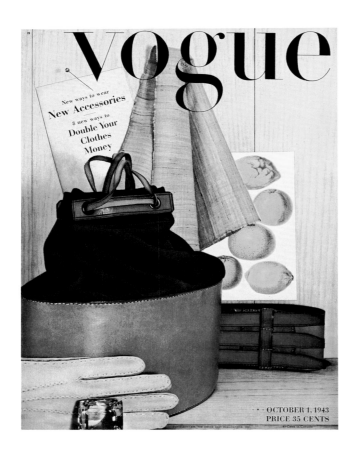

First Vogue *Cover*, New York, 1943.

View into Venetian Canal, Italy, 1945.

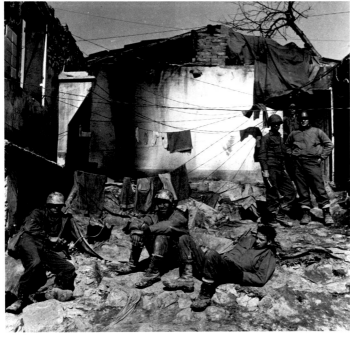

U.S. Soldiers, Italy, 1944–45.

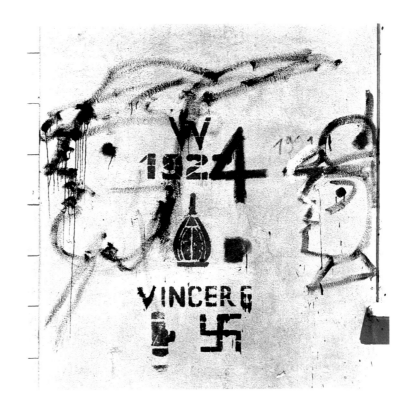

War Wall, Italy, 1945.

1946

Virgil Thomson, New York, 1946.

John Cage, New York, 1946.

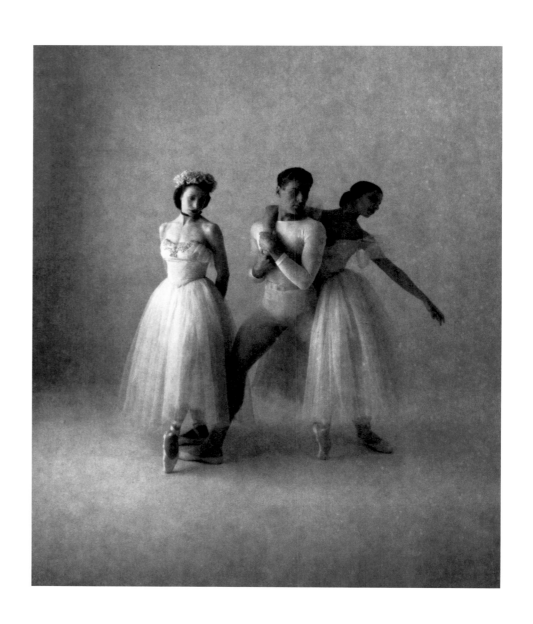

Nora Kaye, André Eglevsky, and Alicia Alonso, New York, 1946.

20

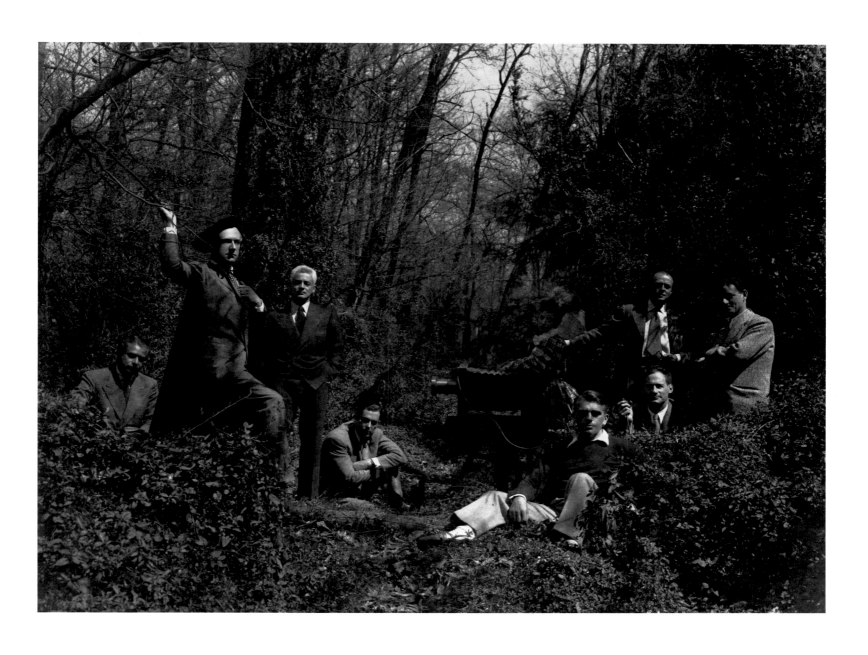

Group of Vogue *Photographers*, Long Island, New York, 1946.

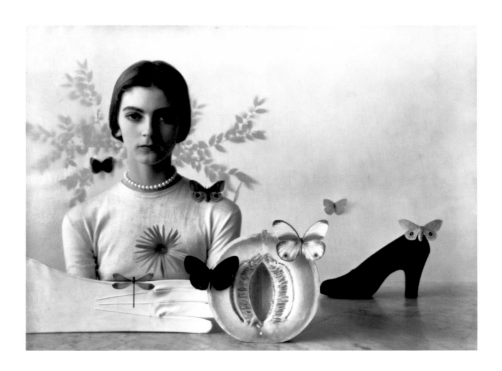

Girl with Fruit, Shoe, and Butterflies (Carmen Dell'Orefice), New York, 1946.

1946

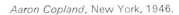

Aaron Copland, New York, 1946.

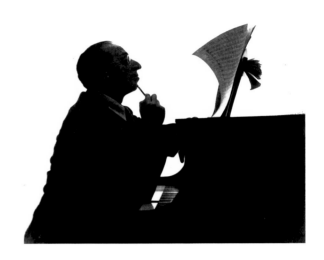

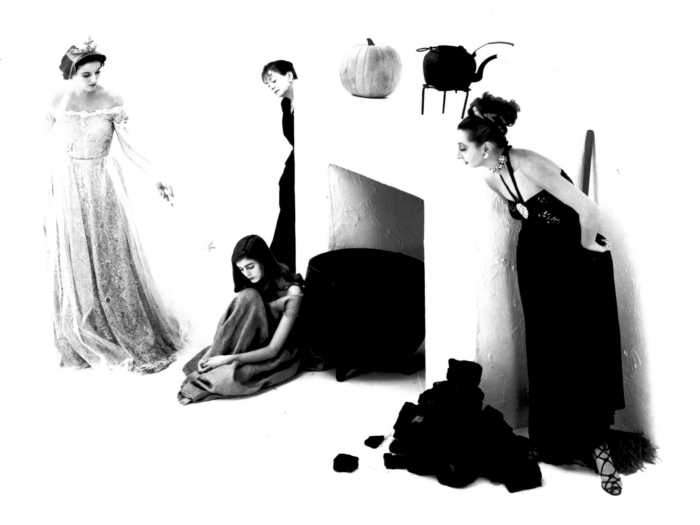

Cinderella, New York, 1946.

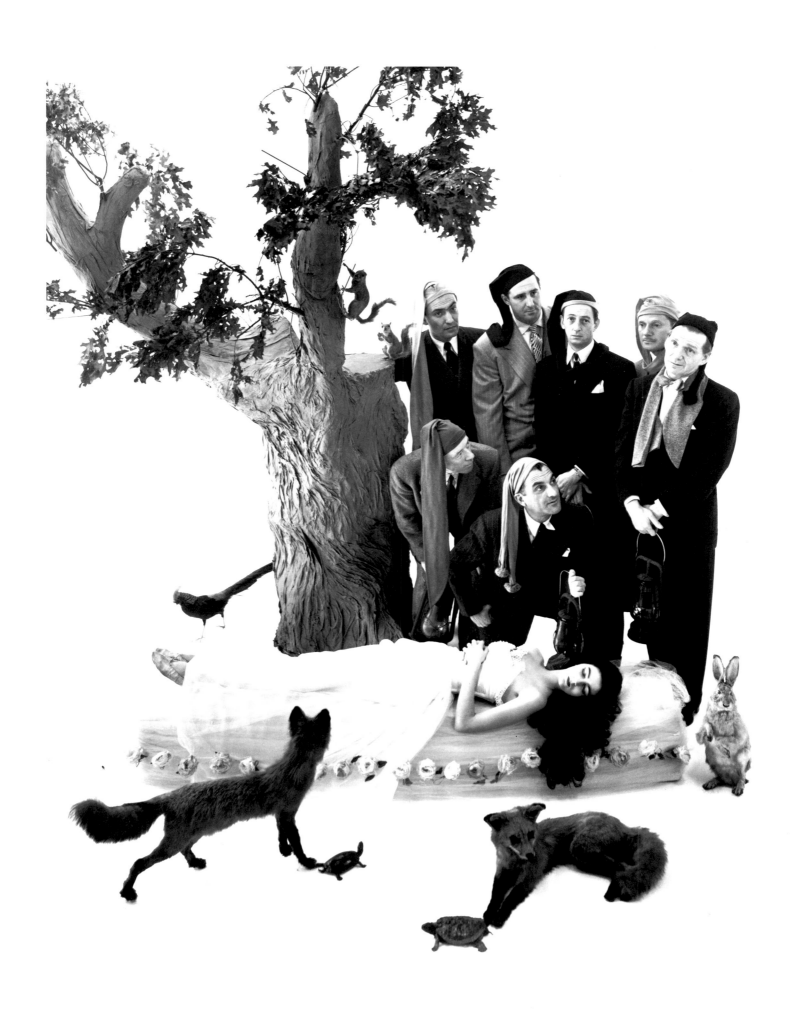

Snow White and the Seven Dwarfs, New York, 1946.

23

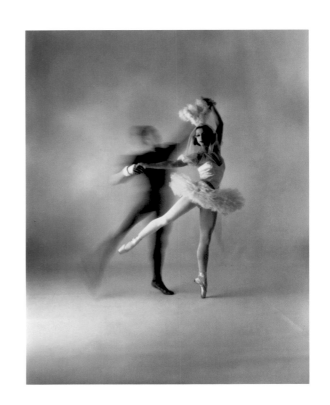

Alexandra Danilova and Frederic Franklin, New York, 1946.

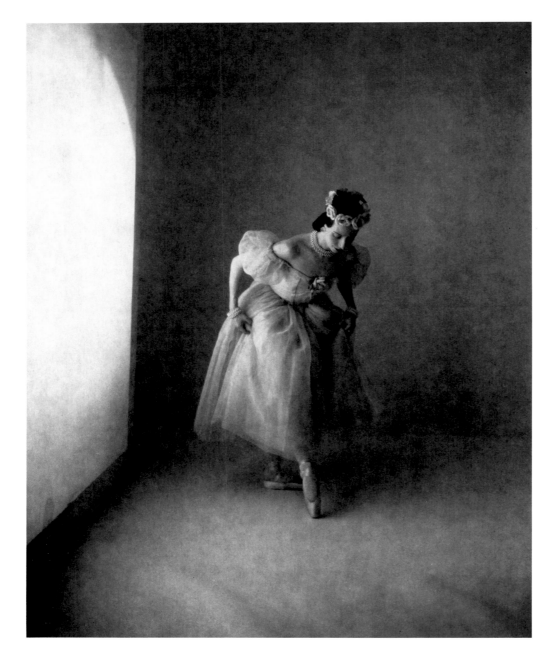

Alicia Markova, New York, 1946.

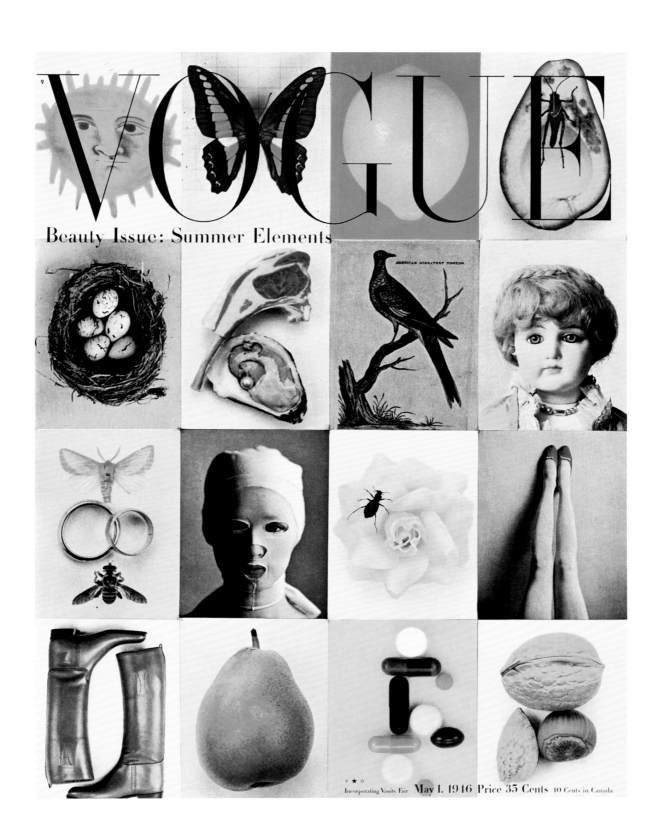

Vogue *Cover: Beauty Elements*, New York, 1946.

In my windowless New York studio I designed a bank of tungsten lights to more or less simulate a skylight. The bank was constructed in a metal frame moved by hand pulley on a ceiling track. I found this to be an agreeable light for the formalized arrangements of people and still lifes I meant to photograph. A drawback of course was the considerable heat of the bulbs and the long exposure times required. For still lifes, exposures could sometimes be hours long.

Theater Accident, New York, 1947.

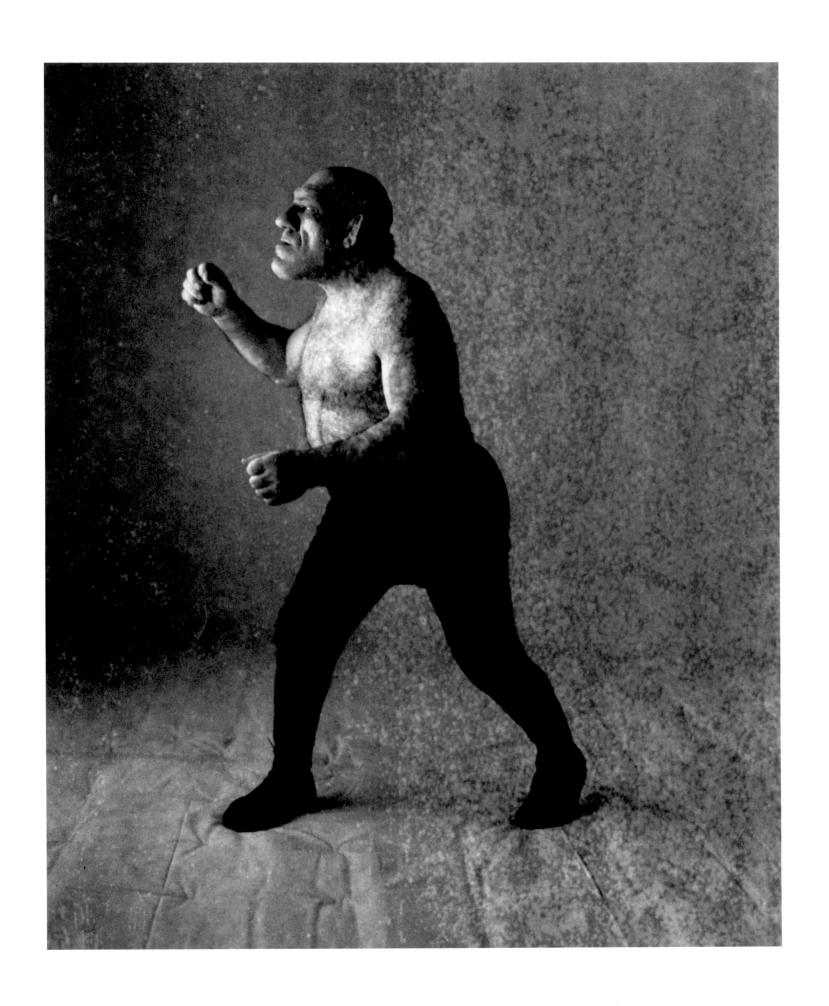

The Angel, New York, 1946.

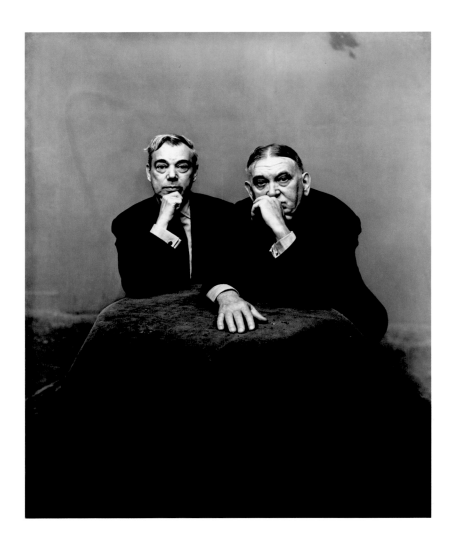

George Jean Nathan and H. L. Mencken, New York, 1947.

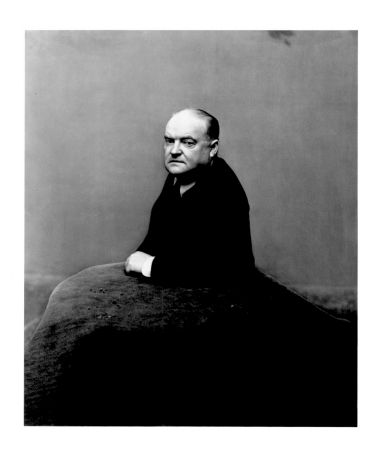

John Marin, New York, 1947.

Edmund Wilson, New York, 1947.

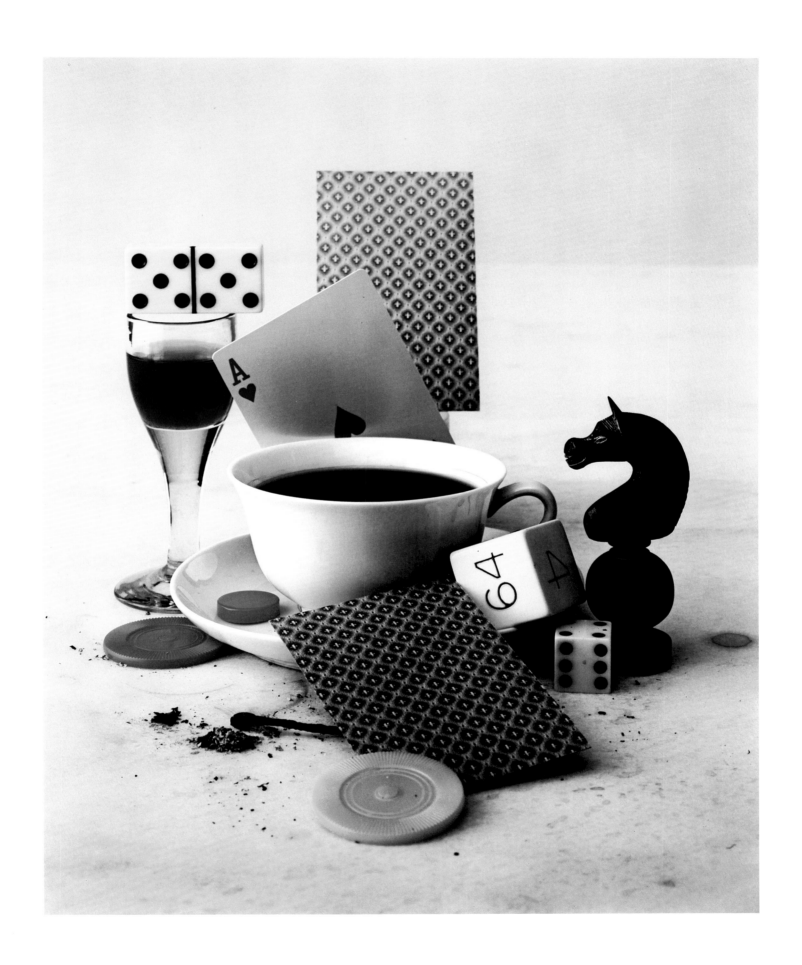

After-Dinner Games, New York, 1947.

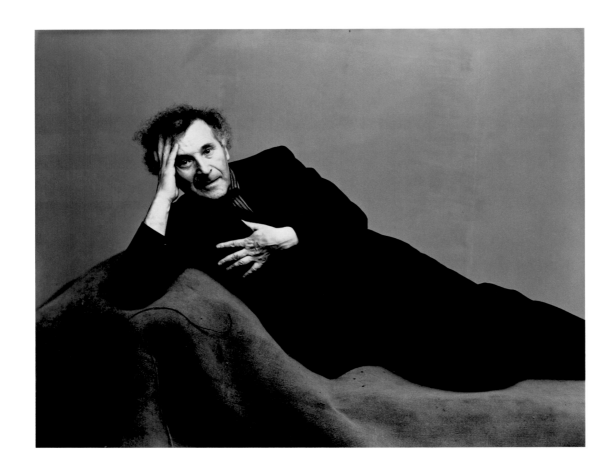

Marc Chagall, New York, 1947.

W. H. Auden, New York, 1947.

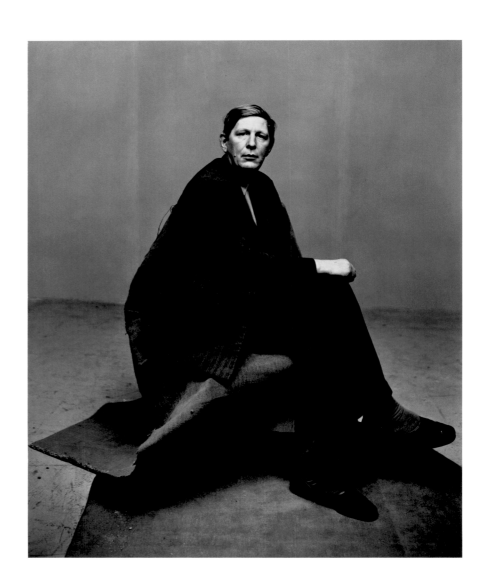

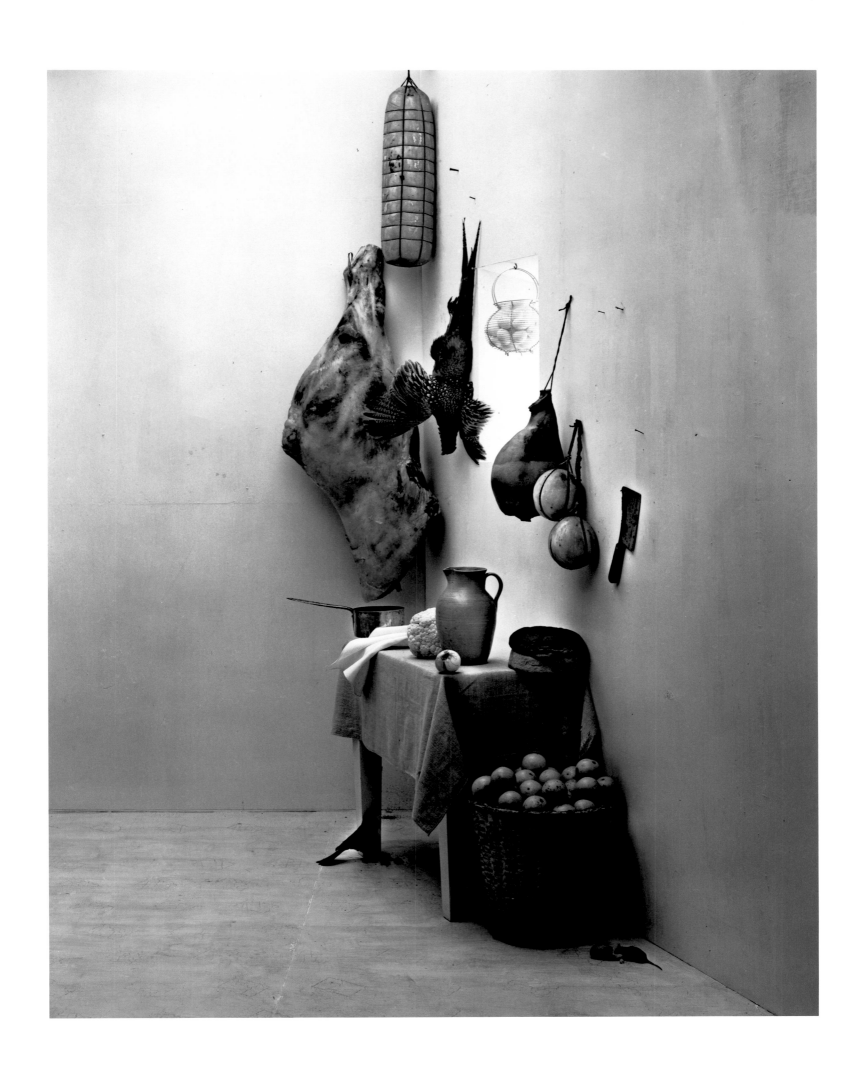

Still Life with Mouse, New York, 1947.

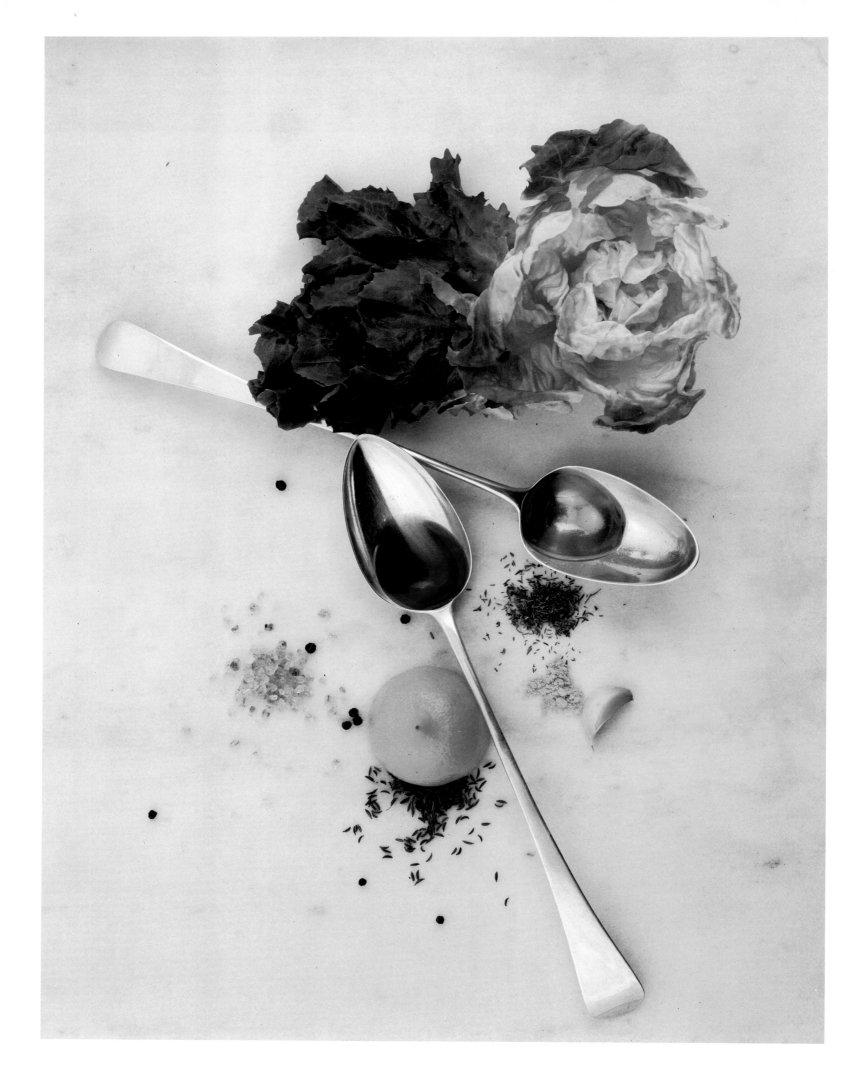

Salad Ingredients, New York, 1947.

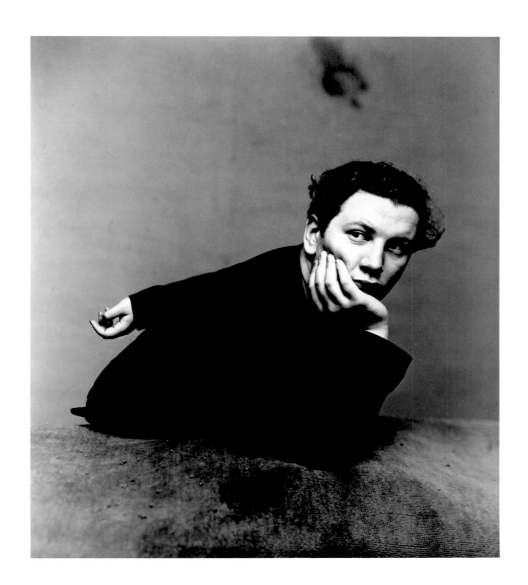

Peter Ustinov, New York, 1947.

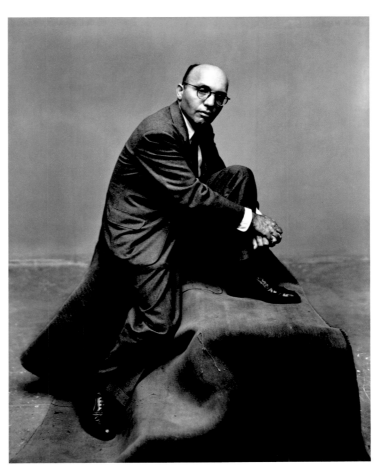

Kurt Weill, New York, 1947.

99-Year-Old House, San Francisco, 1947.

Stephen Spender, New York, 1947.

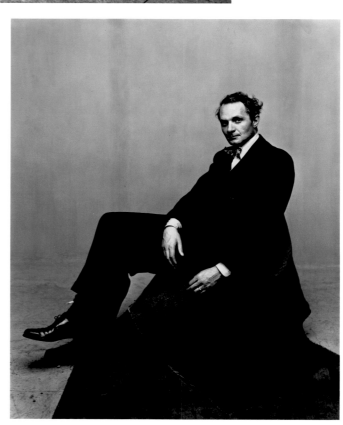

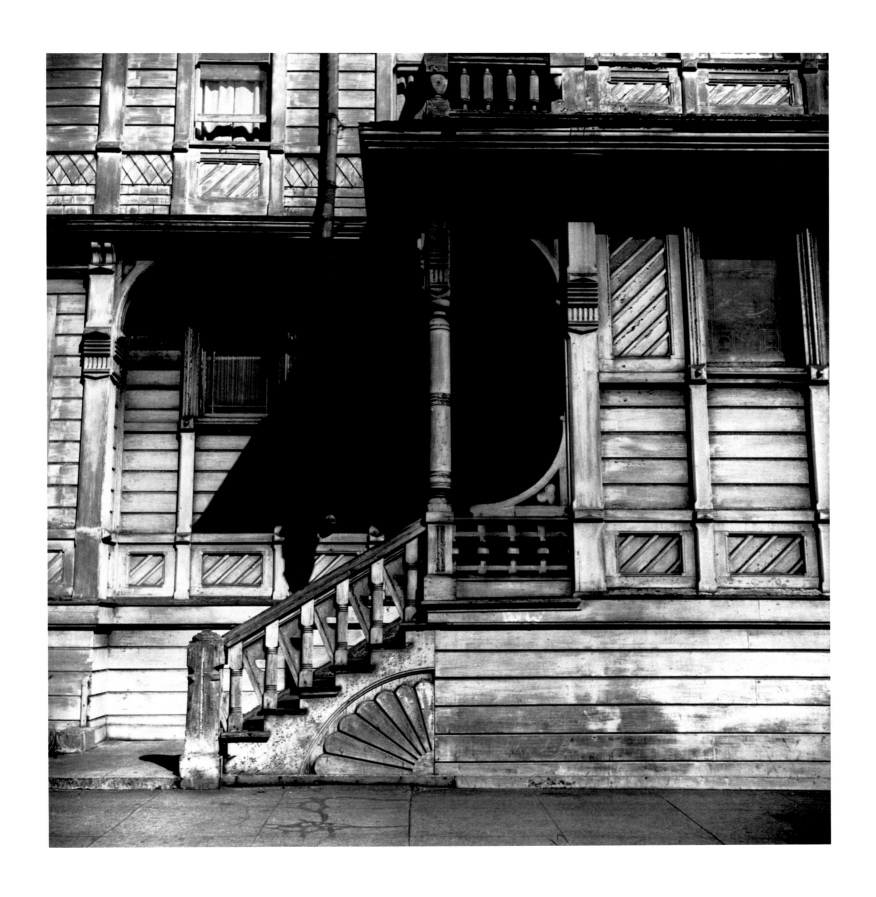

House Front, San Francisco, 1947.

Oliver Smith, Jane Bowles, and Paul Bowles, New York, 1947.

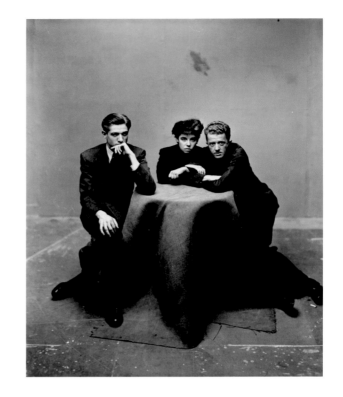

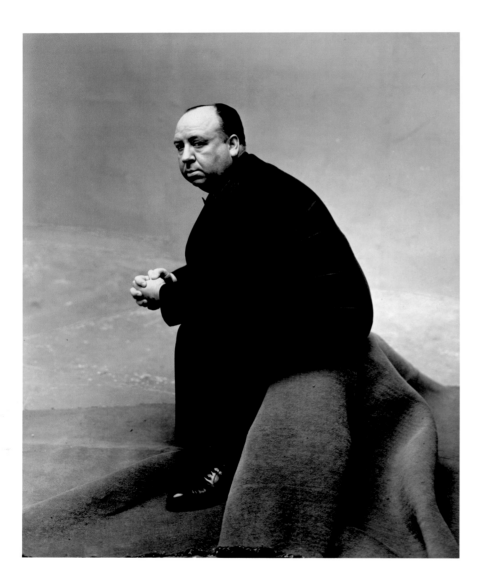

Alfred Hitchcock, New York, 1947.

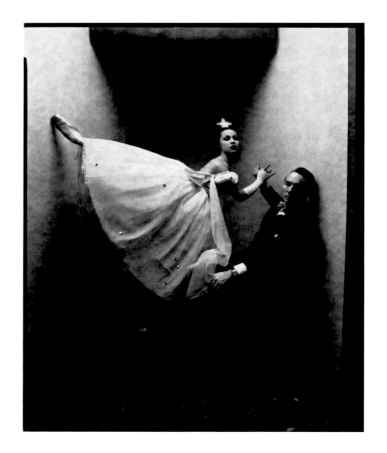

George Balanchine and Maria Tallchief, New York, 1947.

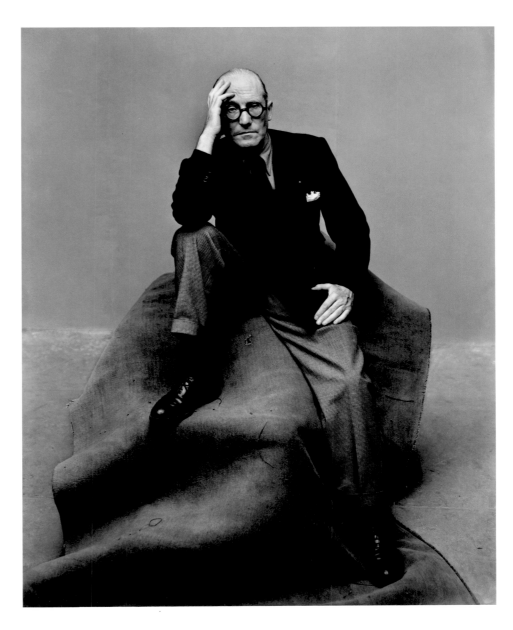

Le Corbusier, New York, 1947.

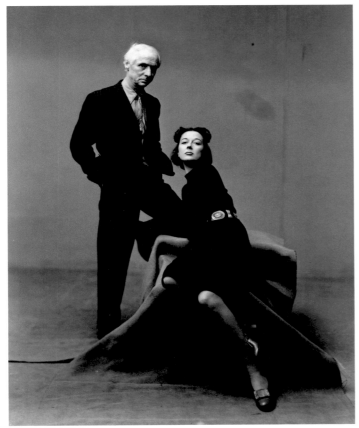

Max Ernst and Dorothea Tanning, New York, 1947.

37

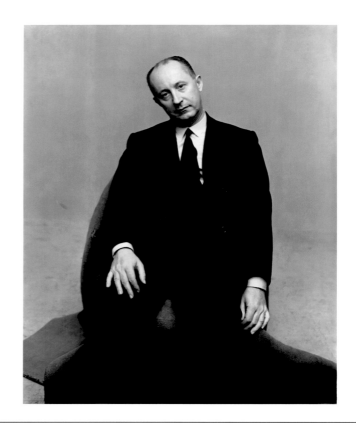

Christian Dior, New York, 1947.

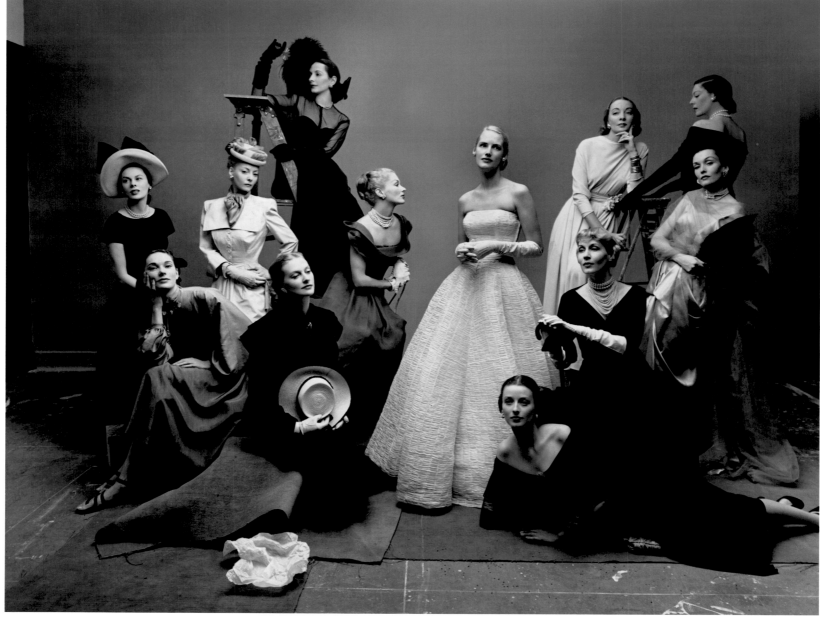

Twelve of the Most Photographed Models of the Period, New York, 1947.

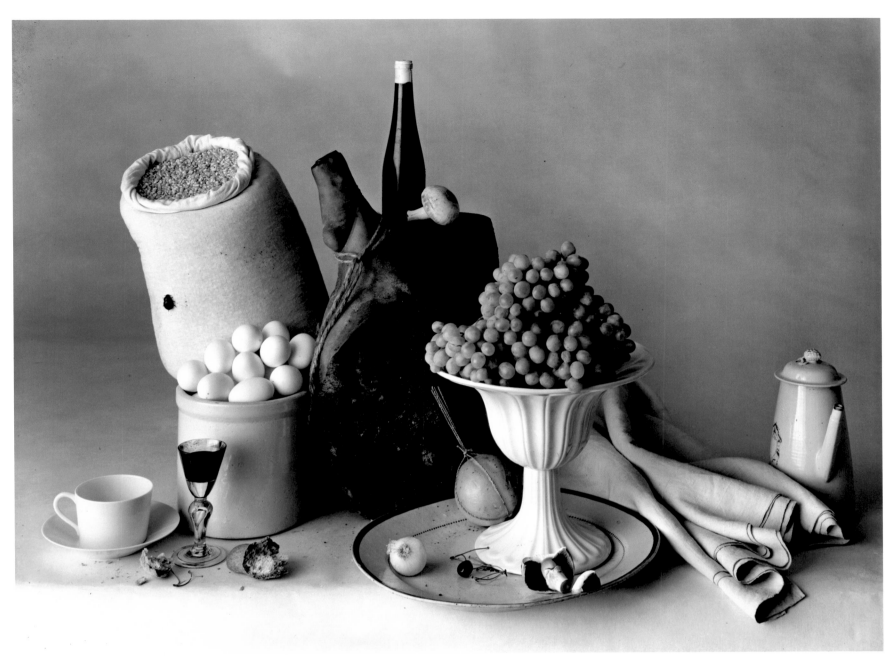

New York Still Life, 1947.

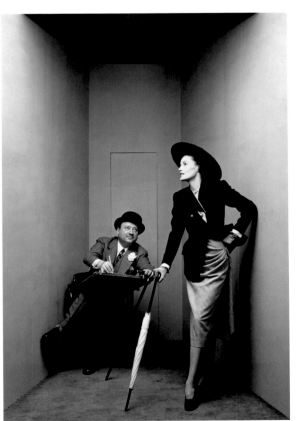

Carl Erickson and Elise Daniels, New York, 1947.

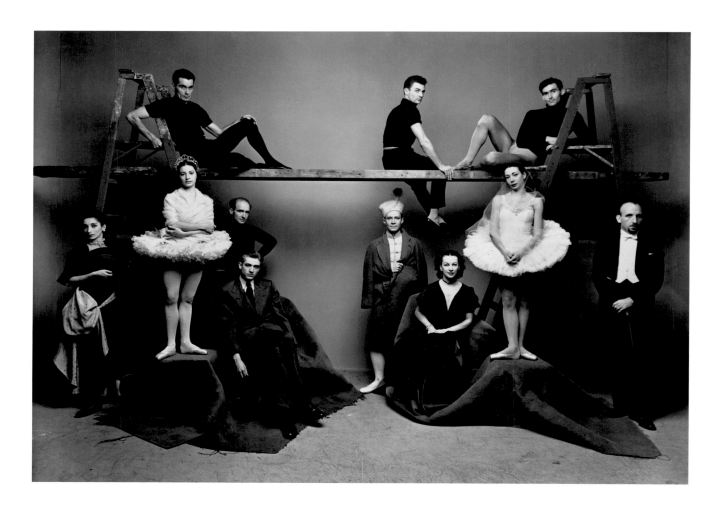

Ballet Theatre Group, New York, 1947.

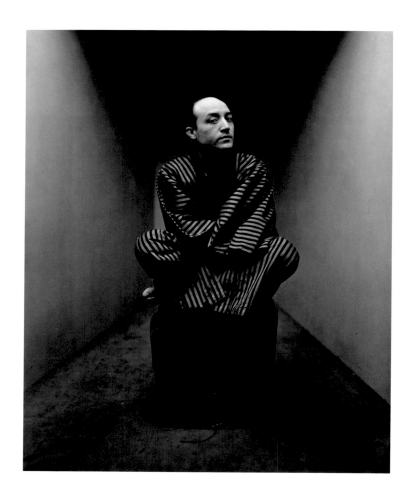

Isamu Noguchi, New York, 1947.

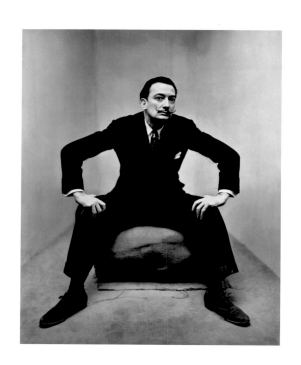

Salvador Dali, New York, 1947.

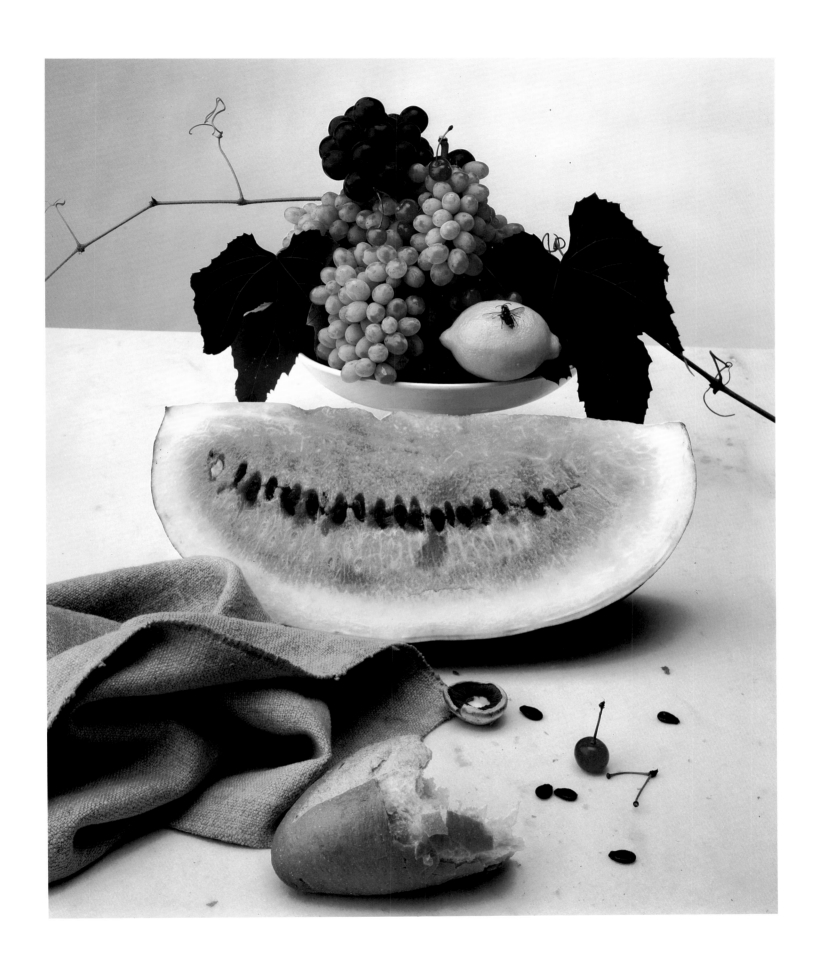

Still Life with Watermelon, New York, 1947.

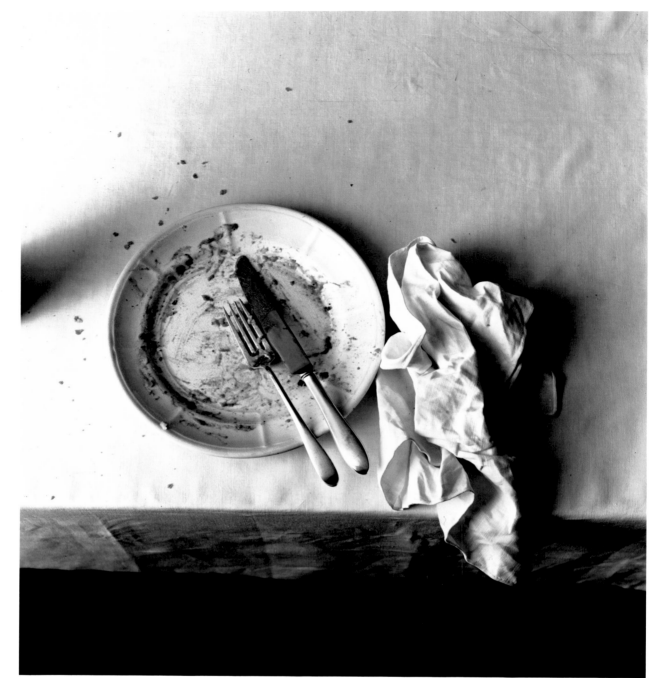

The Empty Plate, New York, 1947.

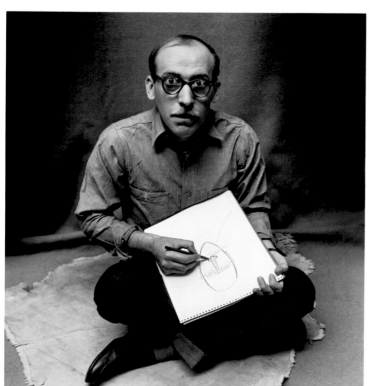

Saul Steinberg, New York, 1947.

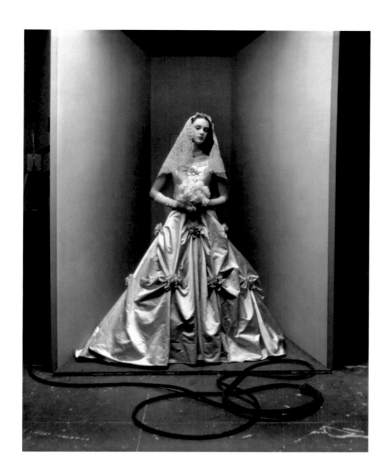

Mrs. Amory S. Carhart, Jr., New York, 1947.

Ray Bolger, New York, 1947.

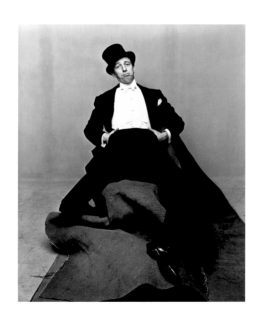

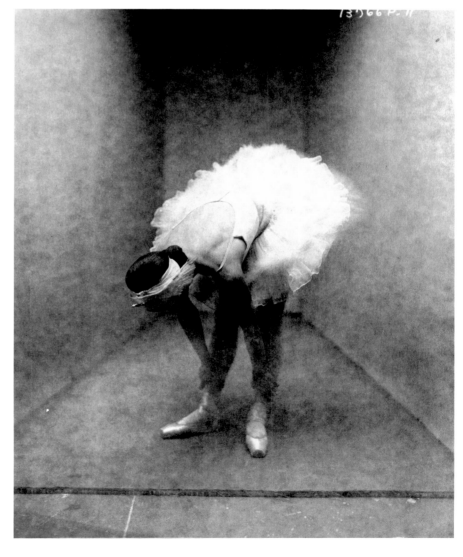

Alexandra Danilova, New York, 1947.

Edmonde Charles-Roux accompanied me in doing most of the portraits I made in France and Italy. She had that valuable quality in a journalist of always being *of* the people we were photographing. Her presence relieved me of some of the language struggle and soothed the nervousness some Frenchmen feel with me.

It was not until much later, in 1986, in a catalogue essay she wrote for an exhibition in Monte Carlo, that I learned with surprise, and some chagrin, of her difficulties in arranging our sittings.

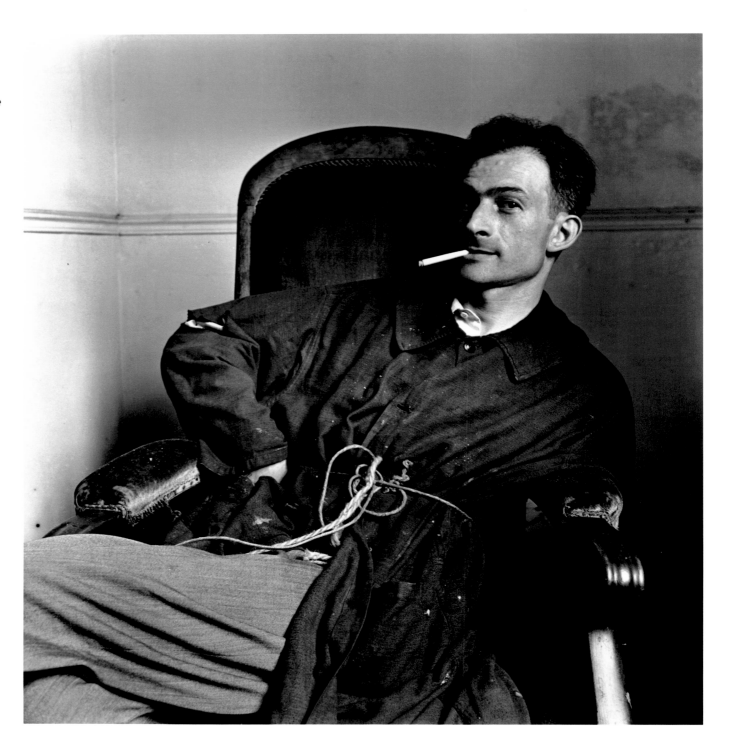

Balthus, Paris, 1948.

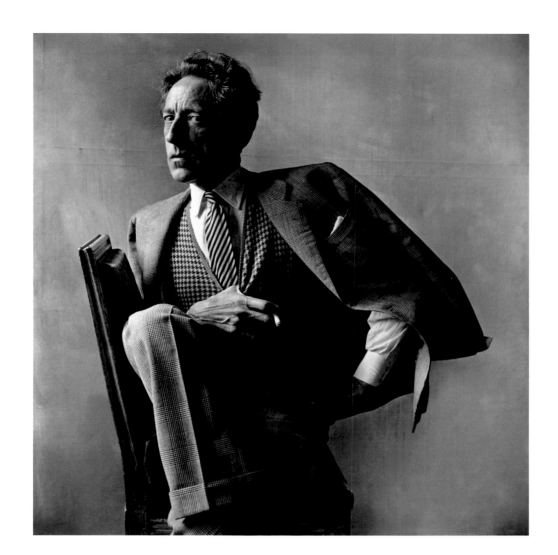

Jean Cocteau, Paris, 1948.

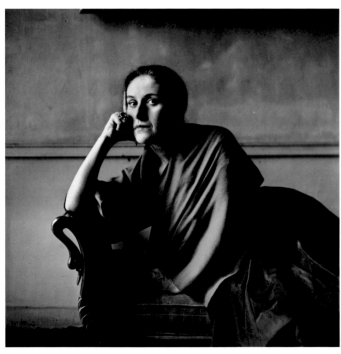

Dora Maar, France, 1948.

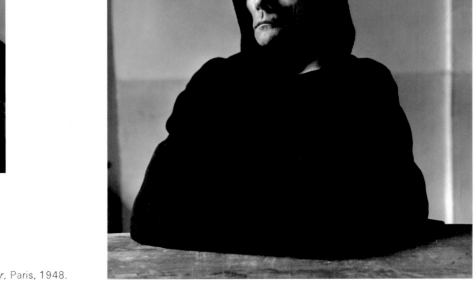

Père Couturier, Paris, 1948.

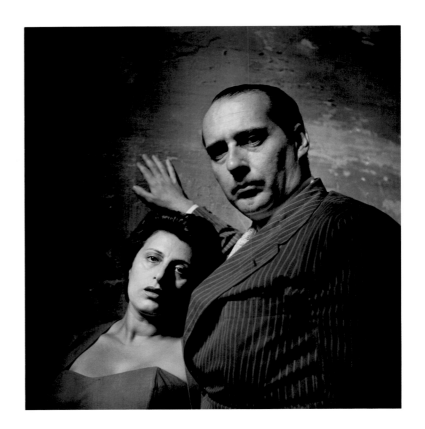

Roberto Rossellini and Anna Magnani, Rome, 1948.

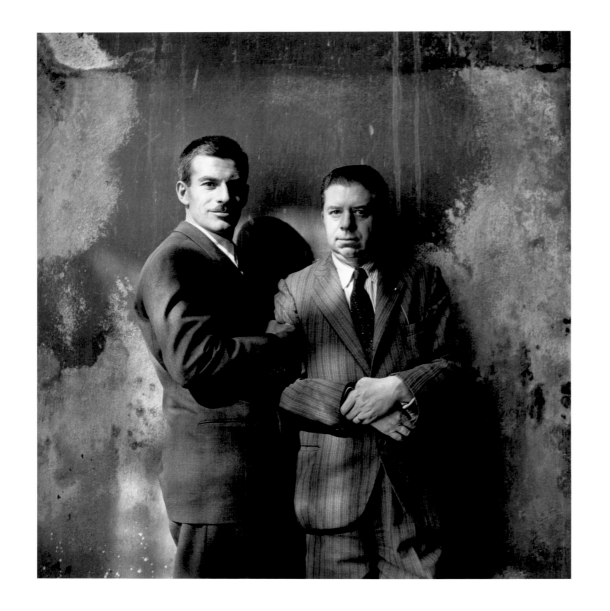

Elio Vittorini and Eugenio Montale, Milan, 1948.

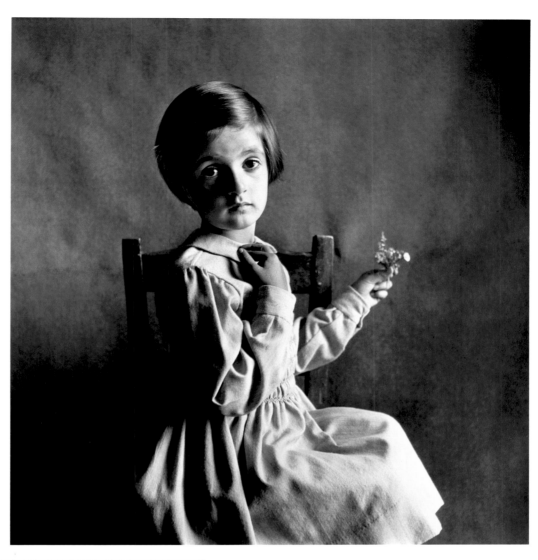

Child of Florence, Italy, 1948.

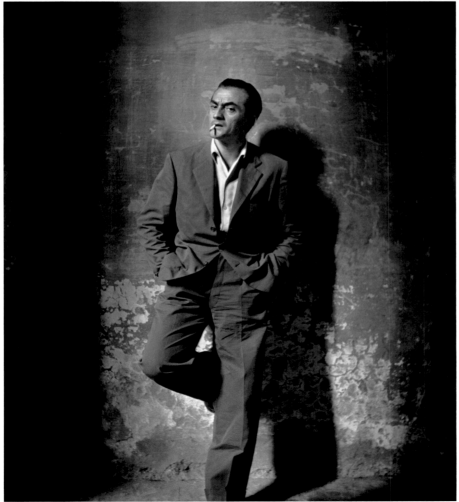

Luchino Visconti, Rome, 1948.

47

1948

A few days before I was to leave for Spain to photograph an essay for Vogue to be called "Picasso's Barcelona," I met Salvador Dali in New York and mentioned my trip to him. I was pleased by the interest he showed in the project but taken aback when I arrived at my Barcelona hotel to find him there, prepared to influence the decisions I made. Since I carried with me from New York a studied agenda, I believe he sensed that his pressure was not entirely welcome. I was grateful, however, when he arranged to have a young relative of his and her friends perform Catalonian dances in costume for the camera, and I soothed his feelings by giving more importance to the cathedral of his esteemed Gaudí than I otherwise might have. I admit I wasn't upset when after a few days he seemed to lose interest and disappeared.

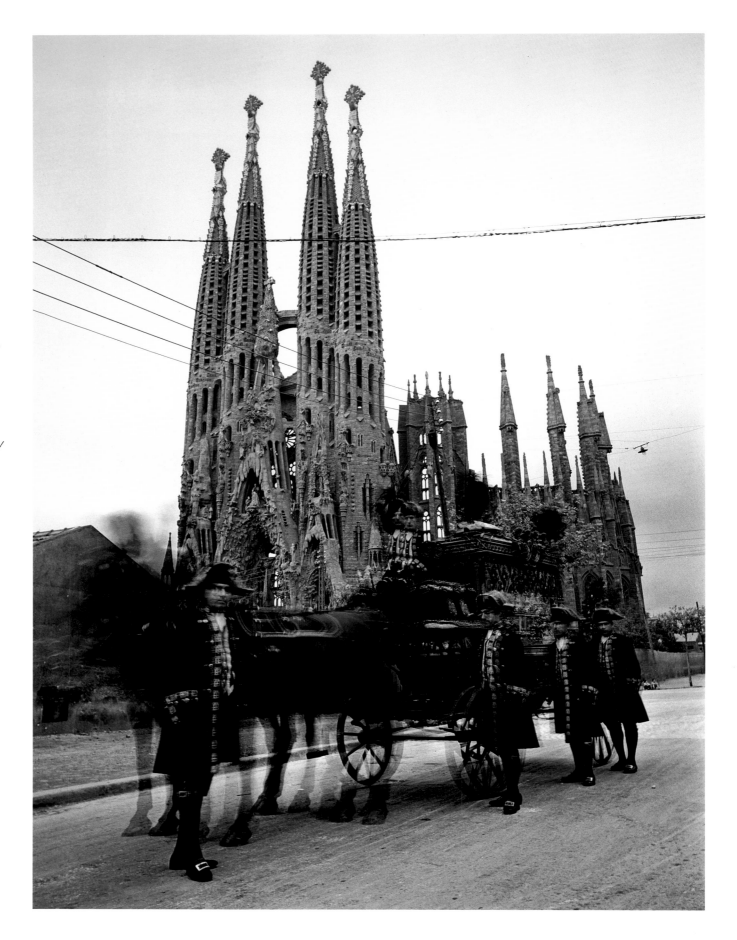

Funeral Cortege, Gaudí Cathedral (La Sagrada Familia), Barcelona, 1948.

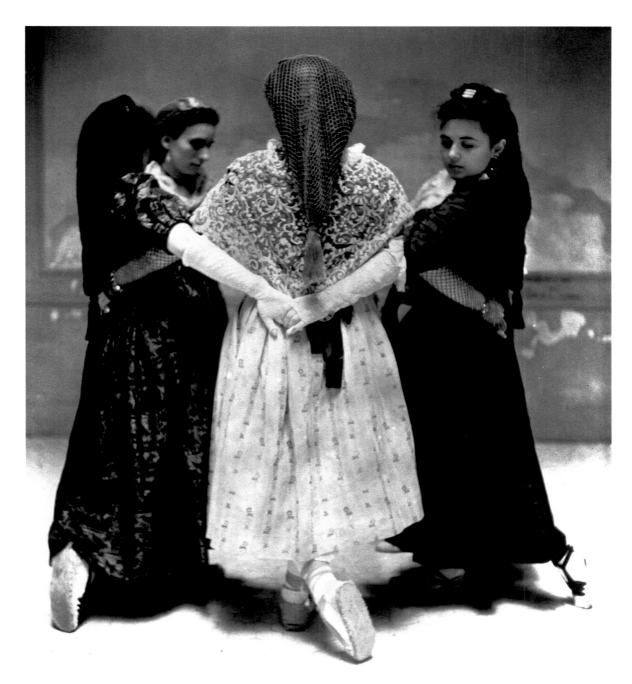

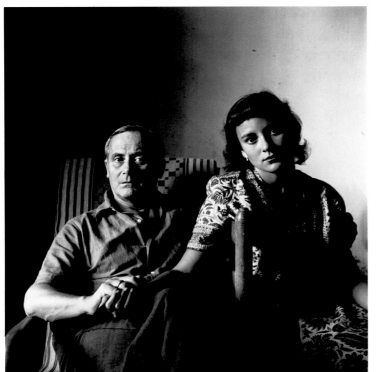

Catalonian Dancers, Barcelona, 1948.

Joan Miró and His Daughter, Dolores, Tarragona, 1948.

49

1948

Sometime in 1948 I began photographing portraits in a small corner space made of two studio flats pushed together, the floor covered with a piece of old carpeting. A very rich series of pictures resulted.

This confinement, surprisingly, seemed to comfort people, soothing them. The walls were a surface to lean on or push against. For me the picture possibilities were interesting; limiting the subjects' movement seemed to relieve me of part of the problem of holding on to them.

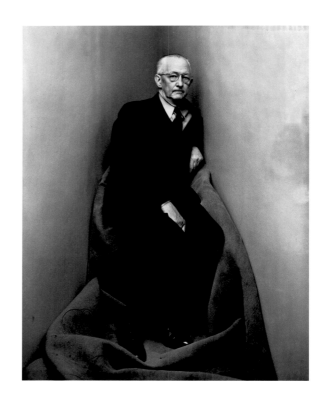

Charles Sheeler, New York, 1948.

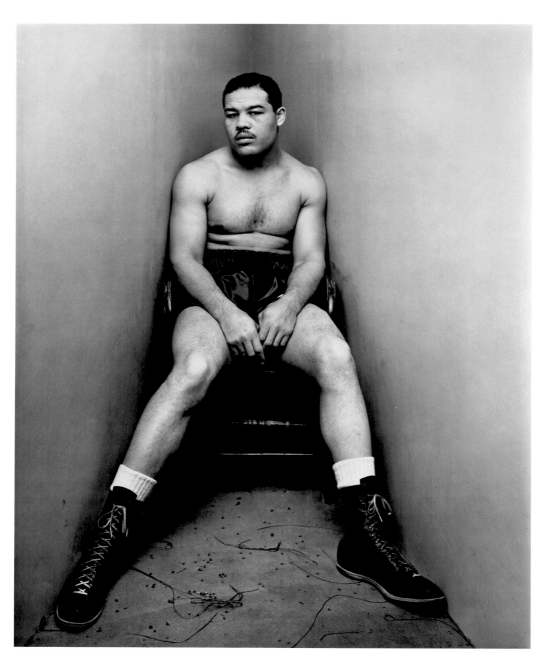

Joe Louis, New York, 1948.

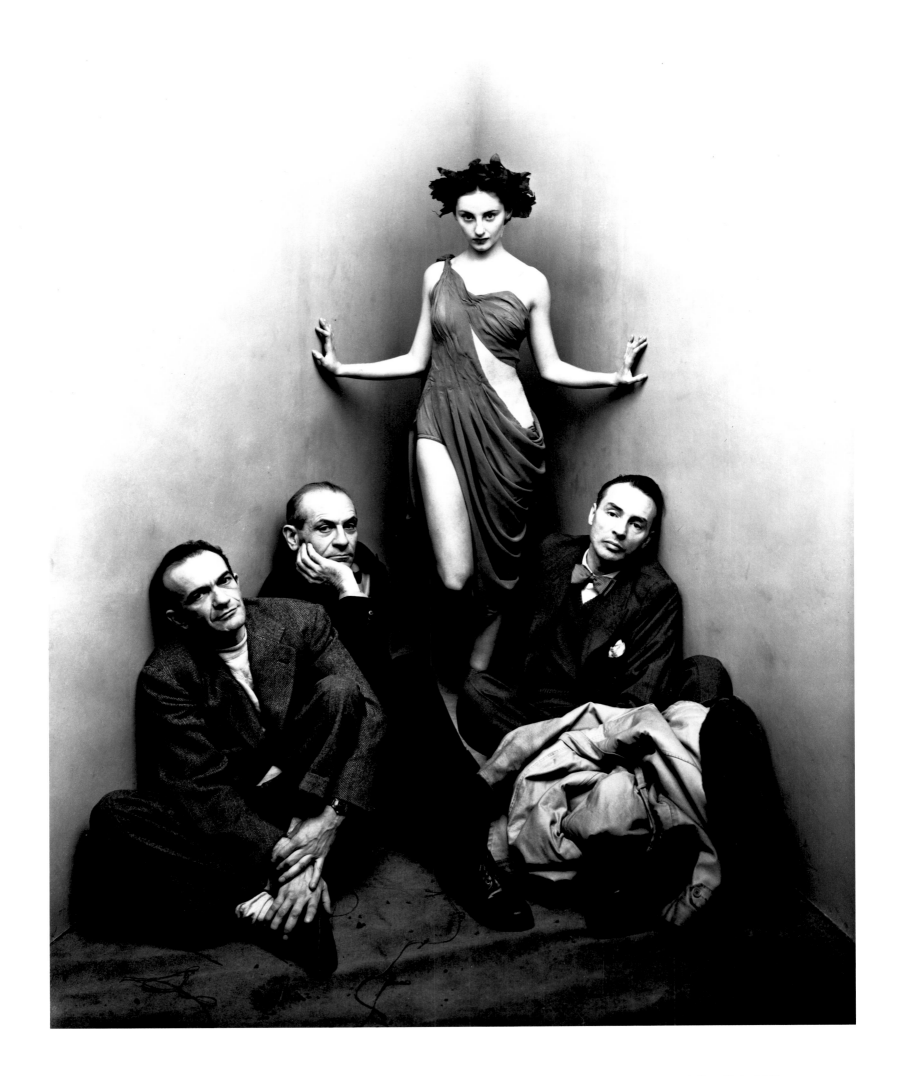

Ballet Society (left to right: Corrado Cagli, Vittorio Rieti, Tanaquil Le Clercq, and George Balanchine), New York, 1948.

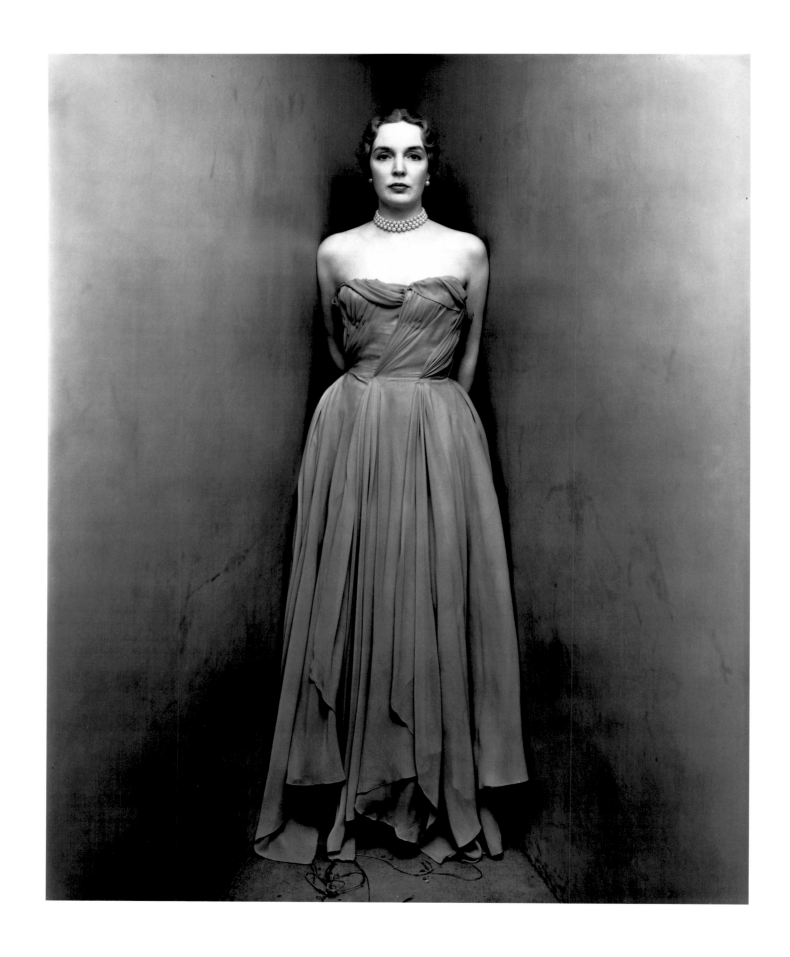

Mrs. William Rhinelander Stewart, New York, 1948.

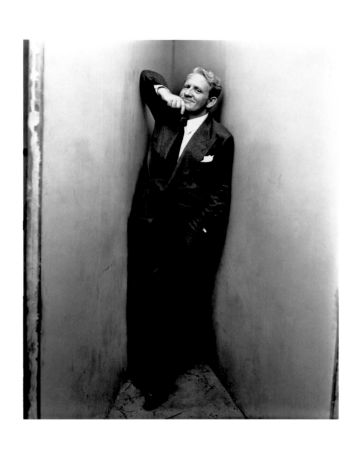

Arthur Rubinstein, New York, 1948.

Spencer Tracy, New York, 1948.

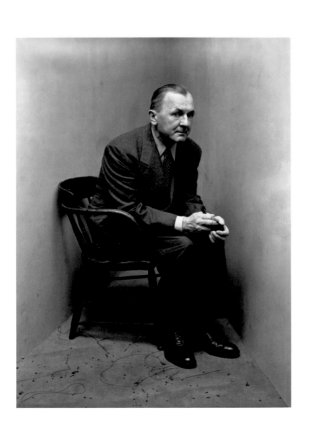

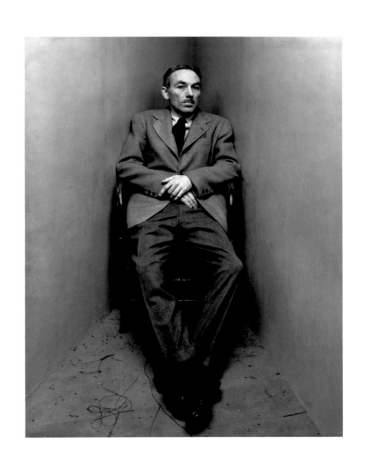

E. B. White, New York, 1948.

George Grosz, New York, 1948.

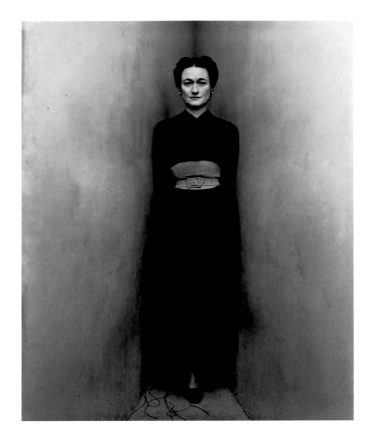

Duchess of Windsor, New York, 1948.

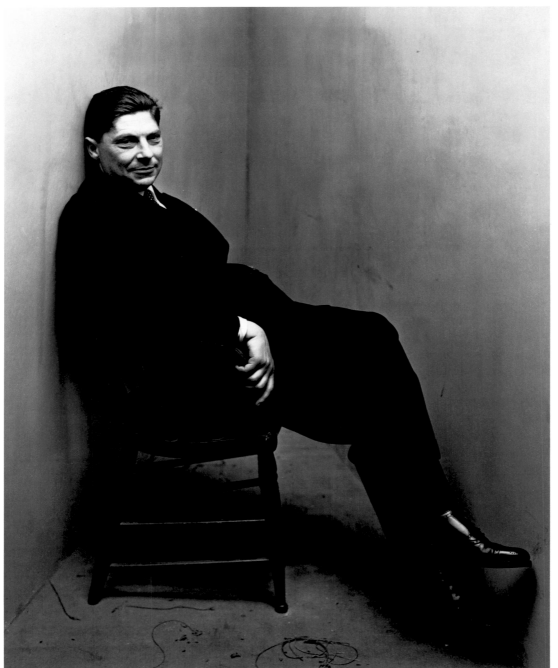

Arthur Koestler, New York, 1948.

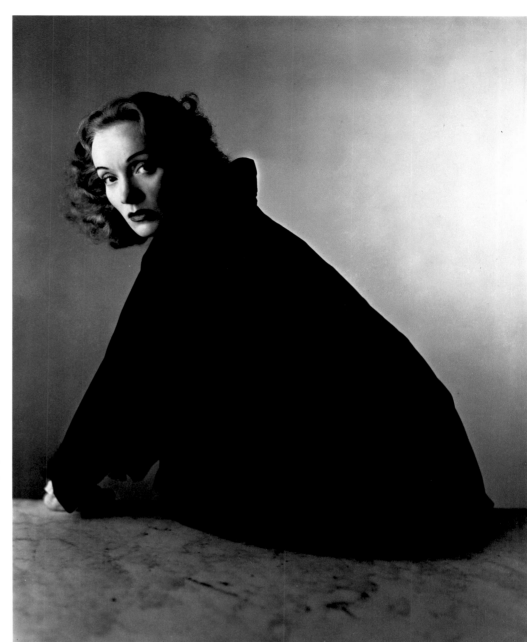

Marlene Dietrich, New York, 1948.

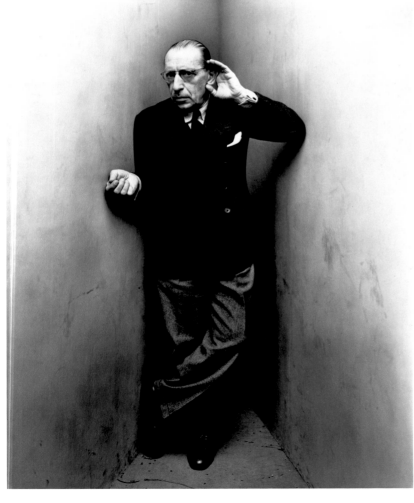

Igor Stravinsky, New York, 1948.

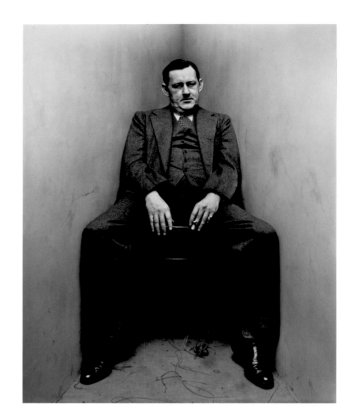

John O'Hara, New York, 1948.

Fashion Photograph in a Café (Jean Patchett), Lima, 1948.

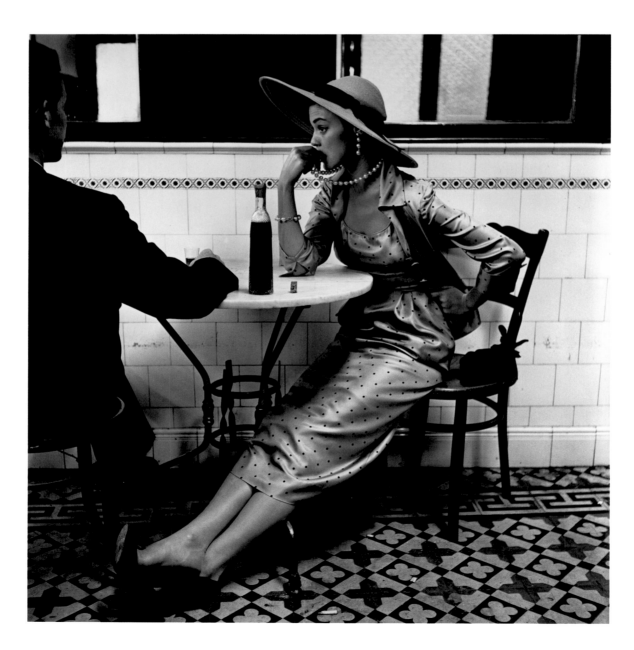

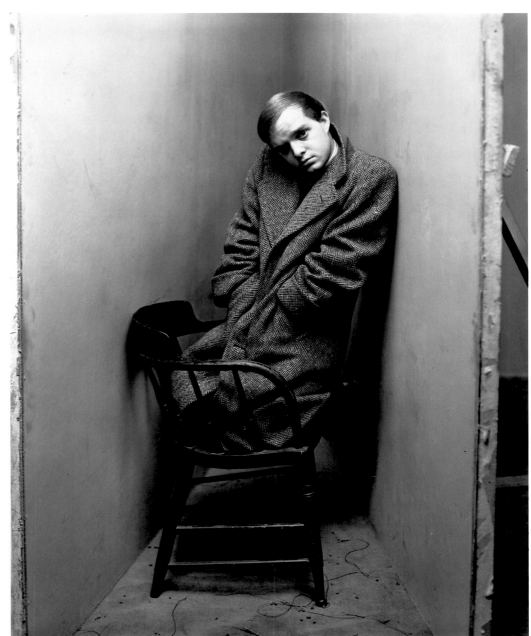

Truman Capote, New York, 1948.

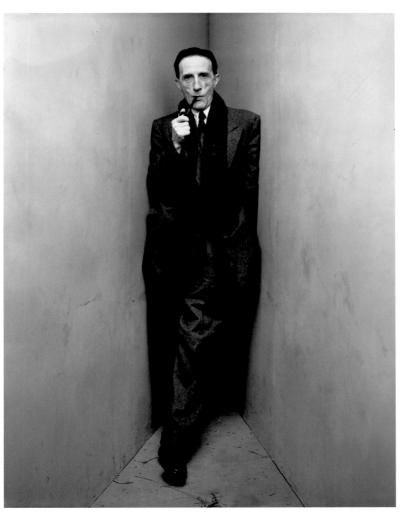

Marcel Duchamp, New York, 1948.

I stayed behind in Peru in December 1948, after an assignment photographing dresses for Vogue in Lima. The rest of our work party left for New York with the exposed film. I decided to spend Christmas in Cuzco, a town I had heard about and had a hunch about. I hungered to begin photographing its people the moment I set eyes on them, but the altitude was too much for me. For three days I was forced to stay in my hotel room. On the fourth day I rose with energy greater than I had ever felt before. I hurried to the center of town, as intoxicated with the people as I had been the moment I stepped off the plane. I longed to photograph. And then, by incredible providence, there in the center of town was a daylight studio! A Victorian leftover, one broad wall of light to the north, a stone floor, a painted cloth backdrop—a dream come true. I hired the use of the studio for the next three days, sending the proprietor away to spend Christmas with his family, and set myself up as town photographer. When subjects arrived to be photographed they found me instead of him. Instead of them paying me, I paid them for posing, a very confusing affair. Still the normal flow of customers was too slow for my appetite. I sent some young people into the streets to more or less capture subjects for me. The best for pictures were country people who came to Cuzco from the valleys below or from the hills above to spend a few days visiting in town.

The people my helpers brought me shook with nervousness at the idea of posing. Some even seemed not to know what a camera was. Their bodies became rigid with fear. Because they understood only their native Quechuan, I had to communicate through two interpreters—too tedious a process. In frustration, I posed the subjects by hand, moving and bending them. Their muscles were stiff and resistant.

Since facing a camera in the hands of a stranger in a strange room was a fearful experience for these simple people, I was surprised and touched that on the second and third mornings the courtyard outside the studio was filled with many subjects of the day before. After they had considered the strange happening, it had come to be an experience they apparently wanted to repeat.

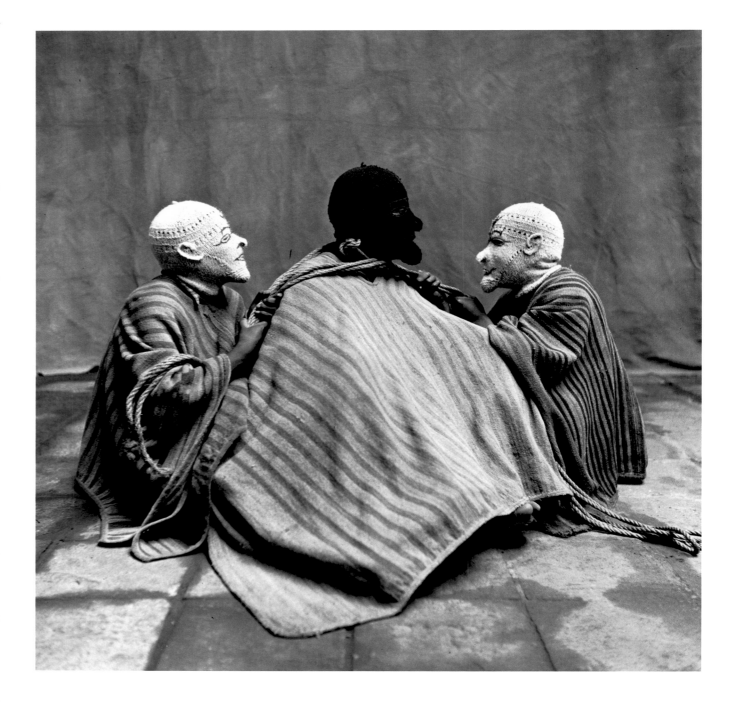

Three Sitting Men in Masks, Cuzco, 1948.

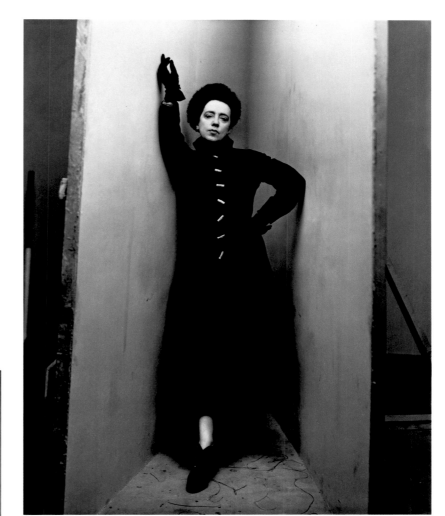

Elsa Schiaparelli, New York, 1948.

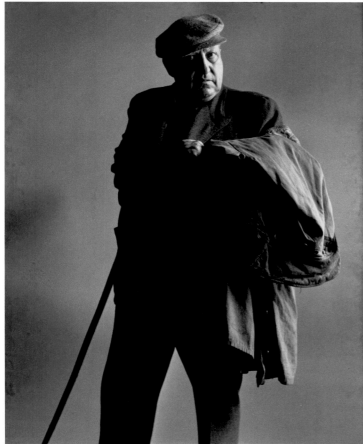

André Derain, Saint-Germain, France, 1948.

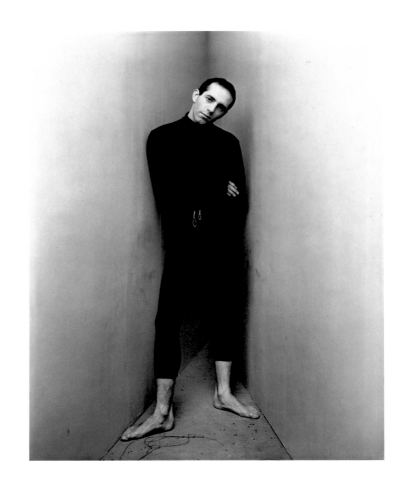

Jerome Robbins, New York, 1948.

Young Quechuan Man, Cuzco, 1948.

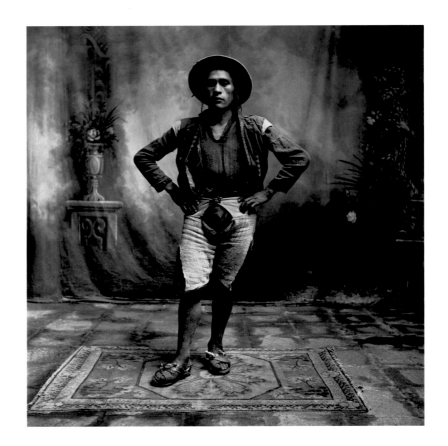

Father Kneeling with Seated Child, Cuzco, 1948.

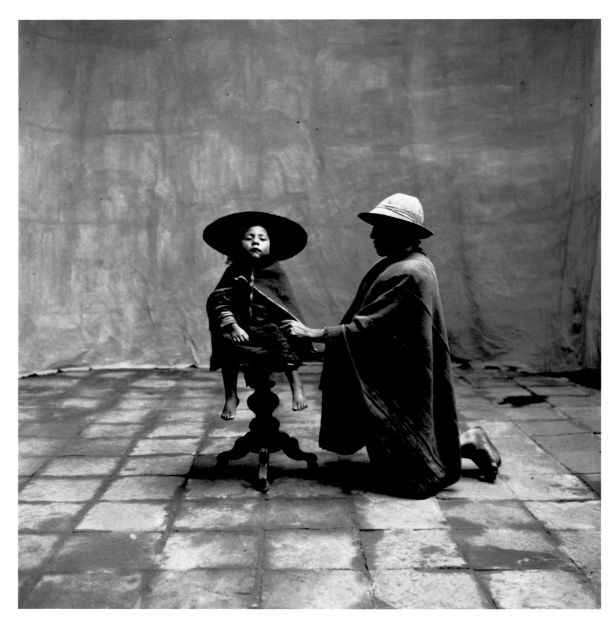

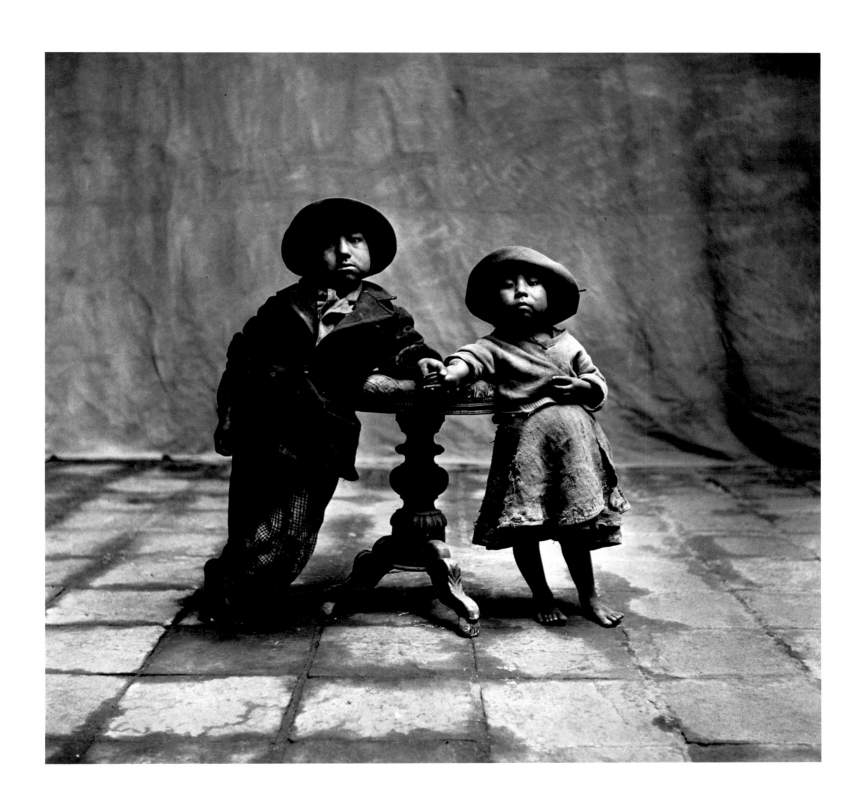

Brother and Sister, Cuzco, 1948.

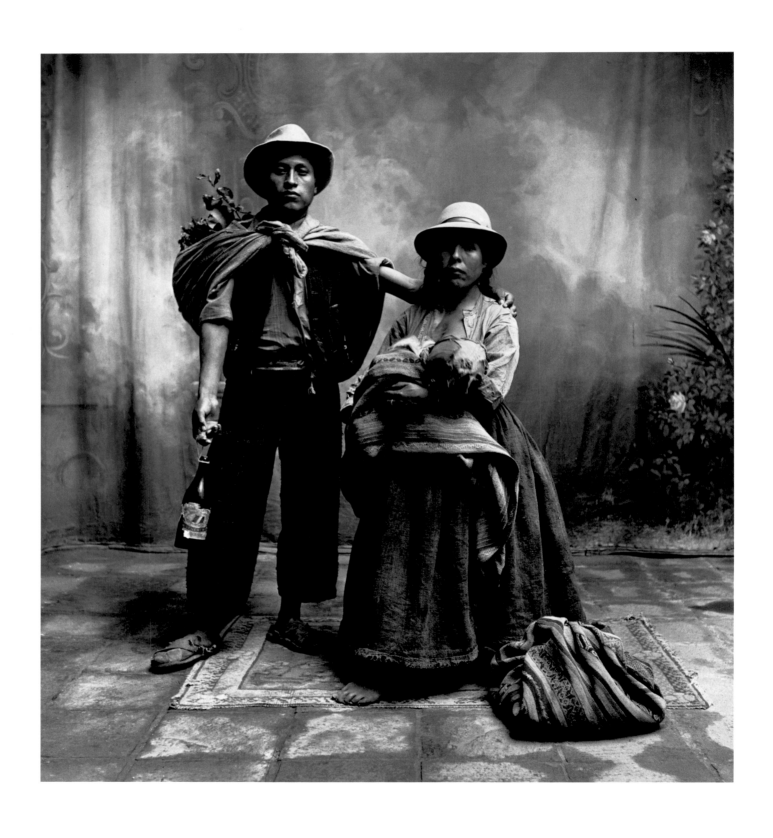

Family with Mother Nursing Child, Cuzco, 1948.

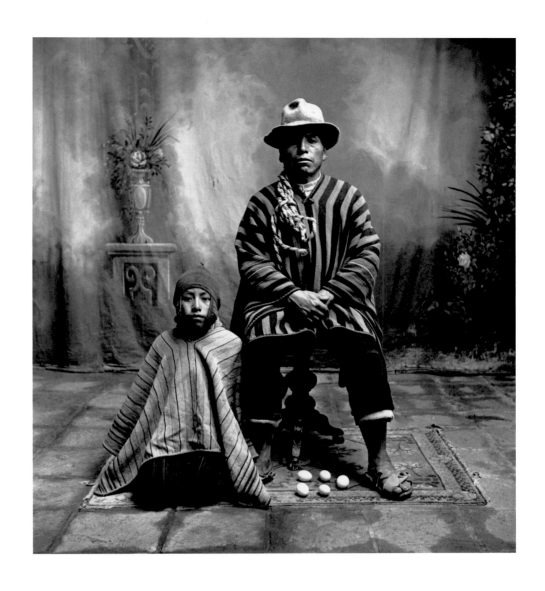

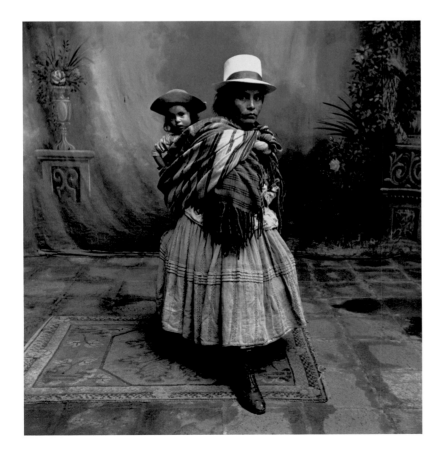

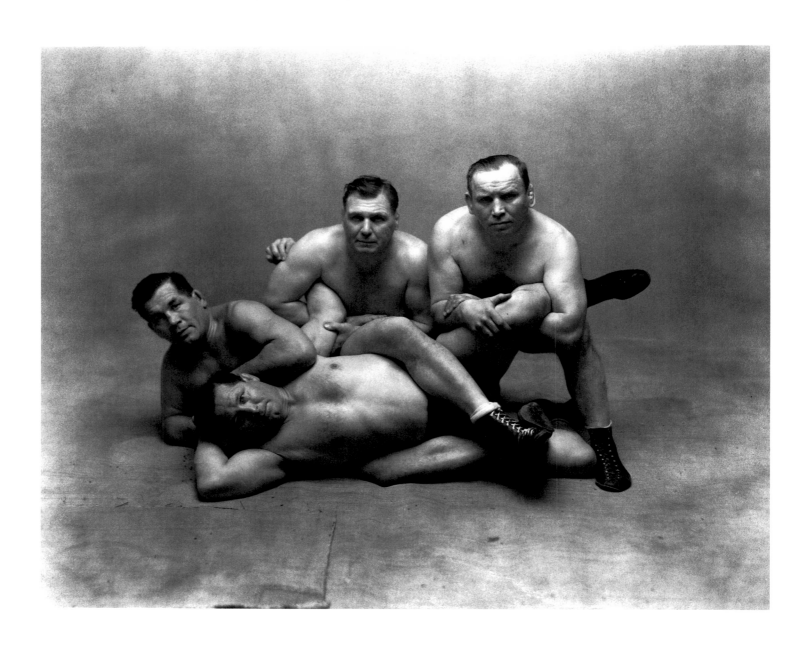

The Dusek Brothers, New York, 1948.

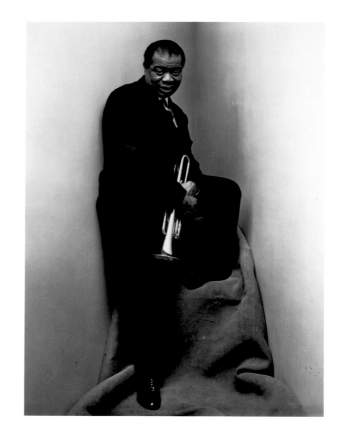

Louis Armstrong, New York, 1948.

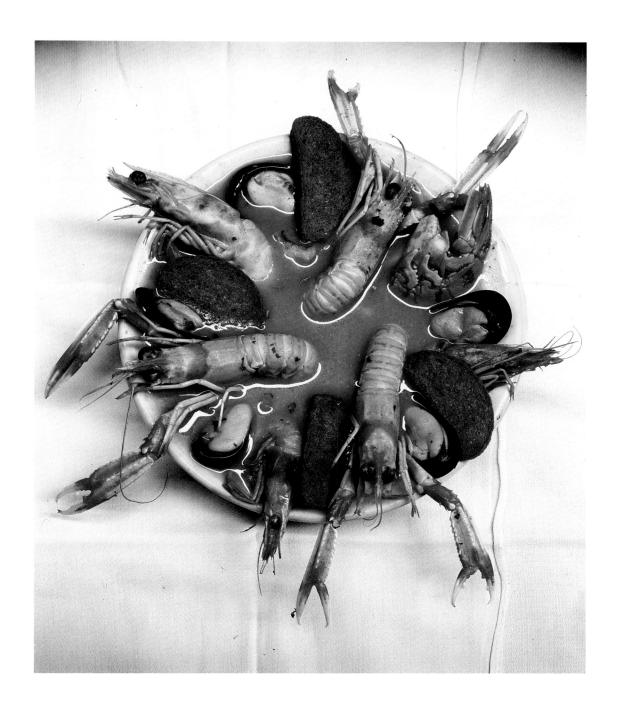

Bouillabaisse at Los Caracoles, Barcelona, 1948.

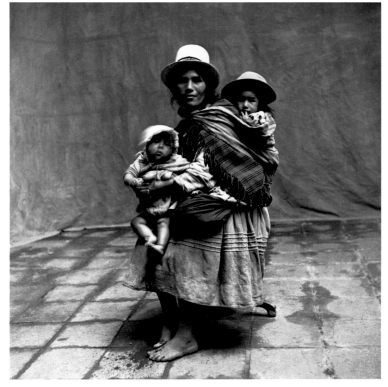

Seated Mother Carrying Two Children, Cuzco, 1948.

During the year 1949, I worked —whenever there was time between assignments—photographing the nude female body. For subjects I turned to women who worked as professional models for painters and sculptors; most were soft and fleshy, some very heavy. But more important, they were comfortable with their bodies. It helped that their personalities were generally relaxed and uncomplaining, and that they were not apprehensive of close examination by the camera. The relationship between us was professional, without a hint of sexual response. Anything else would have made pictures like these impossible.

Nude No. 92, New York, 1949–50.

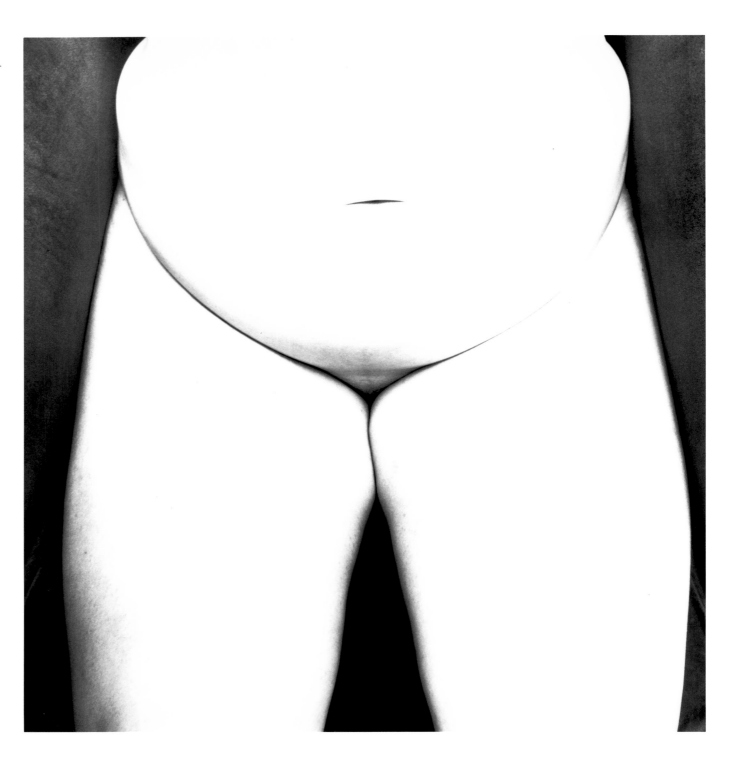

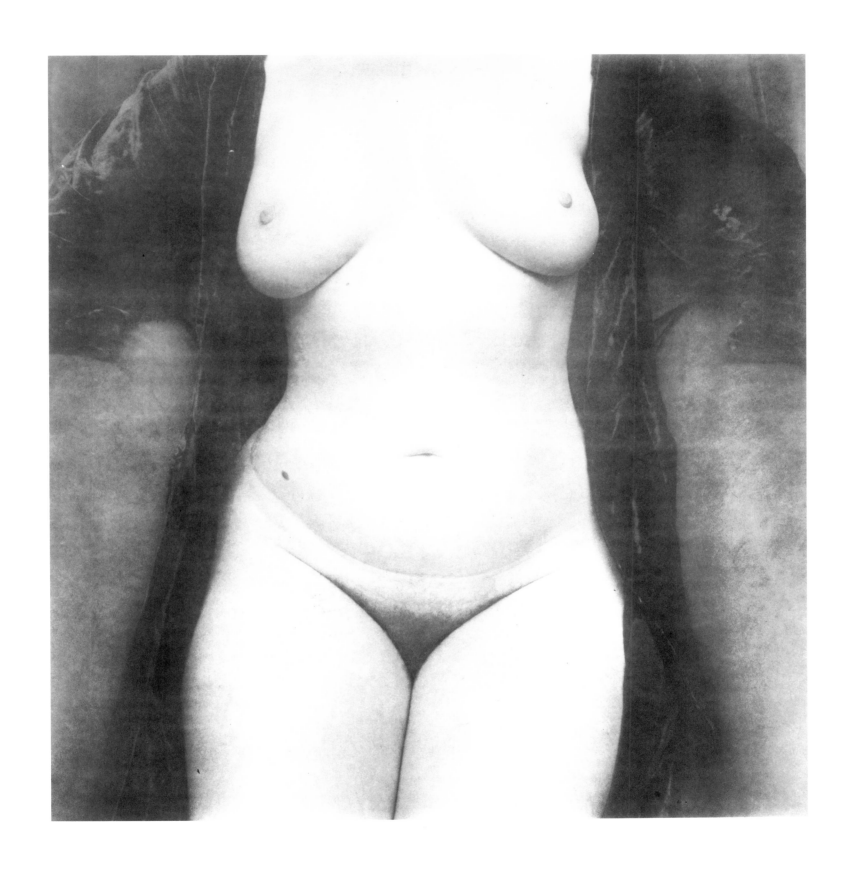

Nude No. 111, New York, 1949–50.

Nude No. 18, New York, 1949–50.

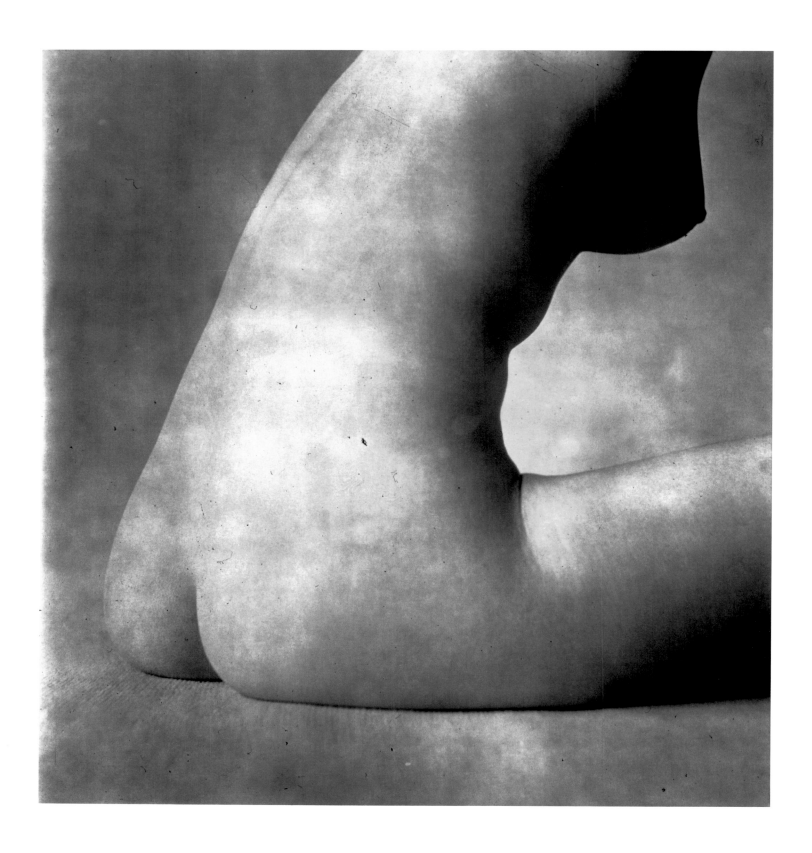

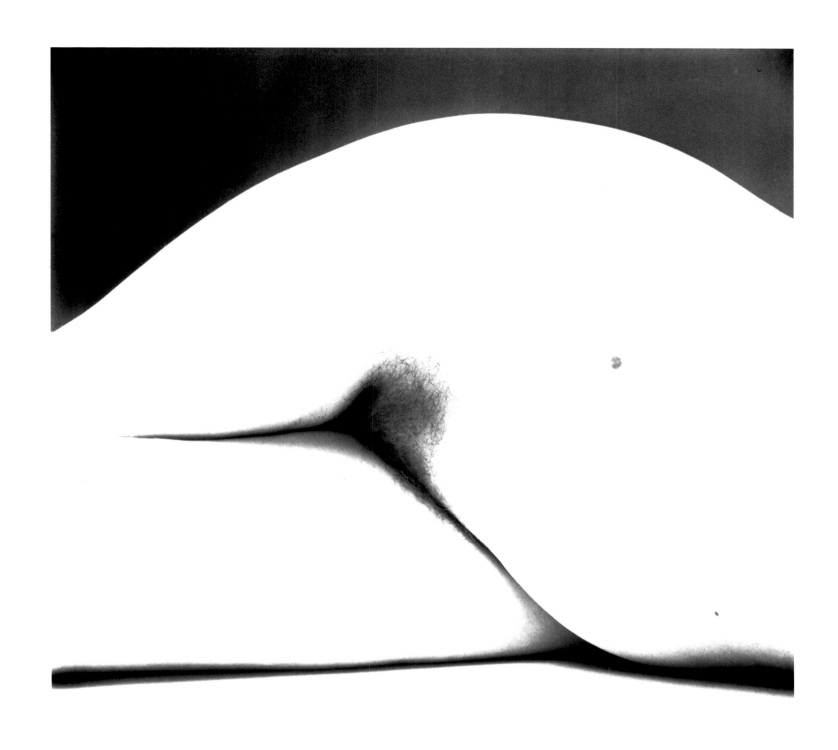

Nude No. 65, New York, 1949–50.

Nude No. 139, New York, 1949–50.

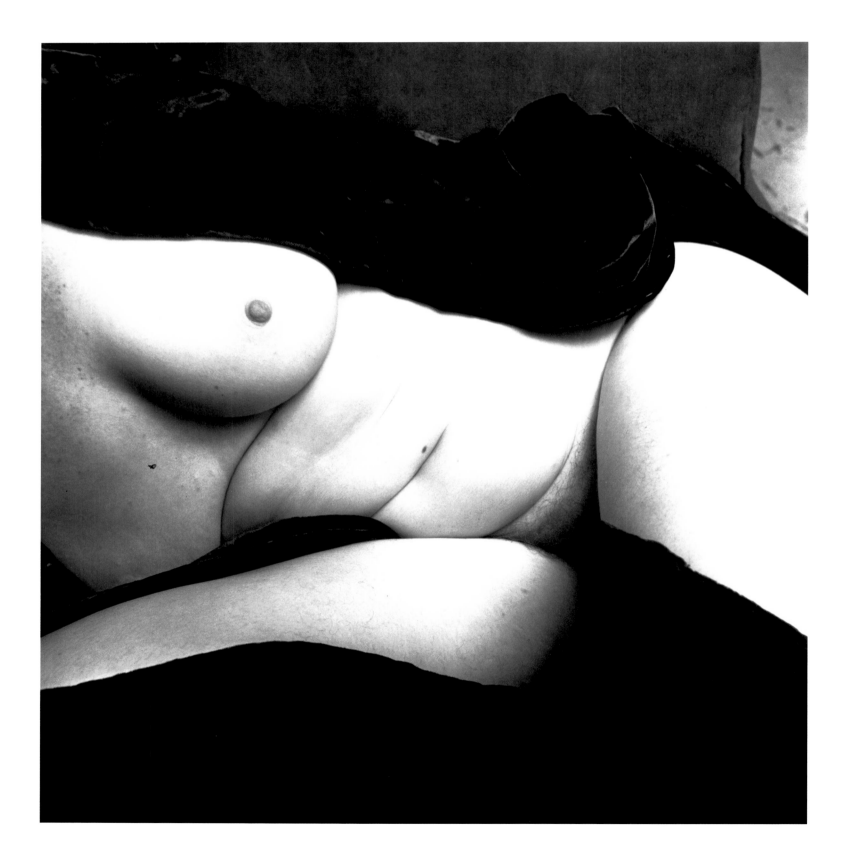

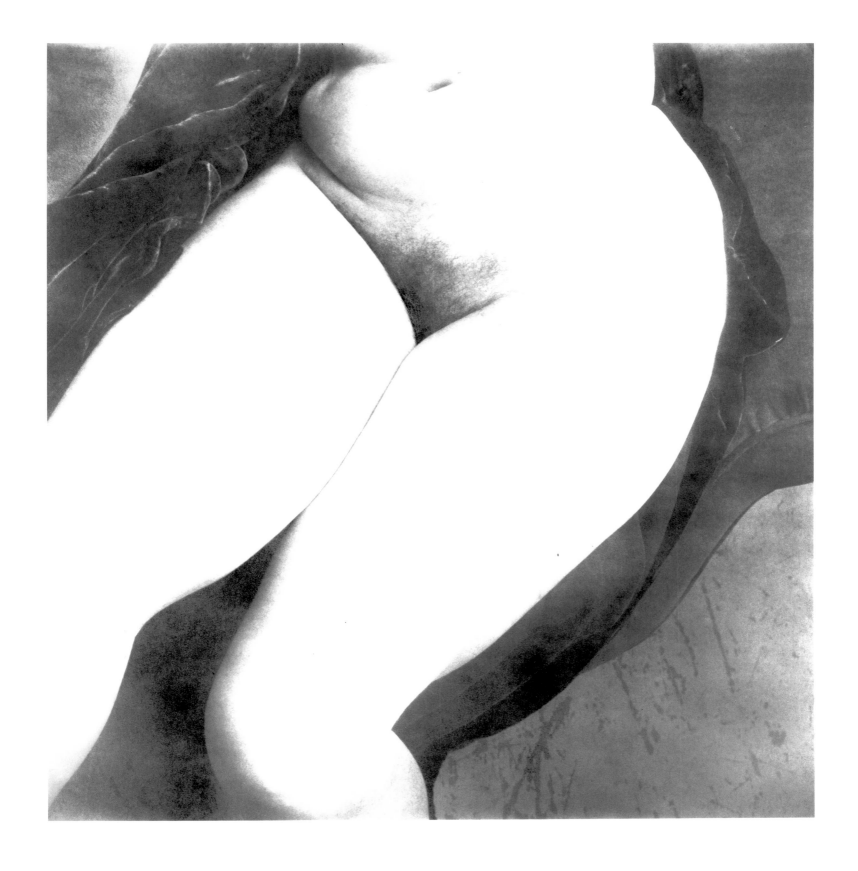

Man Lighting Girl's Cigarette (Jean Patchett), New York, 1949.

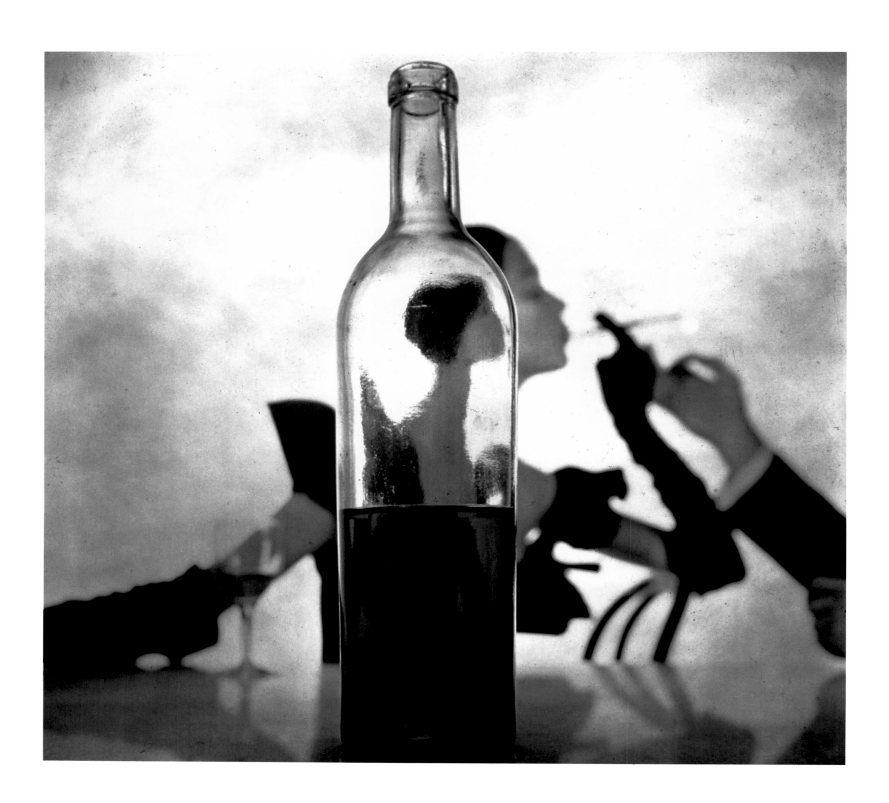

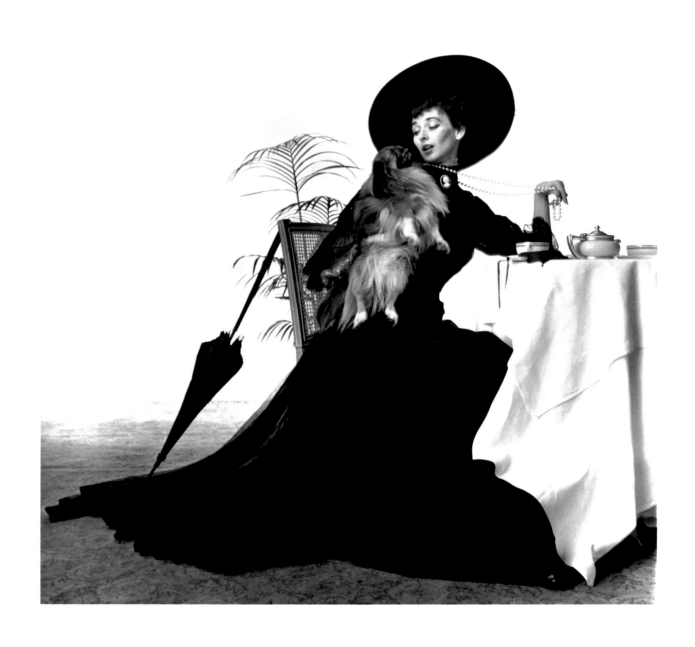

1910 Couture (Dorian Leigh), New York, 1949.

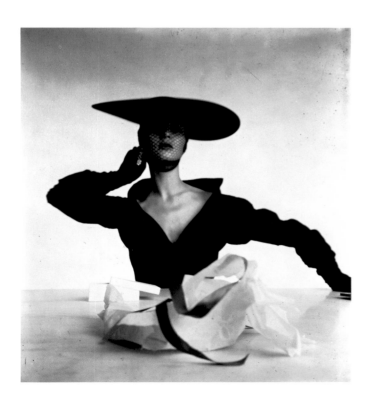

Vogue *Christmas Cover* (Jean Patchett), New York, 1949.

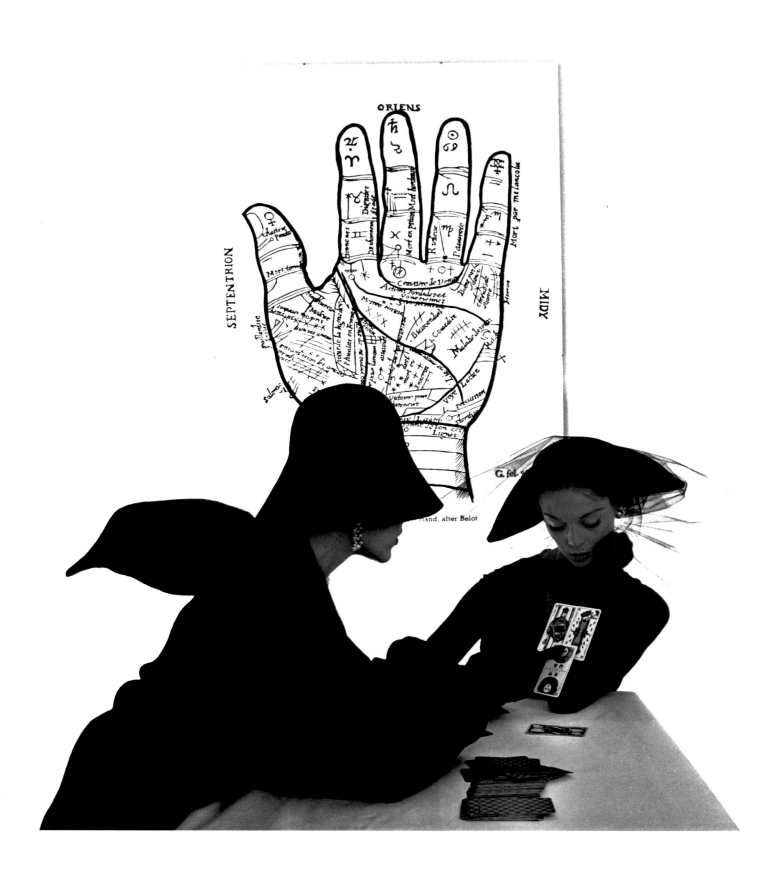

The Tarot Reader (Bridget Tichenor and Jean Patchett), New York, 1949.

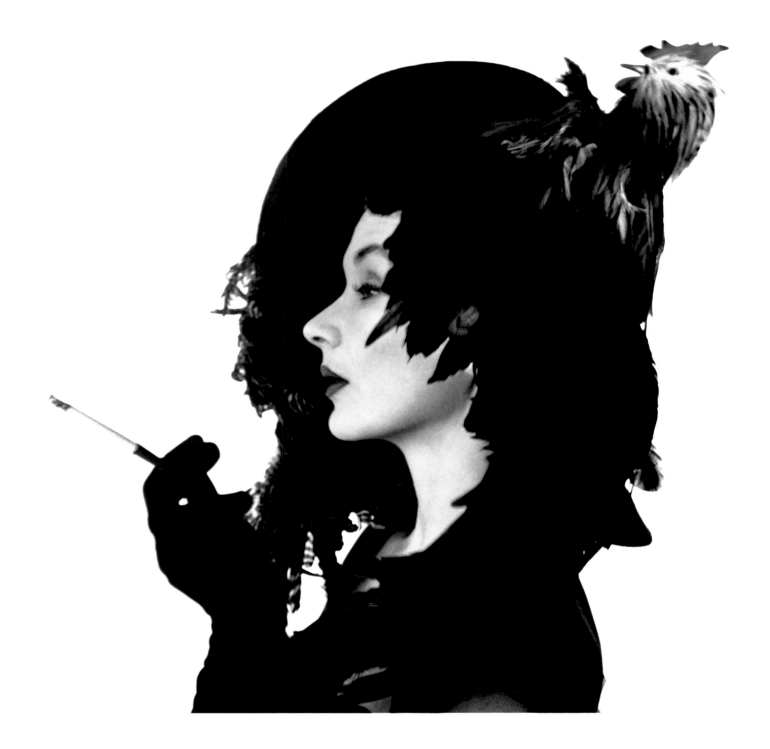

Woman in Chicken Hat (Lisa Fonssagrives-Penn), New York, 1949.

Veiled Hat (Evelyn Tripp), New York, 1949.

Crescent Bicorne Hat (Evelyn Tripp), New York, 1949.

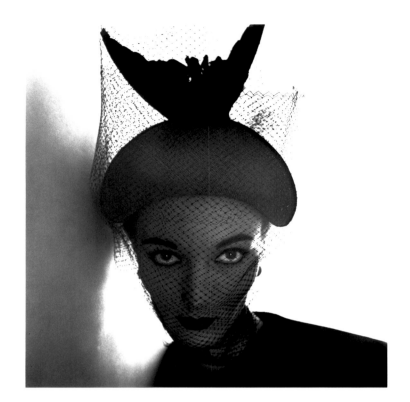

Girl Drinking (Mary Jane Russell), New York, 1949.

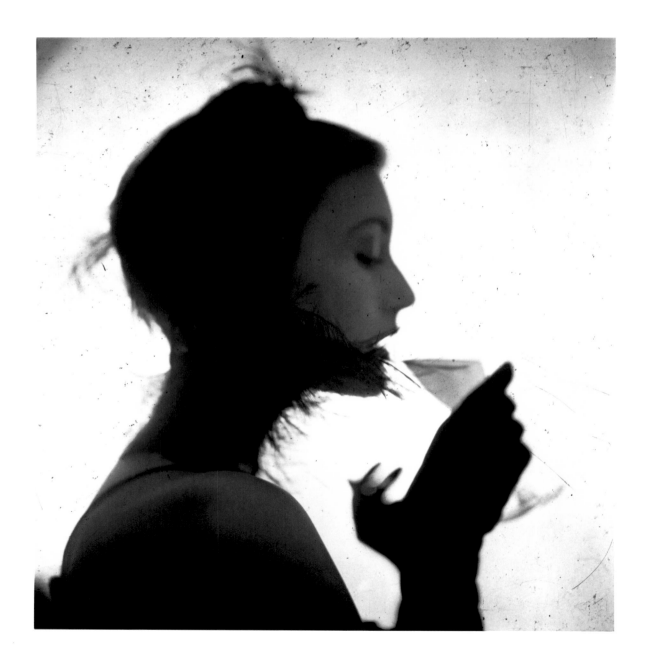

Girl Behind Bottle (Jean Patchett), New York, 1949.

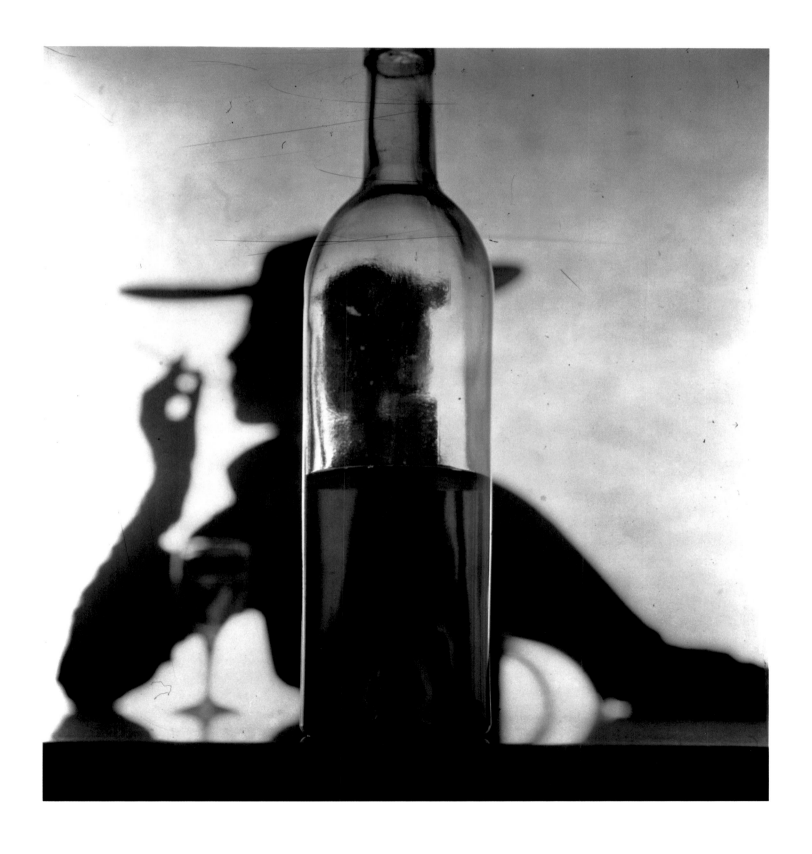

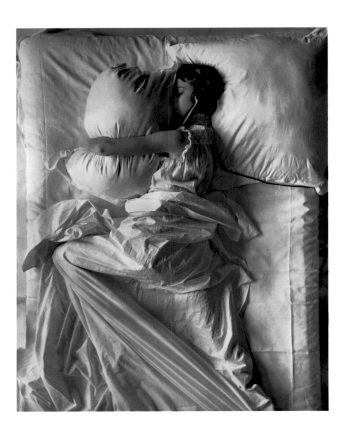

Girl in Bed on the Telephone (Jean Patchett), New York, 1949.

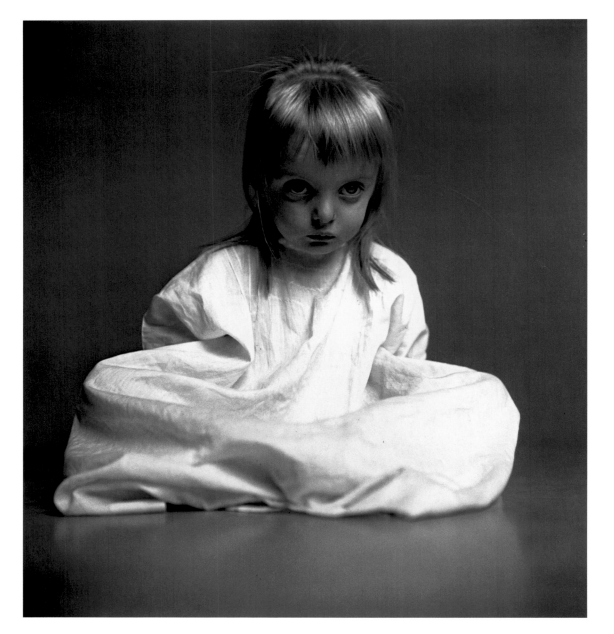

Juliet Auchincloss, New York, 1949.

Summer Sleep, New York, 1949.

Norman Parkinson, New York, 1949.

Always sensitive to possibilities, Alexander Liberman arranged for me in Paris the use of a daylight studio on the rue de Vaugirard, on the top floor of an old photography school. The light was the light of Paris as I had imagined it, soft but defining.

We found a discarded theater curtain for a backdrop. As it turned out, 1950 was the only year we were able to have couture clothes during daylight hours at the height of the collections. Clothes were hurried to the studio and back to the salons by cyclists. In the excitement of the time even Balenciaga was amenable to having us photograph his designs at our studio on our own choice of models.

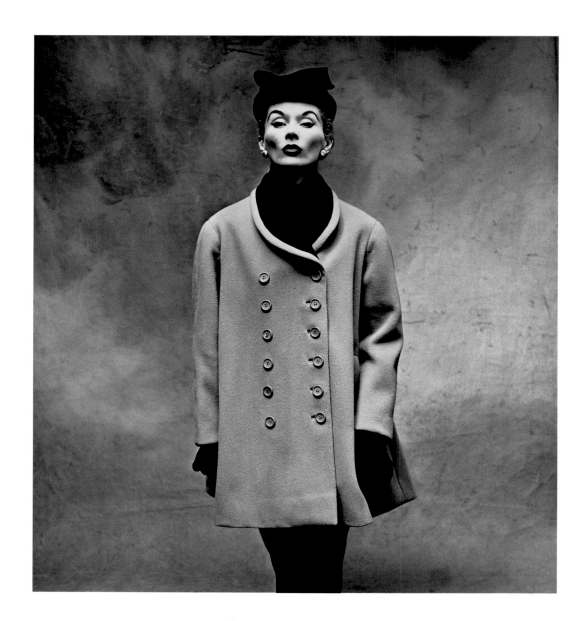

Balenciaga "Little Great Coat" (Lisa Fonssagrives-Penn), Paris, 1950.

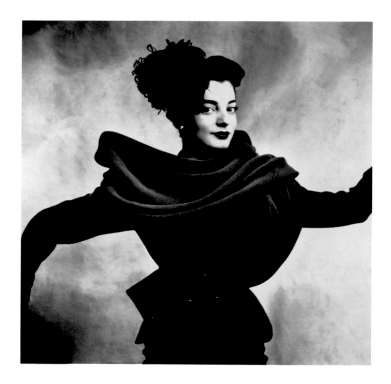

Balenciaga Suit (Régine), Paris, 1950.

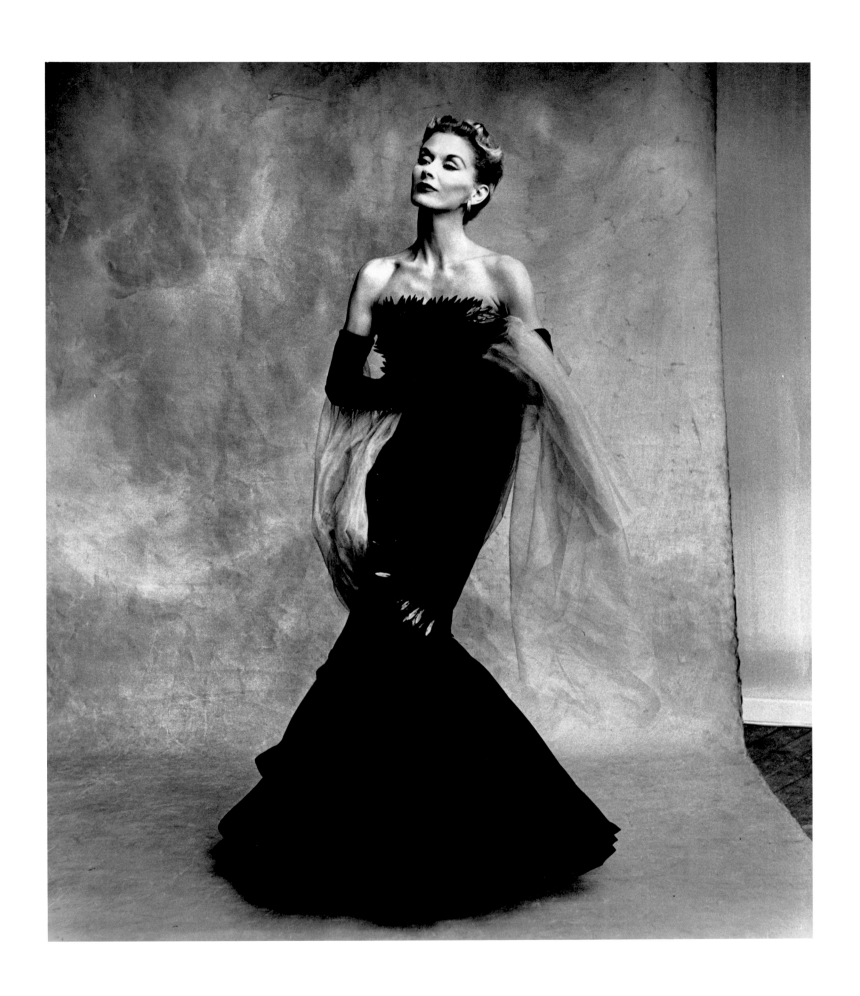

Rochas "Mermaid Dress" (Lisa Fonssagrives-Penn), Paris, 1950.

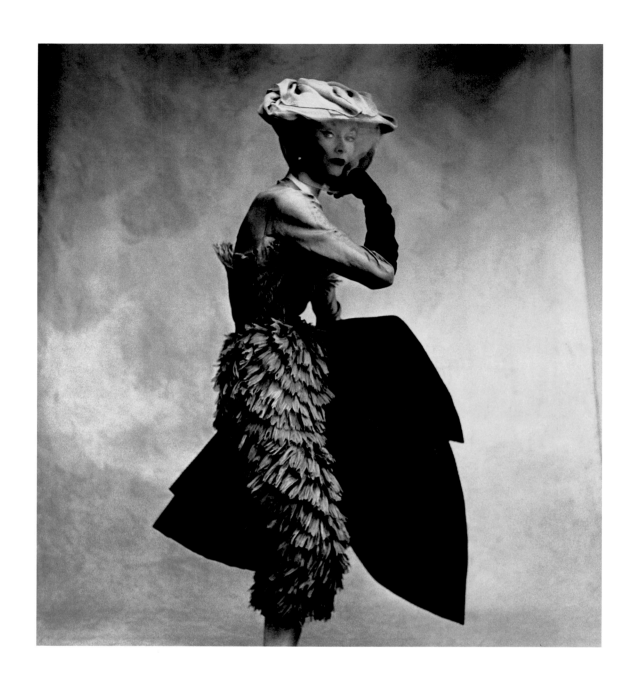

Cocoa-Colored Balenciaga Dress (Lisa Fonssagrives-Penn), Paris, 1950.

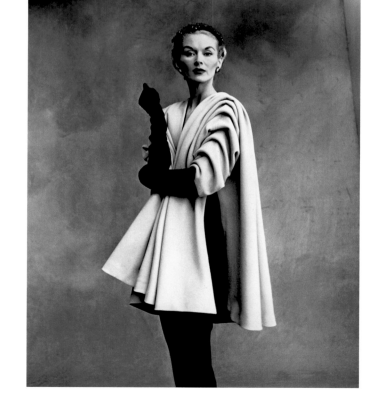

Balenciaga Mantle Coat (Lisa Fonssagrives-Penn), Paris, 1950.

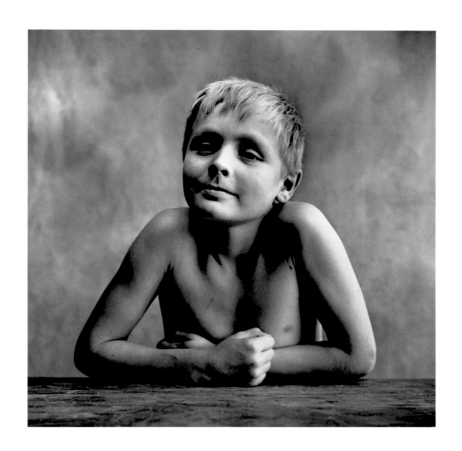

Poulbot, Paris, 1950.

Alberto Giacometti, Paris, 1950.

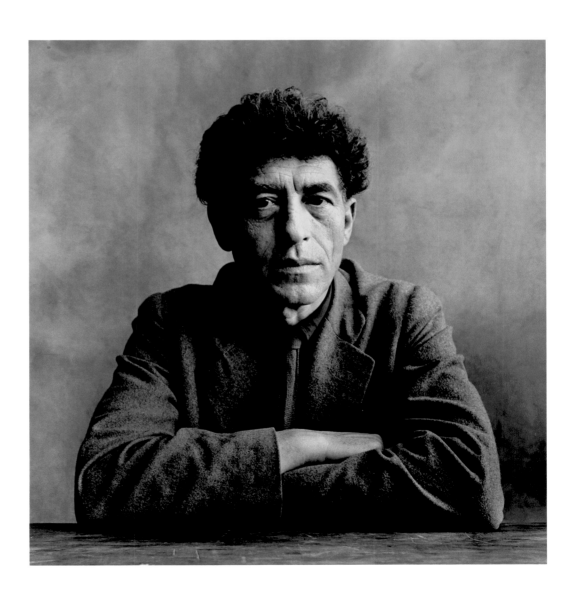

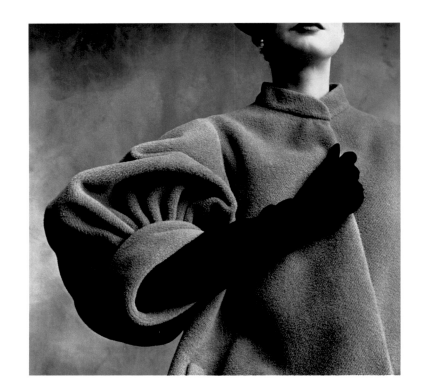

Balenciaga Sleeve (Régine), Paris, 1950.

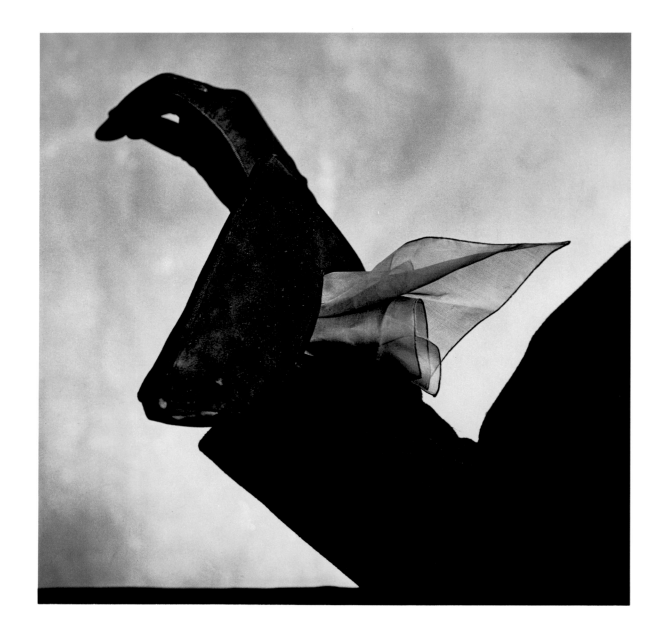

Dior Kerchief Glove, Paris, 1950.

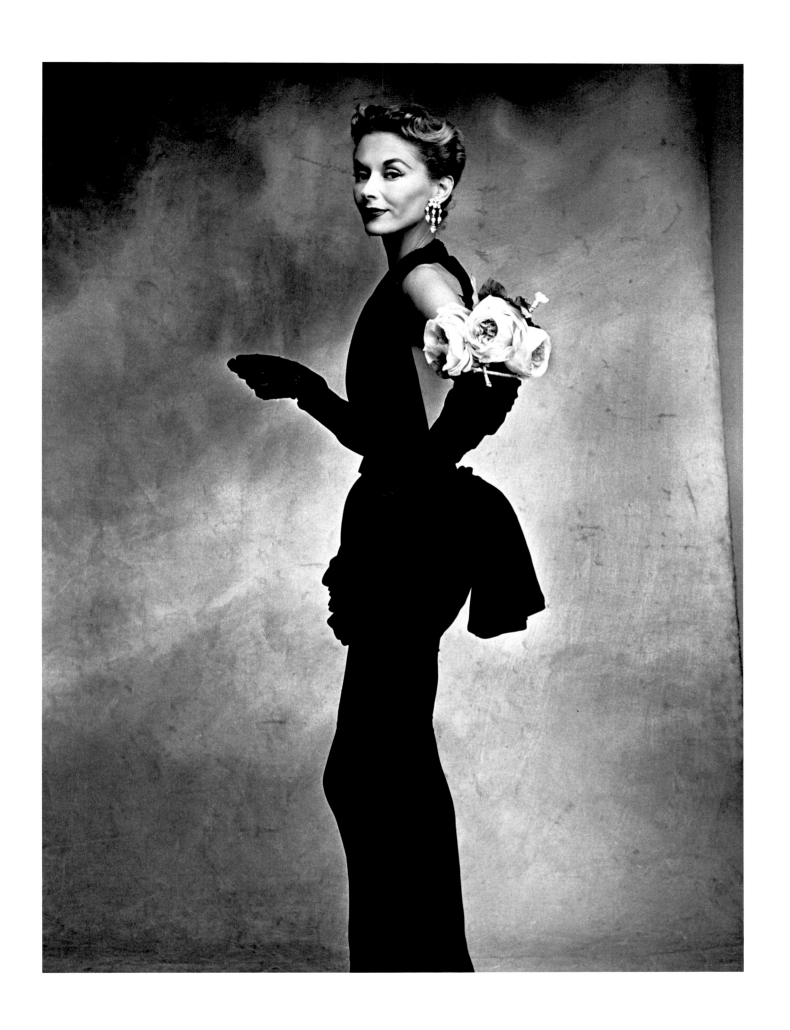

Woman with Roses (Lisa Fonssagrives-Penn in Lafaurie dress), Paris, 1950.

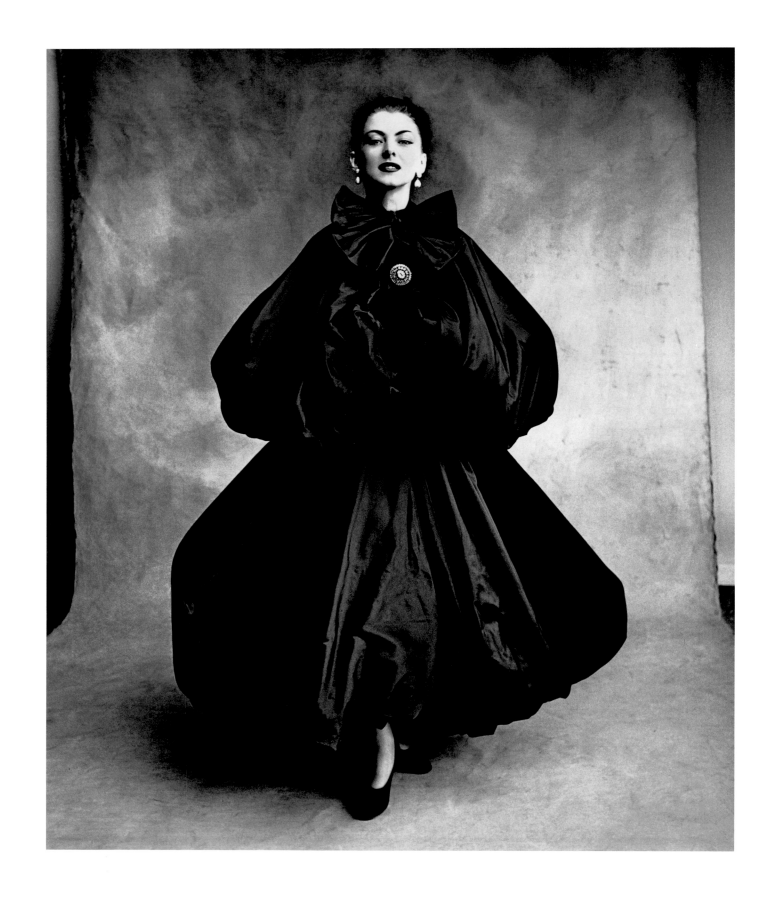

Balenciaga Harem Dress (Diane), Paris, 1950.

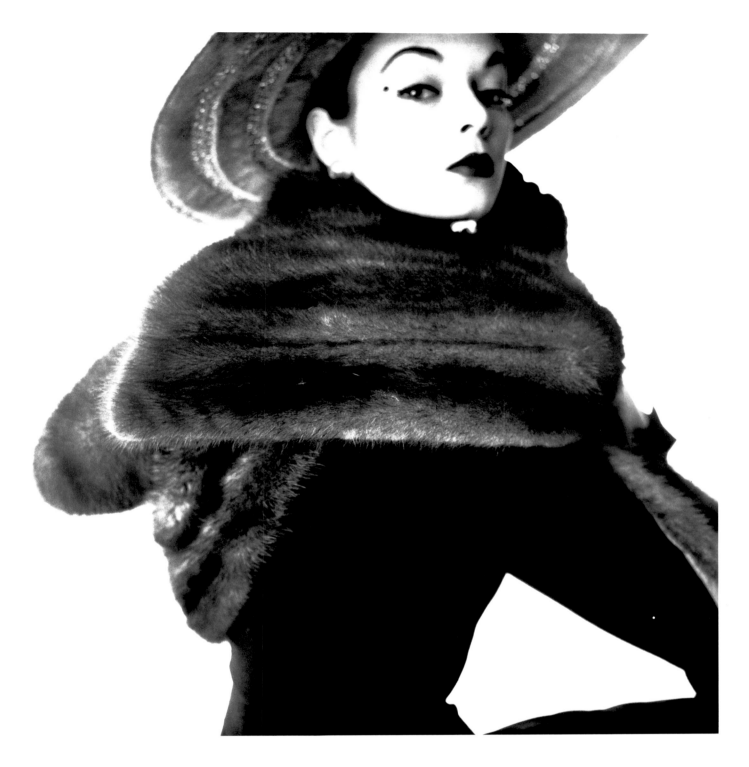

Dior Fur Scarf (Jean Patchett), New York, 1950.

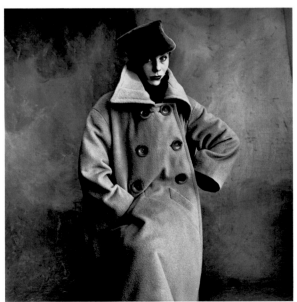

Schiaparelli Coat (Bettina Graziani), Paris, 1950.

In Paris the same summer, Liberman inspired me with the idea of doing a series of pictures of the small trades in the tradition of the "Petits Métiers" of Paris past. French Vogue editor Edmonde Charles-Roux responded to Liberman's suggestion. We hired a young poet she knew to find subjects for us, even extending our scope to include unexpecteds: a poulbot, a Napoleonist, acrobats, and café entertainers. A steady stream of workmen, street vendors, and fringe Parisians climbed the six flights to the studio, where they waited their turn to pose between pictures of couture and portrait sittings of the distinguished.

In each of the three cities—Paris, London, and New York—subjects were found as they practiced their trades and were invited to come to the studio exactly as they were at that time and with their tools of work. They were firmly urged not to attempt to make themselves look different in any way.

In general, the Parisians, the most sophisticated, doubted that we were doing exactly what we said we were doing. They felt there was something fishy going on, but they came to the studio more or less as directed—for the fee involved. The Londoners differed from the French. It seemed to them logical and even a source of pride to be recorded in their work clothes. They arrived at the studio, always on time, and presented themselves to the camera with a seriousness that was endearing.

Of the three groups, the New Yorkers on the whole were the least predictable. In spite of our admonitions, a few arrived for their sittings having shed their work clothes and shaved, even wearing dark Sunday suits, sure this was their first step on the way to Hollywood.

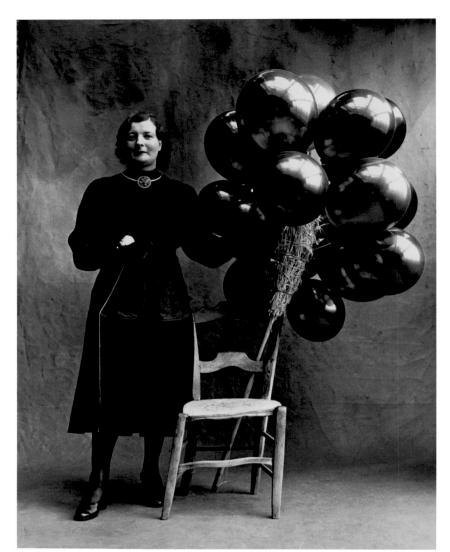

Balloon Seller, Paris, 1950.

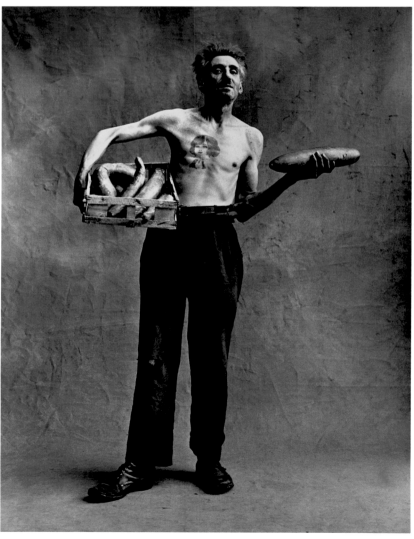

Cucumber Seller, Paris, 1950.

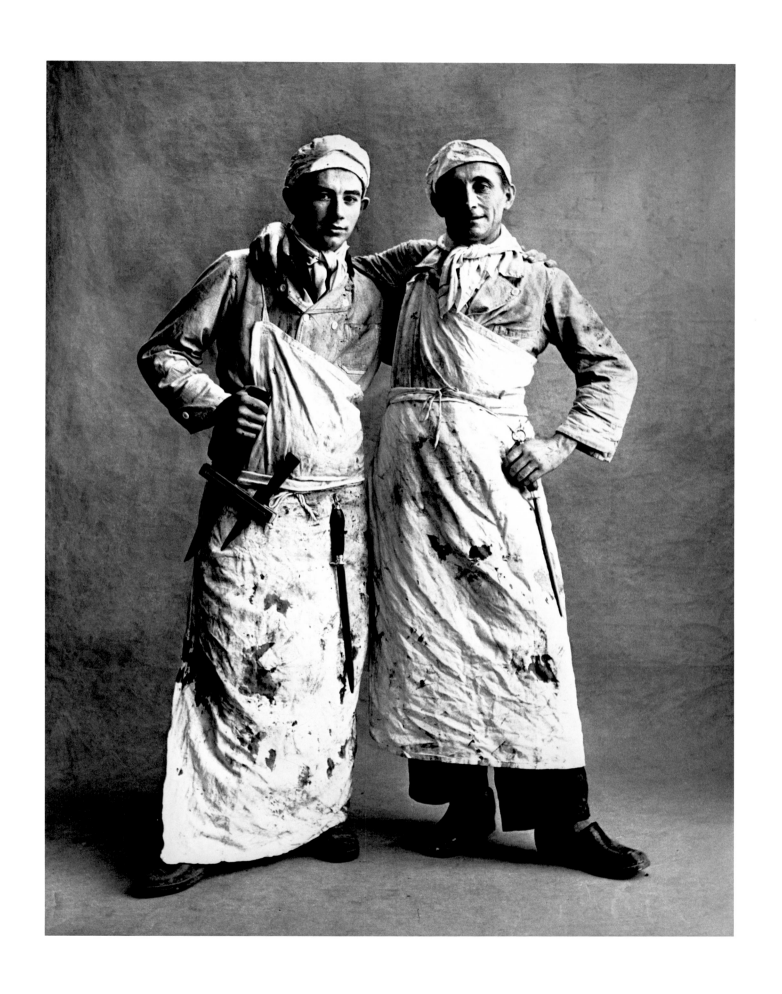

Young Butchers, Paris, 1950.

Pastry Cooks, Paris, 1950.

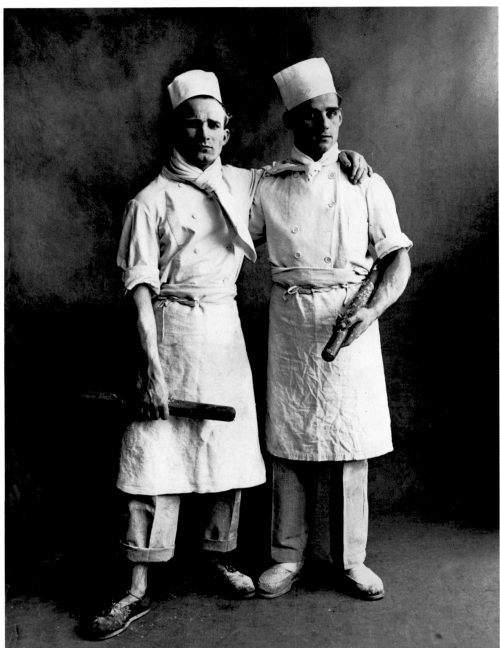

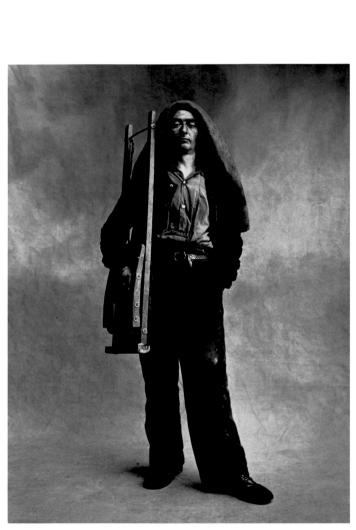

Coal Man, Paris, 1950.

Glazier, Paris, 1950.

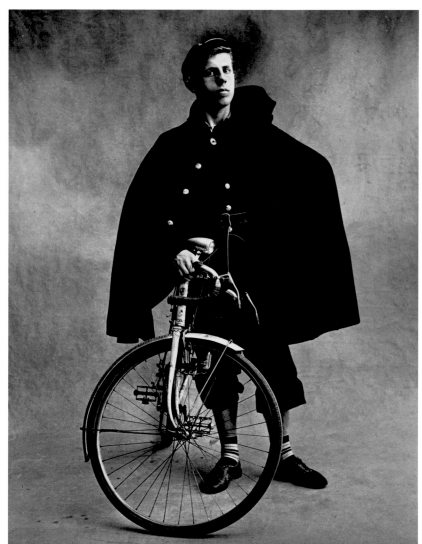

Telegraph Messenger, Paris, 1950.

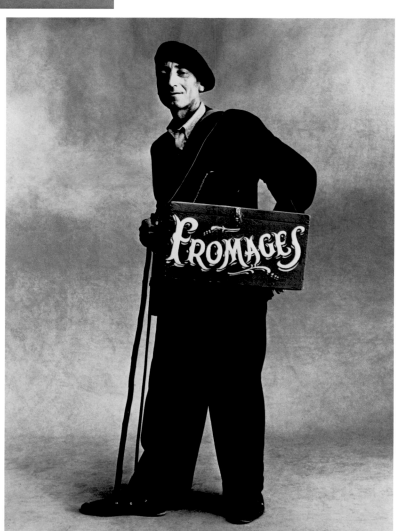

Cheese Seller, Paris, 1950.

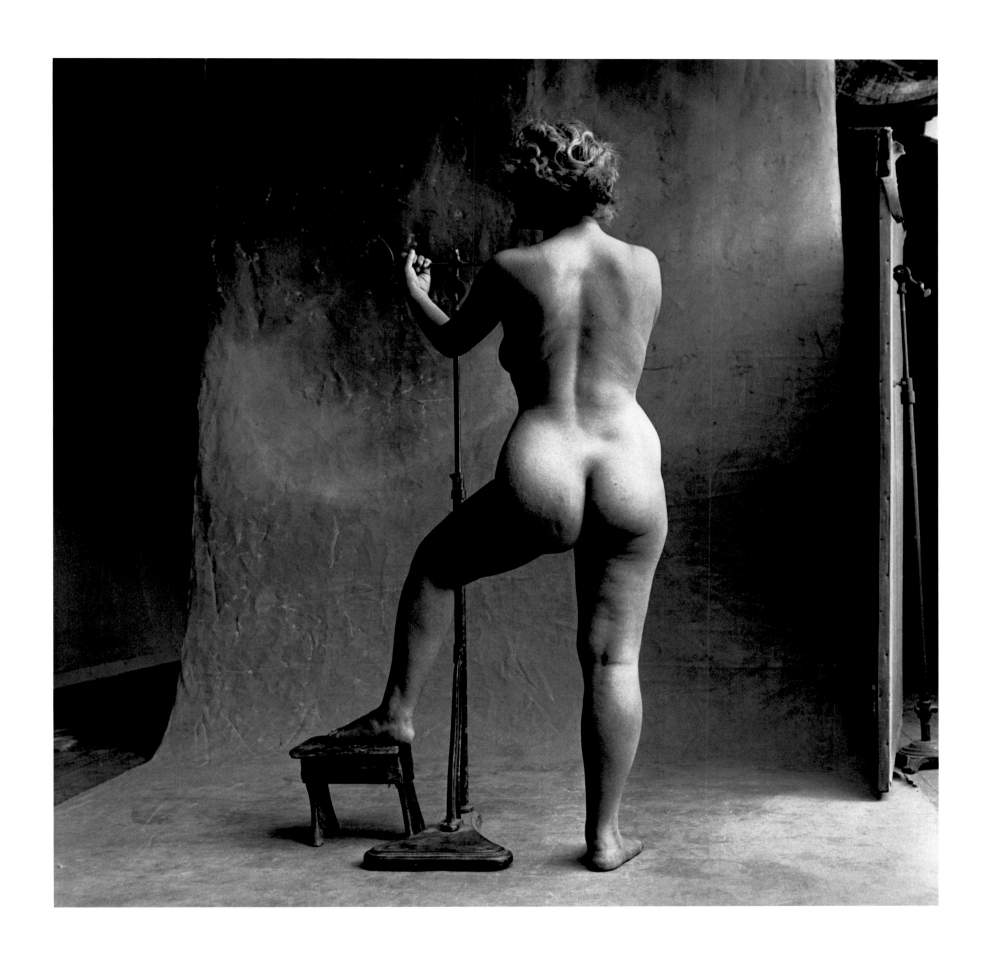

Sculptor's Model, Paris, 1950.

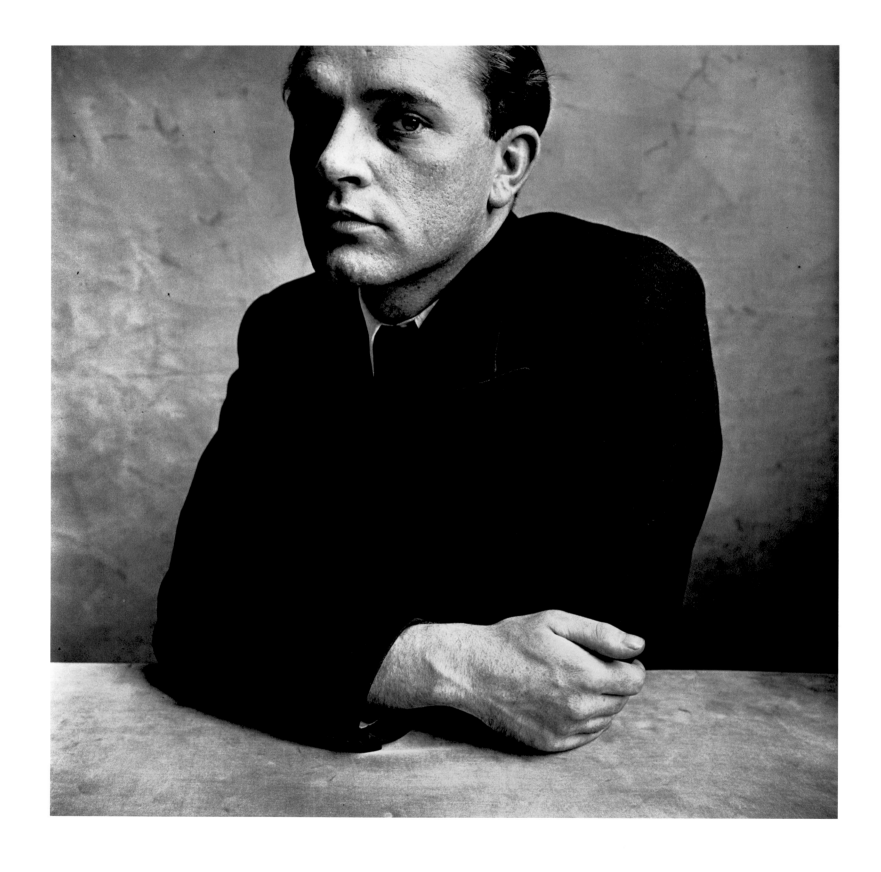

Richard Burton, London, 1950.

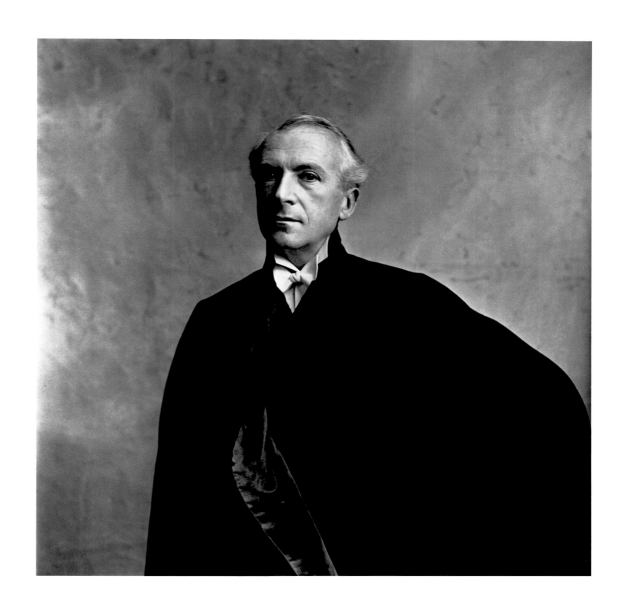

Cecil Beaton, London, 1950.

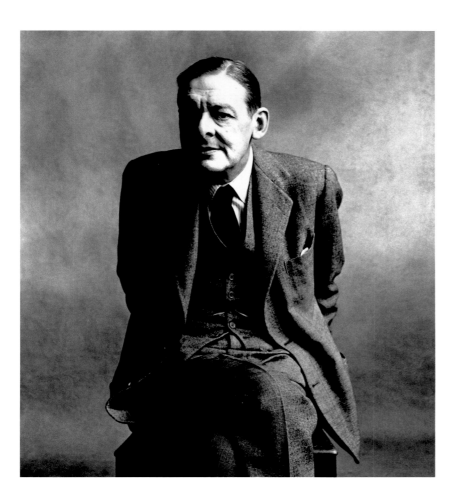

T. S. Eliot, London, 1950.

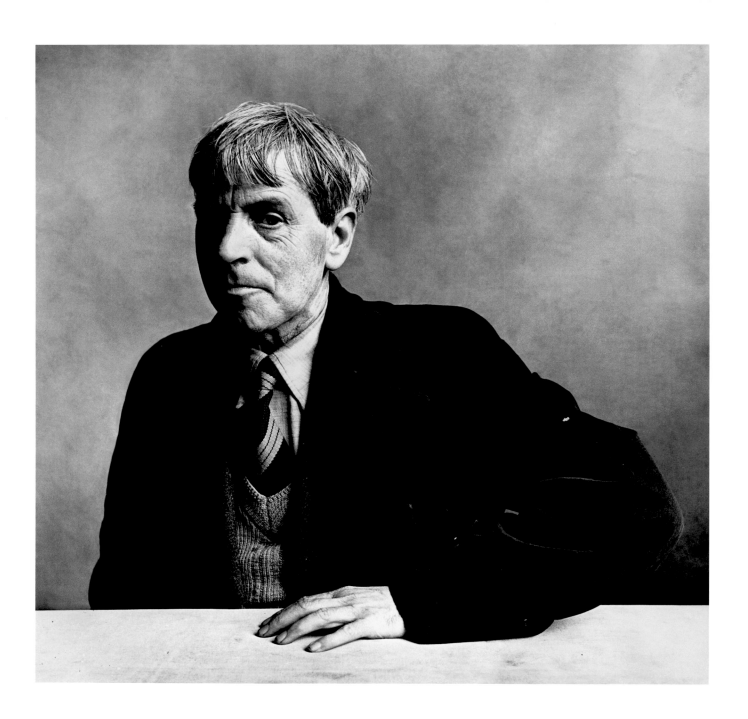

Sir Stanley Spencer, London, 1950.

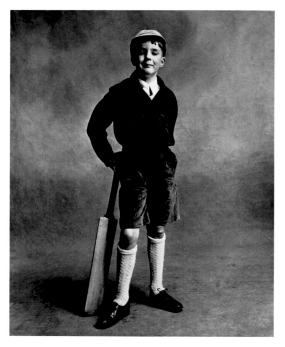

Young Cricketer (Adam Roundtree), London, 1950.

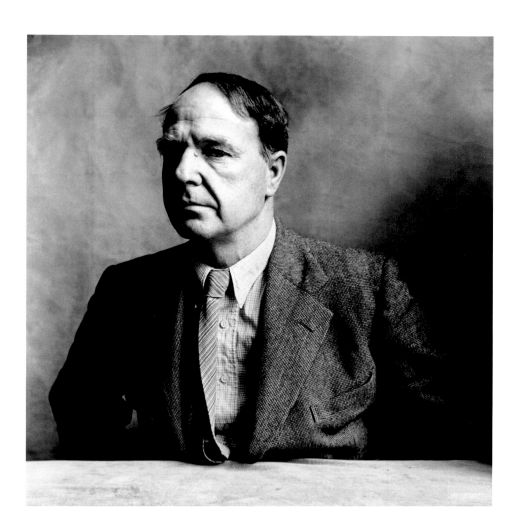

Henry Moore, London, 1950.

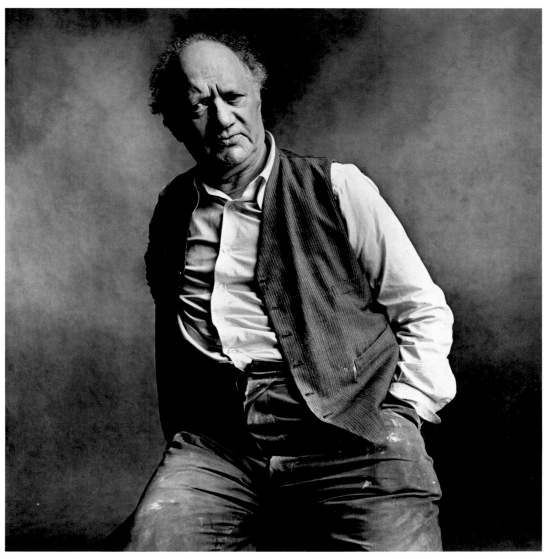

Sir Jacob Epstein, London, 1950.

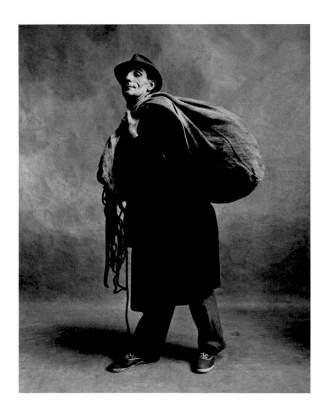

Rag-and-Bone Man, London, 1950.

Charwomen, London, 1950.

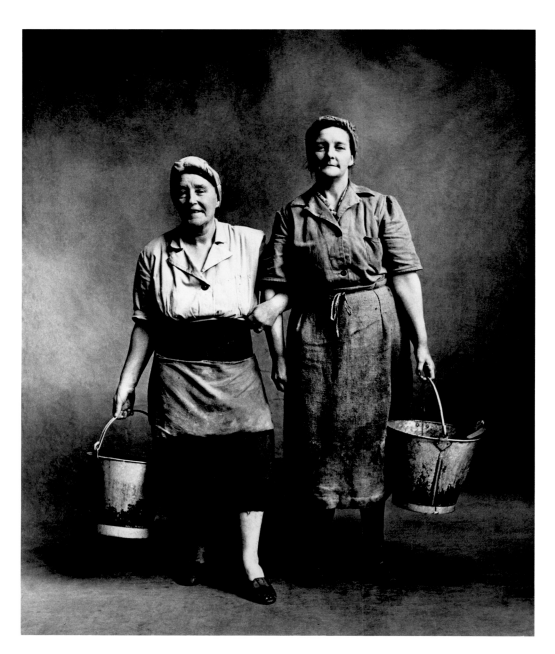

Lorry Washers, London, 1950.

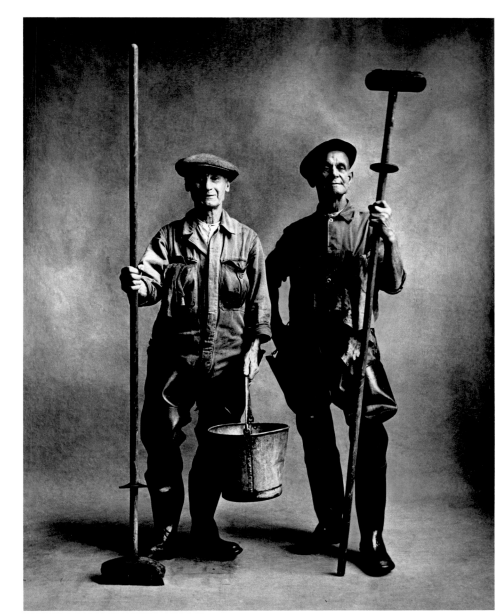

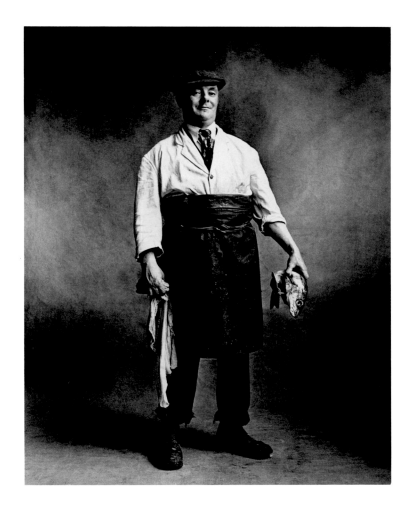

Fishmonger, London, 1950.

Butcher, London, 1950.

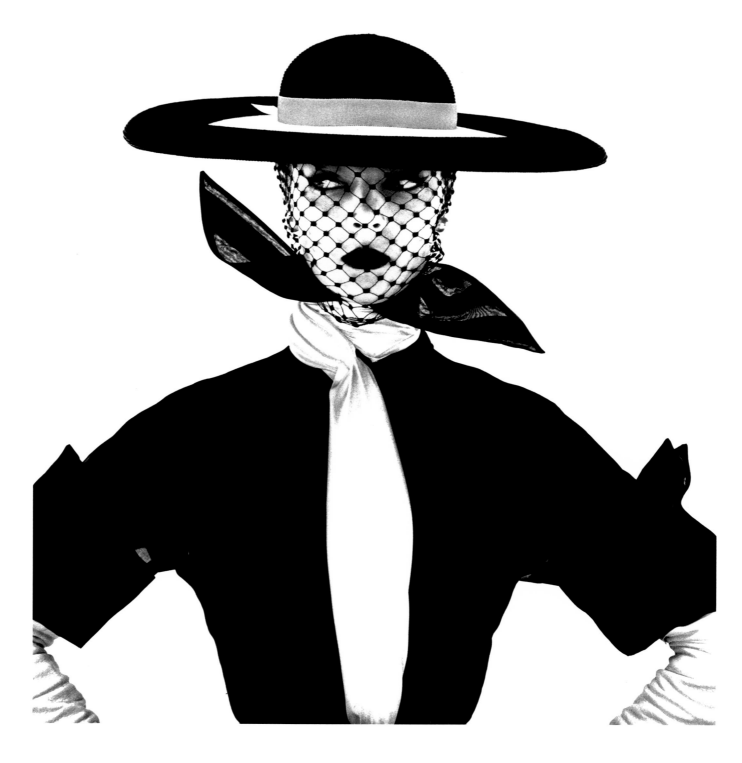

Vogue *Cover* (Jean Patchett), New York, 1950.

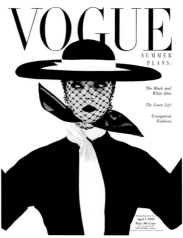

Mrs. Walter Denègre Sohier, New York, 1950.

Carson McCullers, New York, 1950.

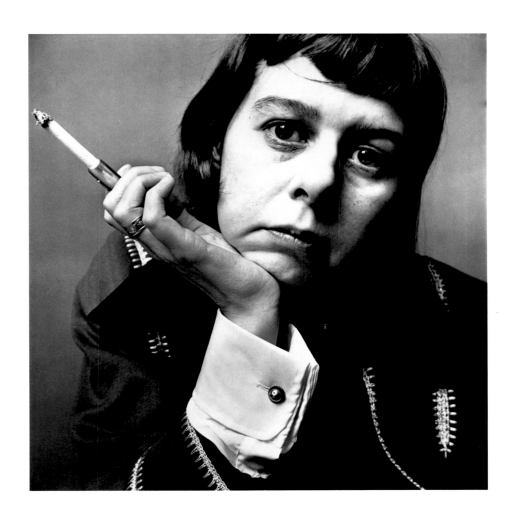

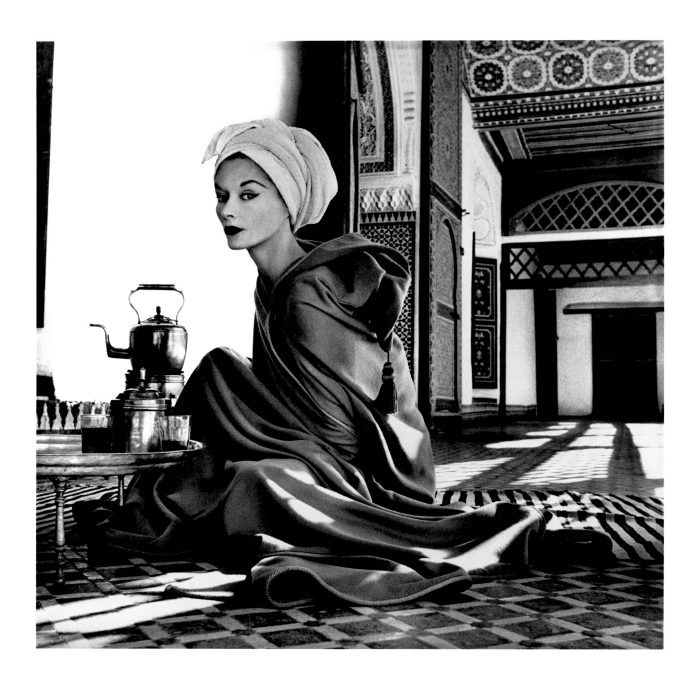

Woman in Palace (Lisa Fonssagrives-Penn), Morocco, 1951.

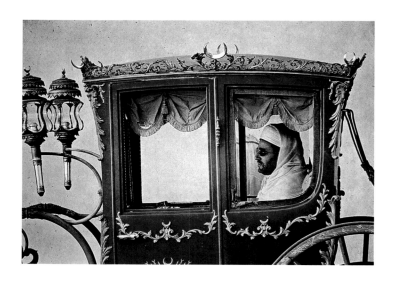

Sultan Mohammed V, Ben Yussef, in His Carriage, Morocco, 1951.

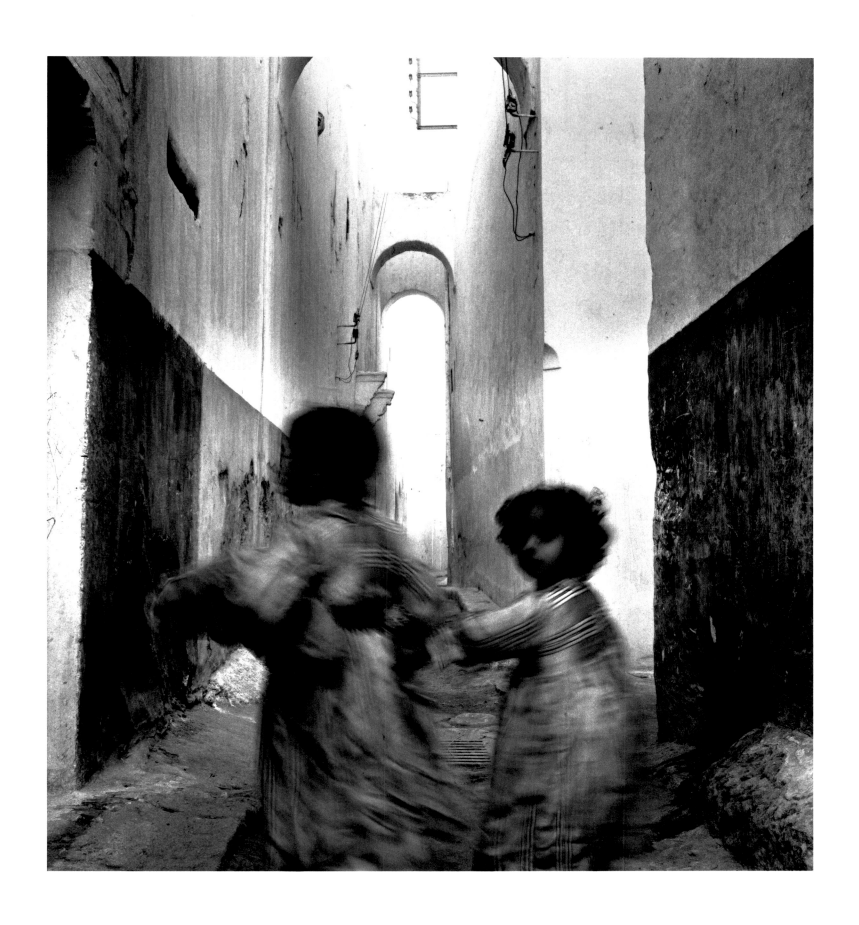

Running Children, Morocco, 1951.

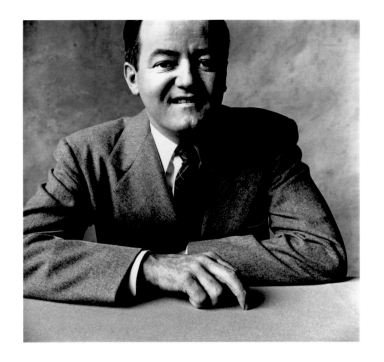

Senator Hubert H. Humphrey, Washington, D.C., 1951.

Plowing Scene on the Seine, France, 1951.

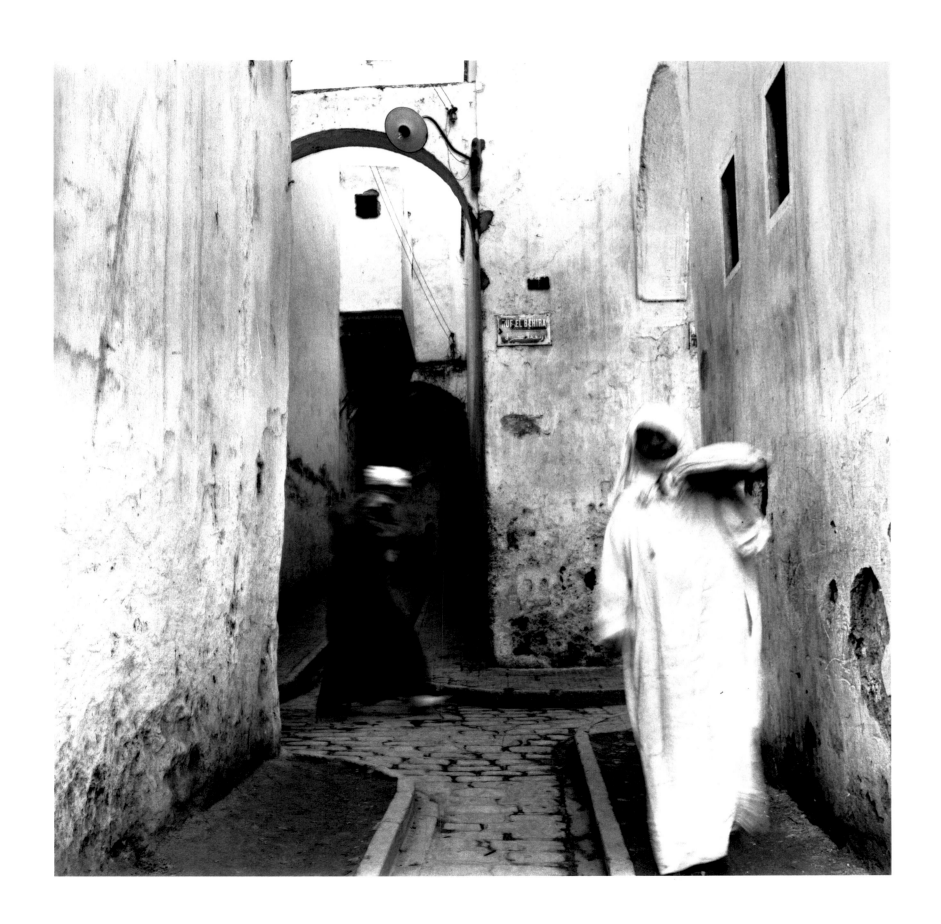

Street Scene, Morocco, 1951.

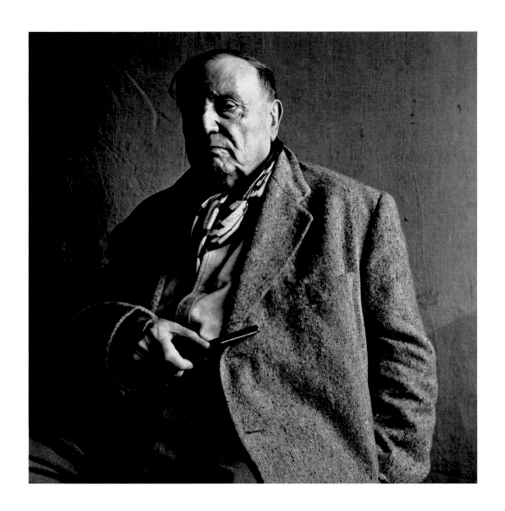

Maurice de Vlaminck, France, 1951.

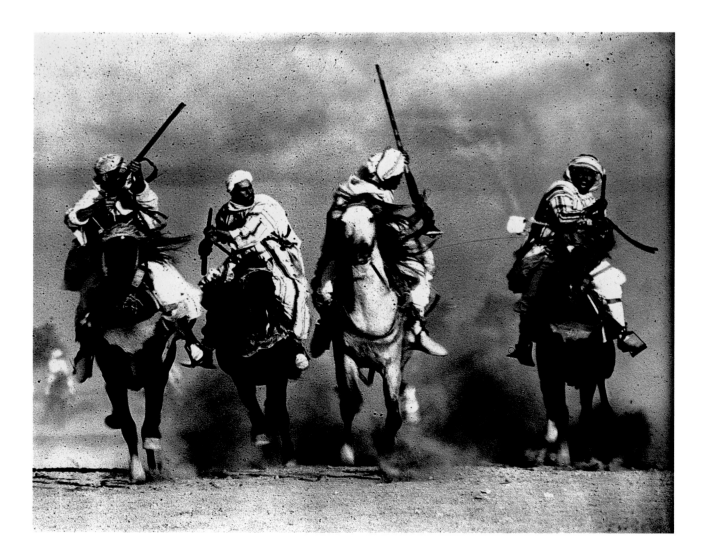

Fantasia, Morocco, 1951.

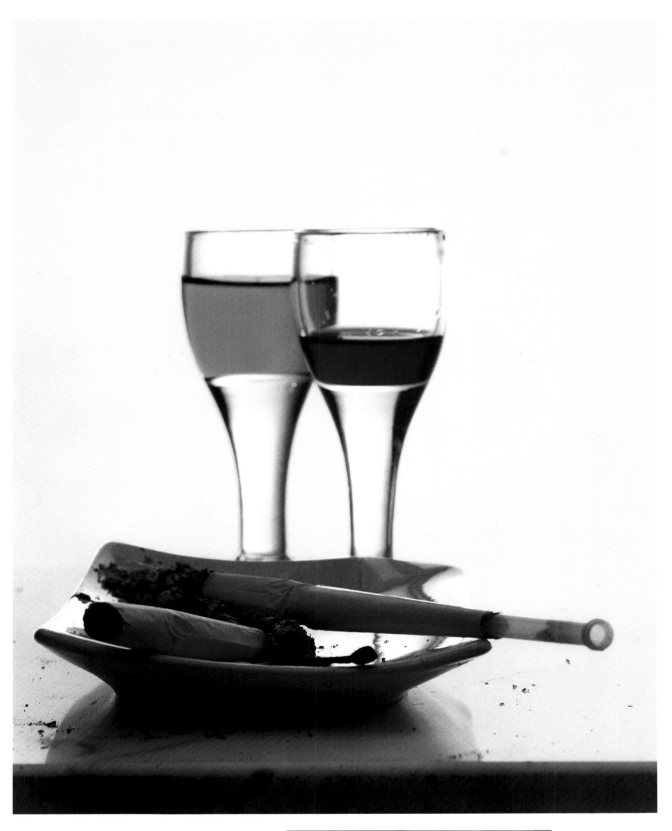

Two Liqueurs, New York, 1951.

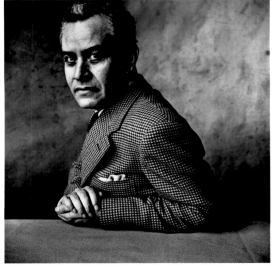

Rufino Tamayo, New York, 1951.

1951

In late summer of 1951 I photo-
graphed in France along the
Seine, with long telephoto
lenses, making sentimental
painterly images of Frenchmen
fishing on Sunday. The equip-
ment we used made it possible
to photograph almost without
being seen.

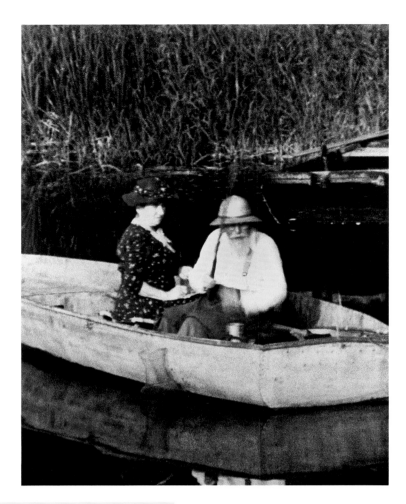

Old Couple on the Seine, France, 1951.

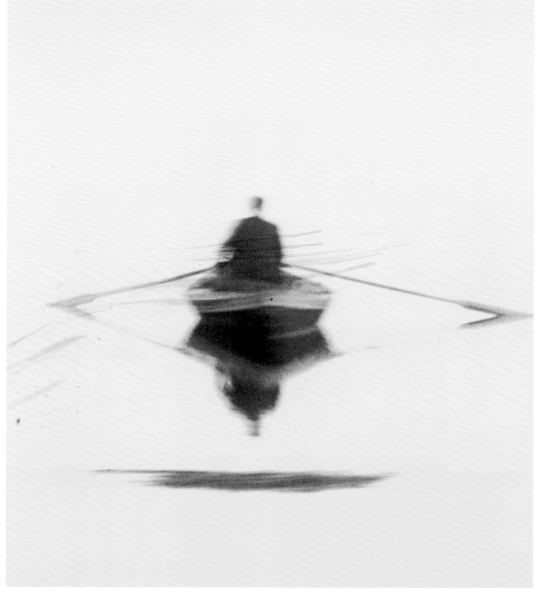

Seine Rowboat, France, 1951.

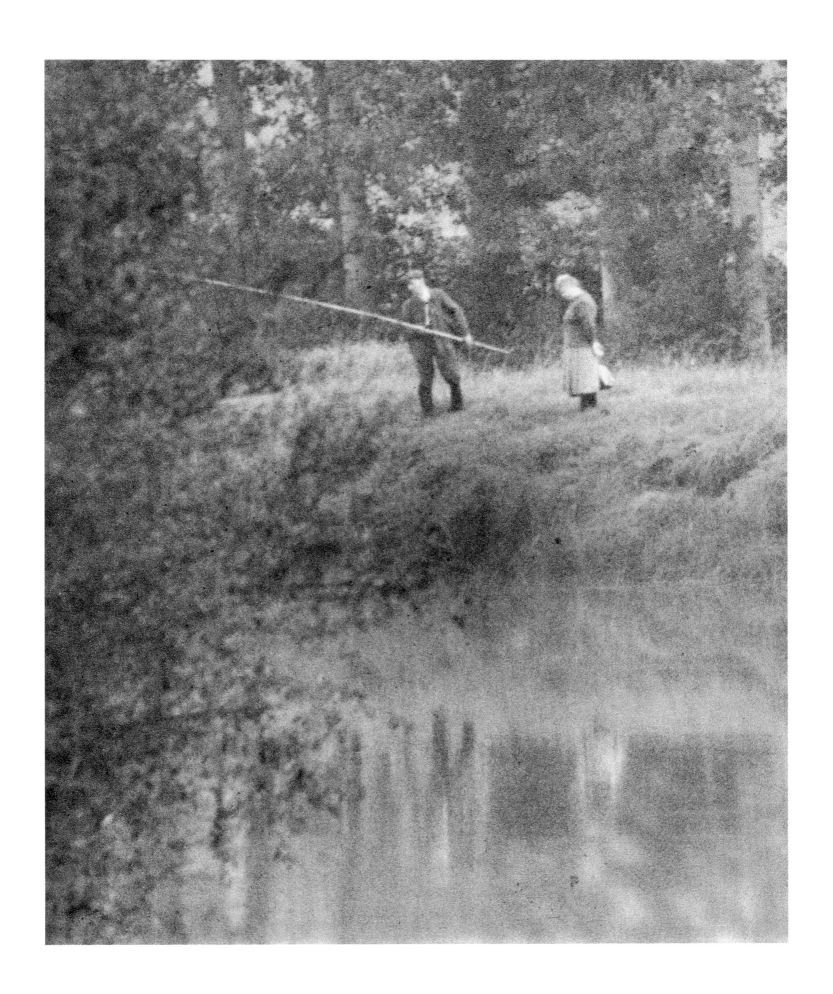

Couple Fishing from Bank of Seine, France, 1951.

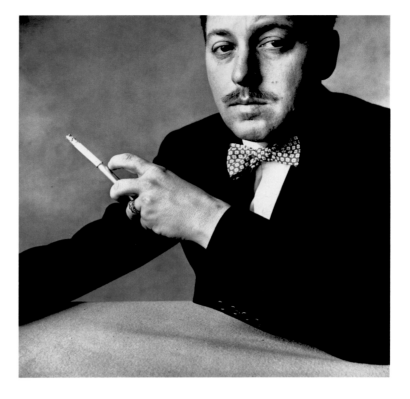

Louis Jouvet came to pose in my New York studio. I worked with a close-up lens on the Rolleiflex. We both became hypnotized with the experience, speaking in whispers for perhaps an hour, aware that something serious was being recorded. Jouvet returned to Paris and sadly was soon dead.

Tennessee Williams, New York, 1951.

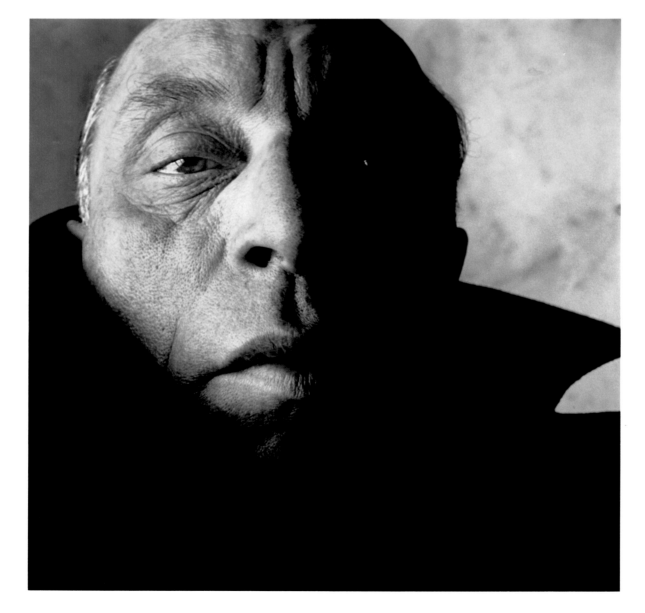

Louis Jouvet, New York, 1951.

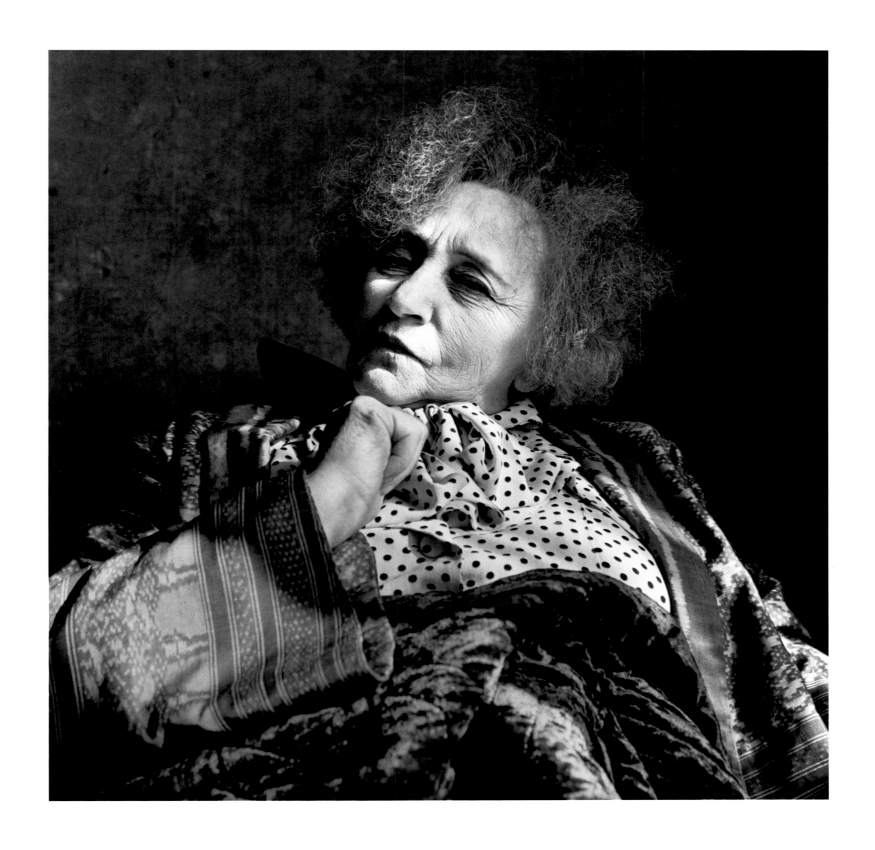

Colette, Paris, 1951.

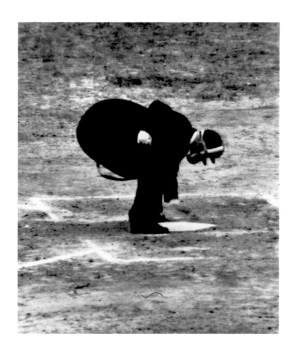

Baseball Umpire, New York, 1951.

Girl with Tobacco on Tongue (Mary Jane Russell), New York, 1951.

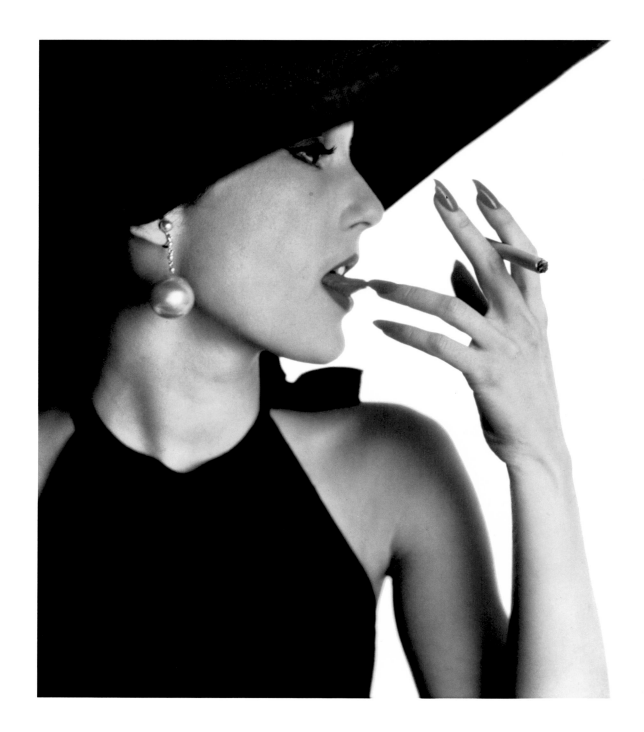

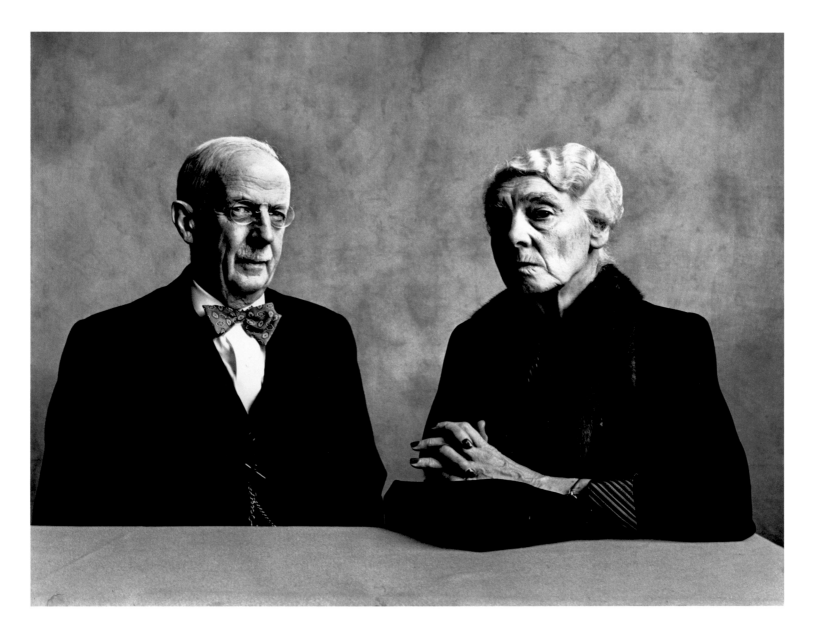

Dr. and Mrs. Gilbert H. Grosvenor, Washington, D.C., 1951.

Large Sleeve (Sunny Harnett), New York, 1951.

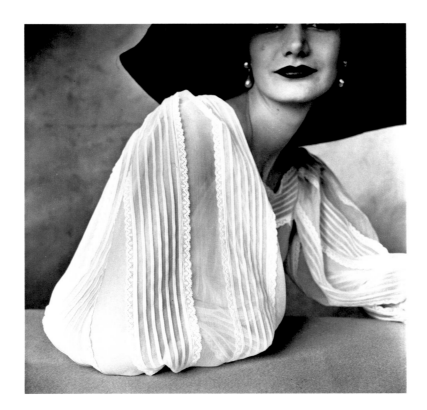

113

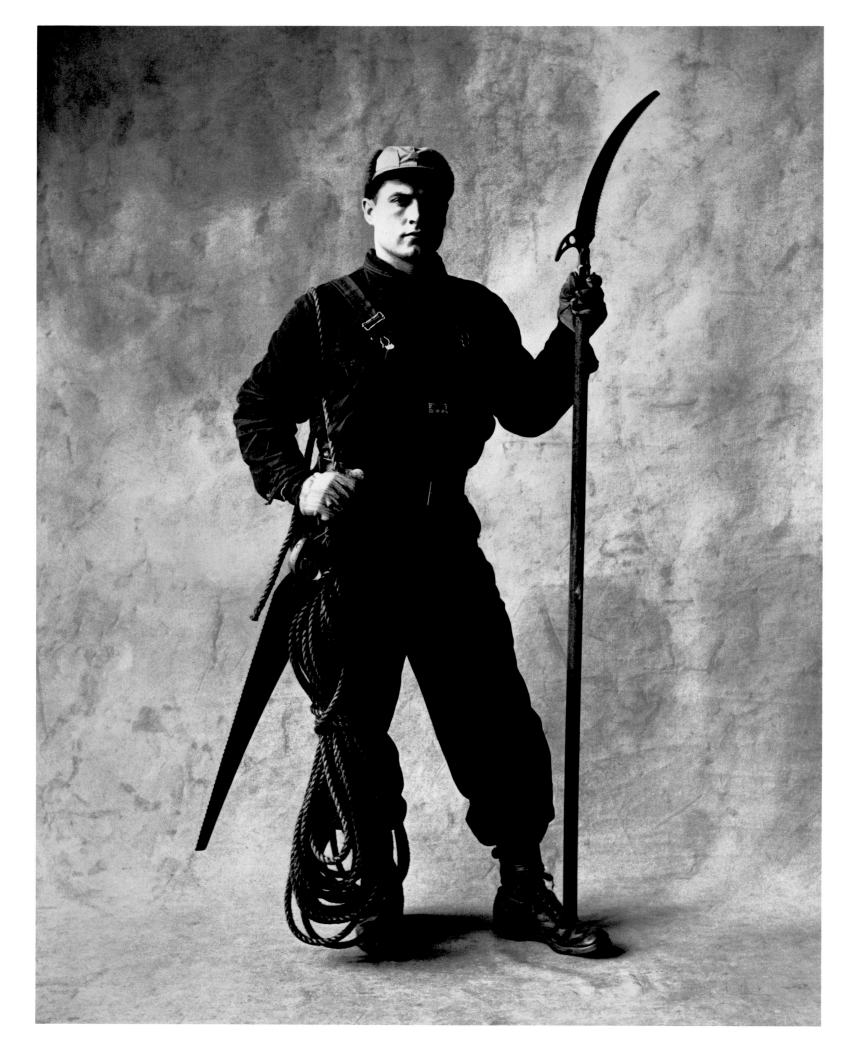

Tree Pruner, New York, 1951.

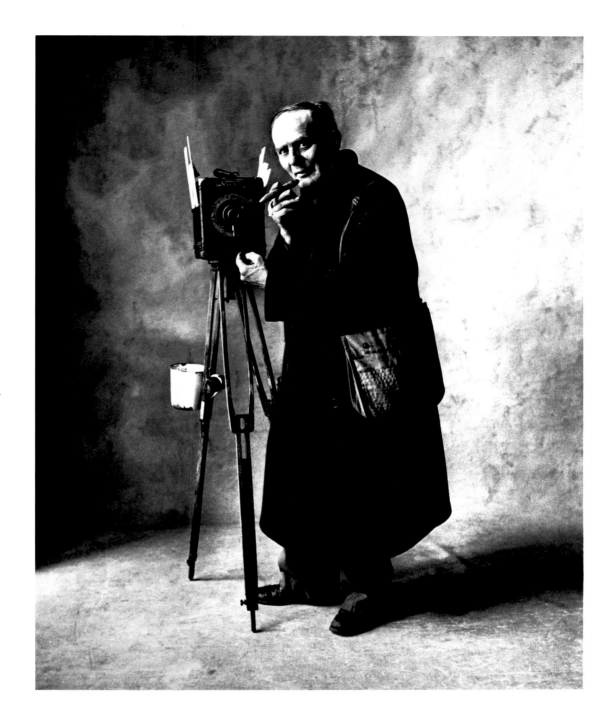

Street Photographer, New York, 1951.

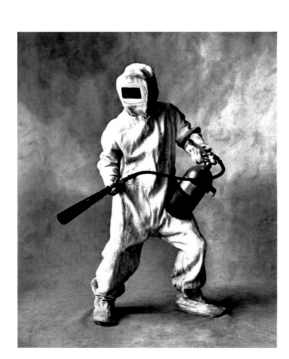

Steel Mill Fire Fighter, New York, 1951.

115

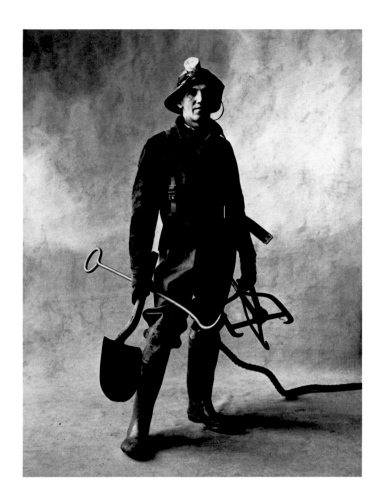

Sewer Cleaner, New York, 1951.

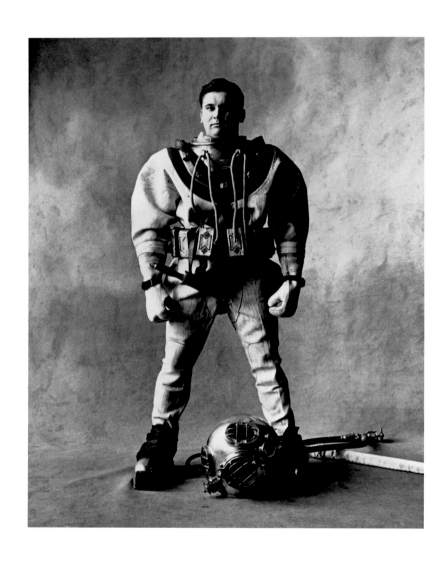

Deep-Sea Diver, New York, 1951.

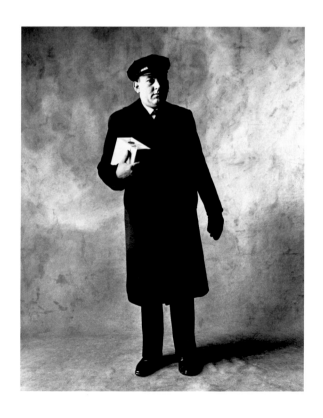

Messenger from Cartier, New York, 1951.

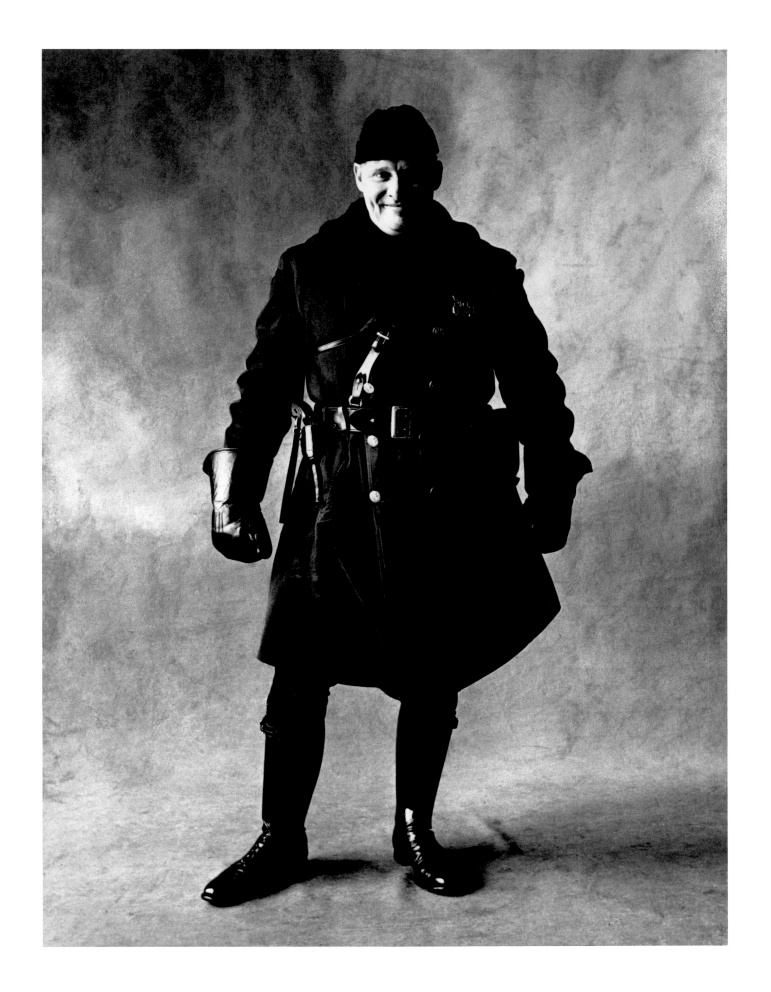

Motorcycle Policeman, New York, 1951.

It was a colleague, Leslie Gill, who in 1952 first spoke to me of stroboscopic light and its importance in the commercial studio. In spite of first misgivings I found myself gradually taken by this form of illumination. It did have useful qualities: its color balance was predictable and repeatable; models did not suffer from heat or long poses; pouring liquids could be frozen in midair.

But my ambivalence remains. I find that when an editorial opportunity presents itself for work away from the studio, I take it. Using simple equipment and daylight alone is for me a pleasure and a replenishment.

Woman in Dior Hat with Martini (Lisa Fonssagrives-Penn), New York, 1952.

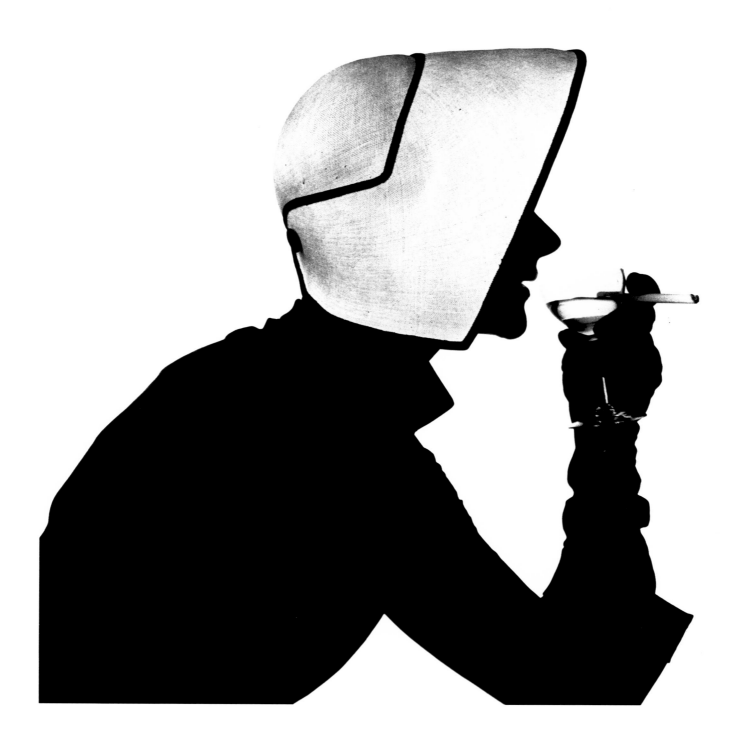

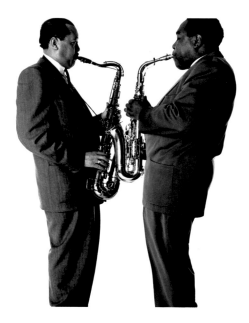

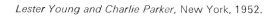
Lester Young and Charlie Parker, New York, 1952.

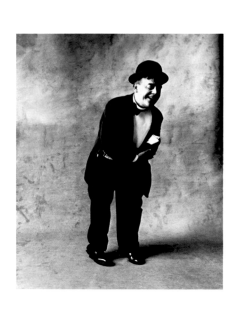

Jimmy Savo, New York, 1952.

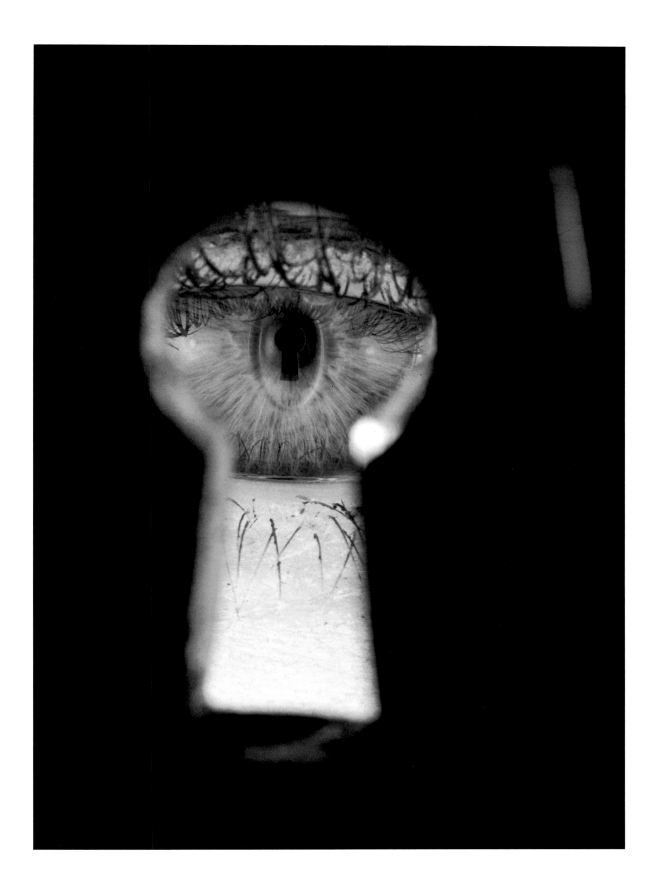

Eye Through a Keyhole, New York, 1953.

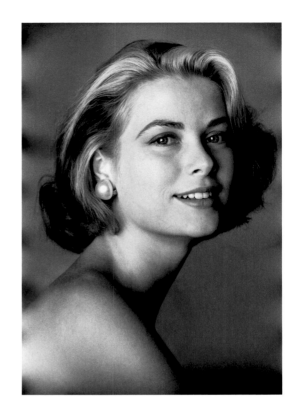

Grace Kelly, New York, 1954.

Bird-Stuffing Ingredients, New York, 1954.

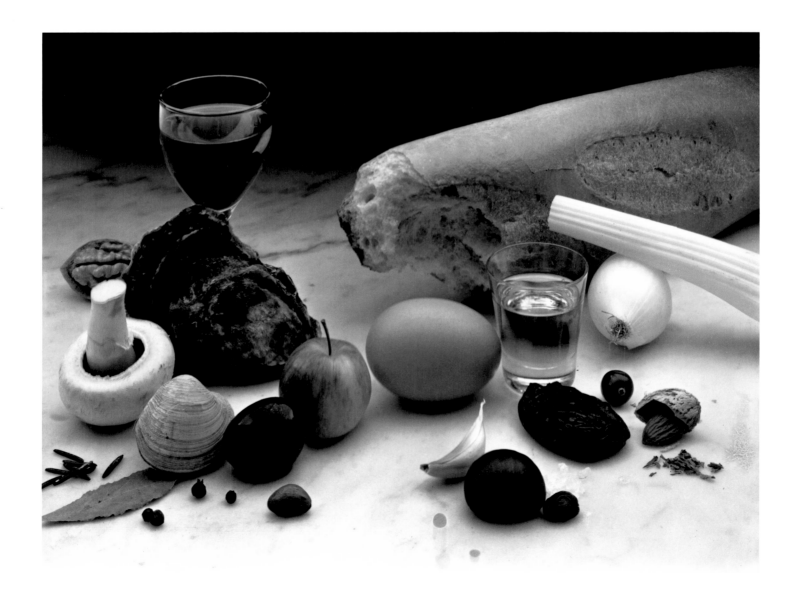

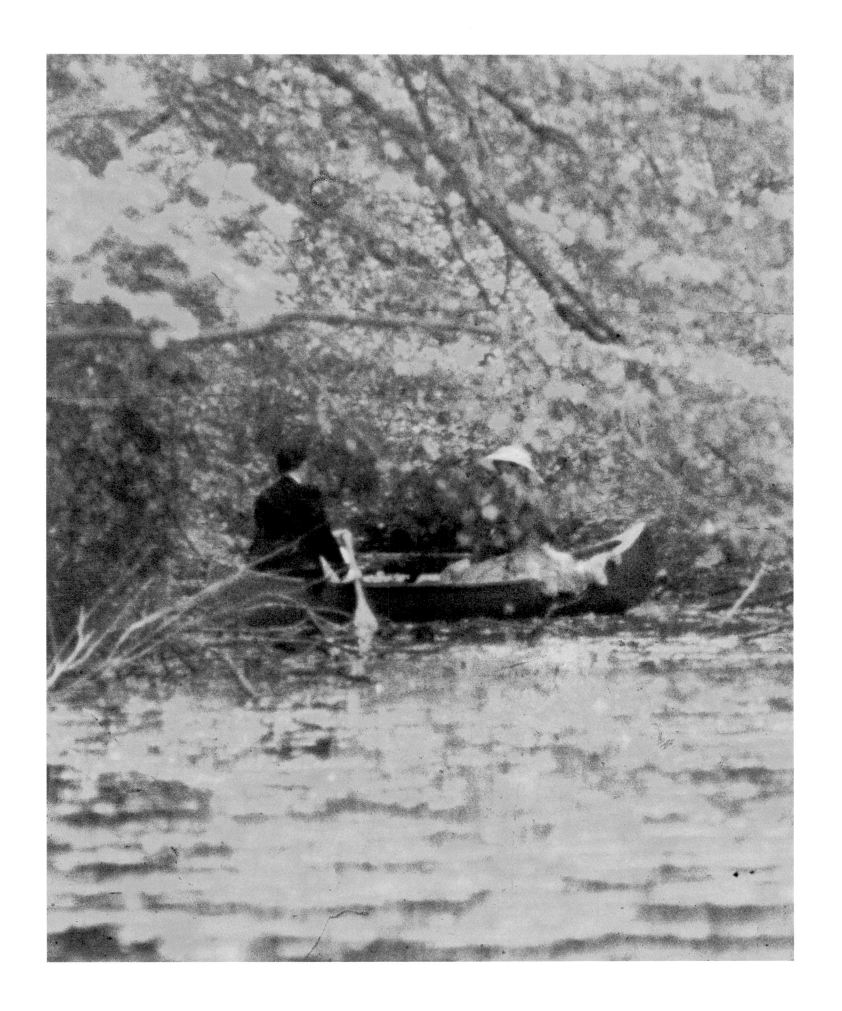

Couple in a Canoe (advertising photograph for De Beers), Long Island, New York, 1954.

Parts of the years 1954 and 1955 were spent photographing the Plymouth car for advertisements. Most of our work was done in Detroit, much in almost paranoid secrecy.

Before the year's model was first shown in the press, the car, our subject, would be delivered to the studio covered in a large cloth, usually at night. The truck that carried it would be unloaded in a private alleyway. Only in the closed studio was the secret object revealed. As we worked on the photograph an armed guard would sit (sometimes asleep) in the studio behind us, protecting his charge.

My first day in Detroit, making our first picture, in ignorance of usual car-photography technique, I illuminated the white surface under the car to make the bumpers glow. The result was admired and treated as brilliant innovation. "Lighting the car upside down" it was called. For the remainder of the two years of the advertising campaign I found myself a prisoner of this tedious way of working.

Ludwig Mies van der Rohe, New York, 1955.

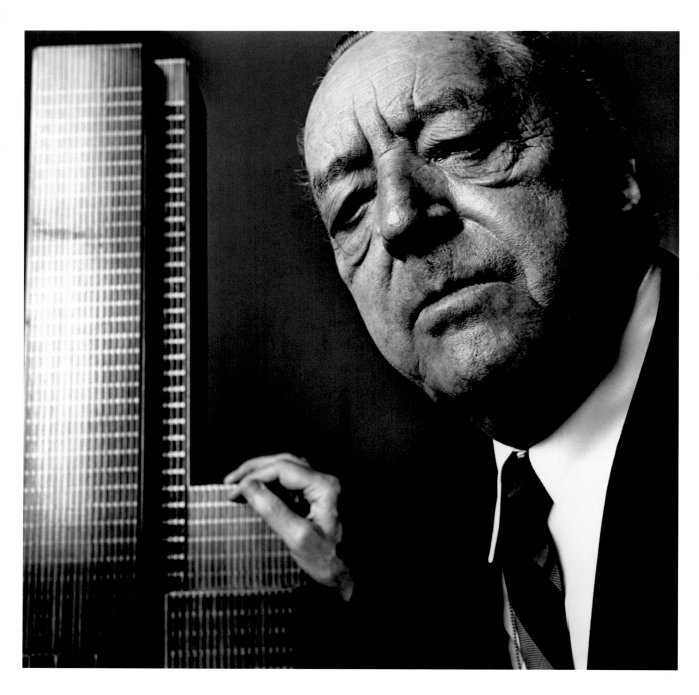

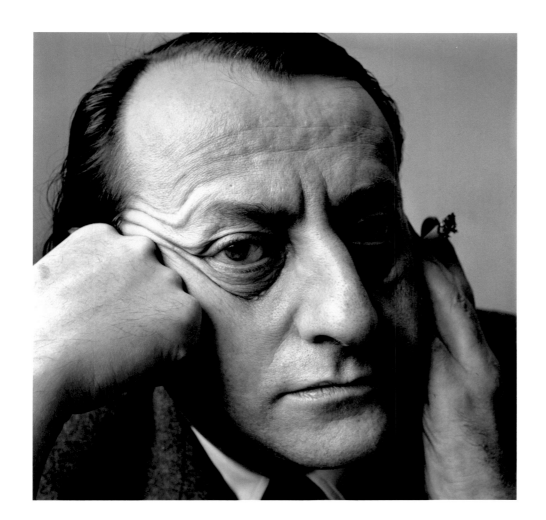

André Malraux, New York, 1954.

Alexander Liberman, New York, 1956.

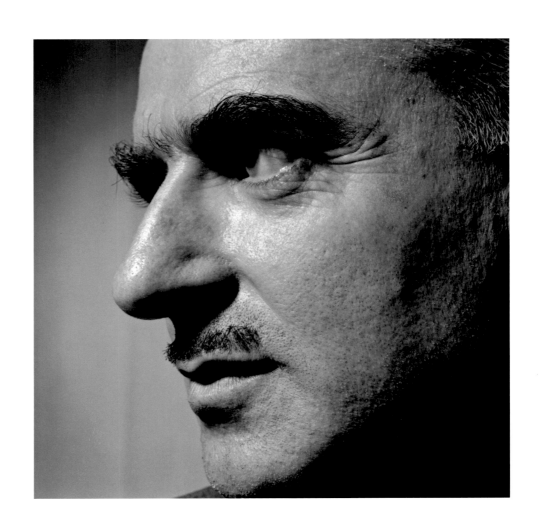

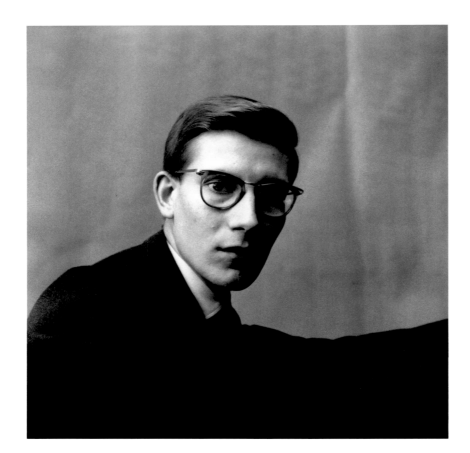

Yves Saint Laurent, Paris, 1957.

Simone de Beauvoir, Paris, 1957.

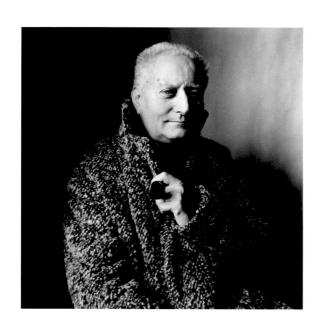

Jean Giono, Manosque, France, 1957.

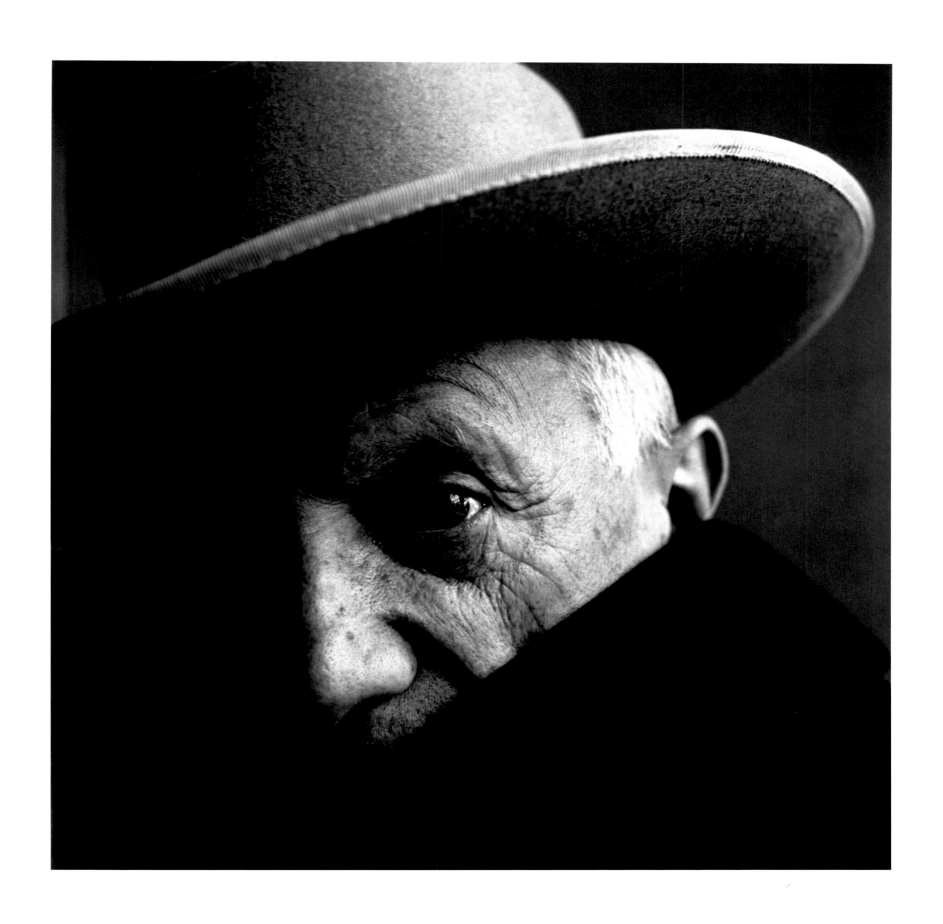

Pablo Picasso at La Californie, Cannes, 1957.

1958

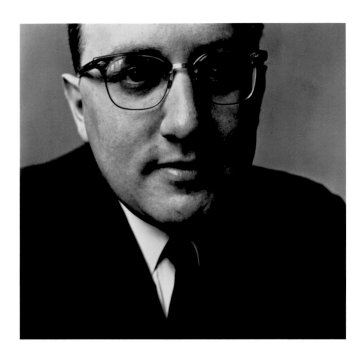

Henry Kissinger, New York, 1958.

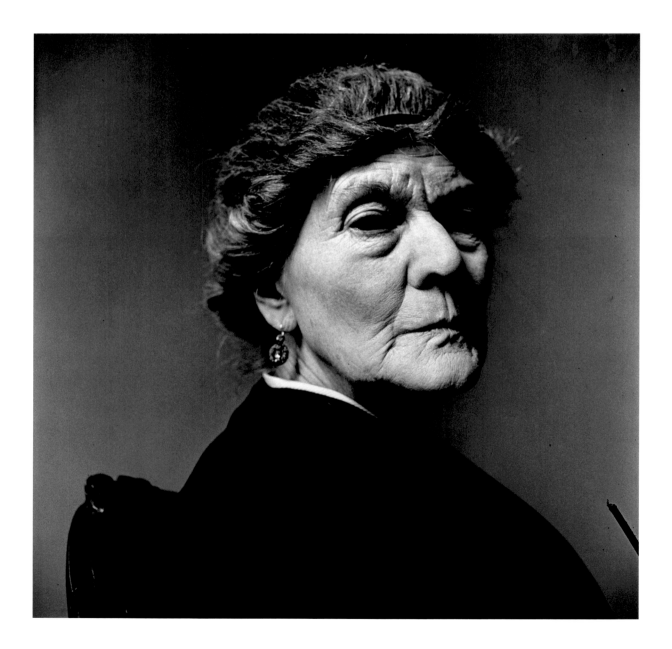

Ivy Compton-Burnett, London, 1958.

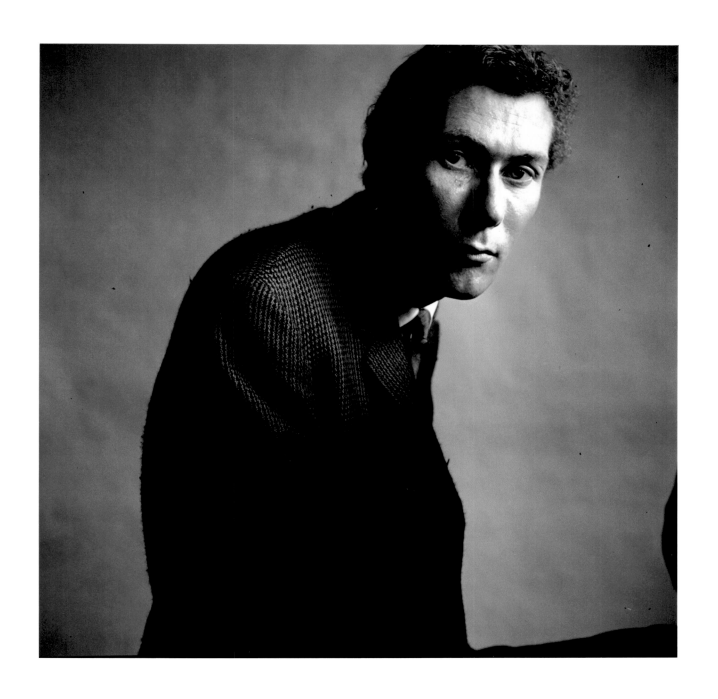

John Osborne, London, 1958.

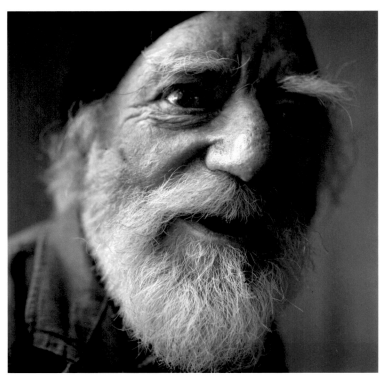

Augustus John, Hampshire, England, 1958.

1959

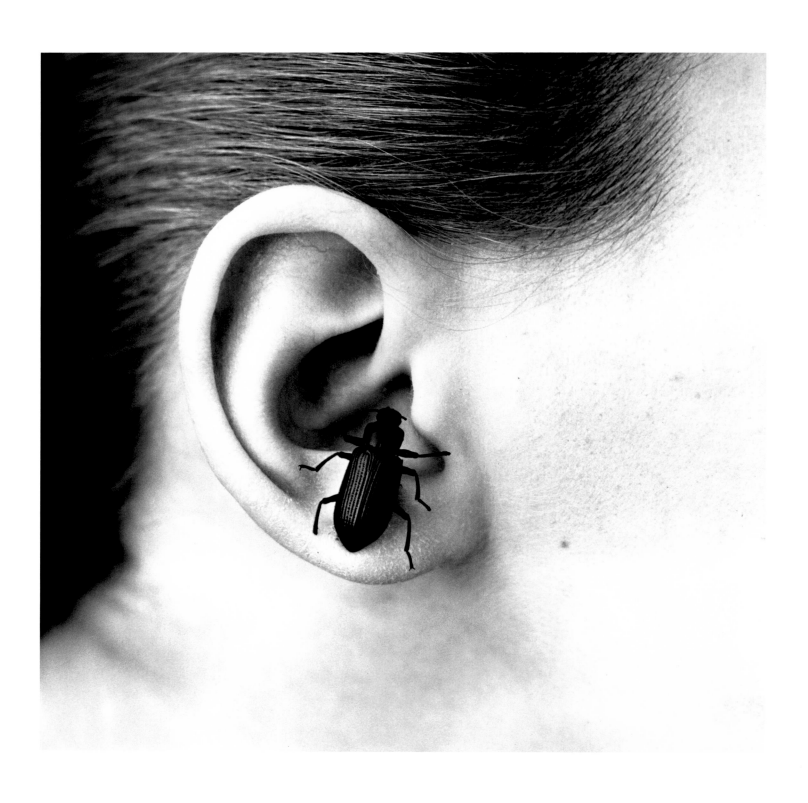

Bug in Ear, New York, 1959.

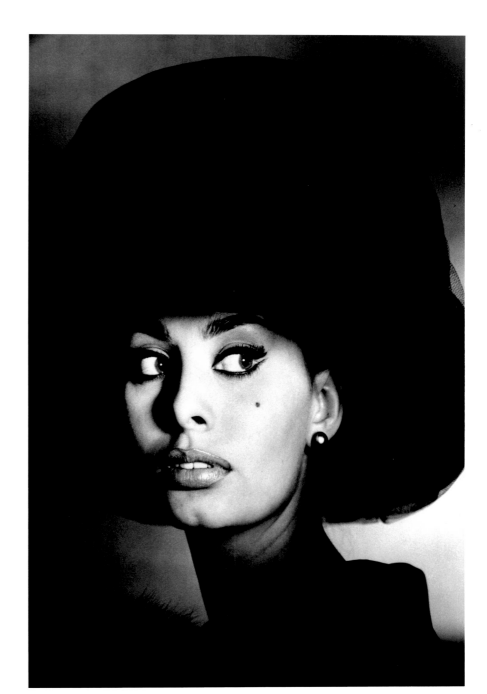

Sophia Loren, New York, 1959.

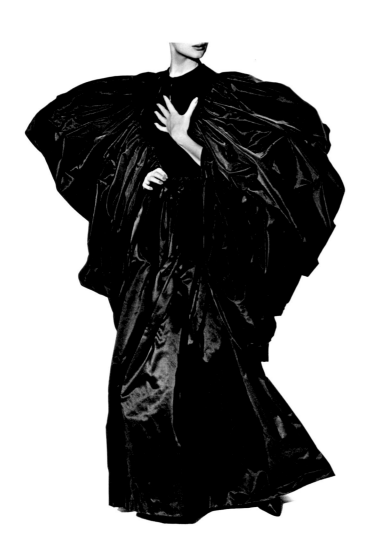

Grès Gown (Isabella Albonico), Paris, 1959.

129

In 1959–61 I had a period of
infatuation with infrared film,
using this seductive material in
photographing beauties for
Vogue. Infrared (as photog-
raphers know) passes through
the surface of skin, even seems
to penetrate flesh. The film
records pupils black, lips pale,
flesh as alabaster. Most of our
beautiful subjects were amused
and pleased to see themselves
transformed.

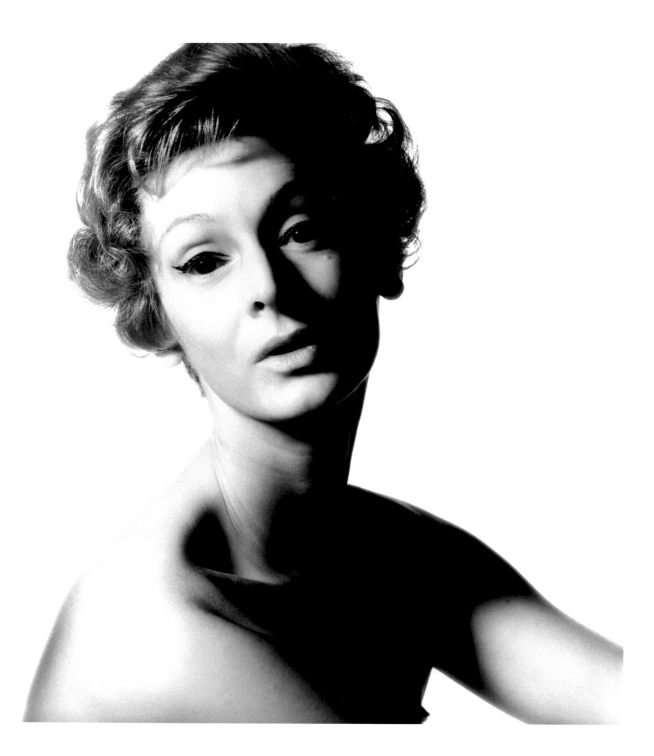

Signora Giovanni Agnelli, New York, 1960.

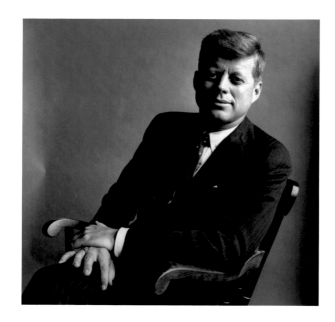

John F. Kennedy, Washington, D.C., 1960.

Frederick Kiesler and Willem de Kooning, New York, 1960.

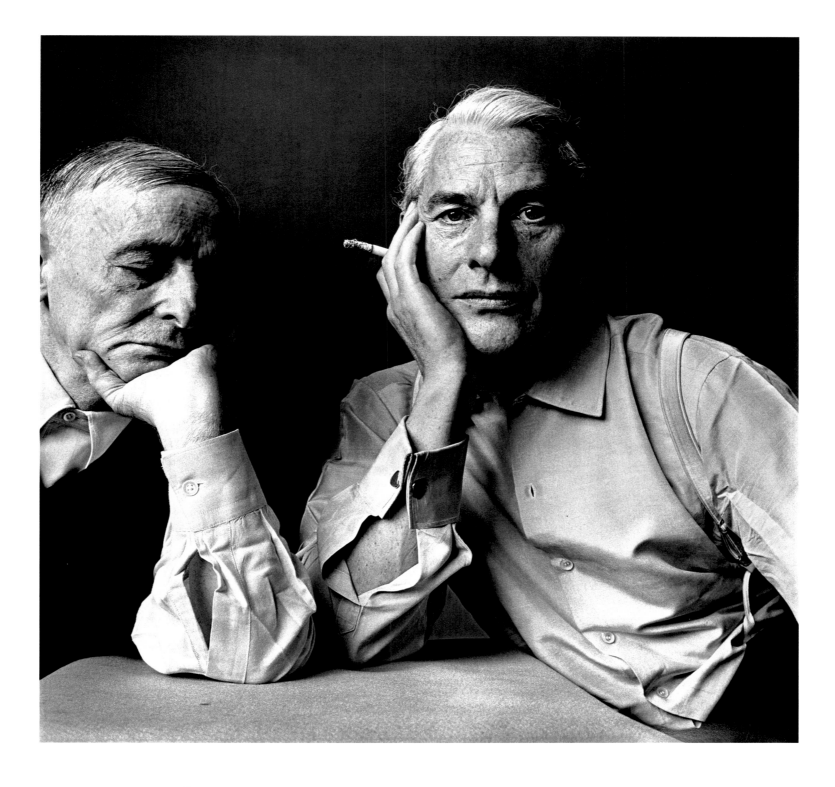

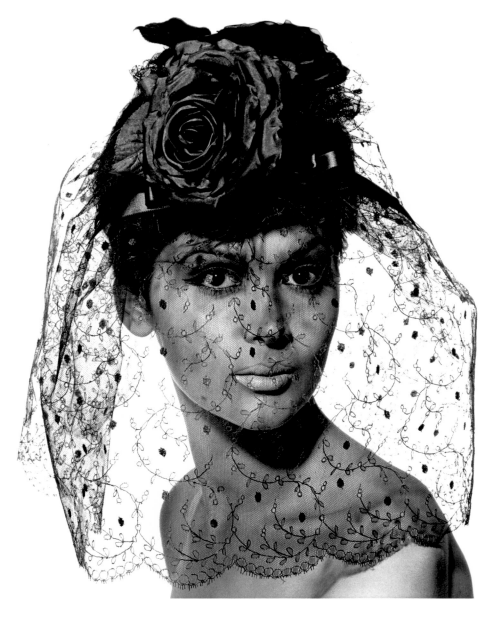

Hat (Isabella Albonico), New York, 1960s.

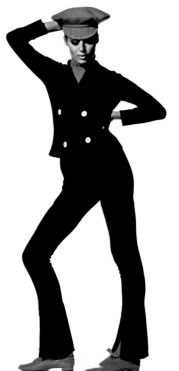

Vogue Fashion (Birgitta Klercker), New York, 1960s.

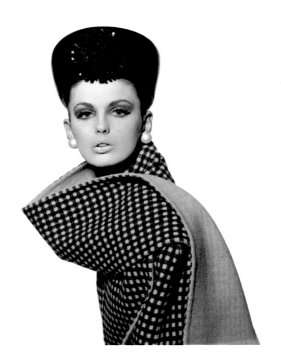

Ricci Stole-Suit (Dorothea McGowan), Paris, 1960.

Vogue *Fashion* (Marisa Berenson), New York, 1960s.

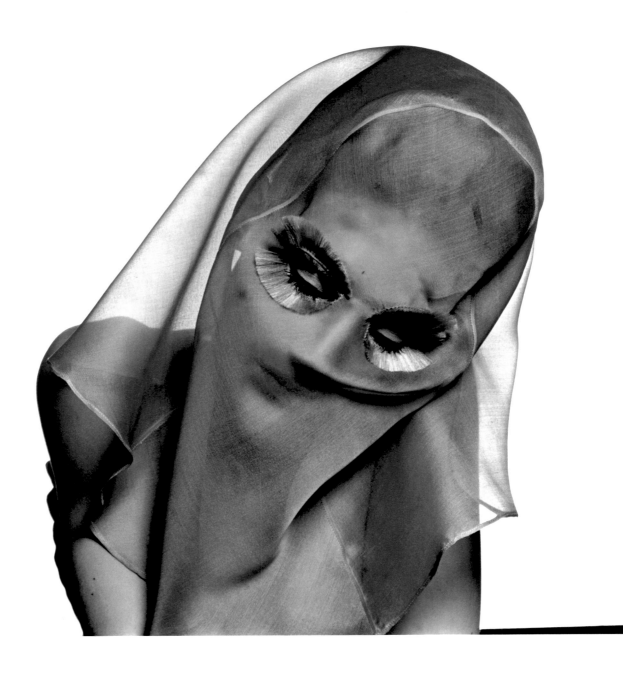

While we were in Paris in
September, people spoke of a
young Russian dancer called
Nureyev who had just defected.
We invited him to pose. I
remember him as shy and under-
standably suspicious. Years later
in New York he posed for me
again, now no longer shy but,
surprisingly, still suspicious.

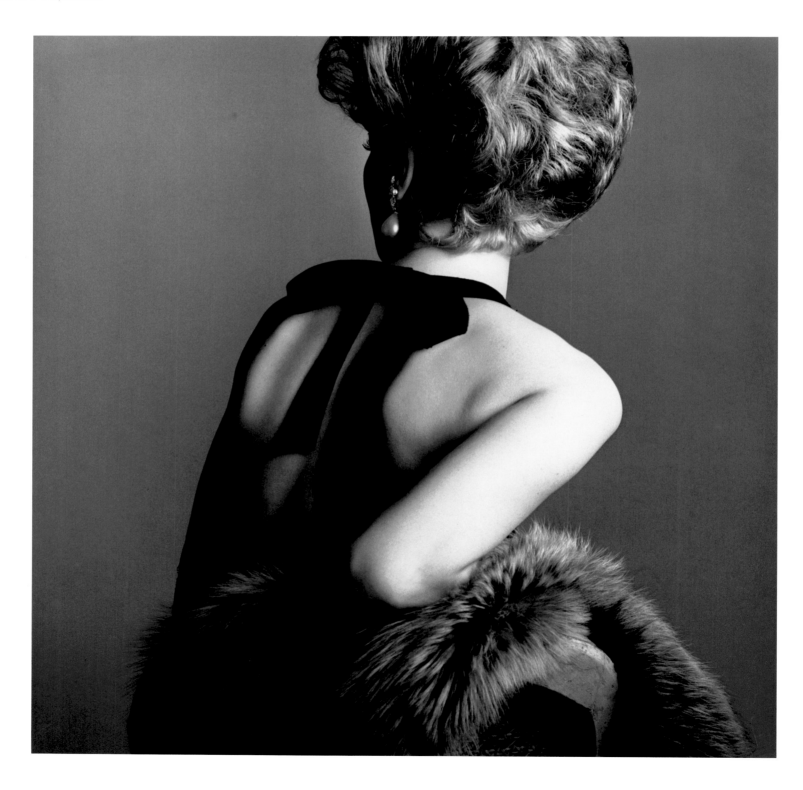

Woman with Bare Back, New York, 1961.

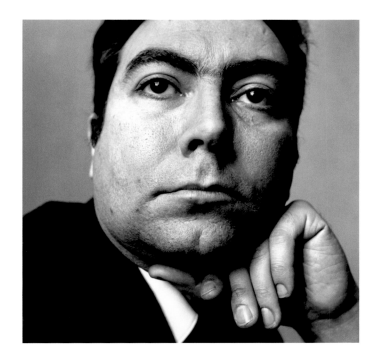

Antonio Tàpies, New York, 1961.

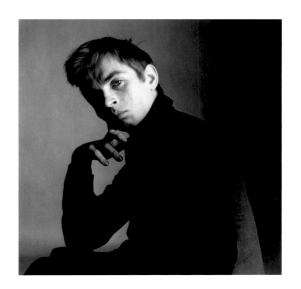

Rudolf Nureyev, Paris, 1961.

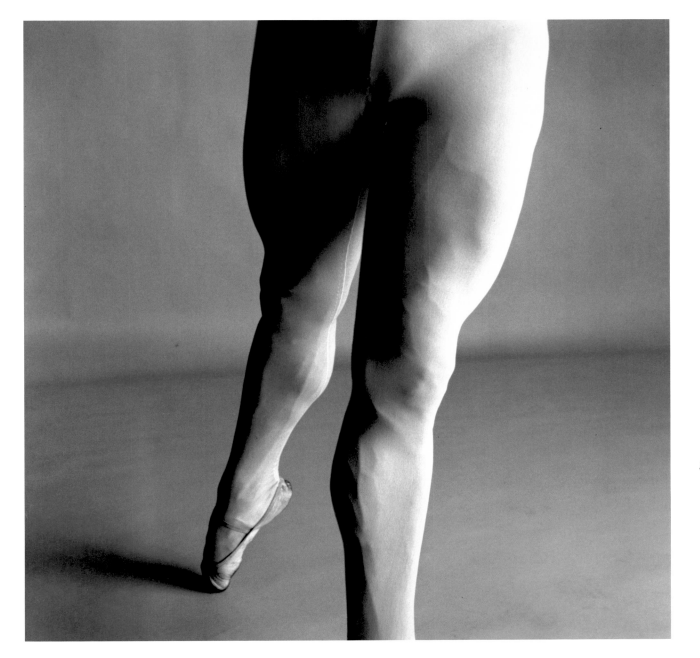

Rudolf Nureyev's Legs, Paris, 1961.

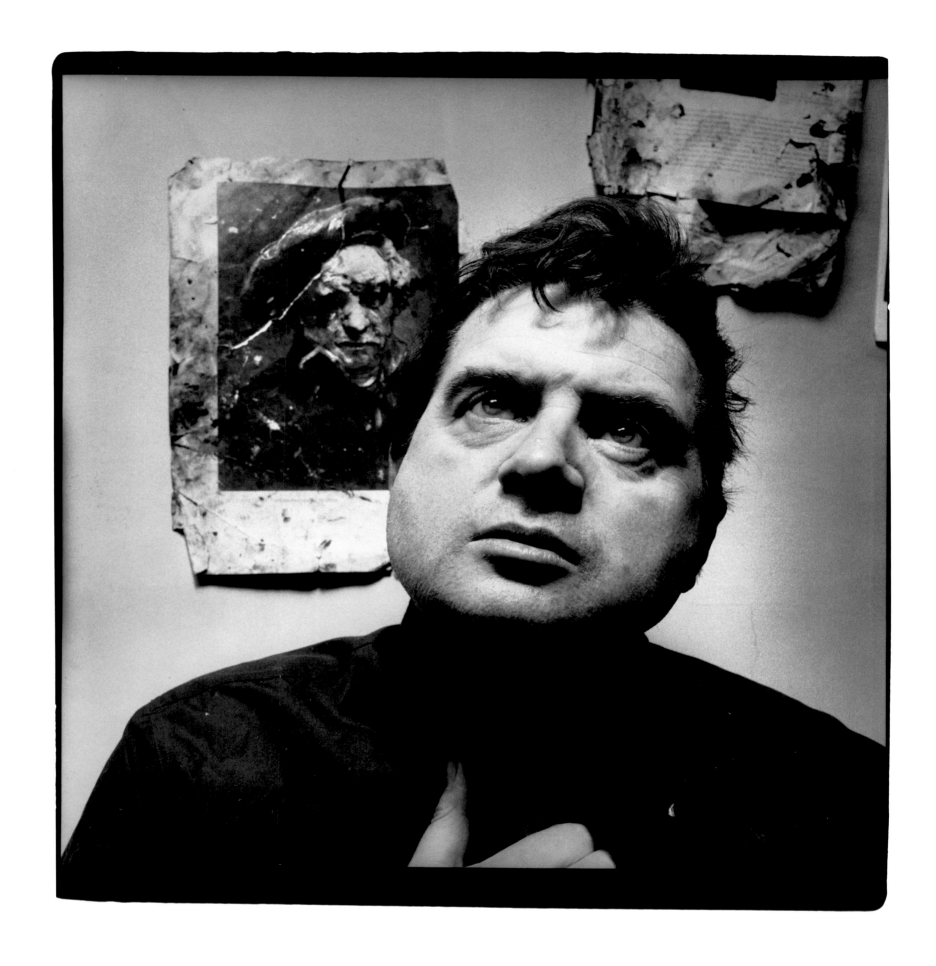

Francis Bacon, London, 1962.

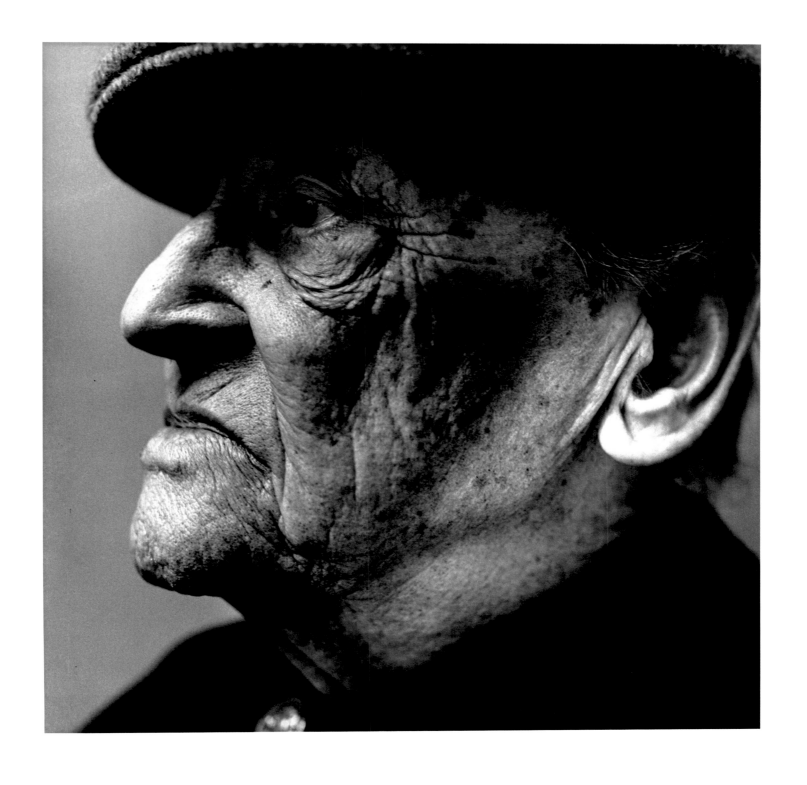

W. Somerset Maugham, Cap Ferrat, France, 1962.

1962

Alberto Moravia, Rome, 1962.

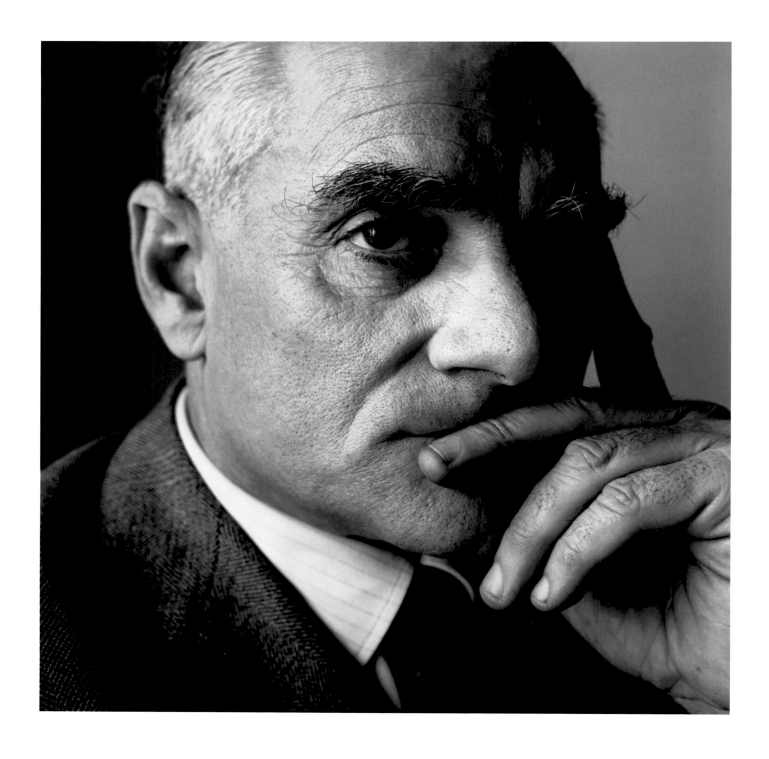

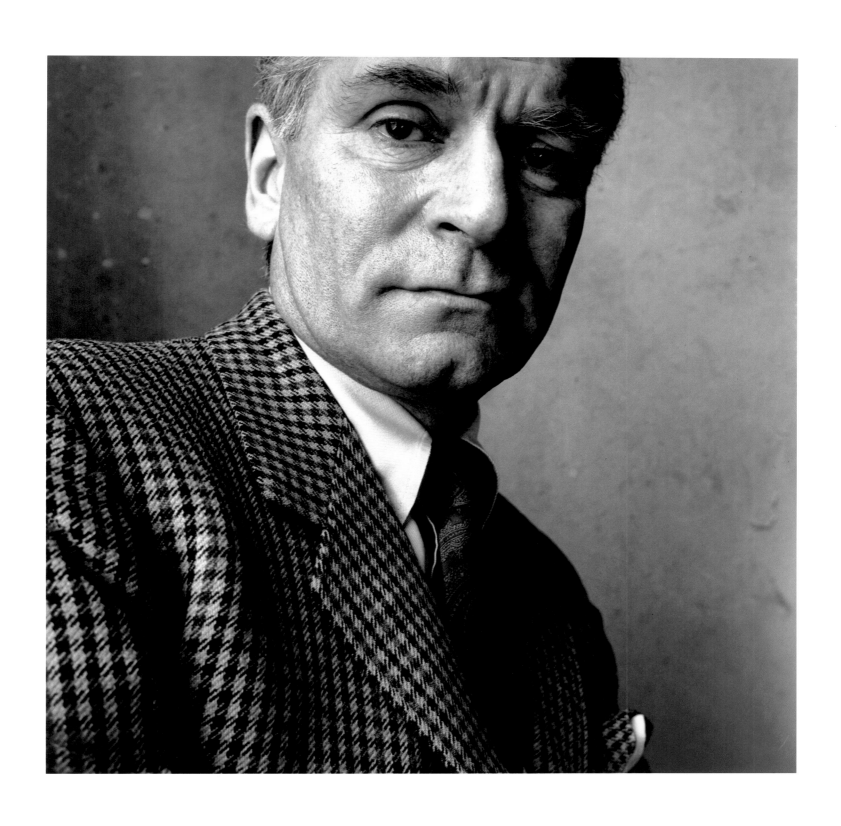

Laurence Olivier, England, 1962.

S. J. Perelman, New York, 1962.

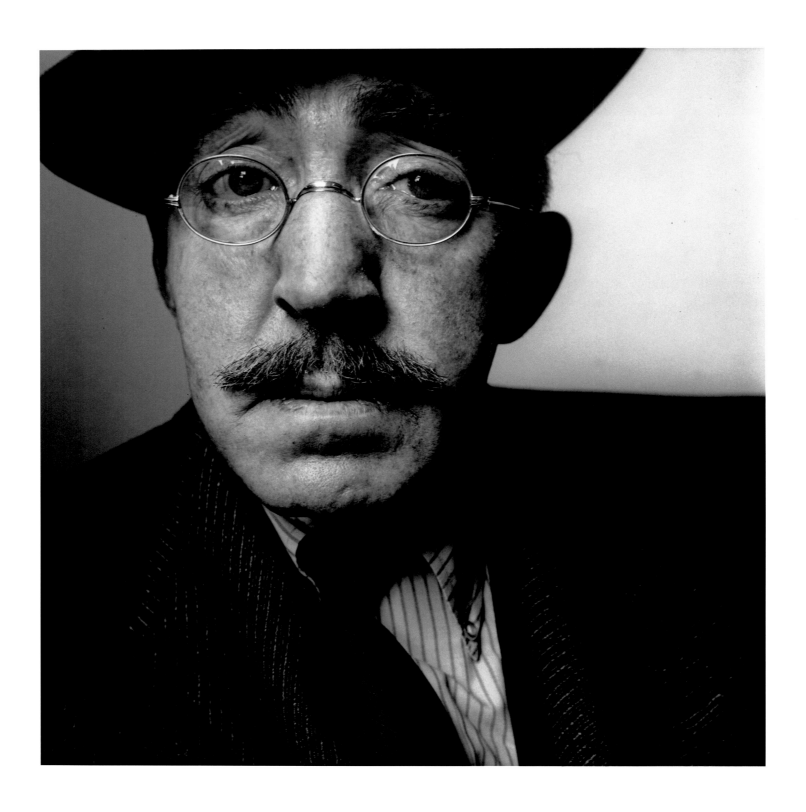

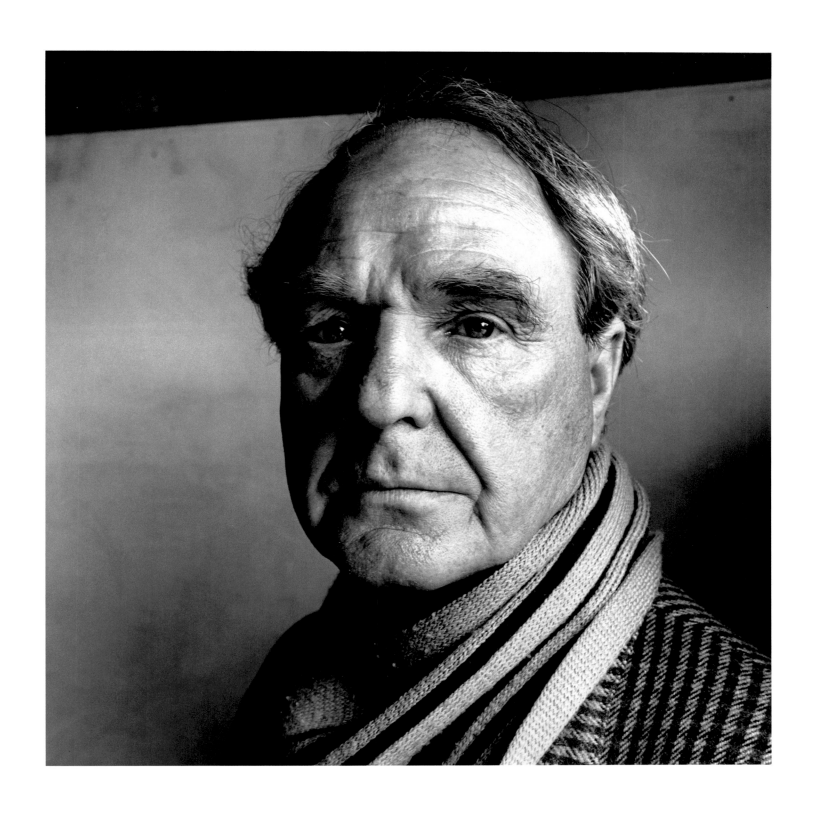

Henry Moore, Much Hadham, England, 1962.

Diamond dealer Harry Winston
found himself one day with three
similar enormous pear-shaped
diamonds in his New York
inventory. We quickly set up a
picture for Vogue right in
Winston's office, in that way
saving time and making unnec-
essary the usual armed guards
had we taken the picture in our
own studio.

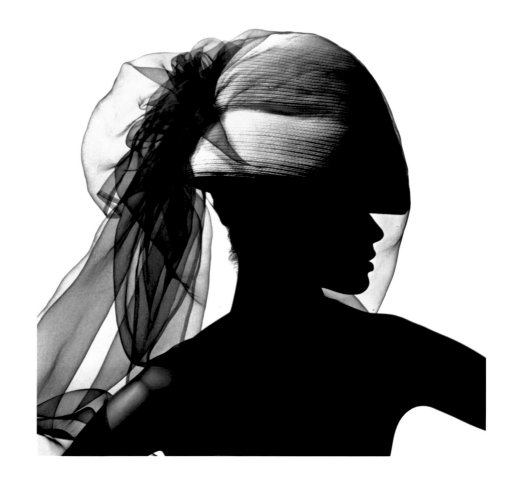

Vogue *Fashion* (Veruschka), 1963.

Beach, Portugal, 1963.

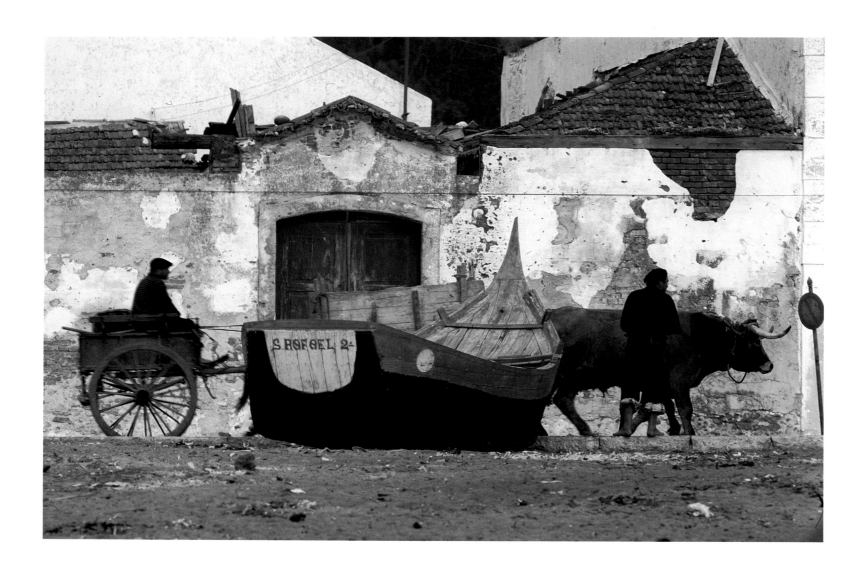

Sometime in 1964 I realized that I was victim of a printmaking obsession, a condition that persists today. The focus of my interest I found in the metal platinum and its related palladium and iridium. With them in combination I found possibilities for the most subtle controls and alteration.

Of course, I did not myself invent this technique, which dates from photography's earlier days. I was simply relearning it and bringing to it both new ignorance and contemporary materials. We are, for example, fortunate to have present-day films that do not change dimensions wet or dry, and I was able to find for myself a method that made possible multiple coatings and developings on the same sheet of paper without loss of image sharpness.

Finally I arrived at the serene pleasure of making the print itself. Over the years I must have spent thousands of hours silently brushing on the liquid coatings, preparing each sheet of paper in anticipation of reaching the perfect print.

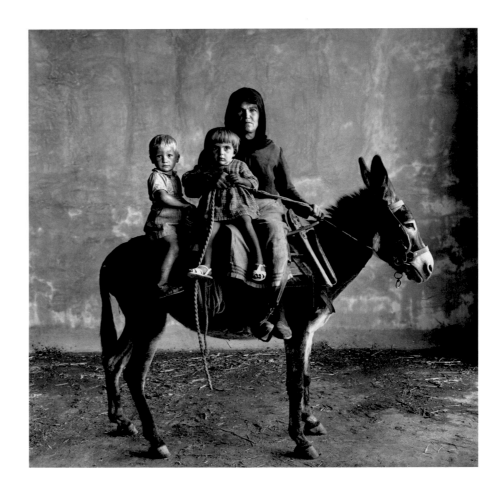

Woman with Two Young Children, Crete, 1964.

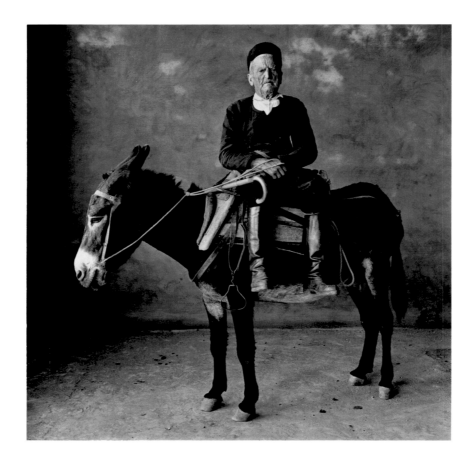

Old Man on Donkey, Crete, 1964.

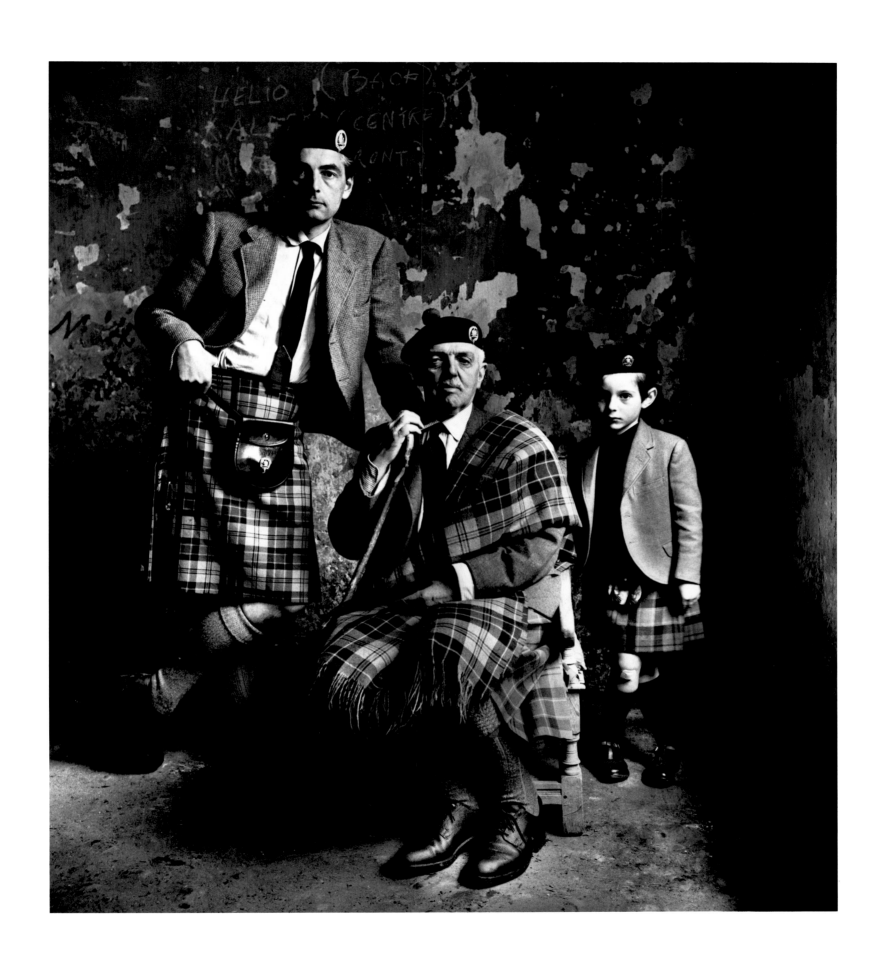

The Earl of Airlie, His Son Lord Ogilvy, and the Honorable David Ogilvy, Scotland, 1963.

1964

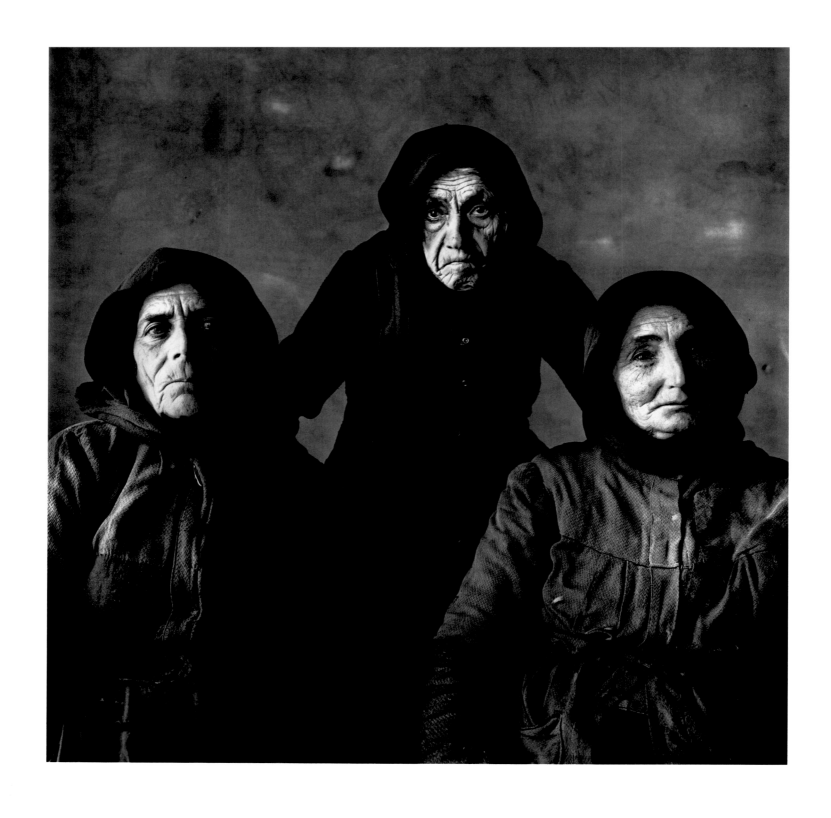

Three Women, Crete, 1964.

146

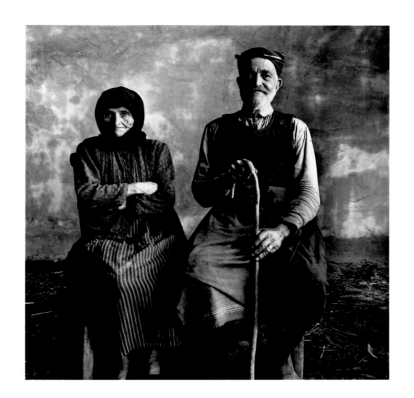

Old Couple, Crete, 1964.

Cretan Landscape, 1964.

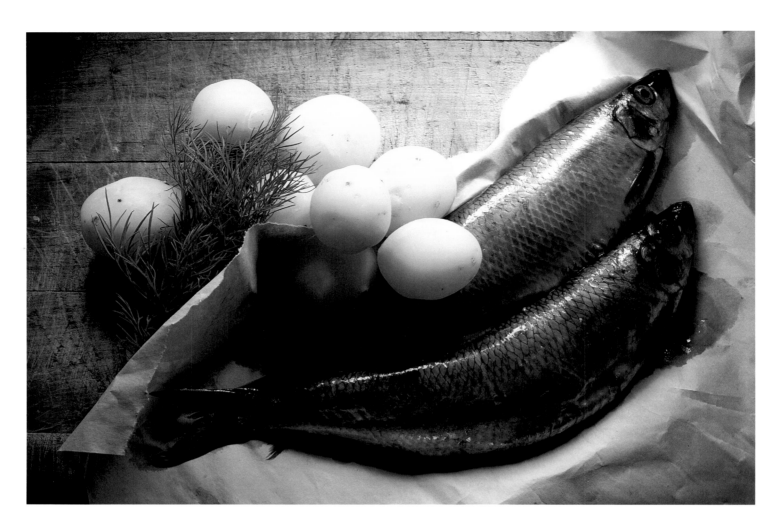

Potatoes and Baltic Herring, Sweden, 1964.

Girl in Grass, Sweden, 1964.

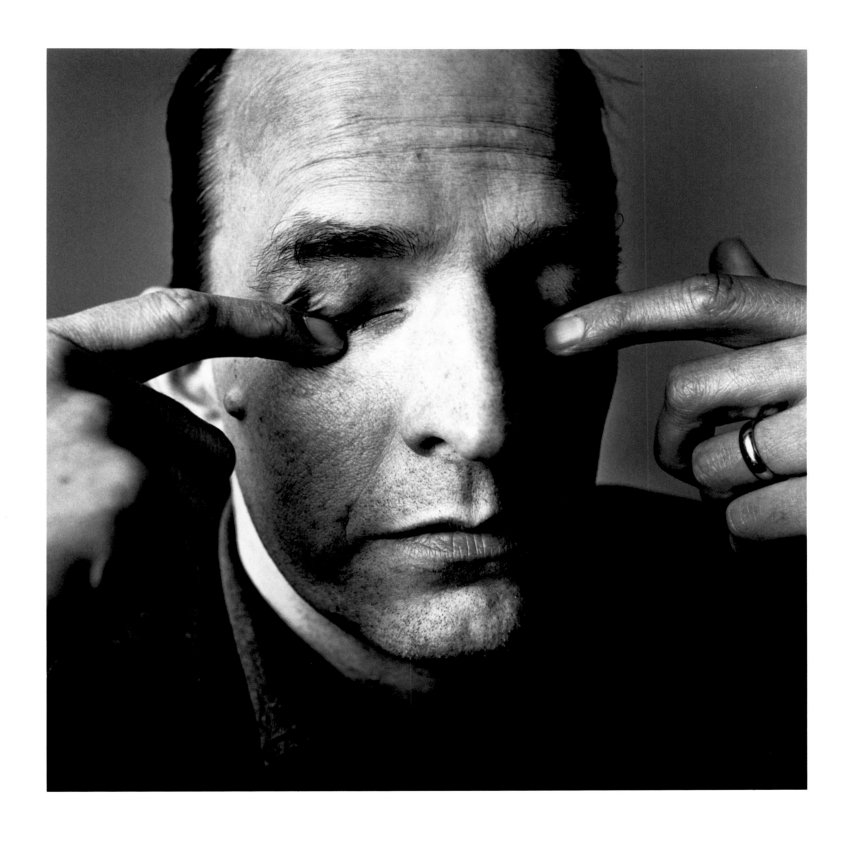

Ingmar Bergman, Stockholm, 1964.

David Smith, Bolton's Landing, Lake George, New York, 1964.

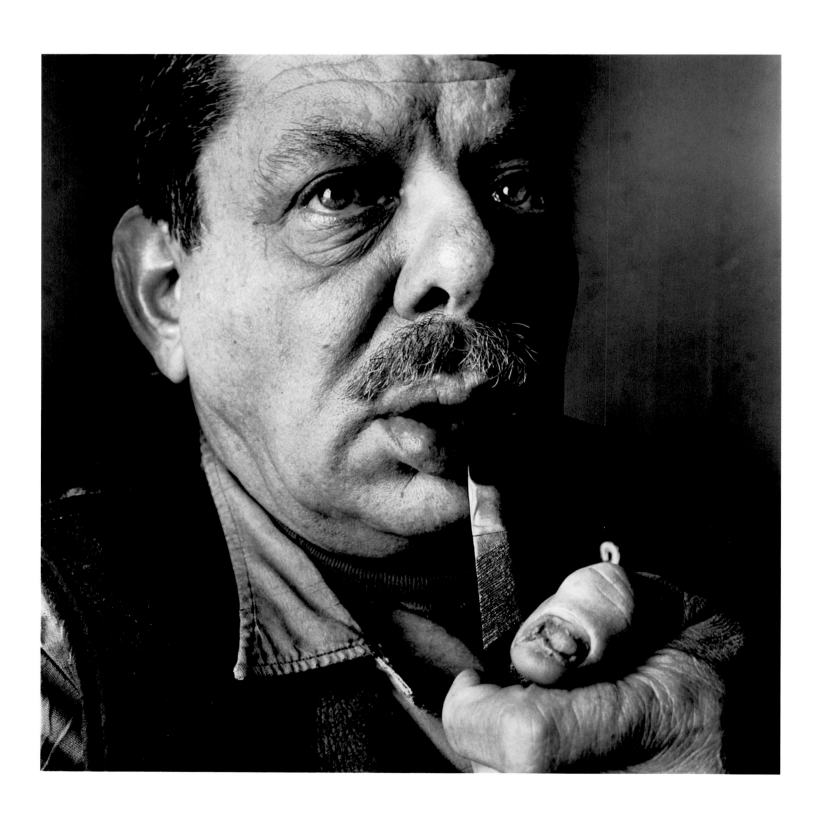

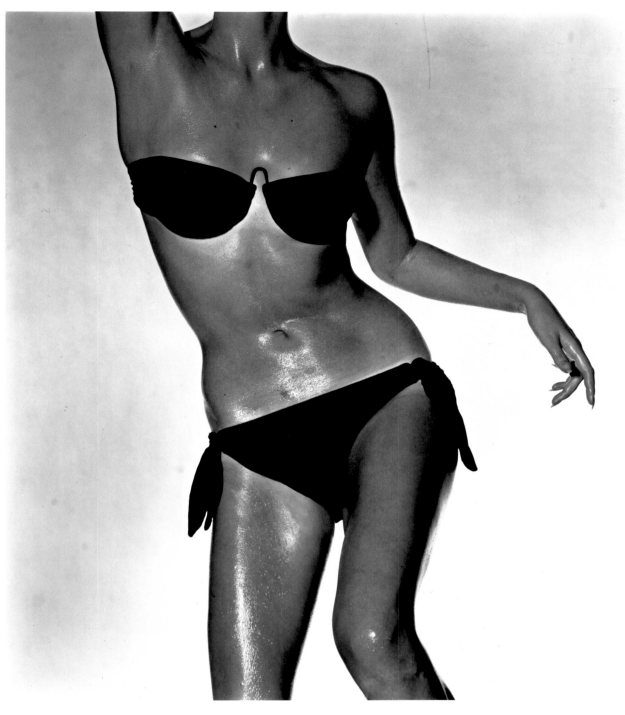

Bathing Suit (Birgitta Klercker), New York, 1964.

Yo-Yo Ma, New York, 1964.

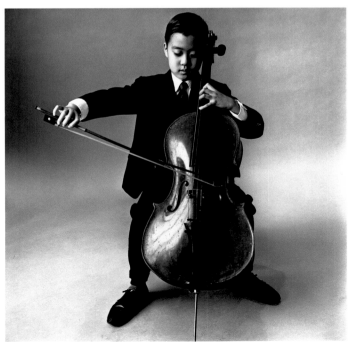

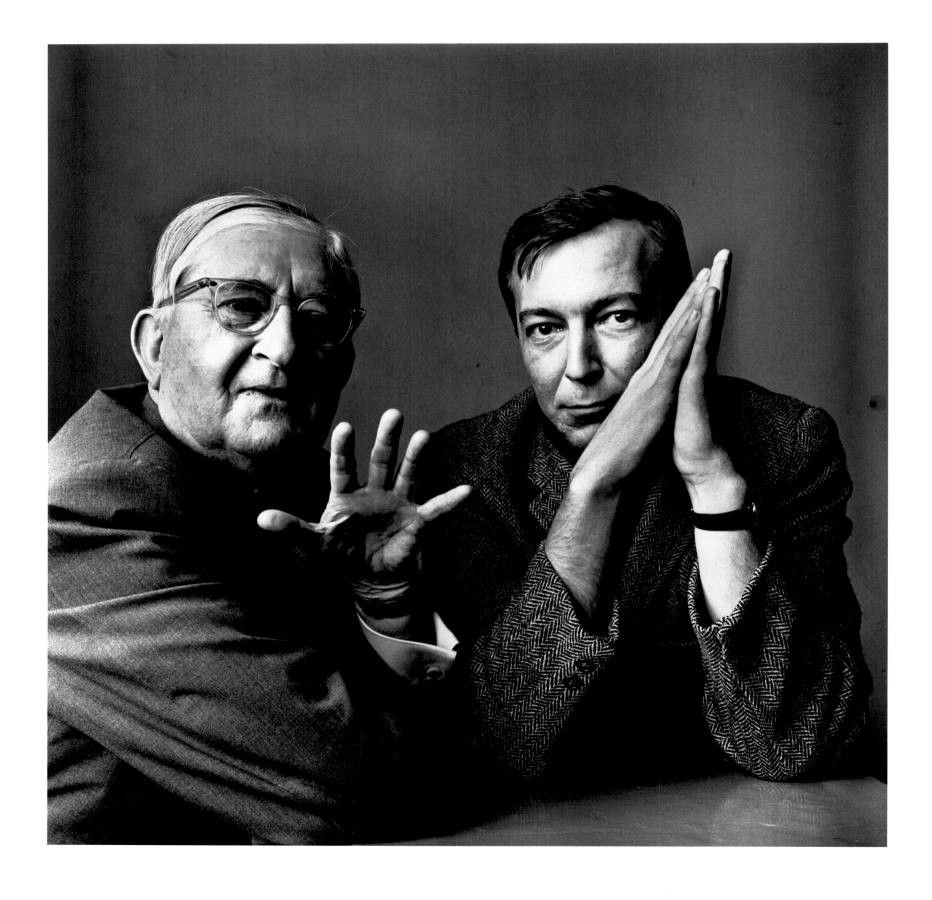

Josef Albers and Jasper Johns, New York, 1964.

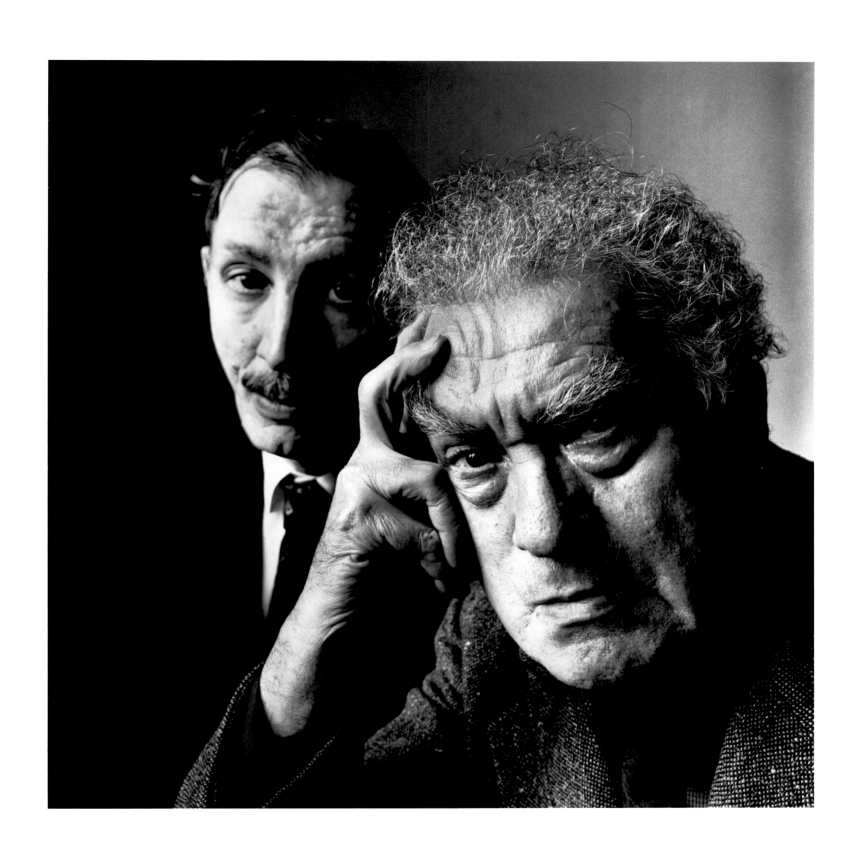

Alan Hovhaness and Edgard Varèse, New York, 1964.

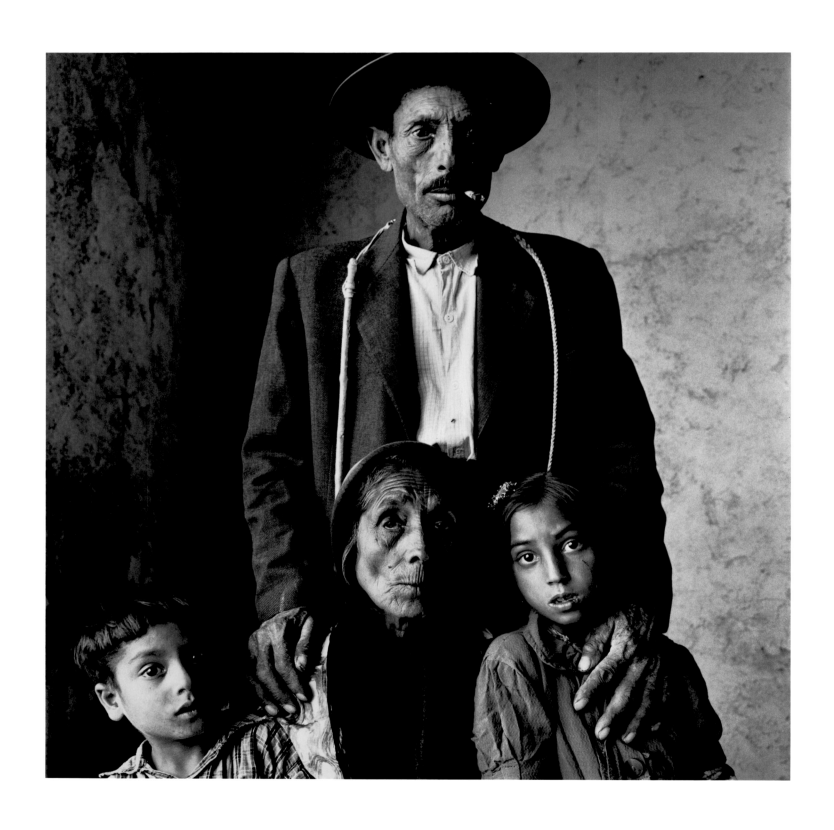

Gypsy Family, Estremadura, Spain, 1965.

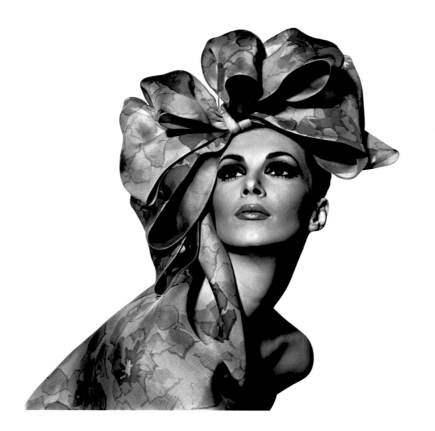

Vogue *Fashion* (Wilhelmina), 1965.

Transparent Raincoat (Veruschka), 1965.

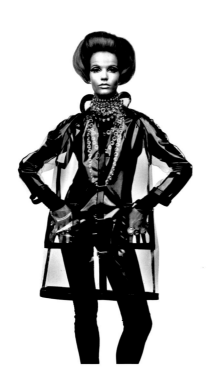

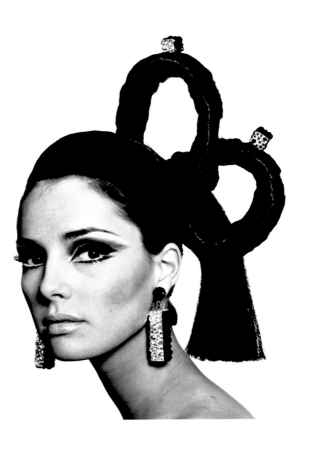

Vogue *Fashion* (Jennifer O'Neill), Paris, 1965.

Truman Capote, New York, 1965.

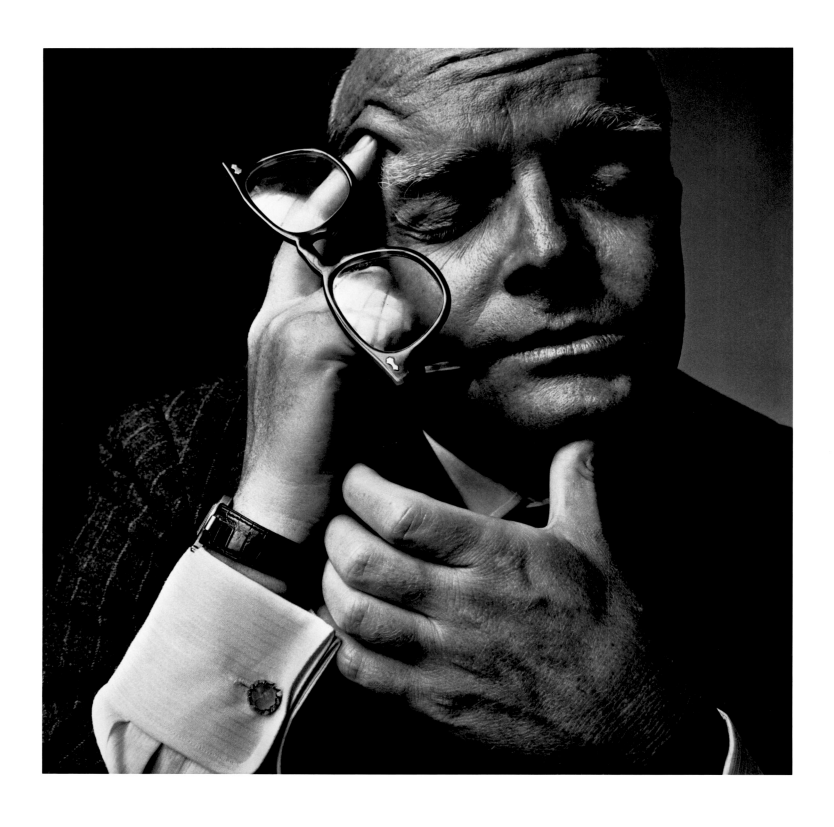

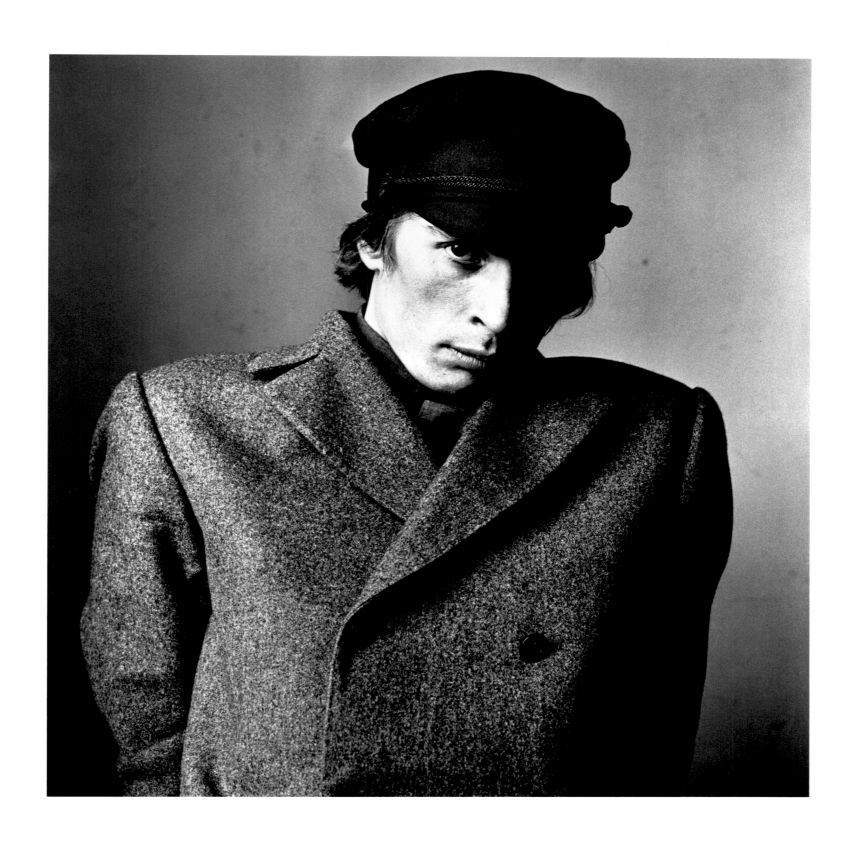

Rudolf Nureyev, New York, 1965.

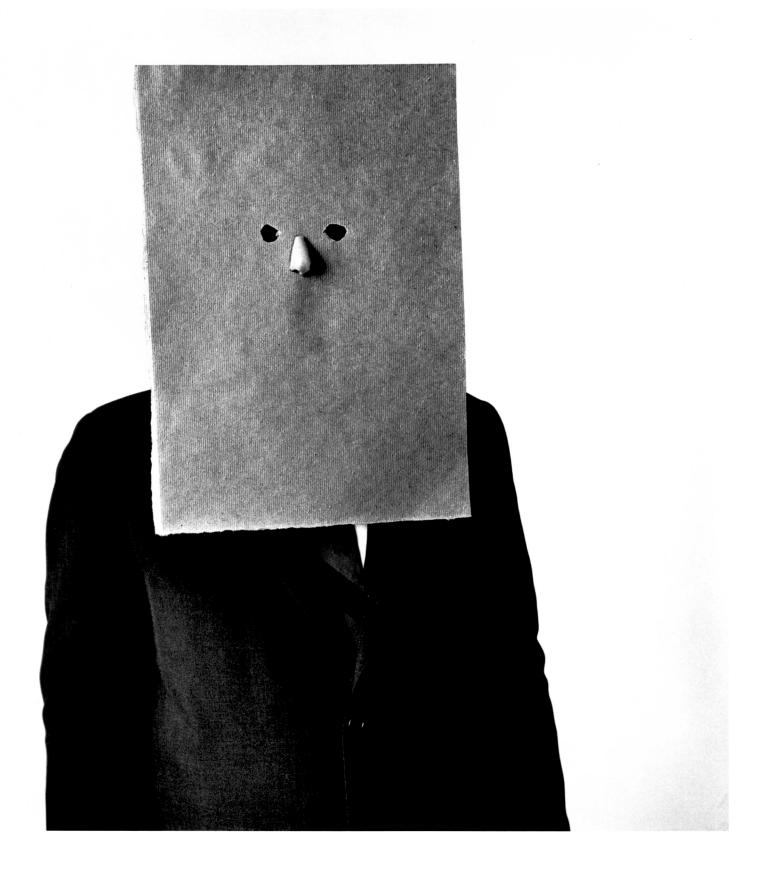

Saul Steinberg in Nose Mask, New York, 1966.

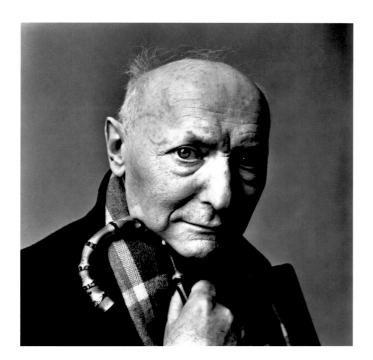

Isaac Bashevis Singer, New York, 1966.

Barnett Newman, New York, 1966.

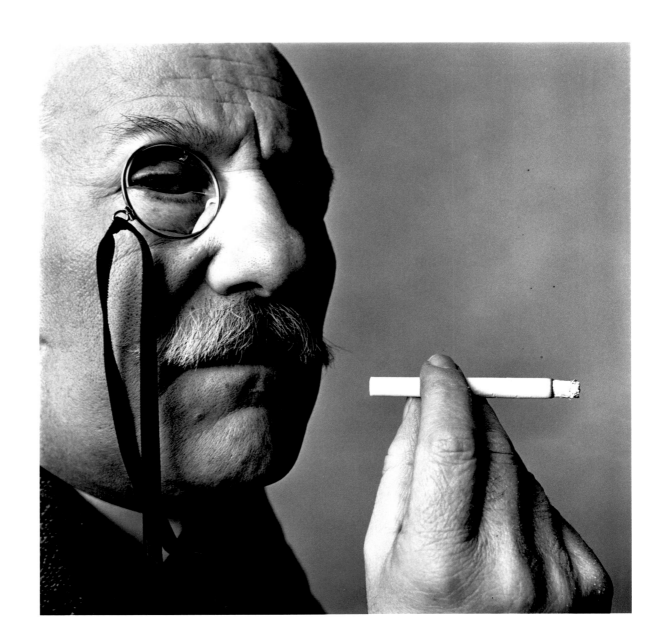

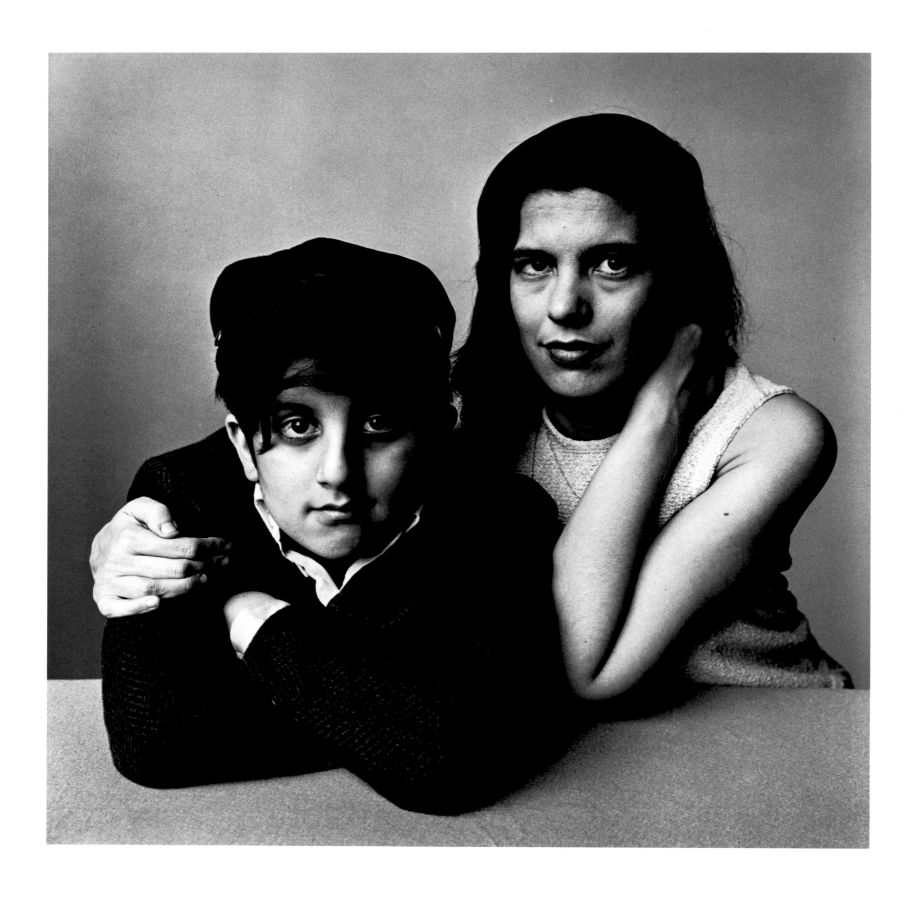

Susan Sontag and David Sontag Rieff, New York, 1966.

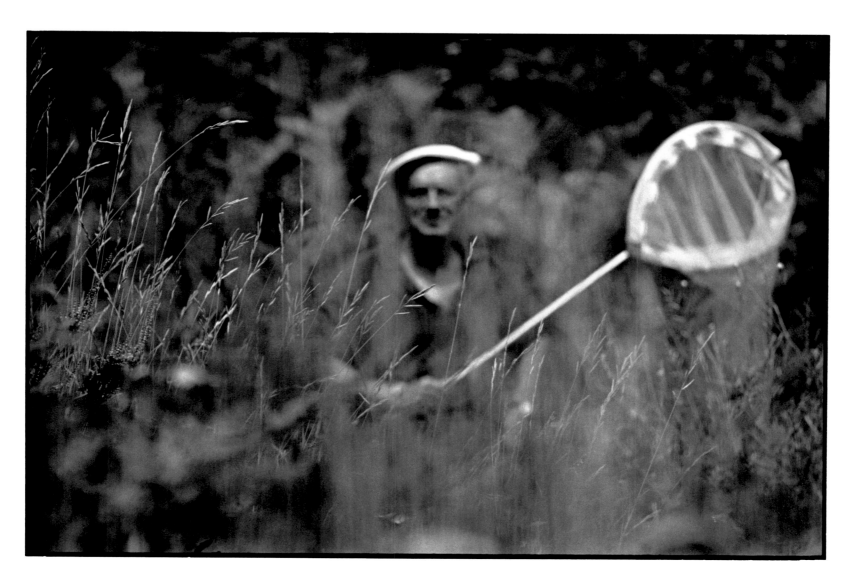

Vladimir Nabokov Chasing Butterflies, Italy, 1966.

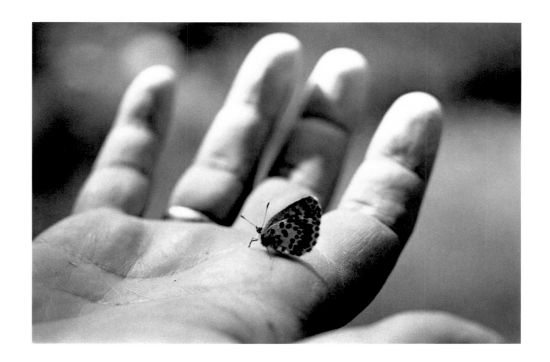

The Hand of Vladimir Nabokov, Italy, 1966.

1966
1967

Alexey Brodovitch and I lunched together at an Italian restaurant in Greenwich Village one day in 1966. I could tell there was already a cloud over his mind. I feared that we would not meet again. He told me of his plan to leave for France to live in Provence, where he had family. He still had a tiny property in Oppède-le-Vieux, a cave he had bought many years before. His architect brother lived in nearby Avignon.

His reason for asking that we lunch that day was to tell me that the Philadelphia College of Art was planning to honor him with a doctorate. Would I receive it for him? I promised.

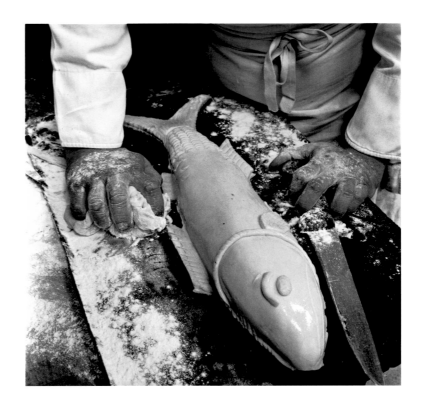

The Hands of Paul Bocuse, Lyons, France, 1966.

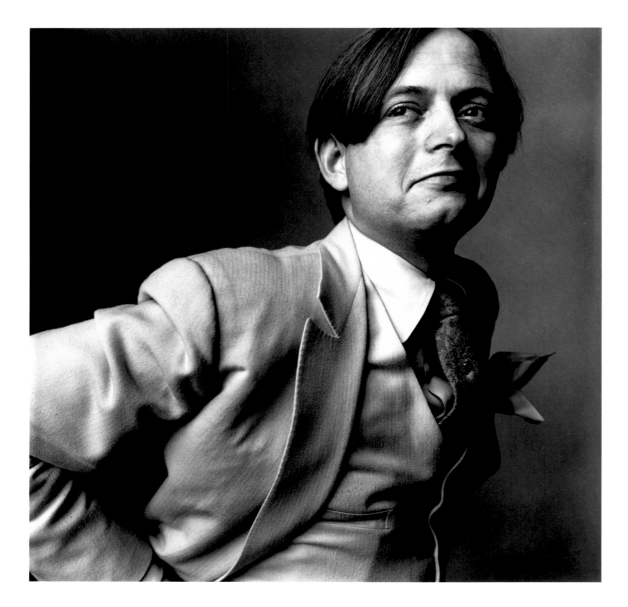

Tom Wolfe, New York, 1966.

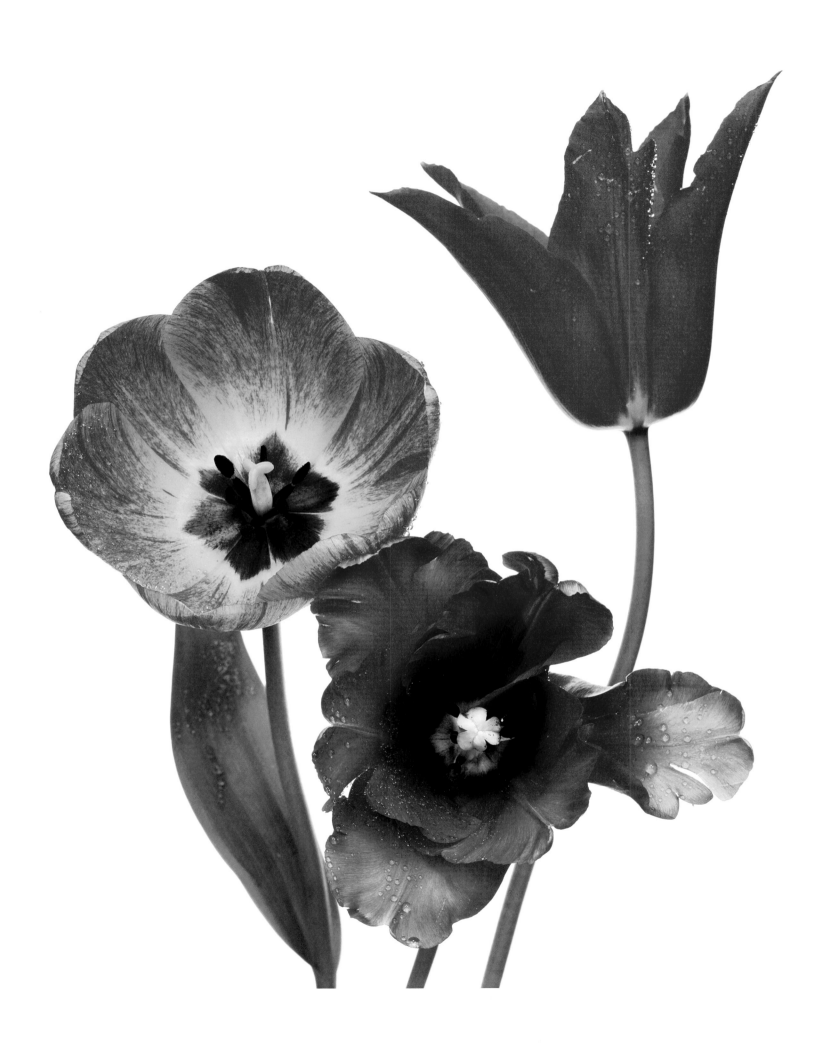

Tulips (Red Shine, Black Parrot, and Gudoshnik), New York, 1967.

1967

In 1967 I photographed a number of tulips, the first of seven series of studies each devoted to one flower. The pictures were published in Christmas issues of Vogue, 1967 to 1973. This material was assembled and published as a book in 1980.

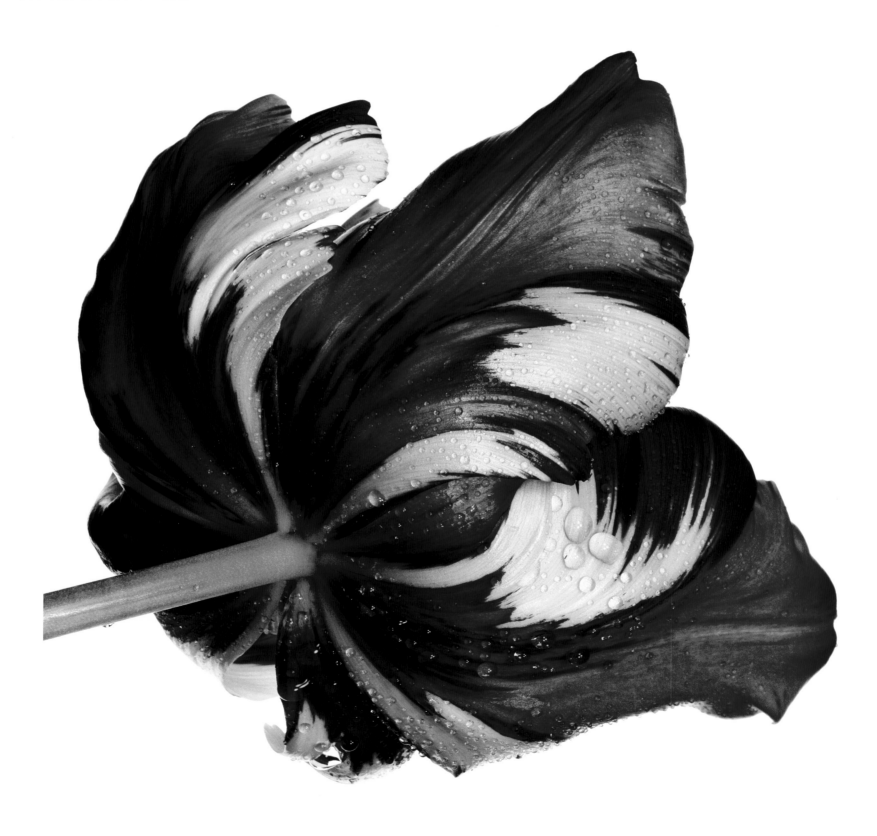

Cottage Tulip (Sorbet), New York, 1967.

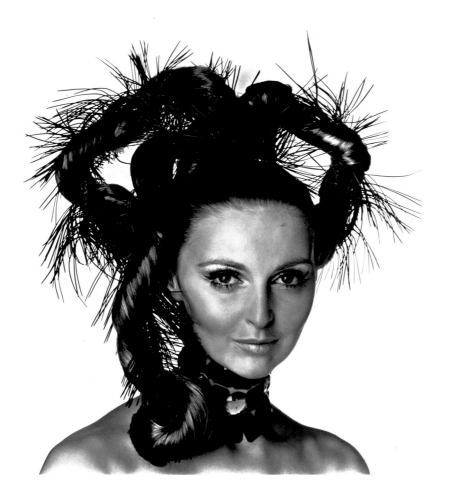

Vogue *Beauty* (Samantha Jones), New York, 1967.

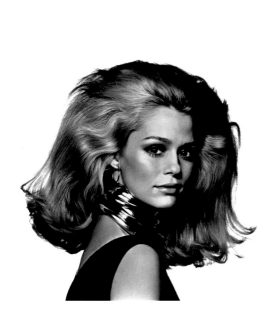

Vogue *Fashion* (Lauren Hutton), New York, 1967.

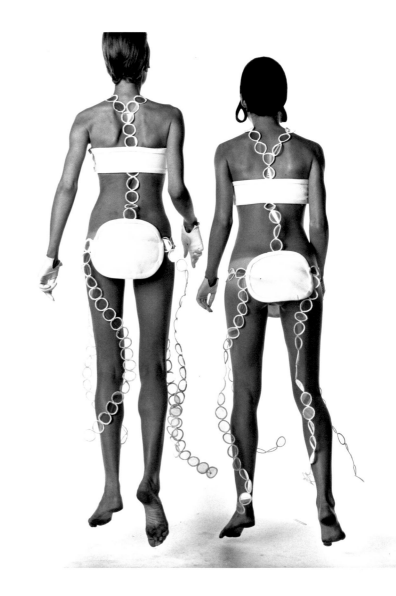

Courrèges Fashion (Veruschka and Ann Turkel), Paris, 1967.

Choosing subjects to photograph from among the hippies took long conversation and testings of good faith. On the other hand, the Hell's Angels quickly agreed to come to the studio for simply a stiff fee. At twelve noon one day we met in the park and looked each other over. A deal was made.

During the actual photographing, the hippies and the rock groups surprised me with their concentration. Their eyes remained riveted on the camera lens; I found them patient and gentle. There was not the distracted quality I might have expected in them.

The Hell's Angels were something else again. They were like coiled springs ready to fly loose and make trouble. The delays and provocations they could produce were endless. Fortunately the hypnotizing lens of the camera and the confinement of the studio held them in check just long enough for the exposures to be made. When the experience was over and we heard their screaming bikes going down the road, I breathed a sigh of relief.

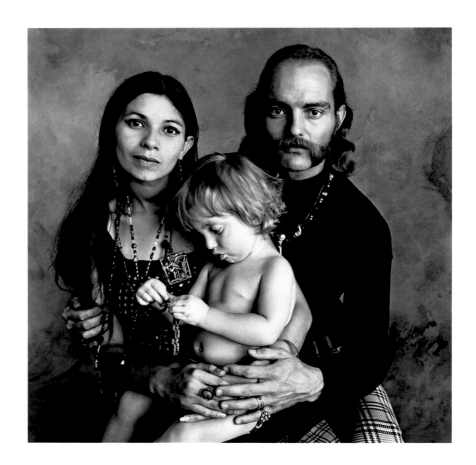

Hippie Family (F), San Francisco, 1967.

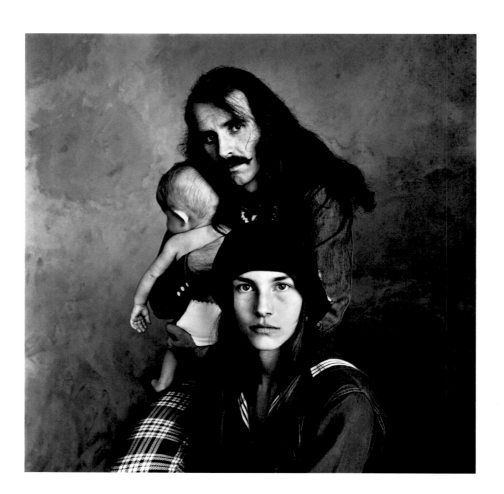

Hippie Family (K), San Francisco, 1967.

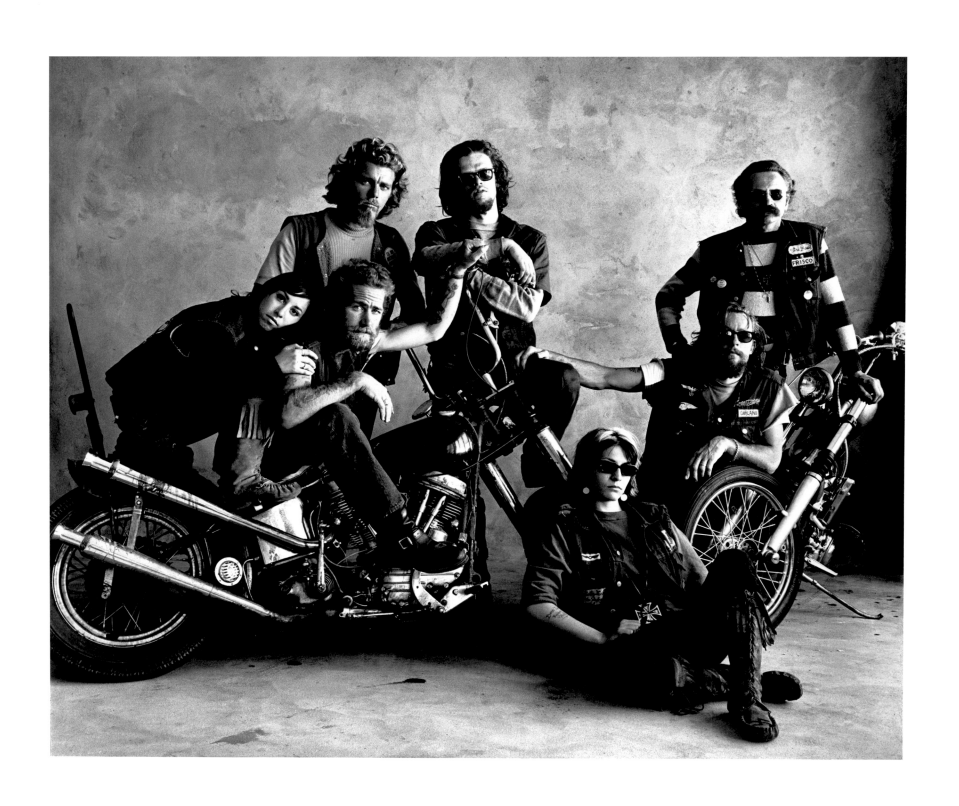

Hell's Angels, San Francisco, 1967.

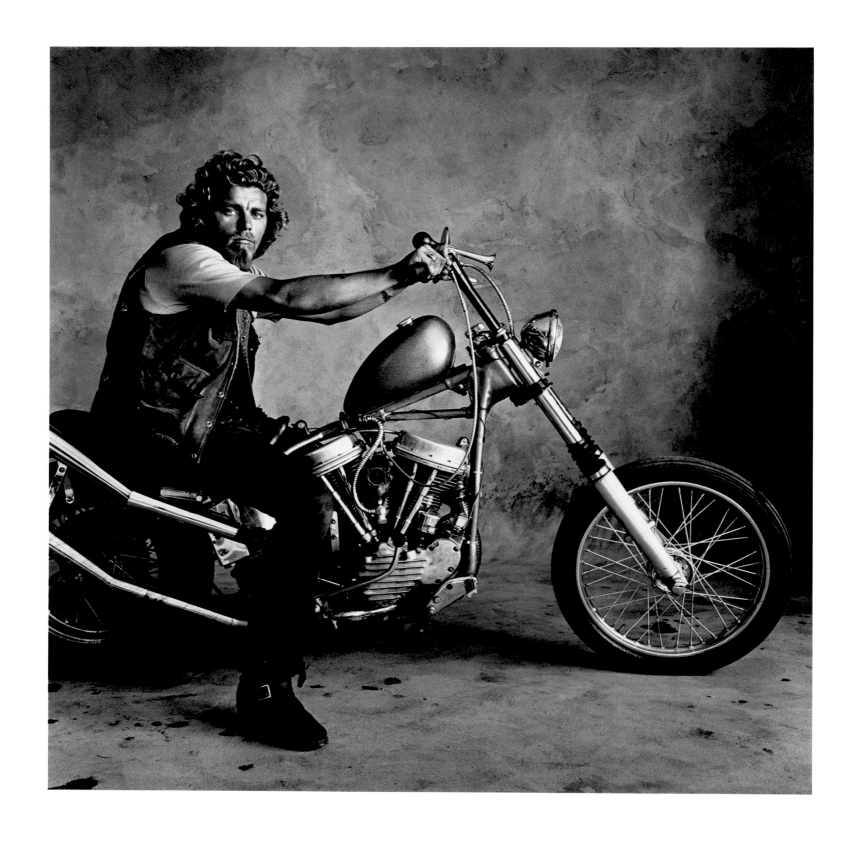

Hell's Angel (Doug), San Francisco, 1967.

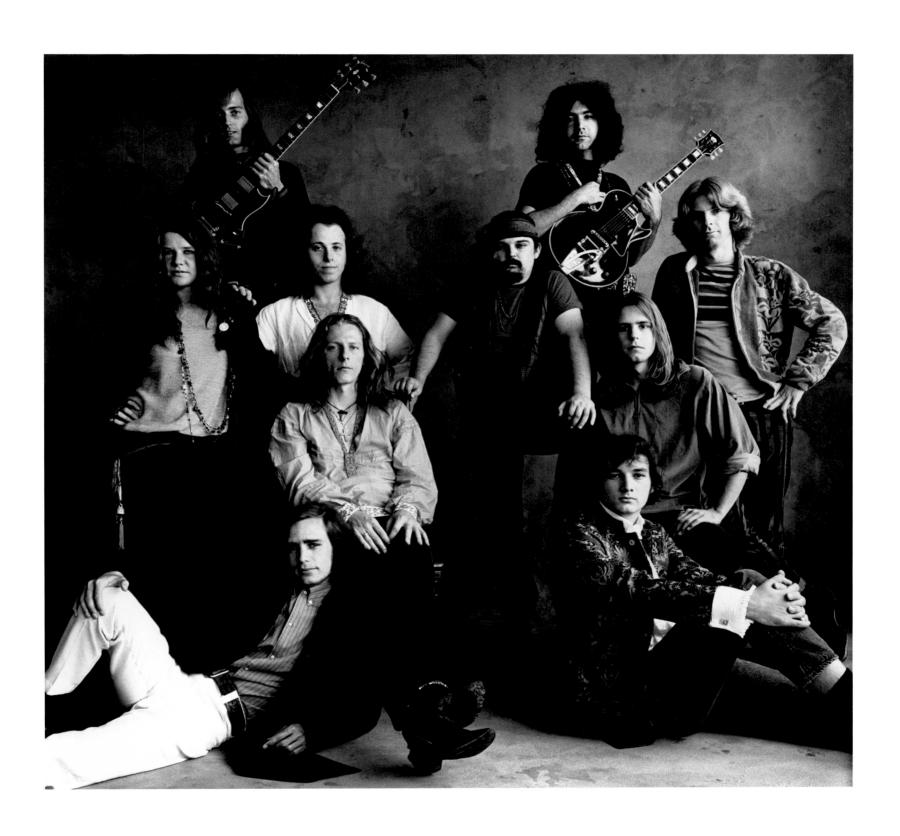

Rock Groups (Big Brother and the Holding Company and The Grateful Dead), San Francisco, 1967.

Old Man, Dahomey, 1967.

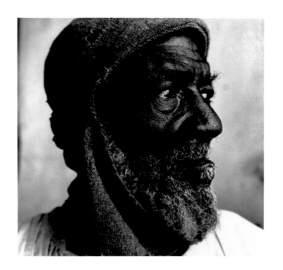

Children, Dahomey, 1967.

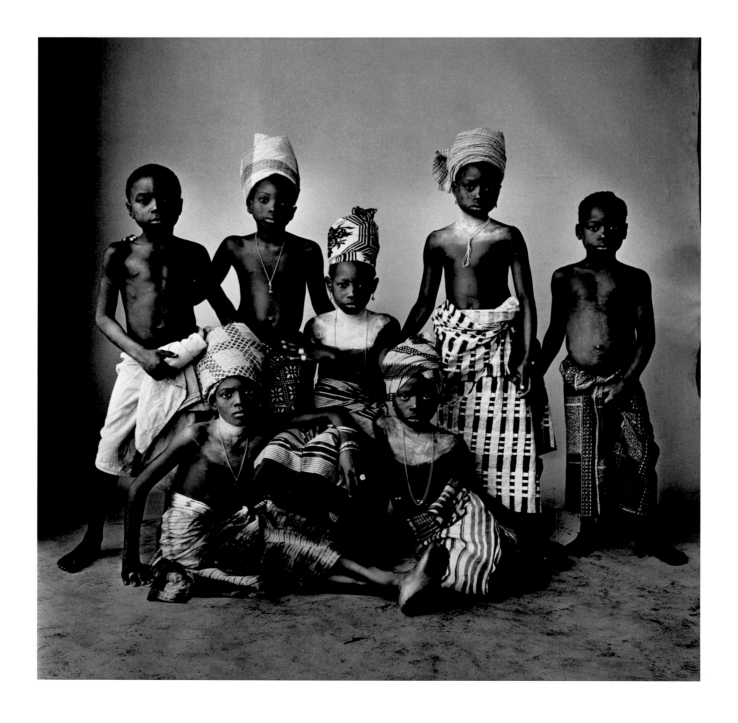

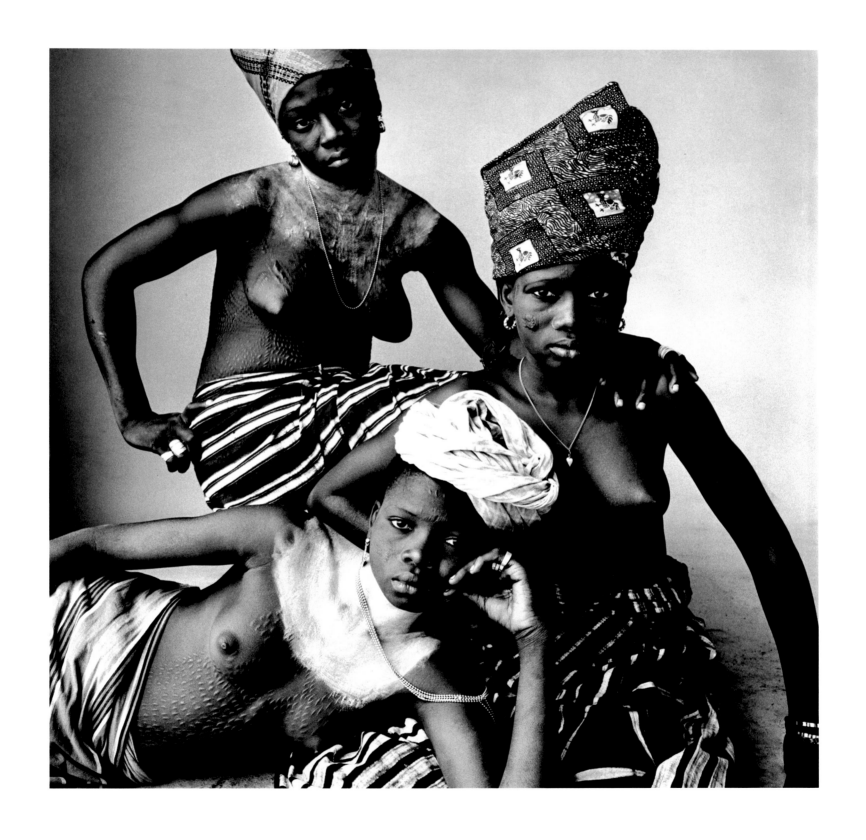

Three Girls, Dahomey, 1967.

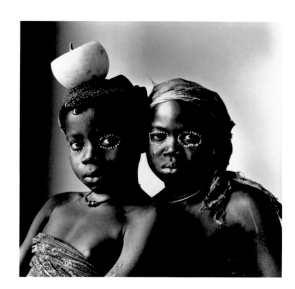

PilaPila Sisters, Dahomey, 1967.

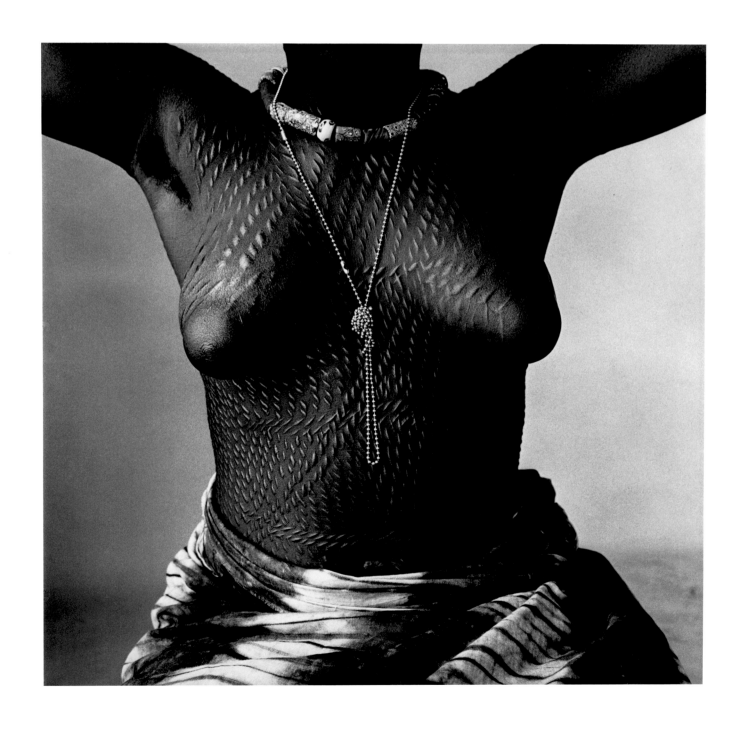

Scarified Girl, Dahomey, 1967.

Five Girls, Dahomey, 1967.

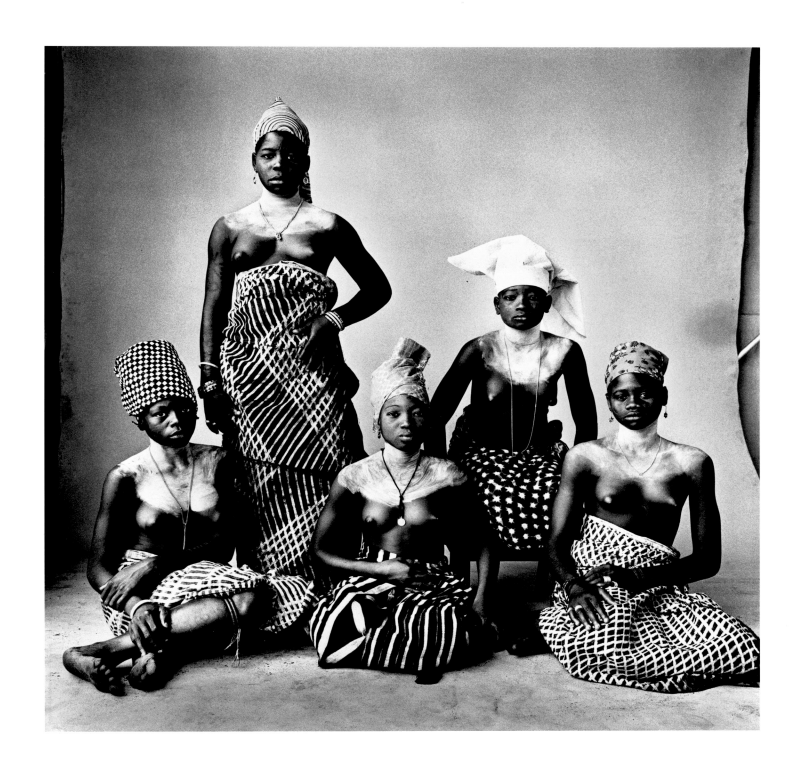

Vogue *Fashion* (Marisa Berenson), 1967.

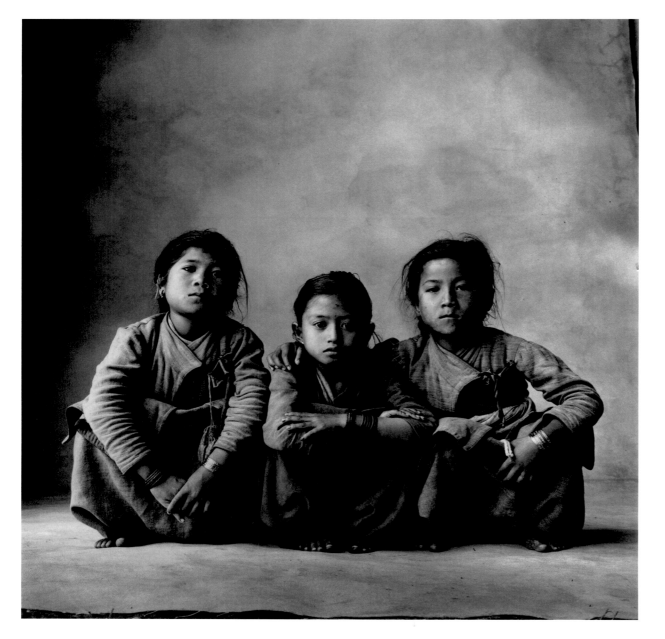

Three Squatting Sisters, Nepal, 1967.

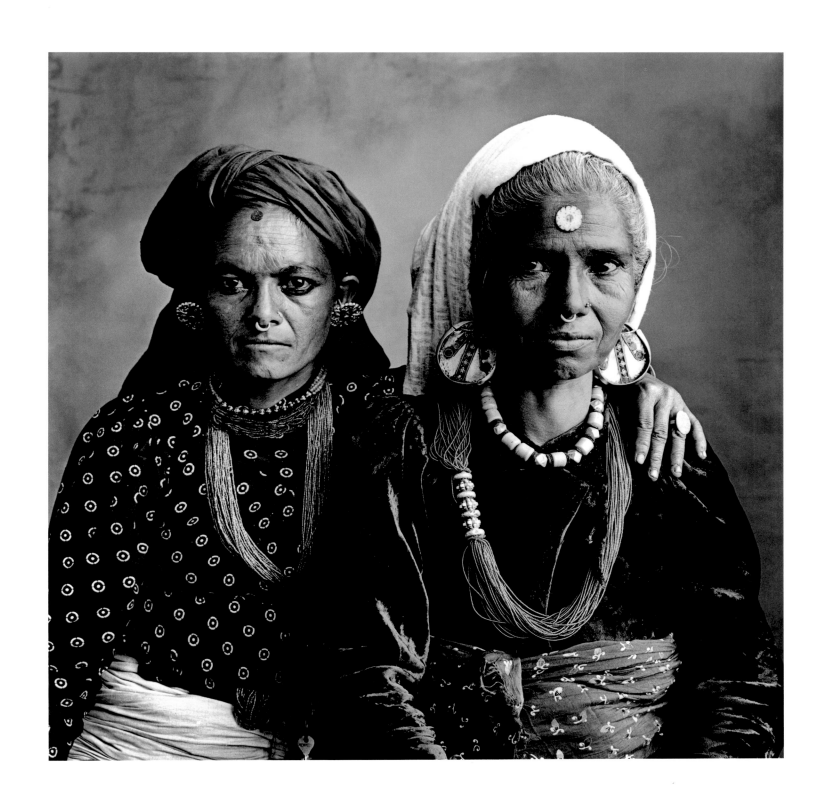

Two Women with Nose Rings, Nepal, 1967.

Single Oriental Poppy, New York, 1968.

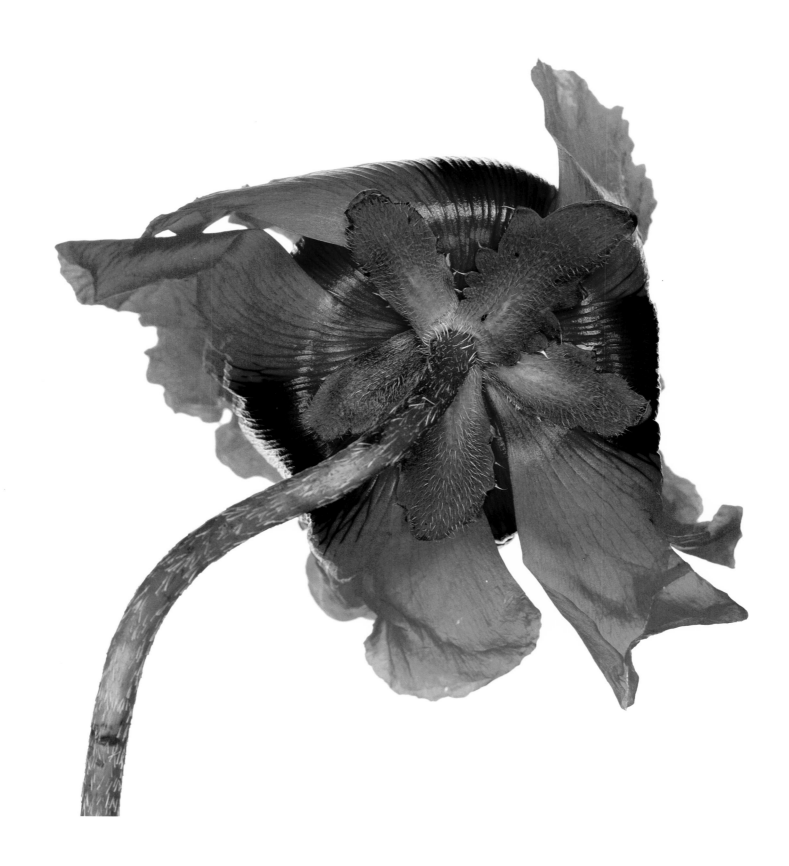

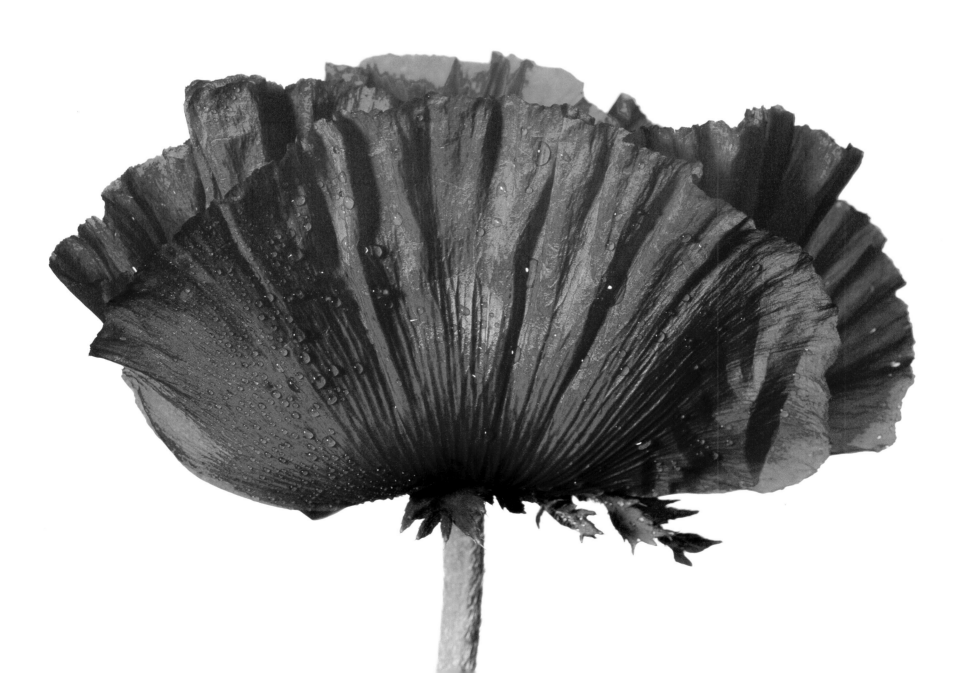

Patou Ostrich-Feather Jumpsuit (Marisa Berenson), Paris, 1968.

Poppy (Glowing Embers), New York, 1968.

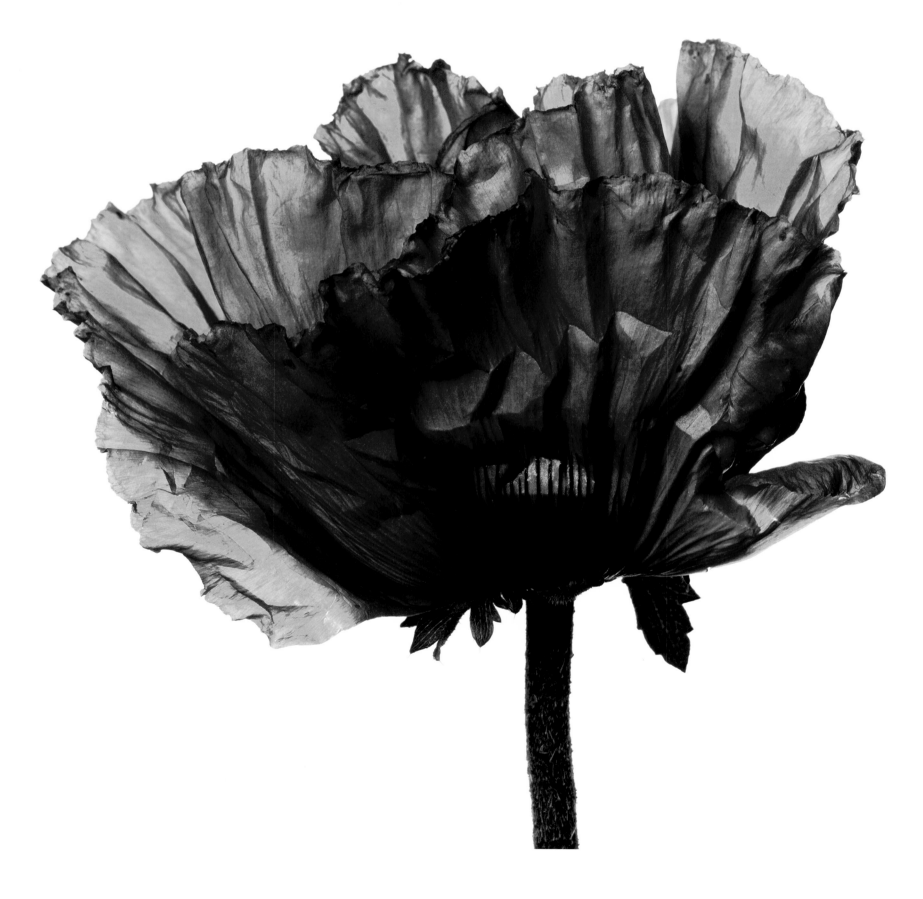

Poppy (Lavender Glory), New York, 1968.

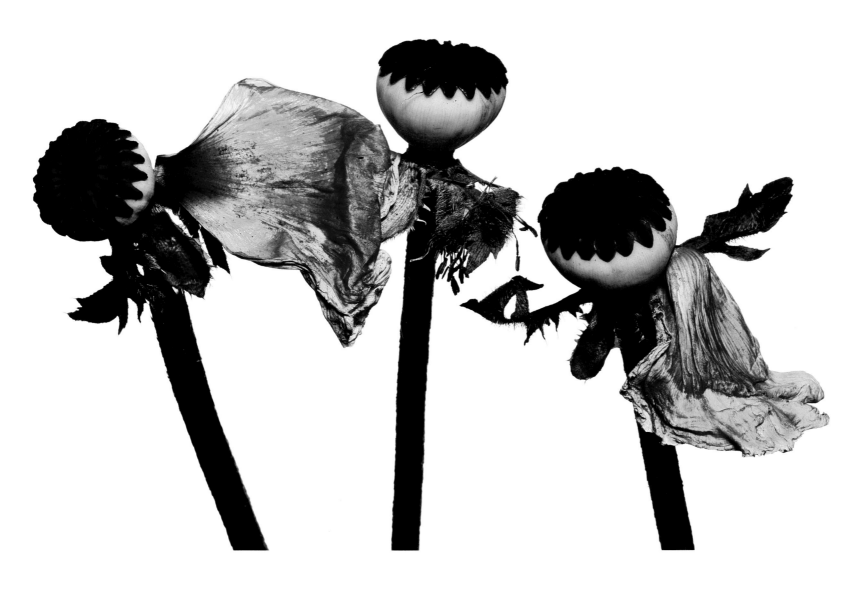

Three Single Oriental Poppies, New York, 1968.

Coretta Scott King, New York, 1968.

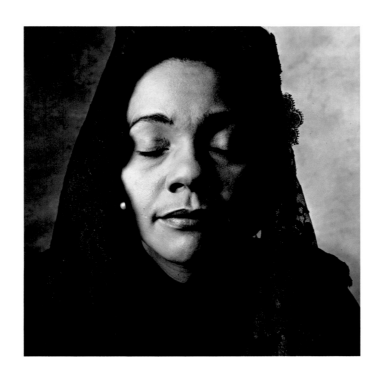

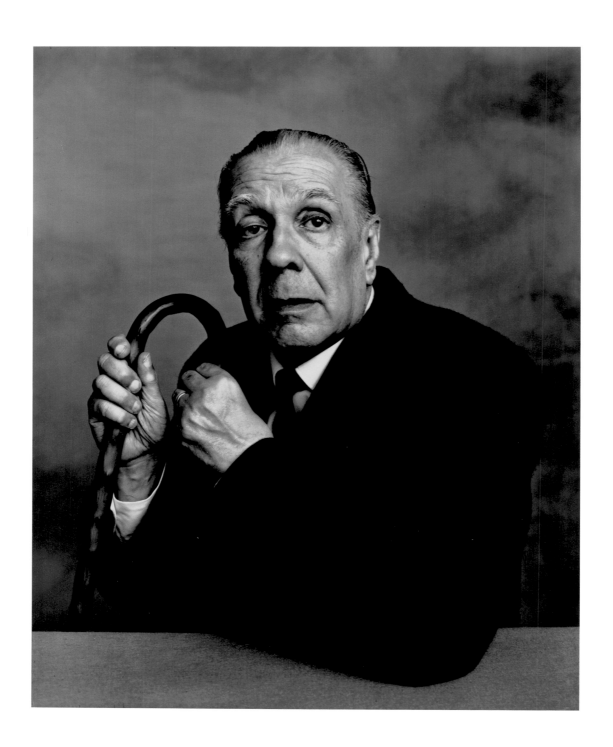

Jorge Luis Borges, New York, 1969.

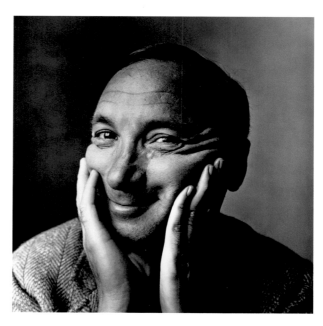

Neil Simon, New York, 1969.

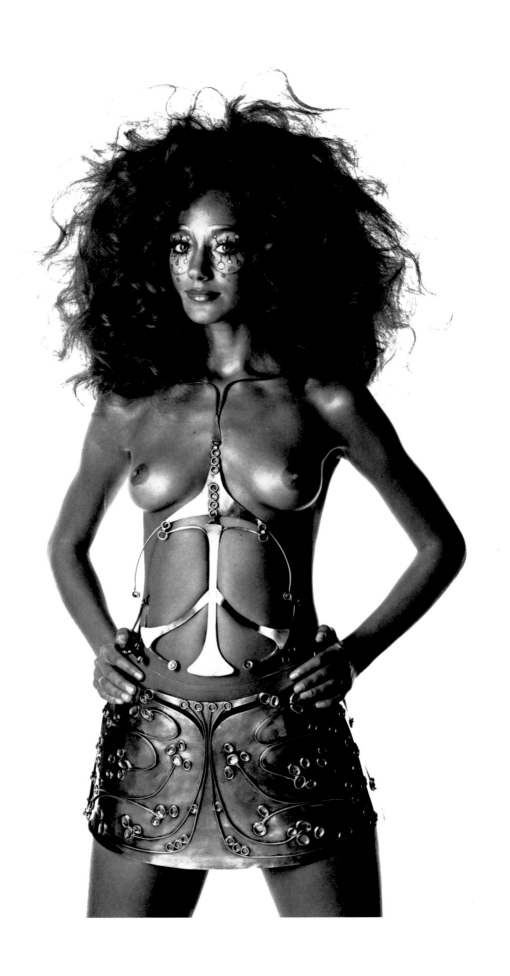

Ungaro Bride (Marisa Berenson), Paris, 1969.

1969

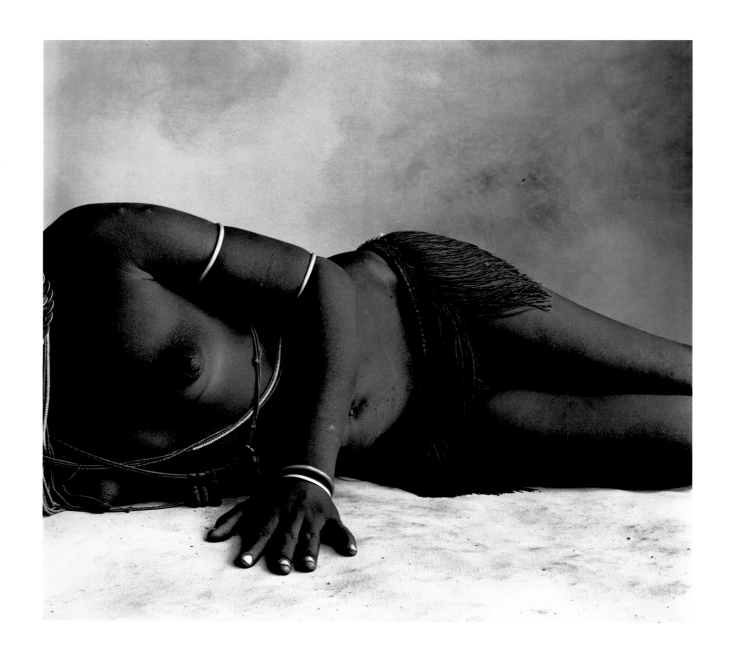

Chieftain's Wife, Cameroon, 1969.

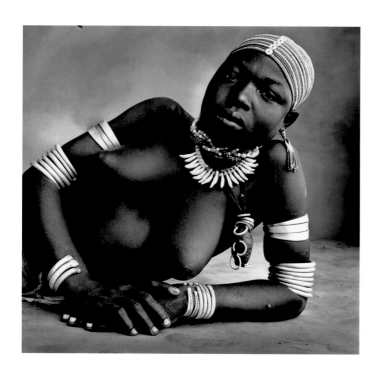

Sultan's Fiancée, Cameroon, 1969.

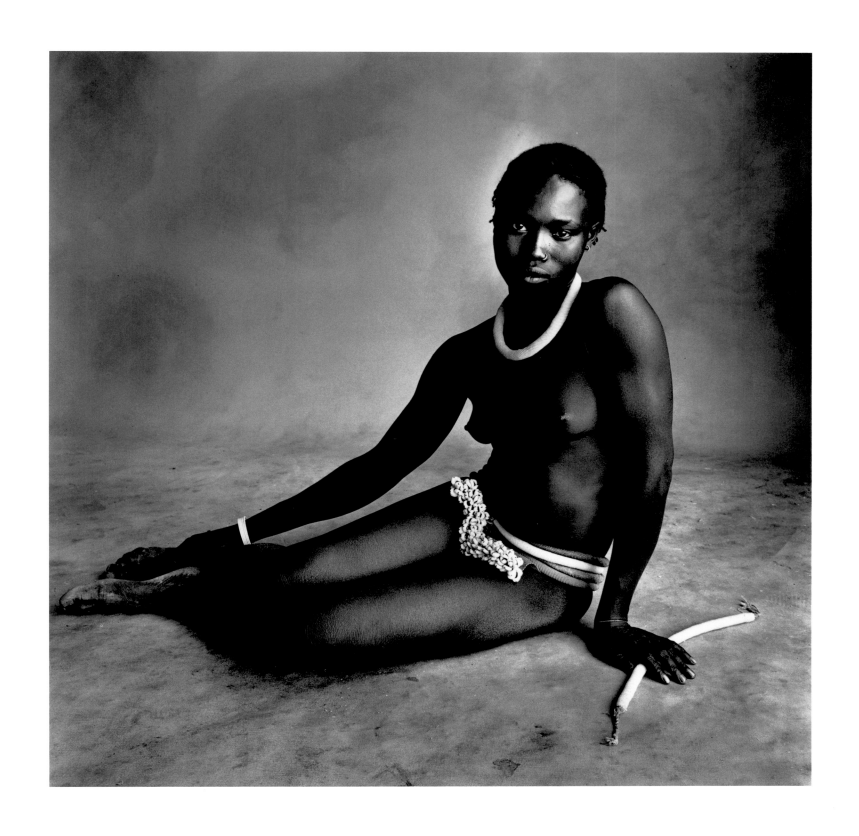

Nubile Young Beauty of Diamaré, Cameroon, 1969.

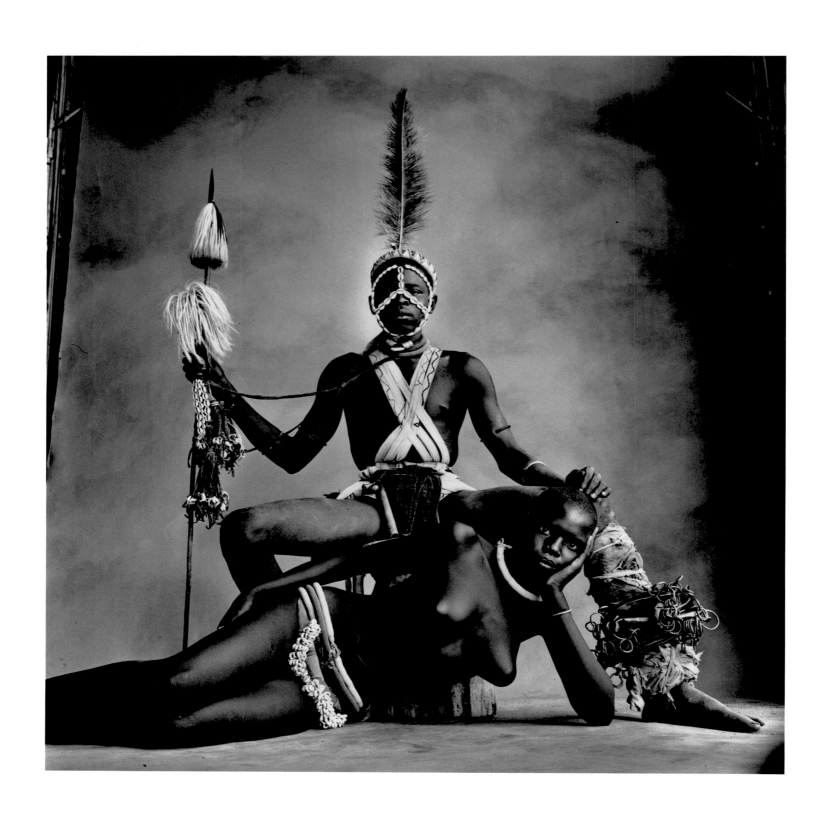

Seated Warrior and Reclining Girl, Cameroon, 1969.

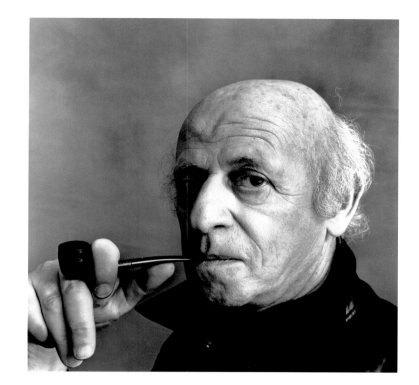

Richard Lindner, New York, 1969.

Vogue *Fashion* (Mouche), Paris, 1969.

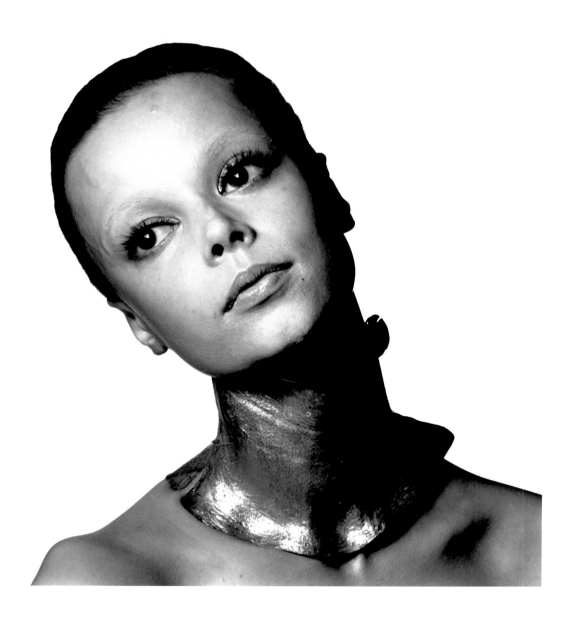

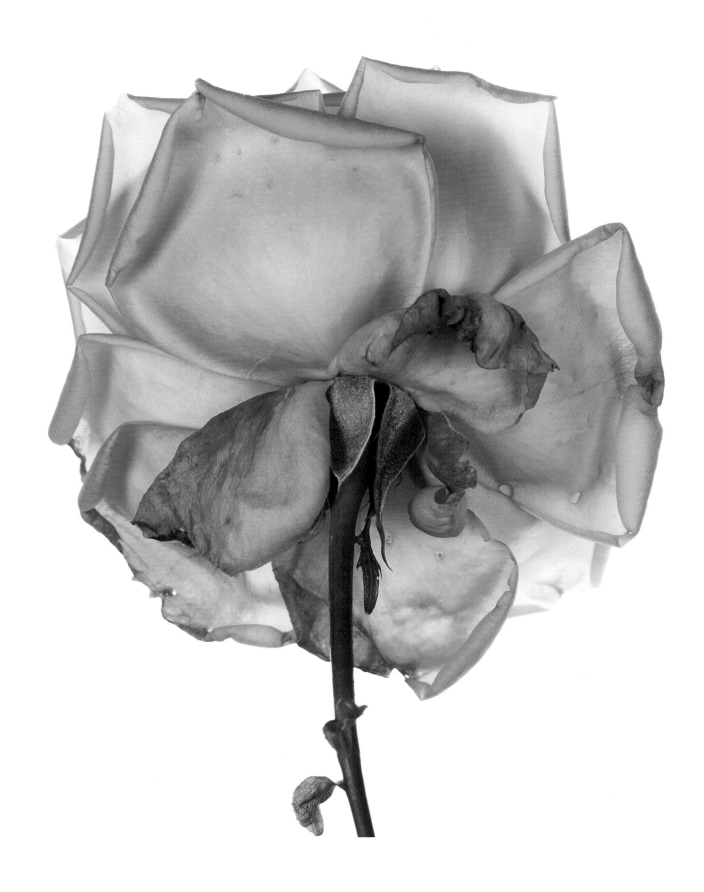

Rose (Blue Moon), London, 1970.

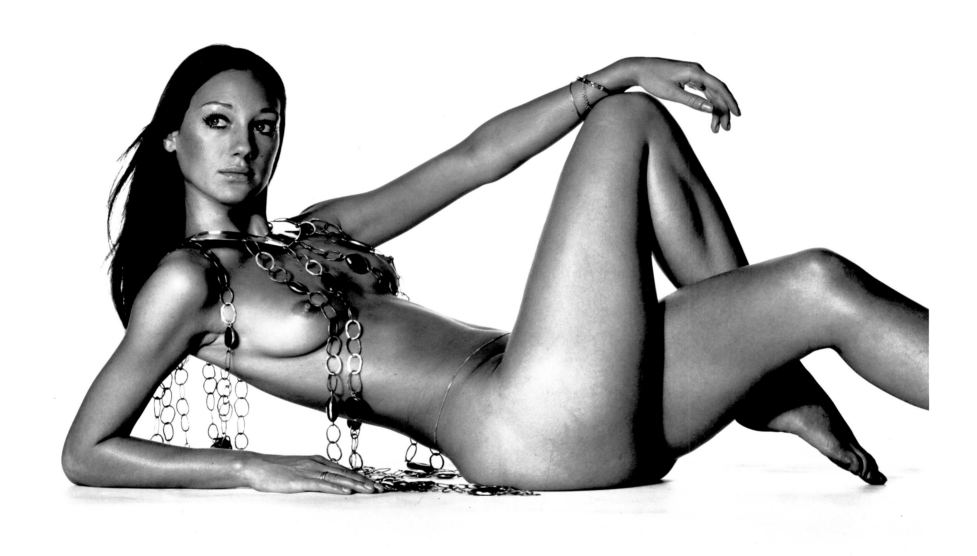

Vogue *Fashion* (Marisa Berenson), 1970.

Father, Son, and Grandfather, New Guinea, 1970.

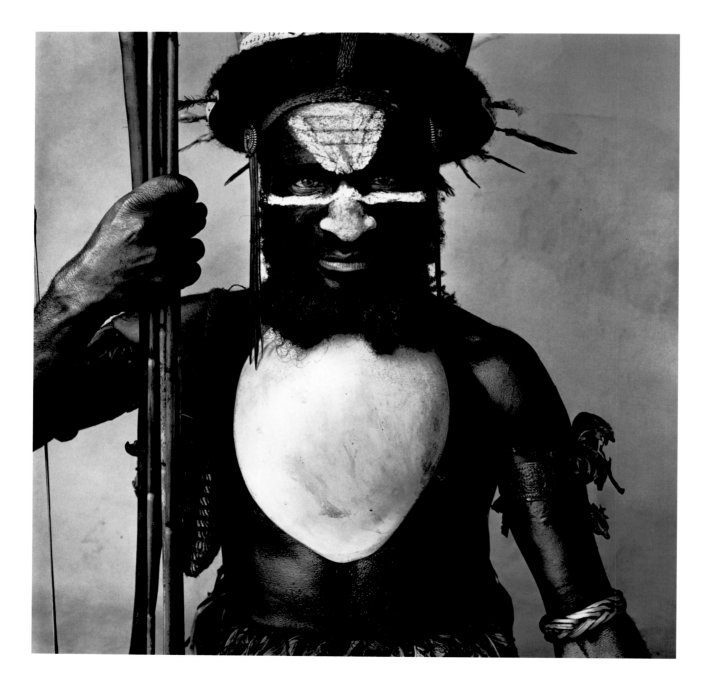

Tambul Warrior, New Guinea, 1970.

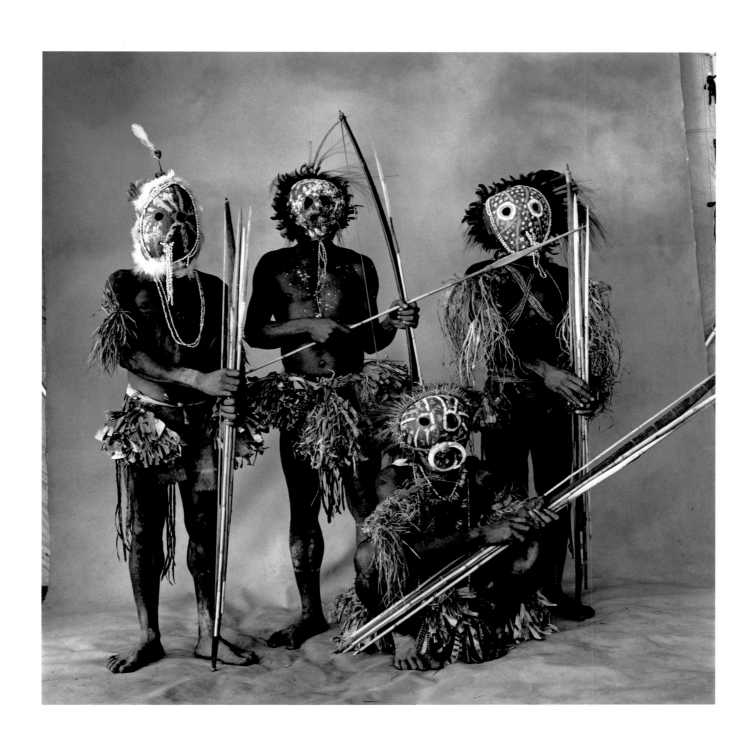

Four Unggai, New Guinea, 1970.

Five Okapa Warriors, New Guinea, 1970.

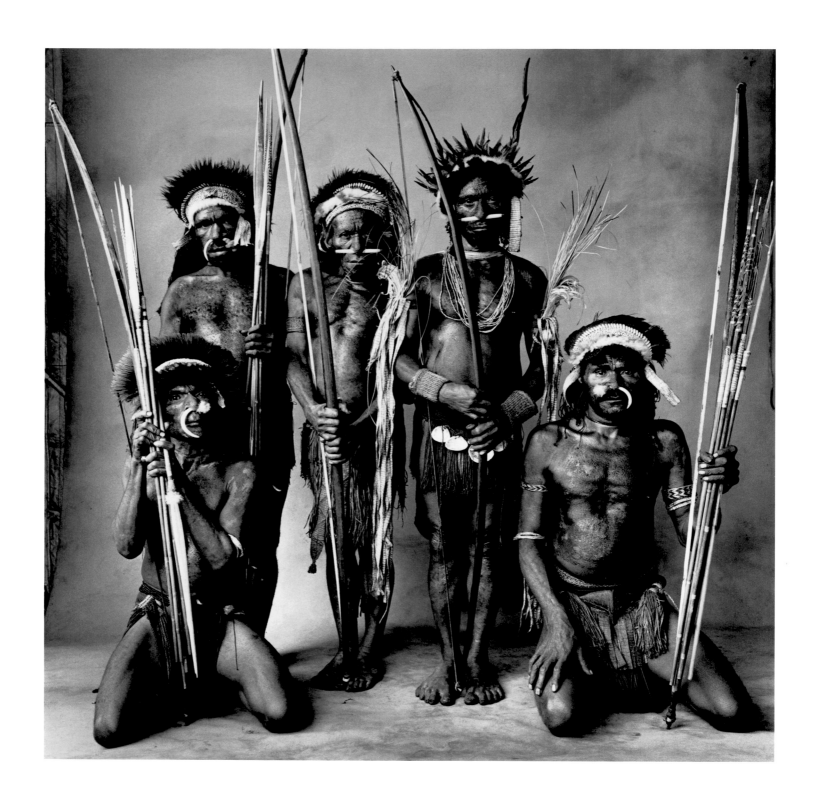

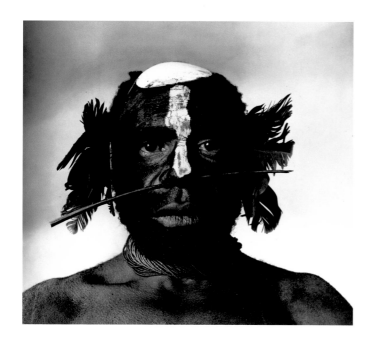

Tribesman, New Guinea, 1970.

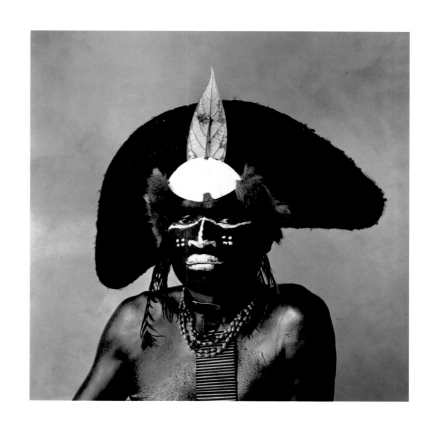

Enga Tribesman, New Guinea, 1970.

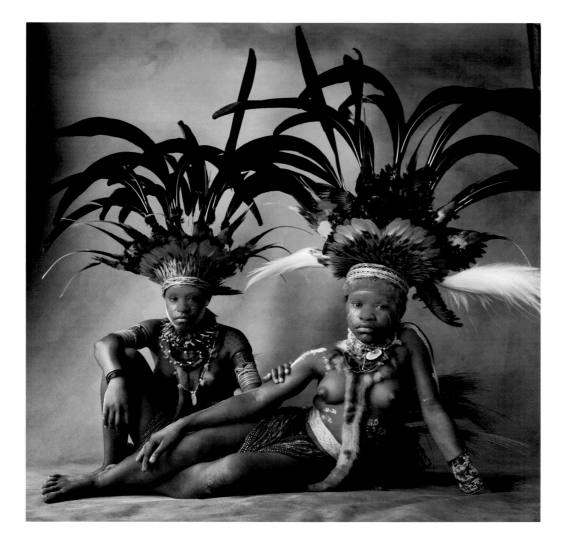

Two Young Women, New Guinea, 1970.

Man with Pink Face, New Guinea, 1970.

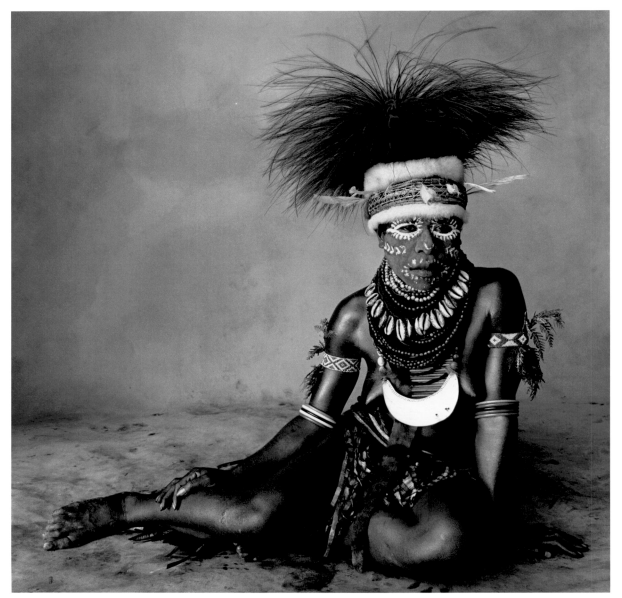

Sitting Woman, New Guinea, 1970.

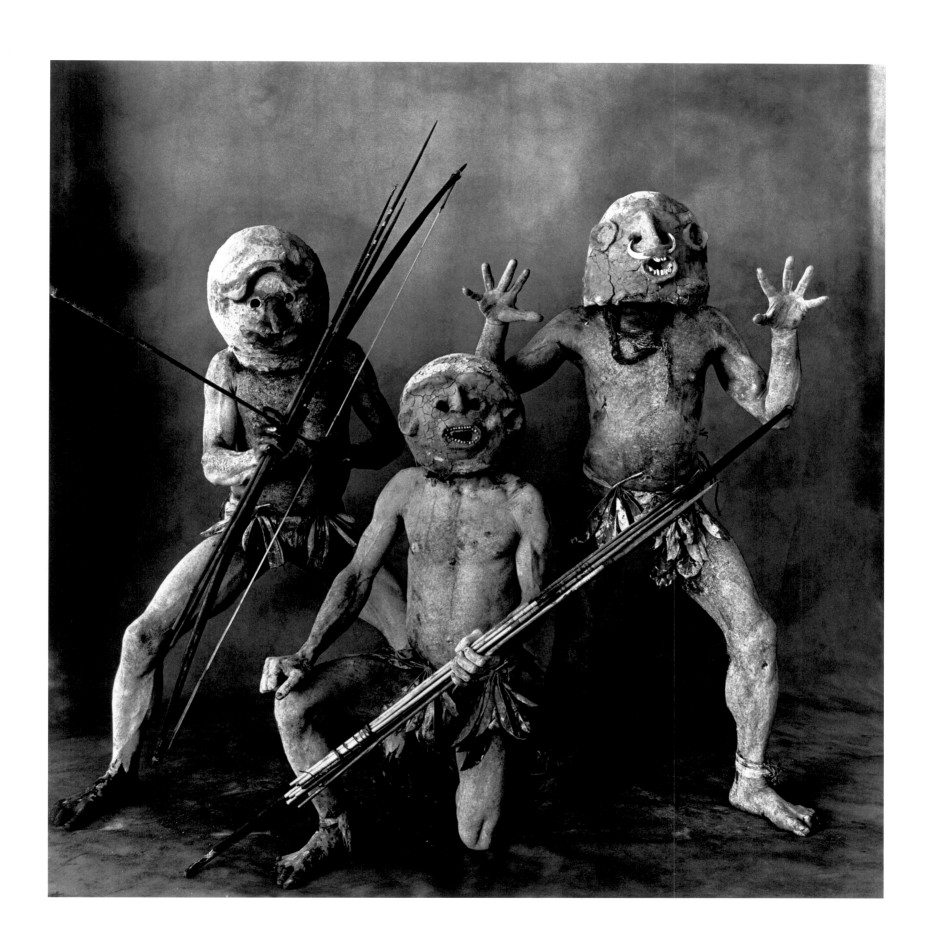

Three Asaro Mudmen, New Guinea, 1970.

Two Glasses of Water, New York, 1970.

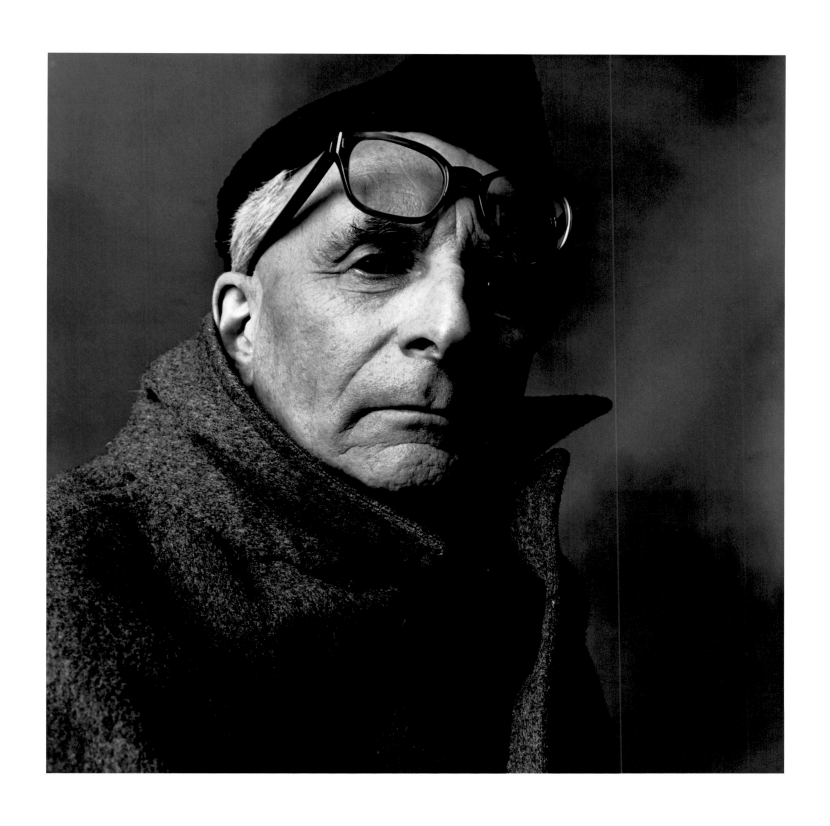

Claude Lévi-Strauss, Burgundy, France, 1970.

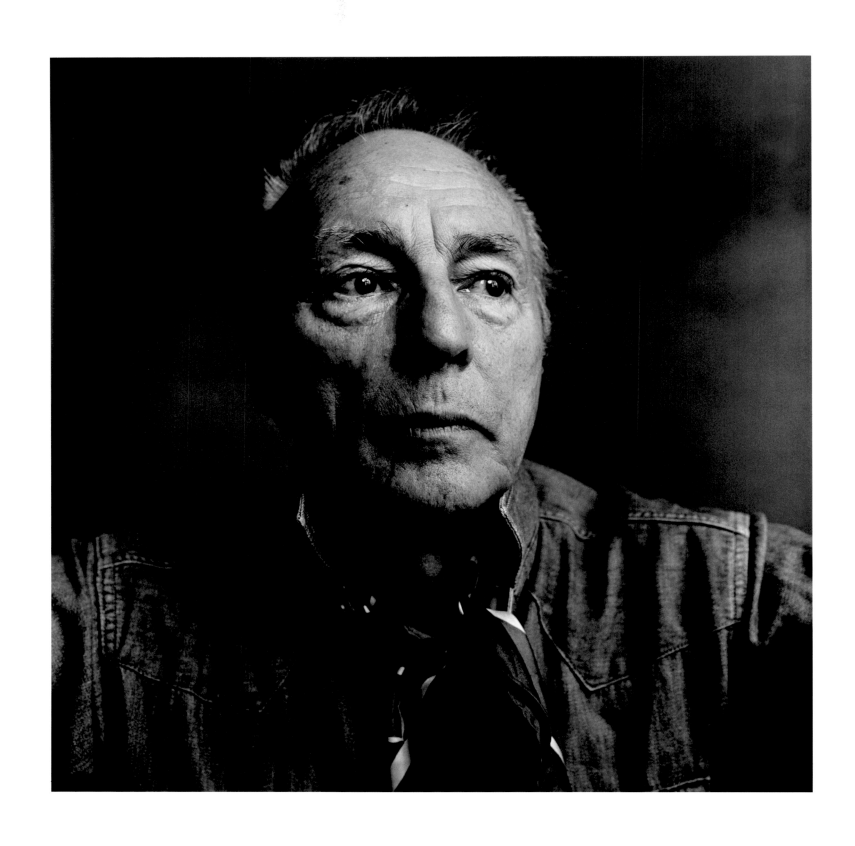

George Balanchine, New York, 1971.

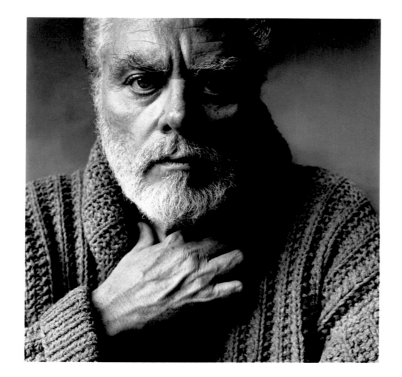

Tony Smith, South Orange, New Jersey, 1971.

Anaïs Nin, New York, 1971.

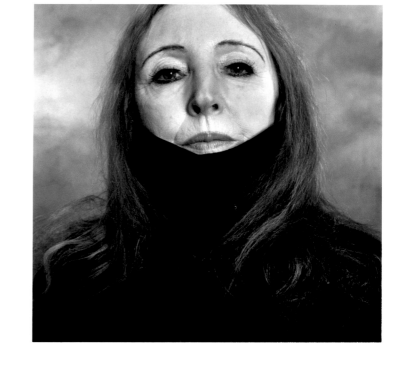

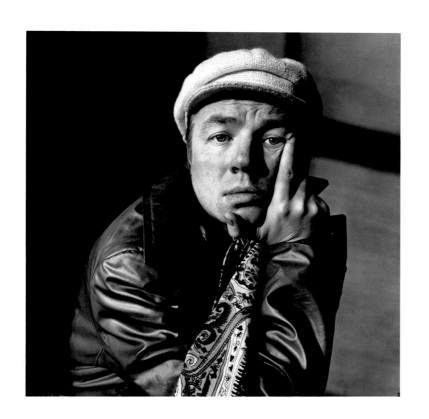

Andrei Voznesensky, New York, 1971.

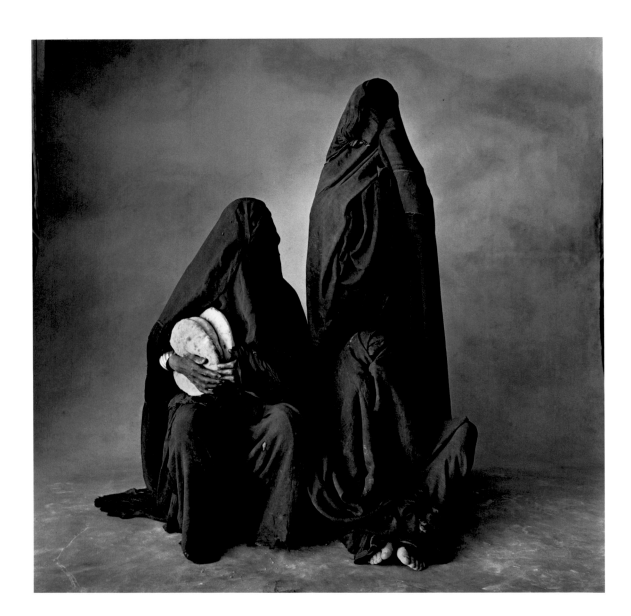

Three Rissani Women with Bread, Morocco, 1971.

Young Berber Shepherdess, Morocco, 1971.

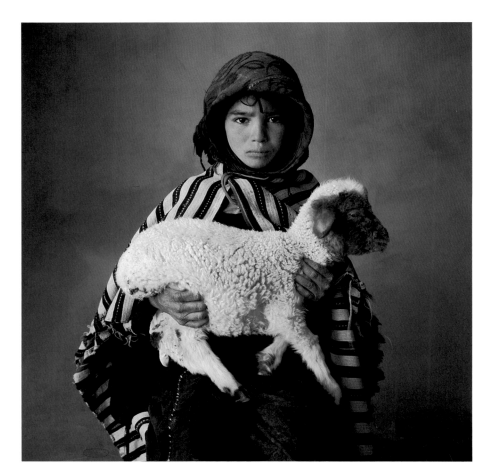

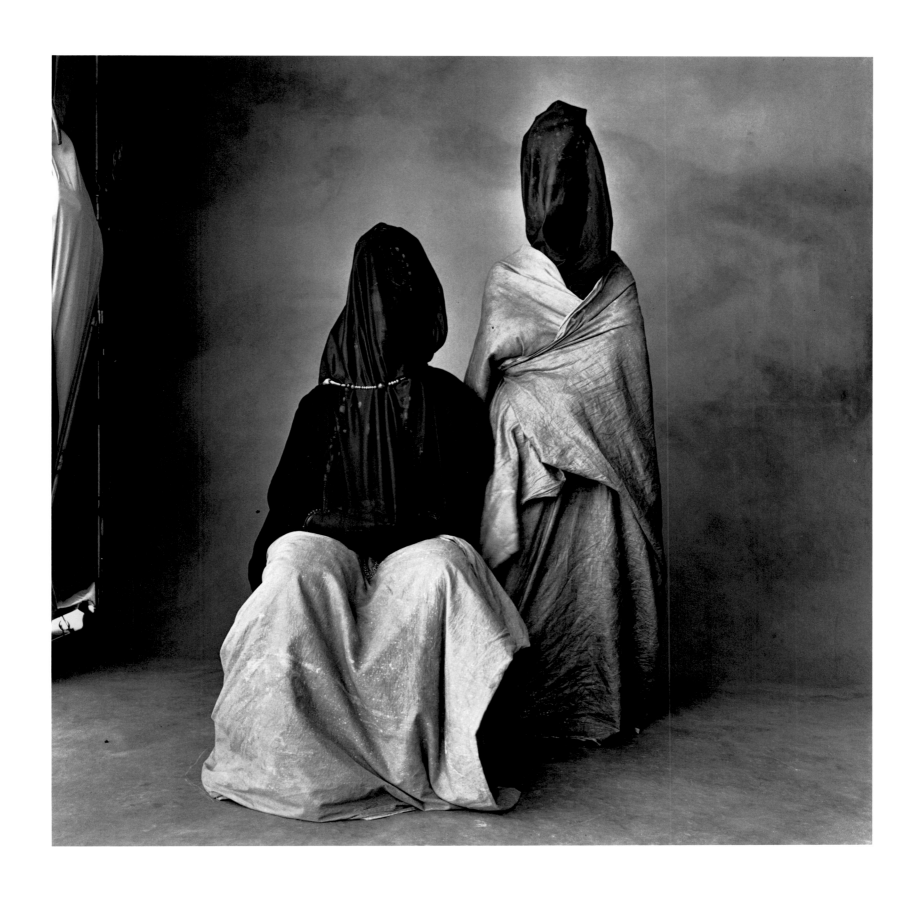

Two Guedras, Morocco, 1971.

Woman in Black, Man in White, Morocco, 1971.

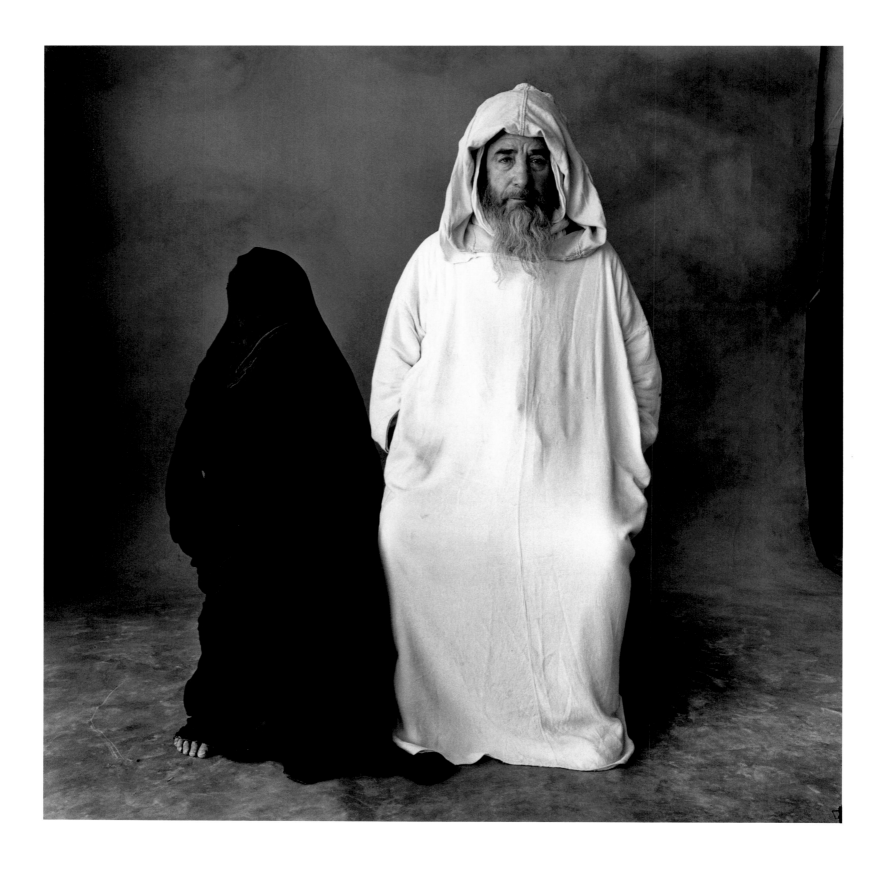

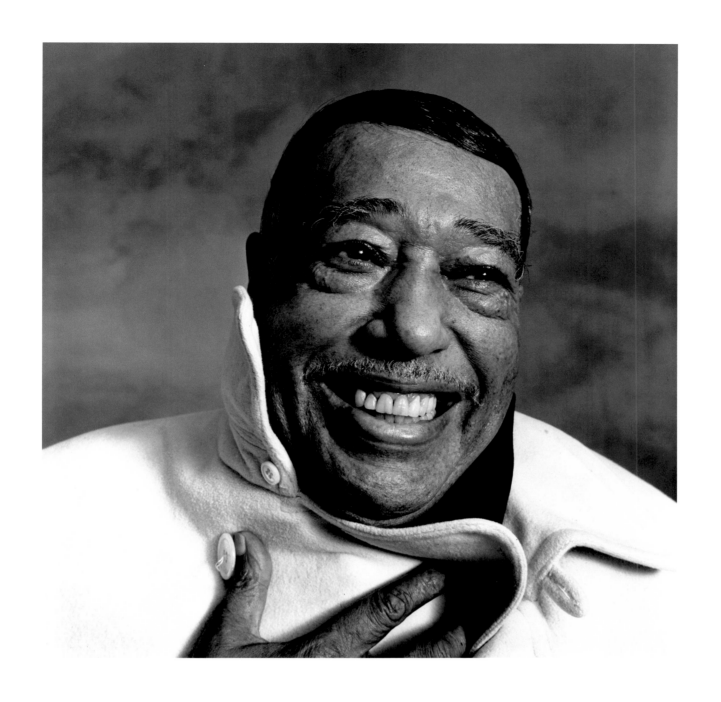

Duke Ellington, New York, 1971.

A Child of Imilchil, Morocco, 1971.

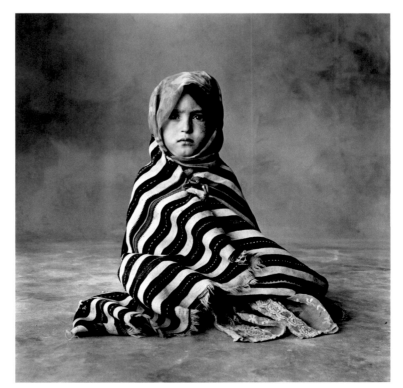

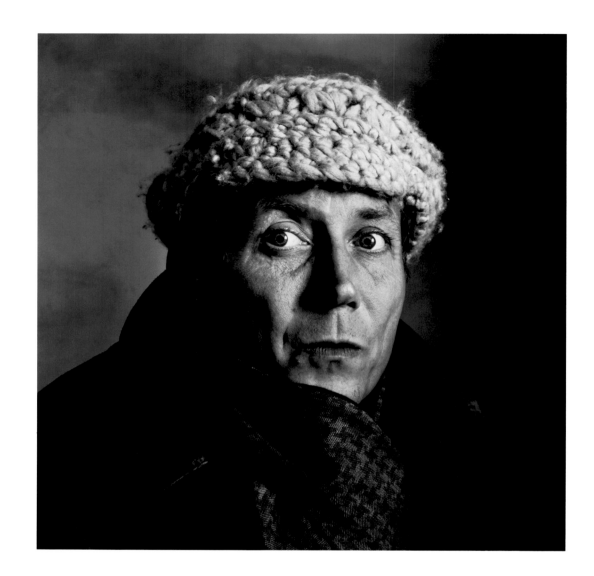

Yevgeny Yevtushenko, New York, 1972.

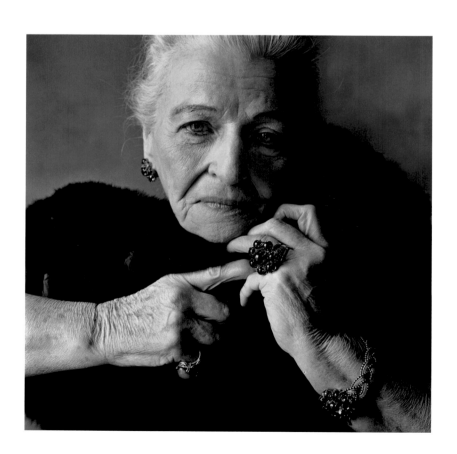

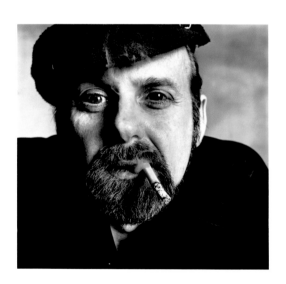

Bob Fosse, New York, 1972.

Pearl S. Buck, Vermont, 1972.

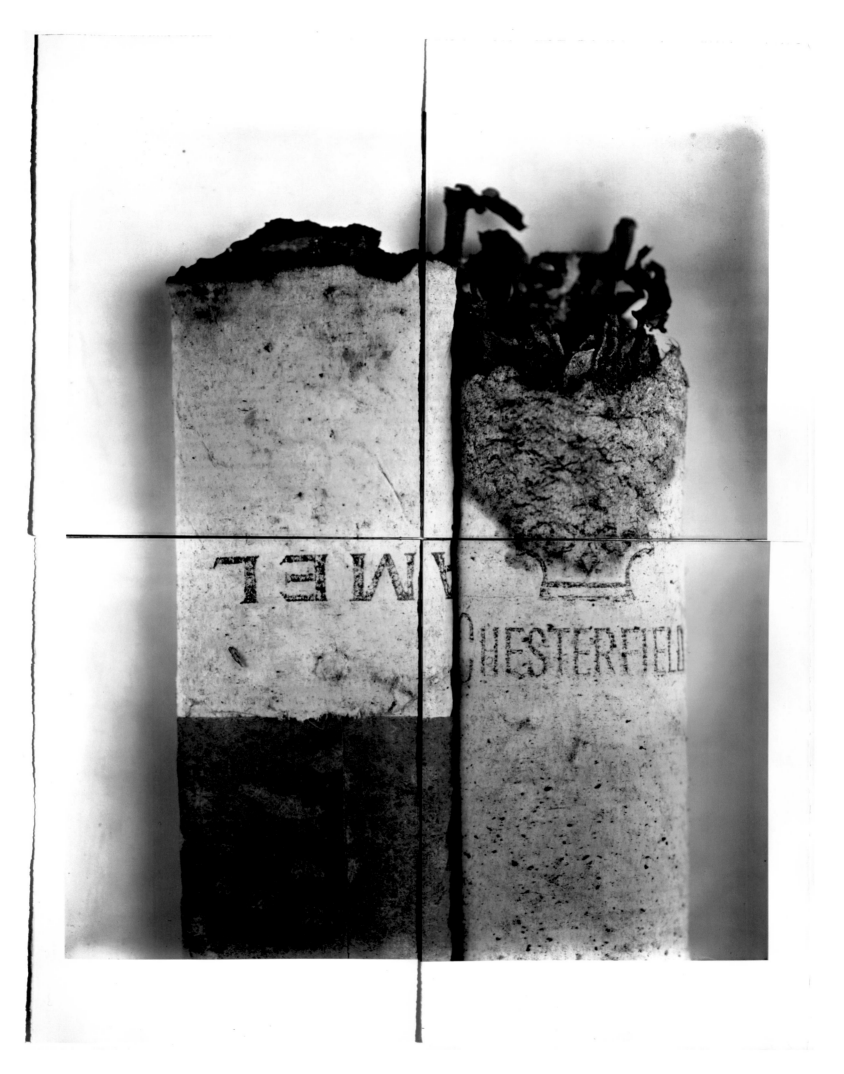

Cigarette No. 37 (four-section platinum print), New York, 1972.

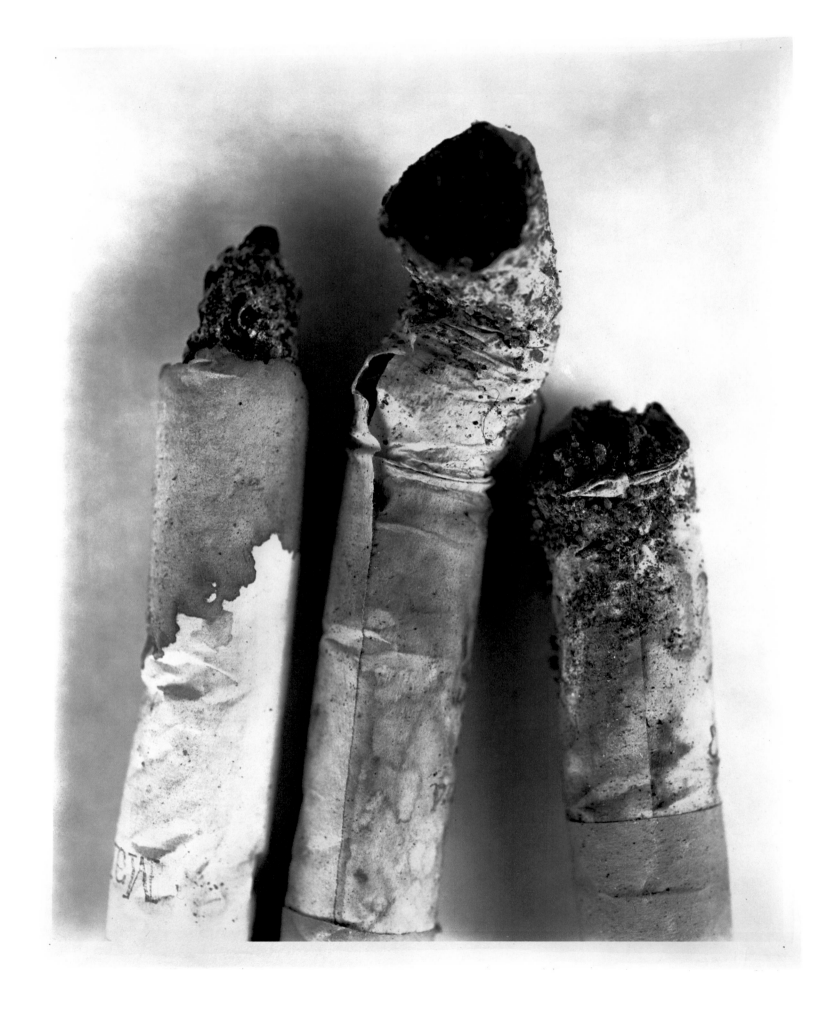

Cigarette No. 123, New York, 1972.

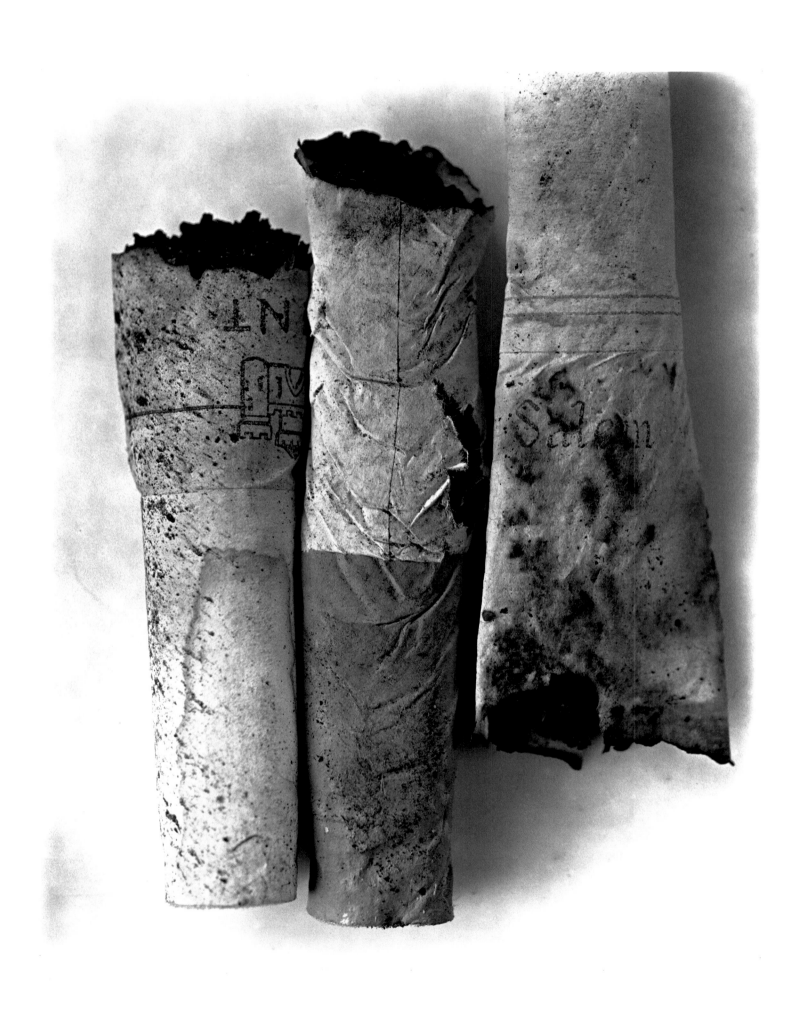

Cigarette No. 52, New York, 1972.

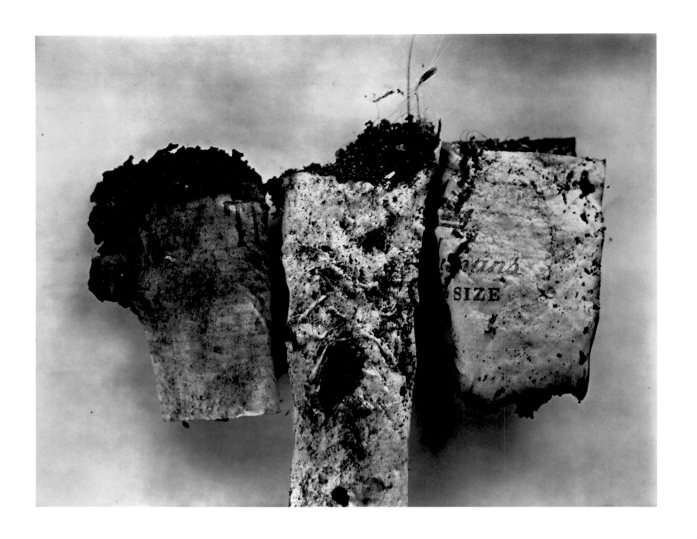

Cigarette No. 85, New York, 1972.

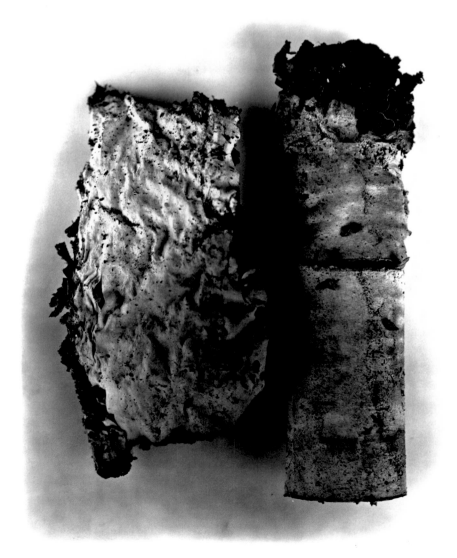

Cigarette No. 42, New York, 1972.

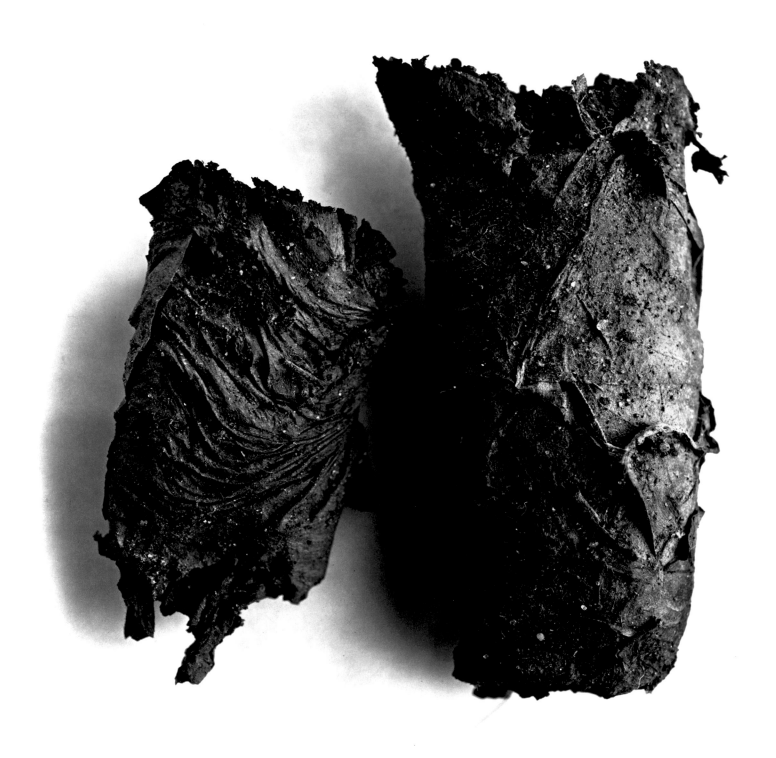

Cigarette No. 69, New York, 1972.

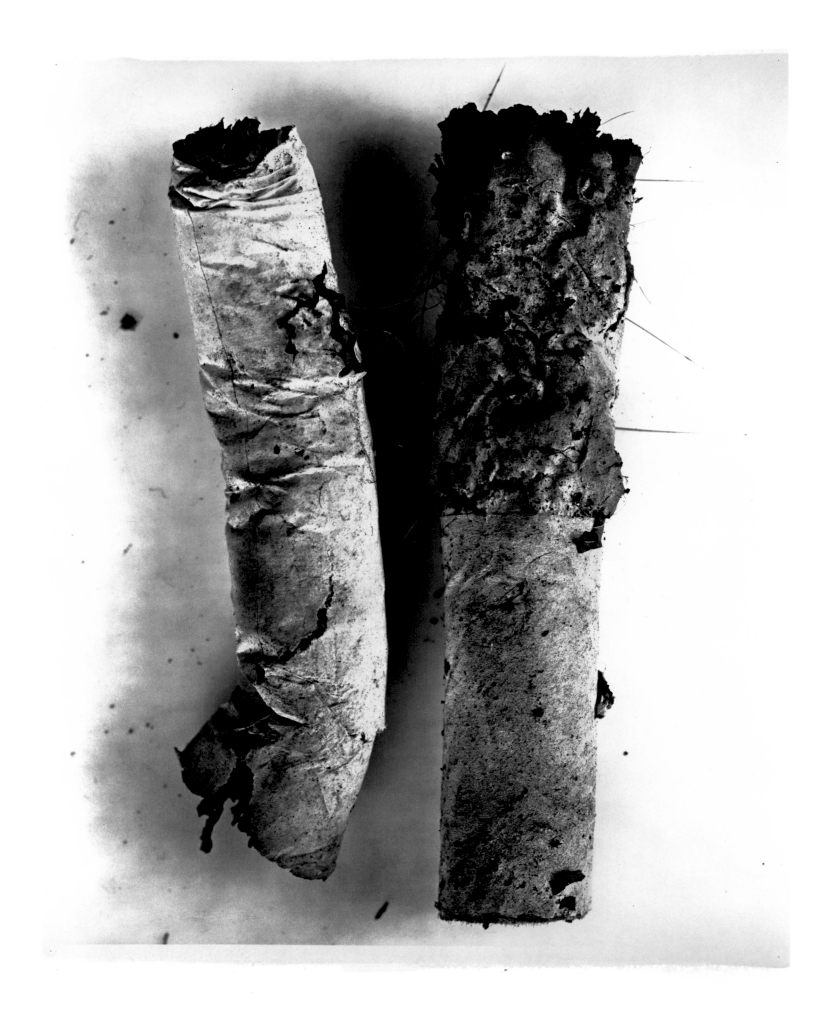

Cigarette No. 17, New York, 1972.

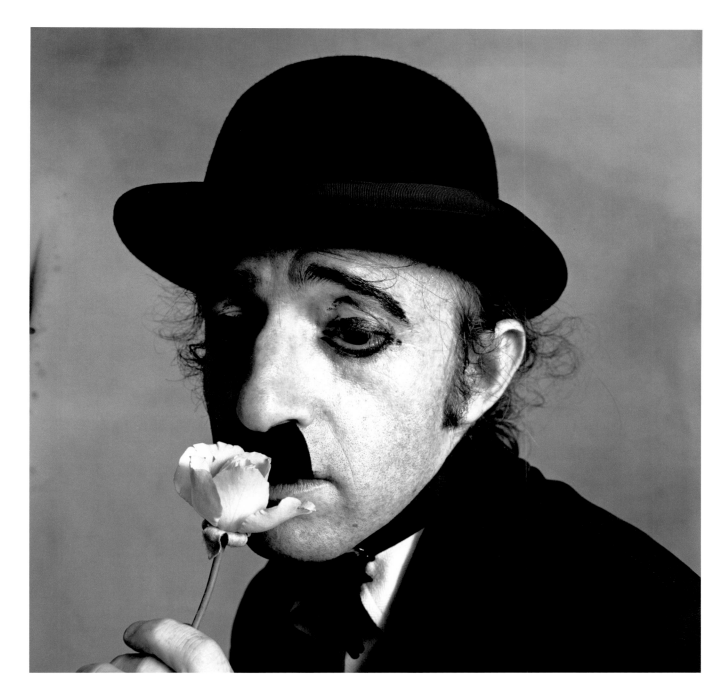

Woody Allen as Charlie Chaplin, New York, 1972.

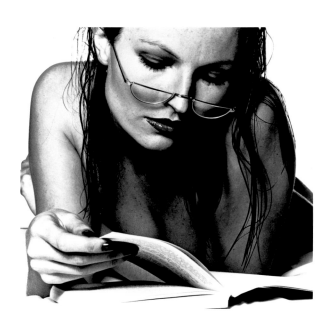

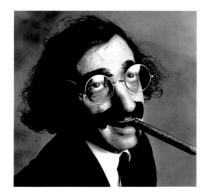

Woody Allen as Groucho Marx.

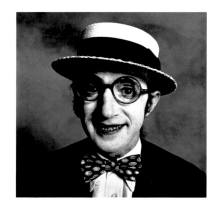

Woody Allen as Harold Lloyd.

Woman Reading, New York, 1972.

1974

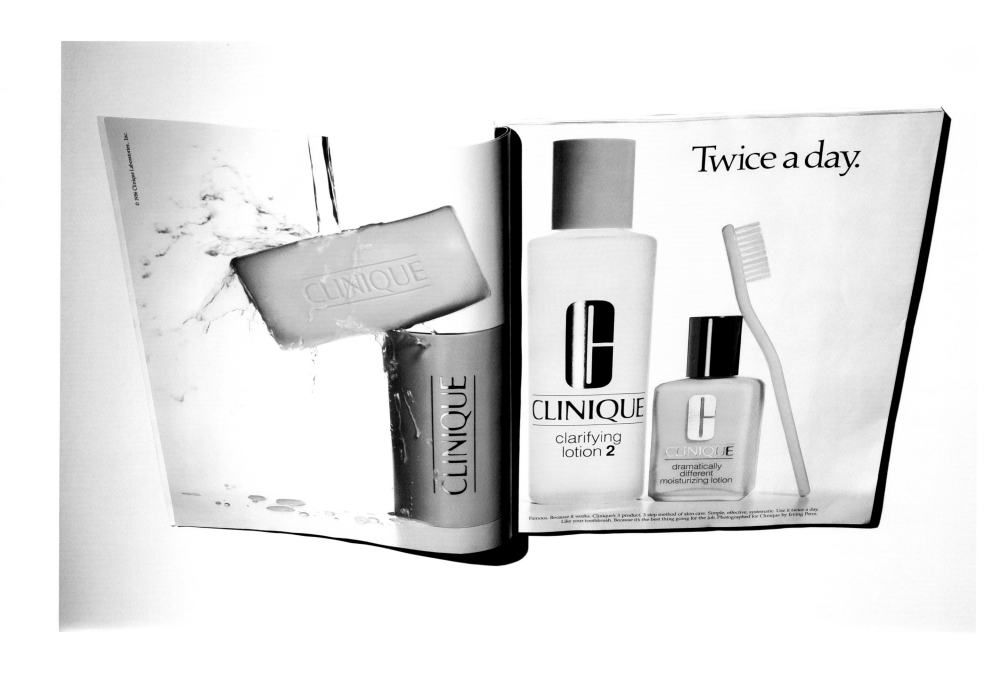

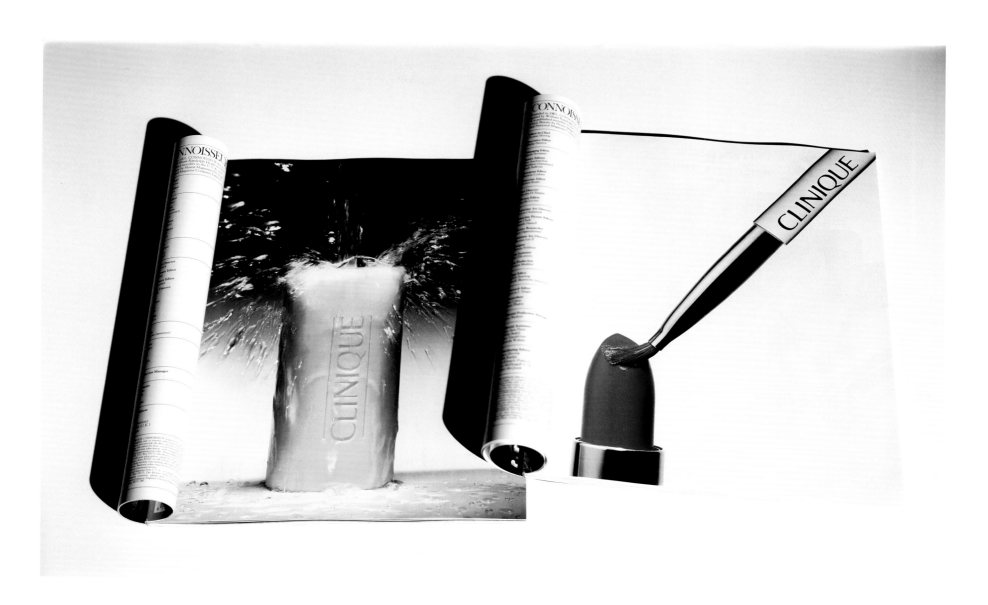

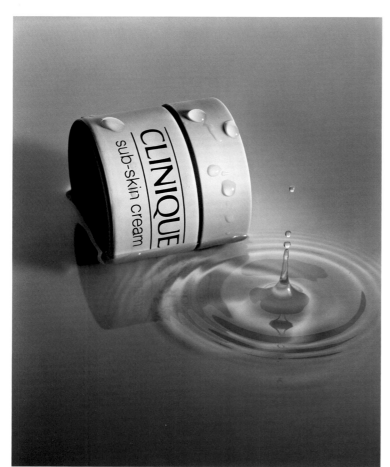

Advertising Photographs for Clinique, New York, 1974 to the present.

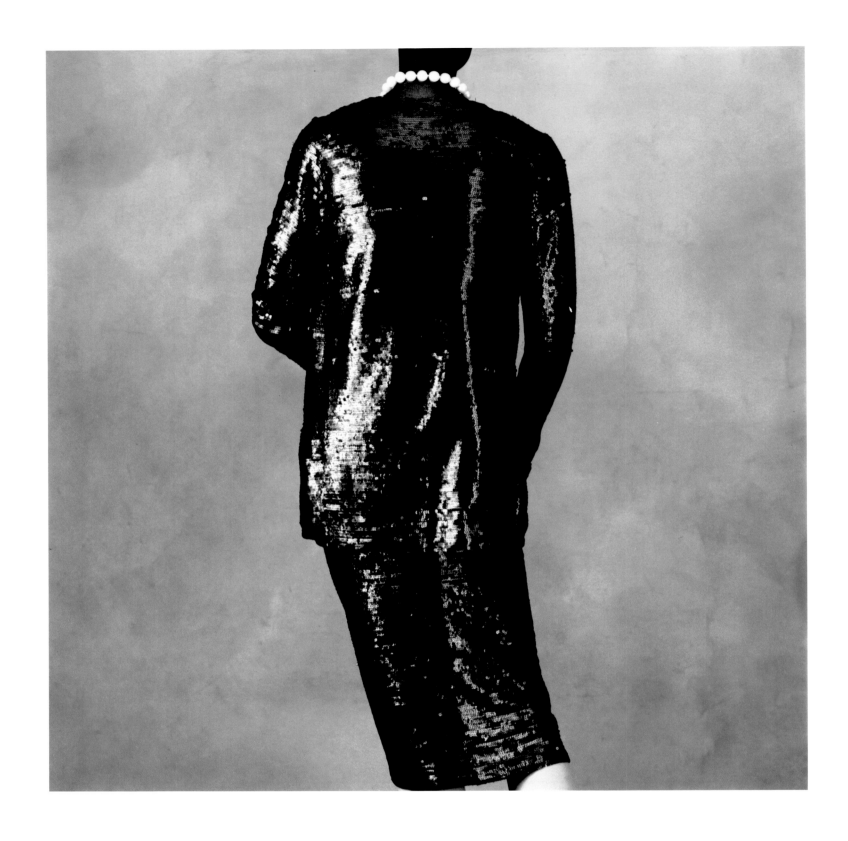

Chanel Sequined Suit of 1926, New York, 1974.

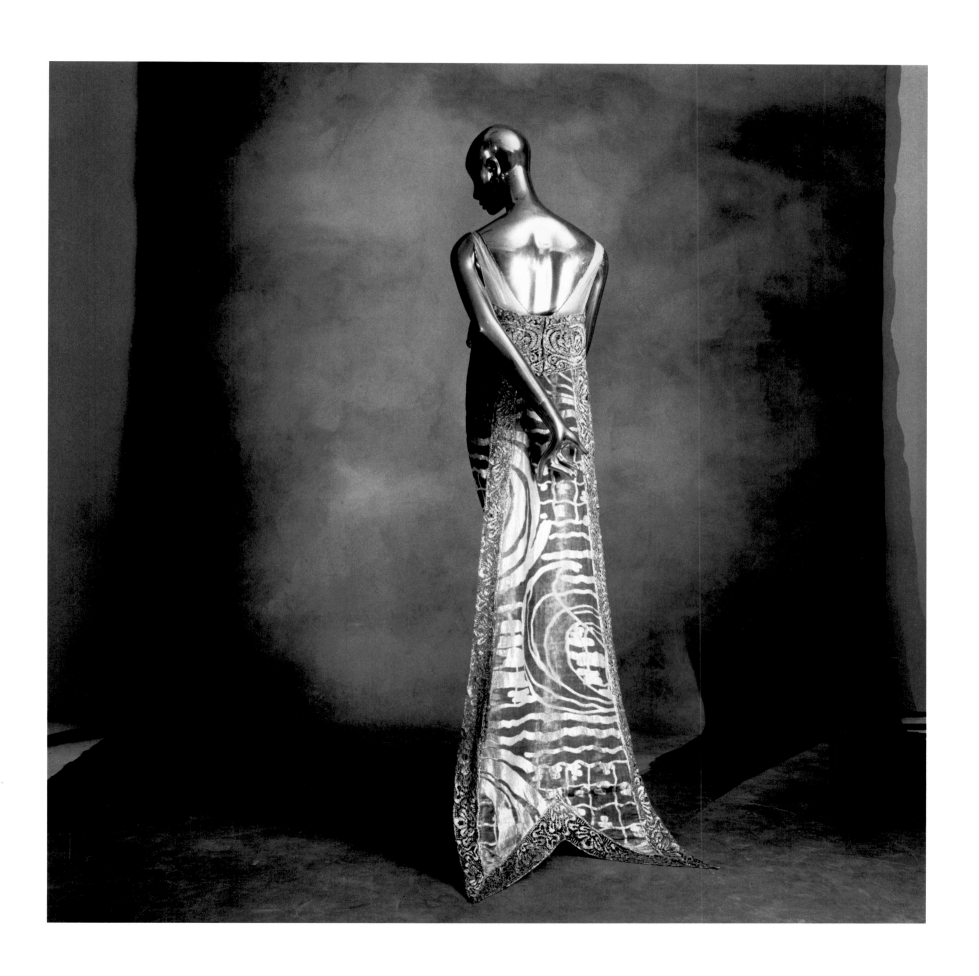

Callot Swallowtail Dress of c. 1919, New York, 1974.

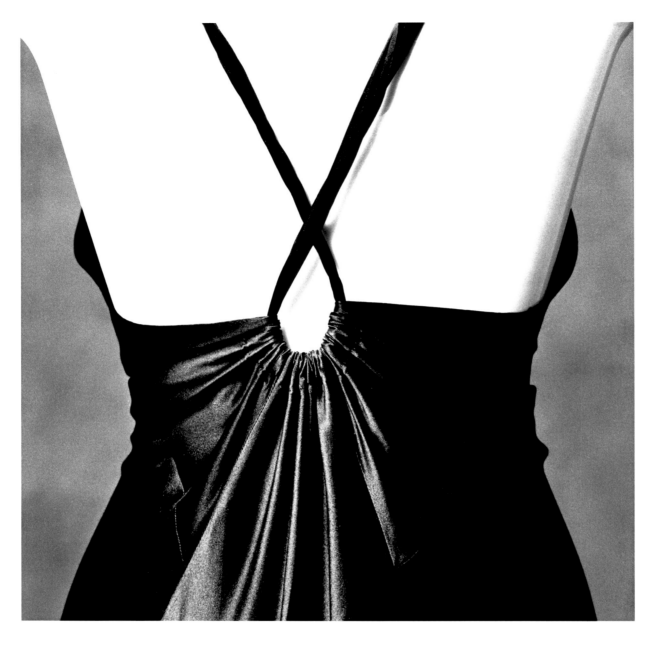

Vionnet Harness Dress of c. 1935, New York, 1974.

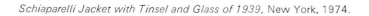

Schiaparelli Jacket with Tinsel and Glass of 1939, New York, 1974.

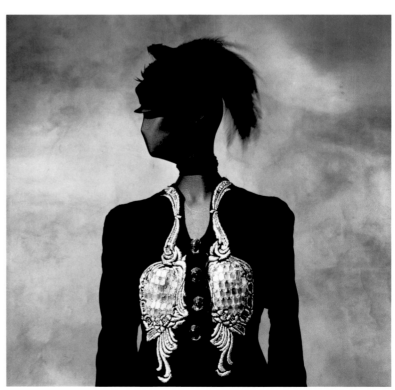

Vionnet Dress with Fan of 1925–26, New York, 1974.

Evenings as I walked from my studio to the train station I saw at my feet a treasure of the city's refuse, intriguing distorted forms of color, stain, and typography. The gutters were rich with cast-offs flattened and reformed by rain and traffic.

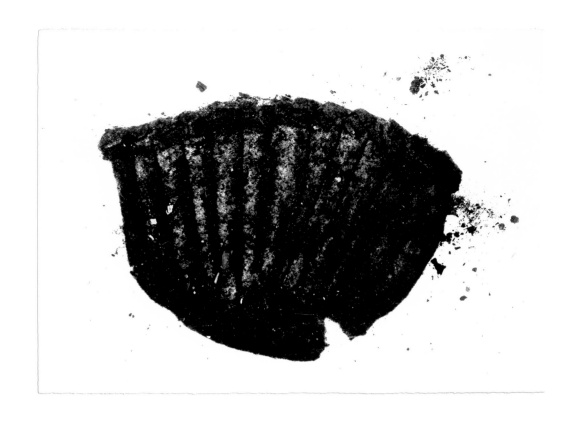

Fluted Cup, New York, 1975.

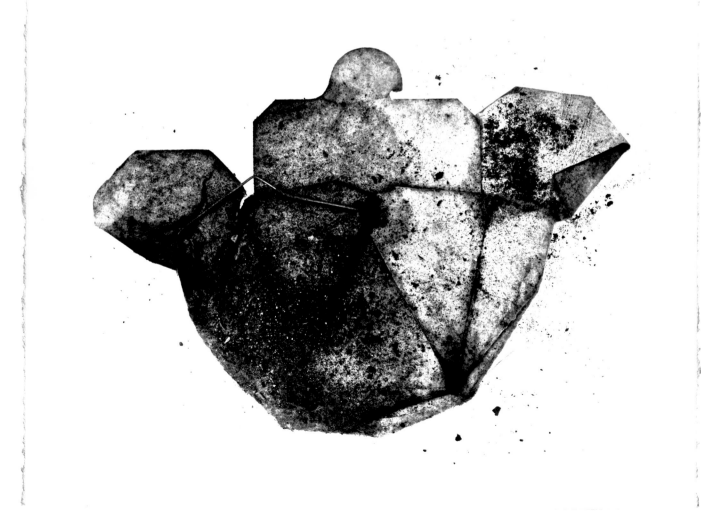

Deli Package, New York, 1975.

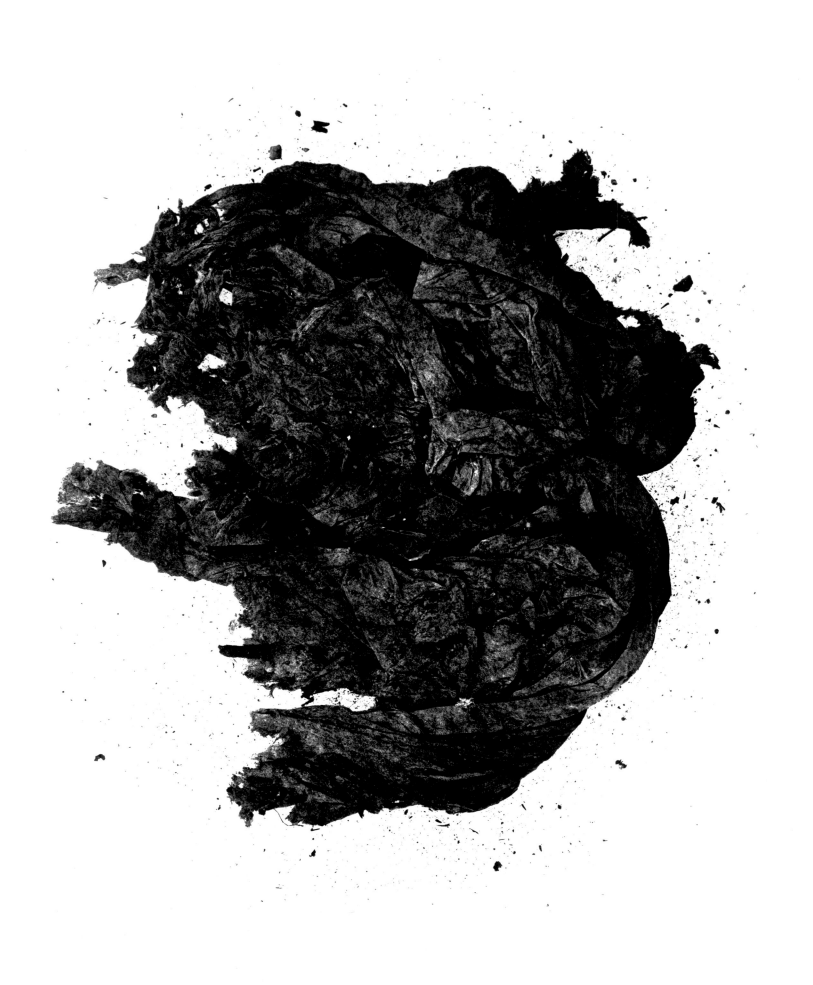

Rag Face, New York, 1975.

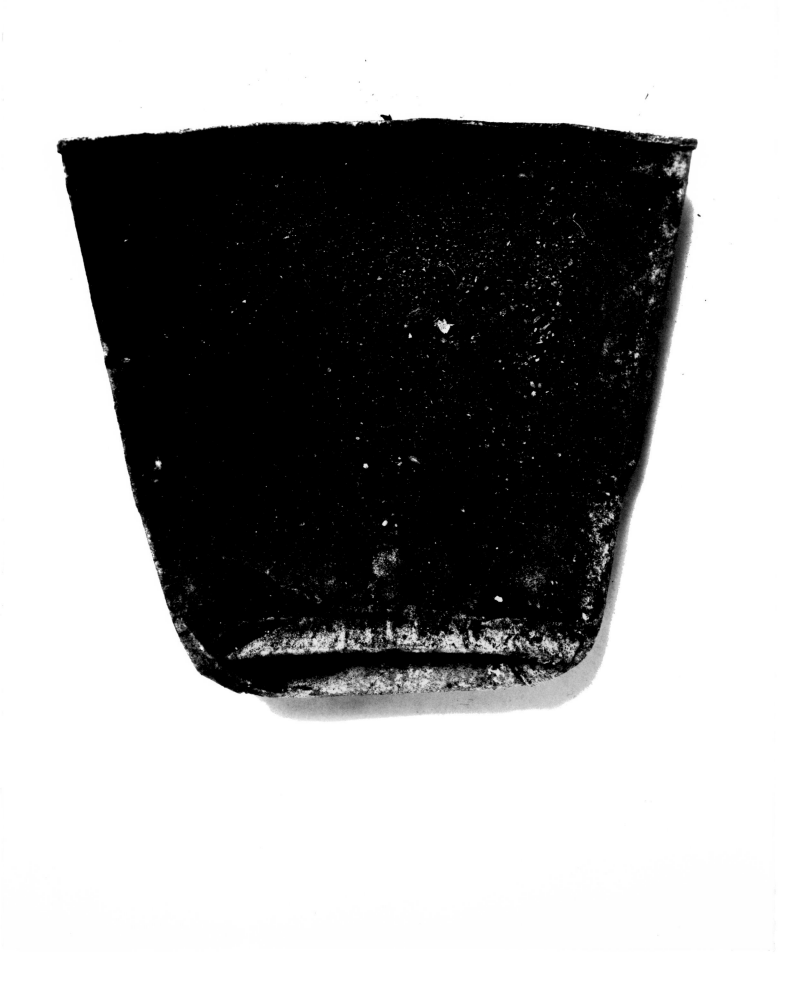

Paper Cup with Shadow, New York, 1975.

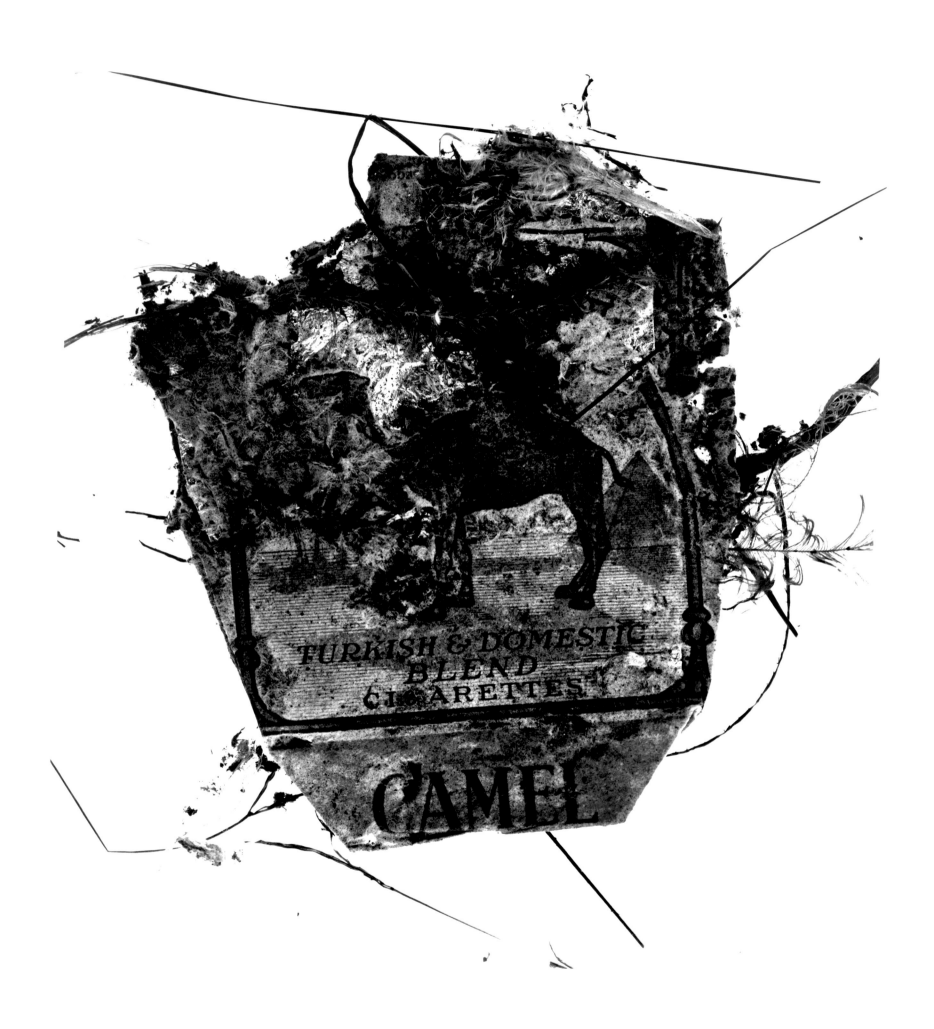

Camel Pack, New York, 1975.

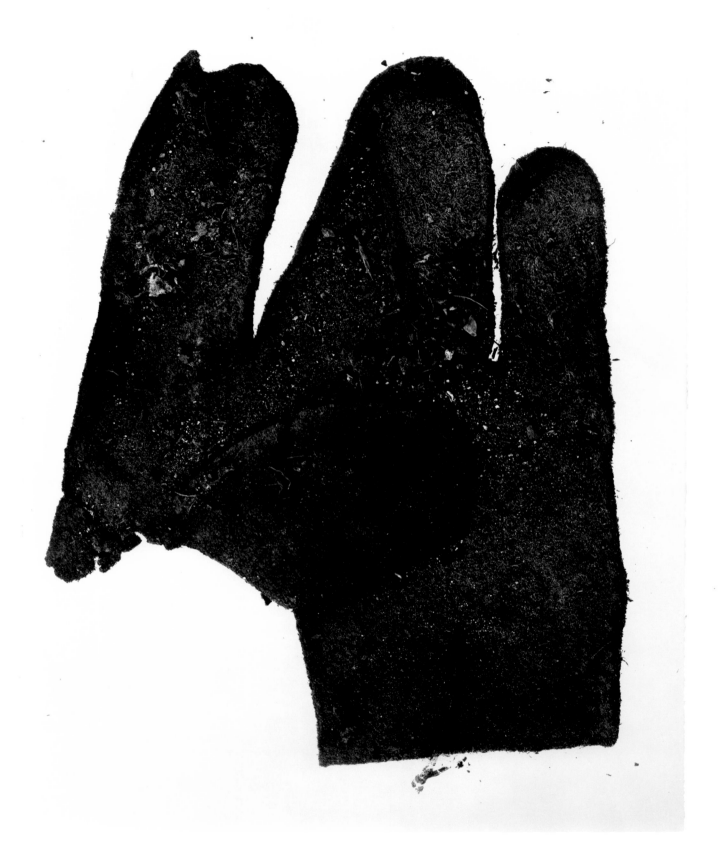

Flat Glove, New York, 1975.

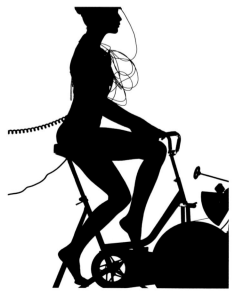

Wired Woman (Jerry Hall), New York, 1975.

Twisted Paper, New York, 1975.

Still Life (advertising photograph for Vivitar), New York, 1976.

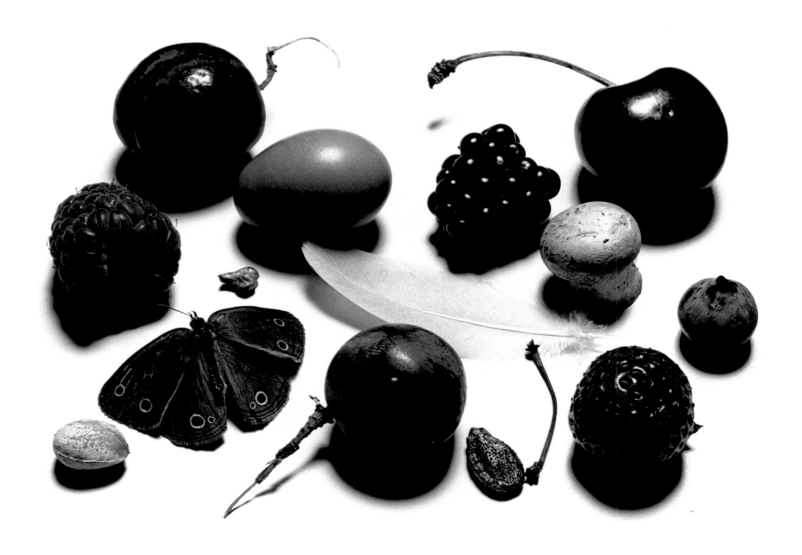

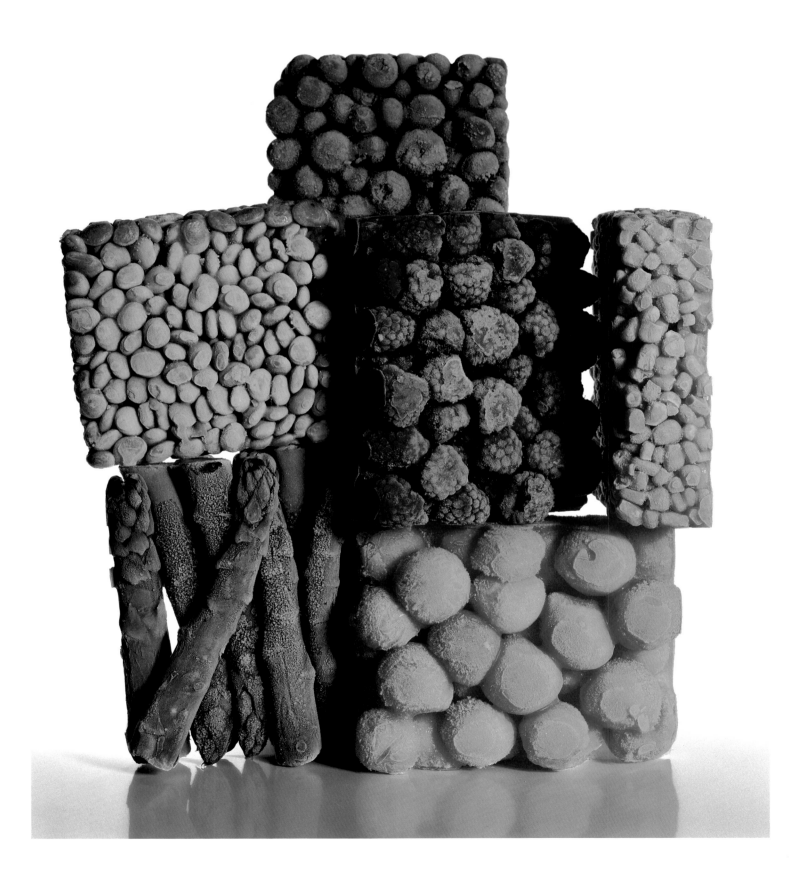

Frozen Foods, New York, 1977.

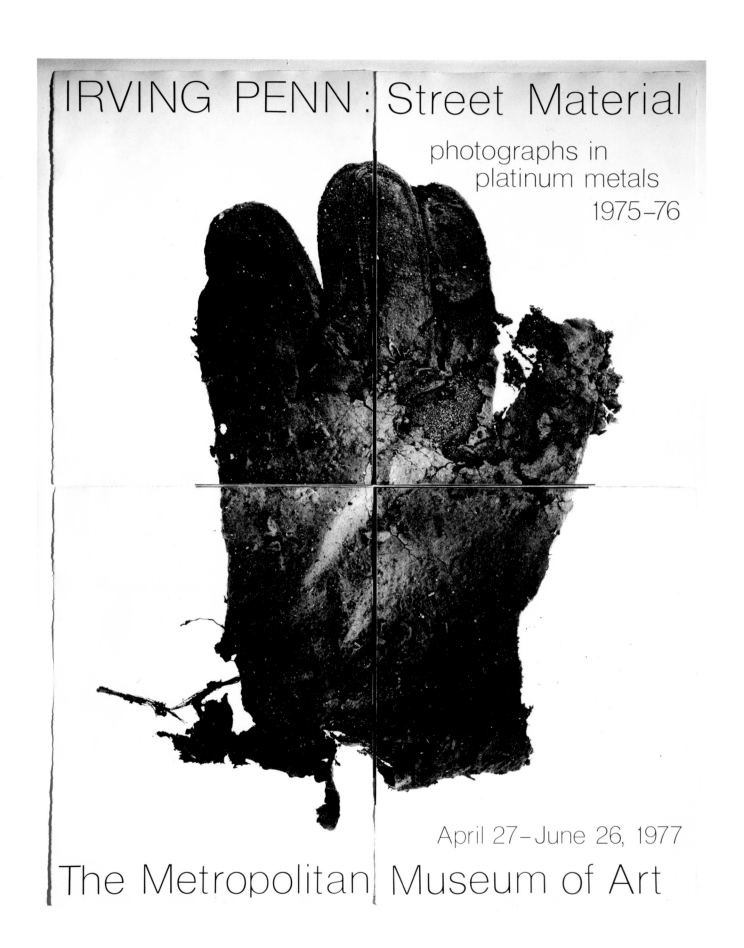

Mud Glove (four-part platinum entrance poster for Metropolitan Museum of Art exhibition), New York, 1977.

Alexander Liberman, Connecticut, 1977.

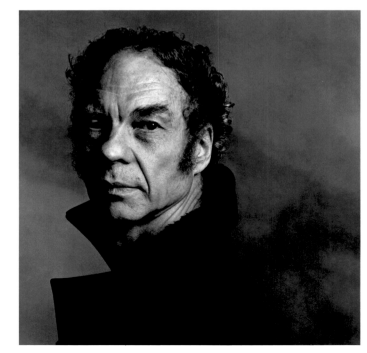

Merce Cunningham, New York, 1978.

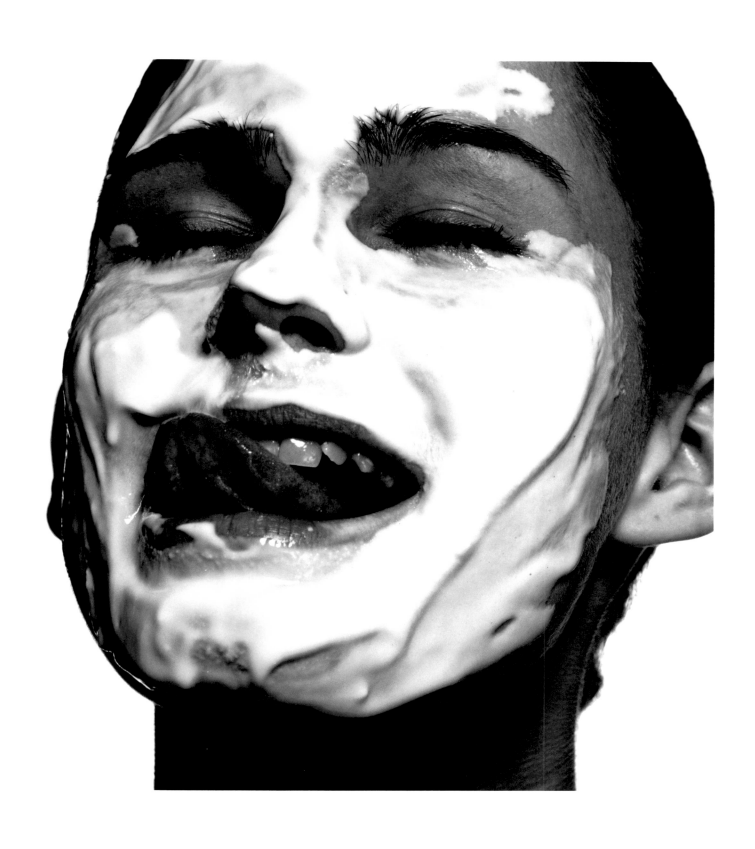

Vogue *Beauty, Yogurt Mask* (Juli Foster), New York, 1978.

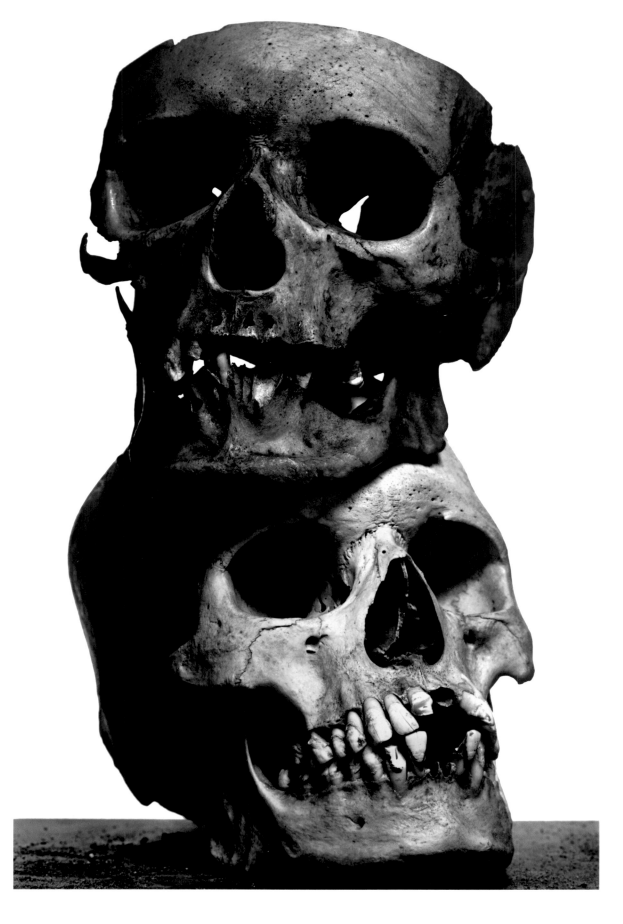

The Poor Lovers, New York, 1979.

Ink Drawing, New York, 1979.

Truman Capote, New York, 1979.

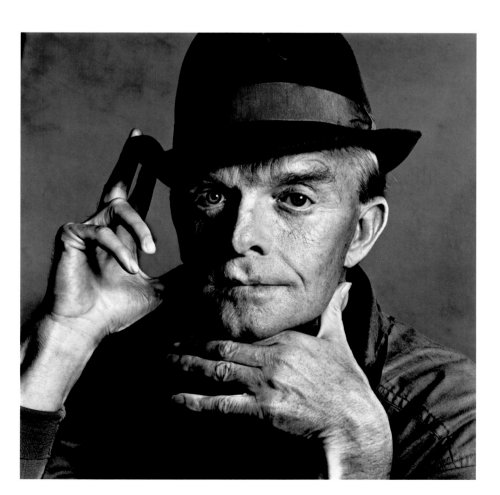

For some years I had been accumulating scraps of material that obsessed me: bits of glass, metal, and bone; a human cranium; old sewing machines; a variety of dusts. In 1979 I acquired an early twelve-by-twenty-inch banquet camera and had it altered. A five-foot track was made and a long bellows substituted for the original short one. I found a number of excellent long lenses. My intention was to make a platinum printing negative twelve-by-twenty inches right in the camera. We made thirty-two negatives between 1979 and 1980. The platinum prints themselves however took a year of work. When the prints were shown I admit I was surprised at the hostility they provoked.

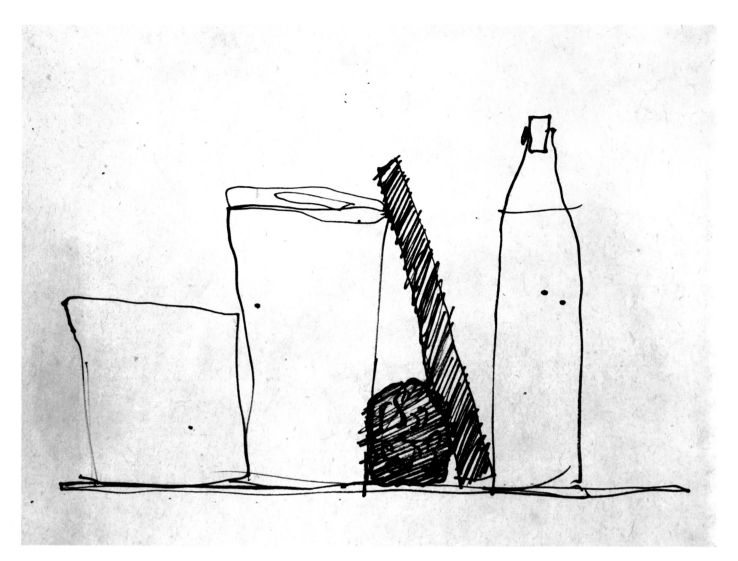

Drawing, New York, 1979.

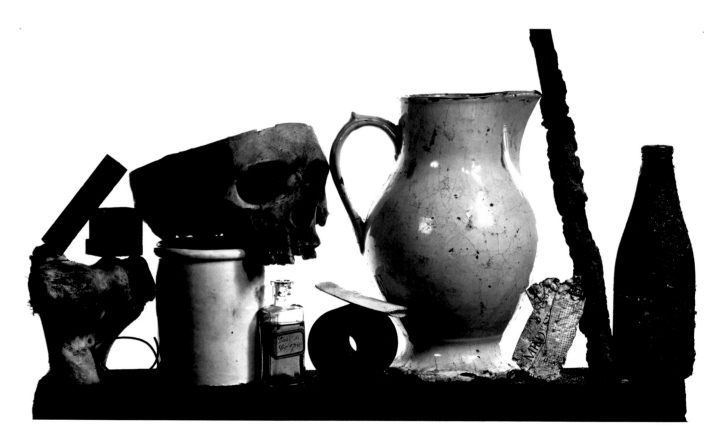

Composition with Pitcher and Eau de Cologne, New York, 1979.

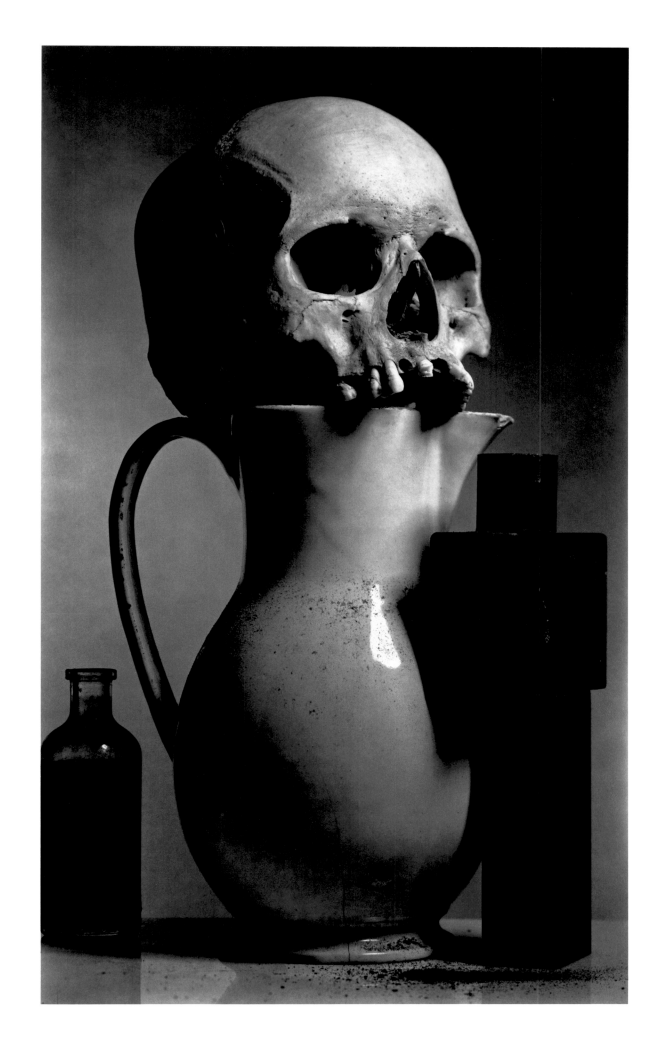

Ospedale, New York, 1980.

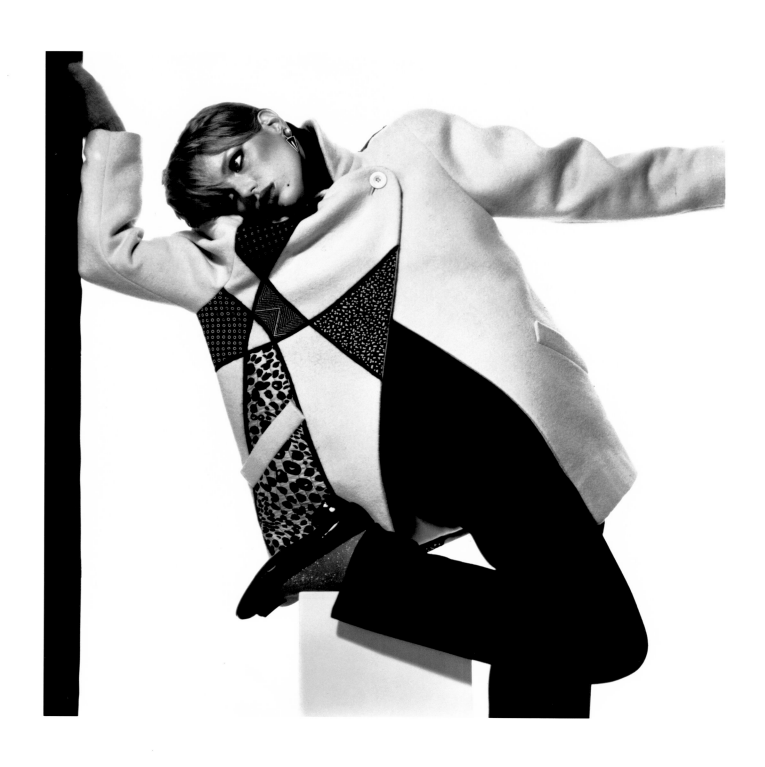

Vogue *Fashion* (Patti Hansen), New York, 1980.

Drawing : *Composition with Sewing Machine, Skull, and Pitcher*, New York, 1979.

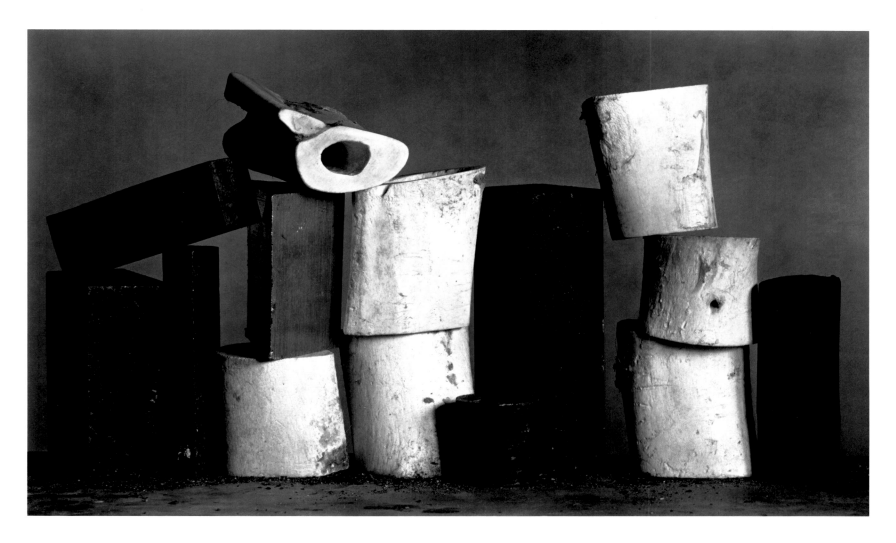

Seven Metal, Seven Bone, New York, 1980.

1980

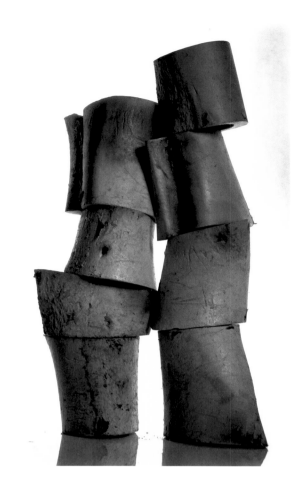

Edifice, New York, 1980.

Still Life with Shoe, New York, 1980.

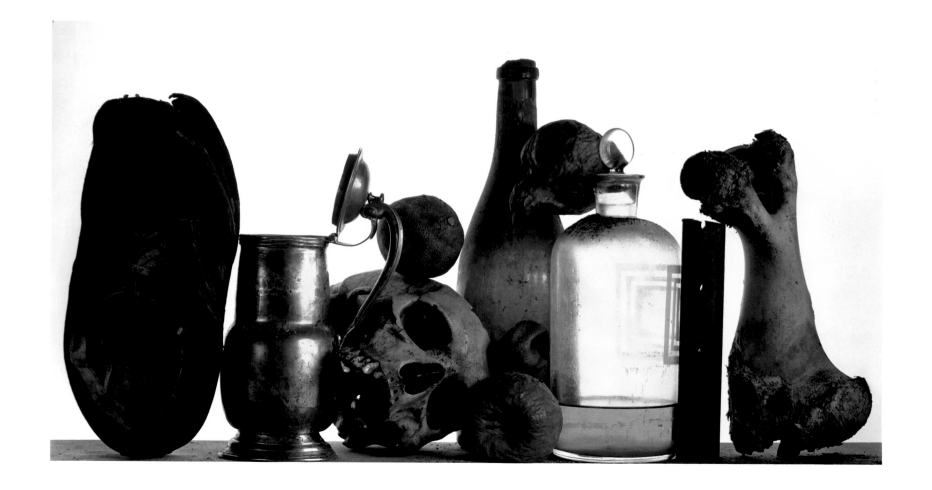

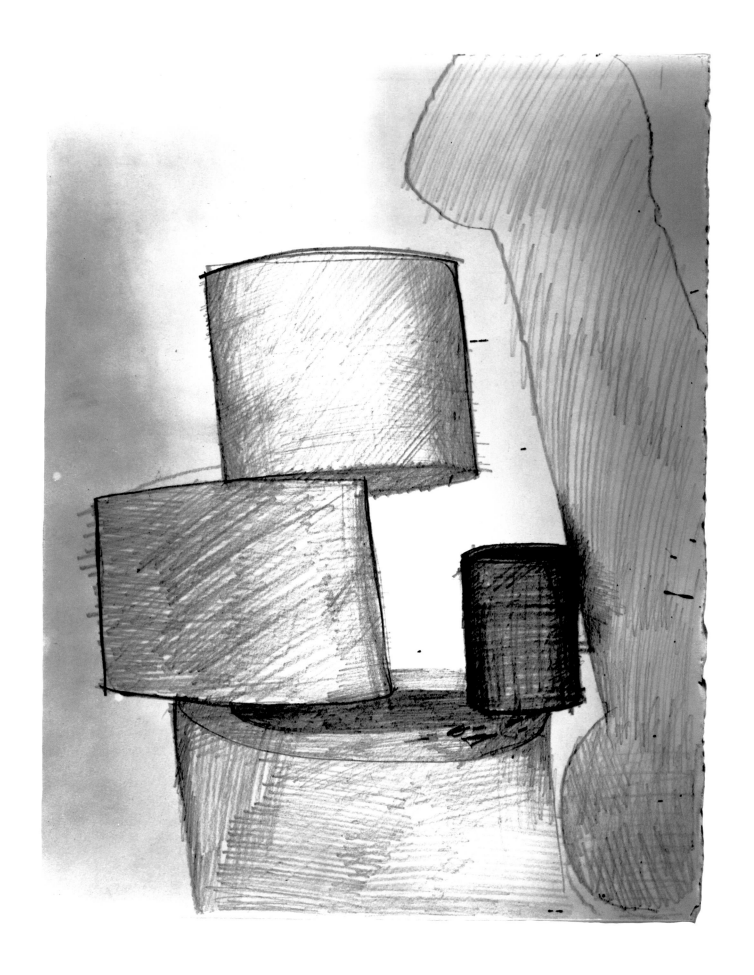

Drawing, New York, 1980.

1980

Joseph Brodsky, New York, 1980.

Blast, New York, 1980.

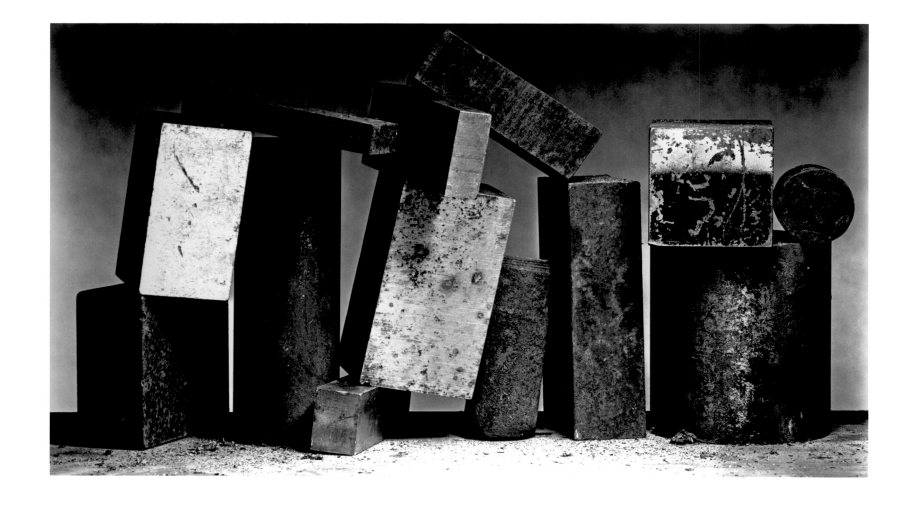

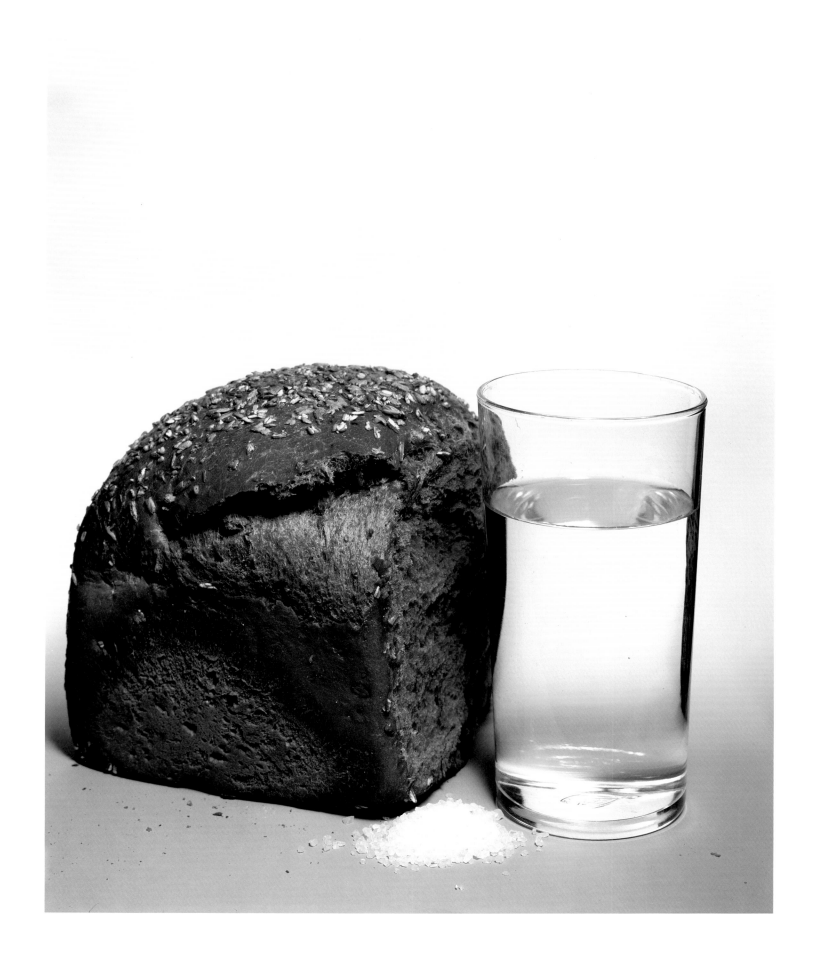

Bread, Salt, and Water, New York, 1980.

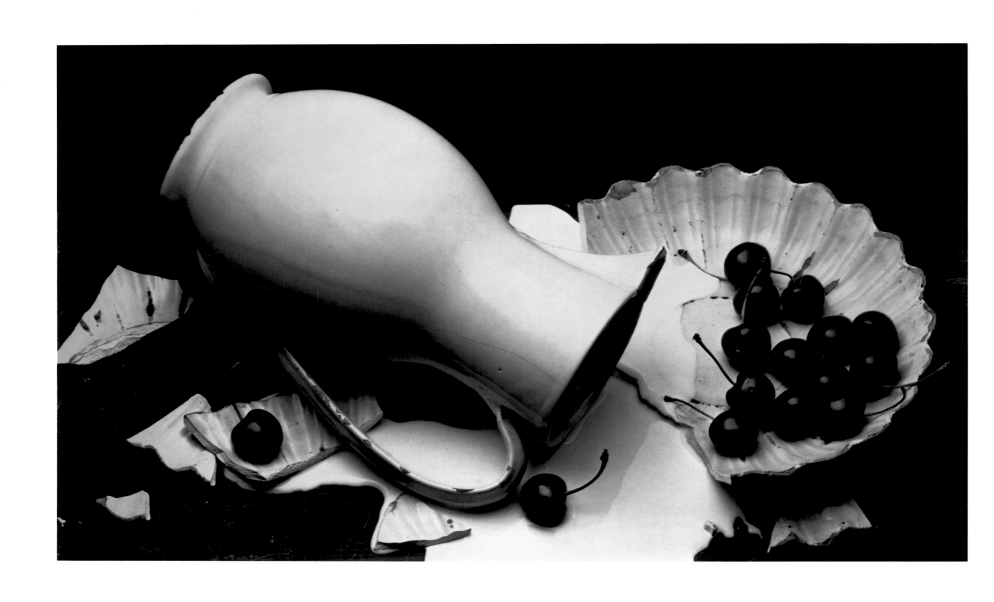

Spilled Cream, New York, 1980.

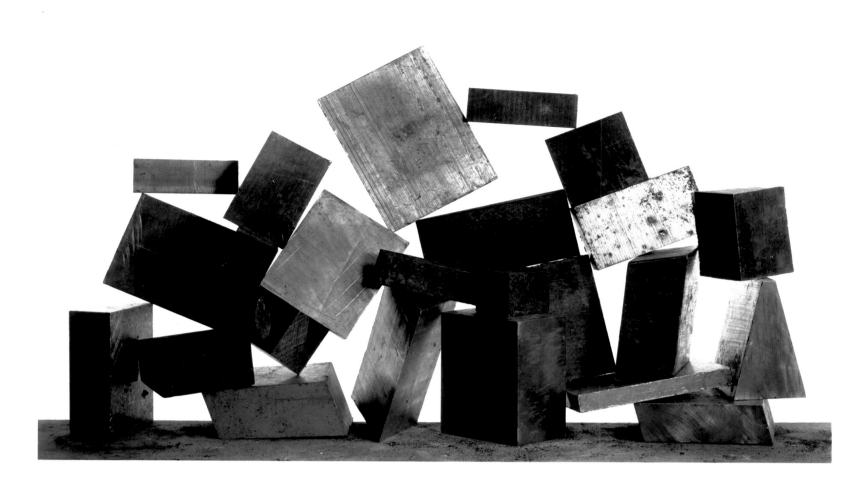

Collapse, New York, 1980.

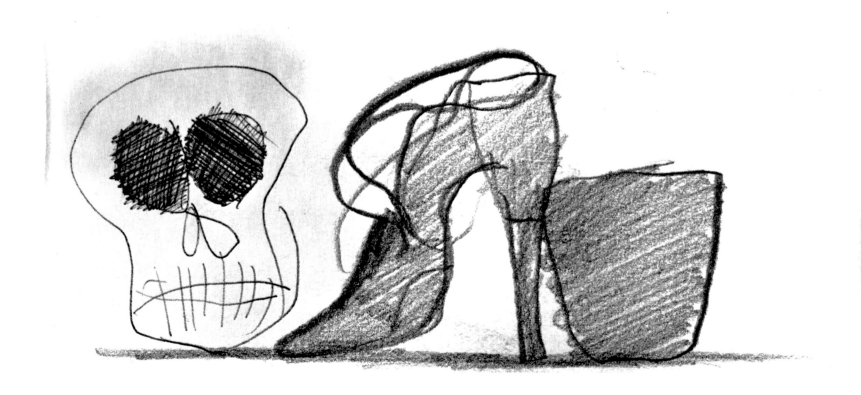

Drawing: *Skull, Shoe, and Cup*, New York, 1980.

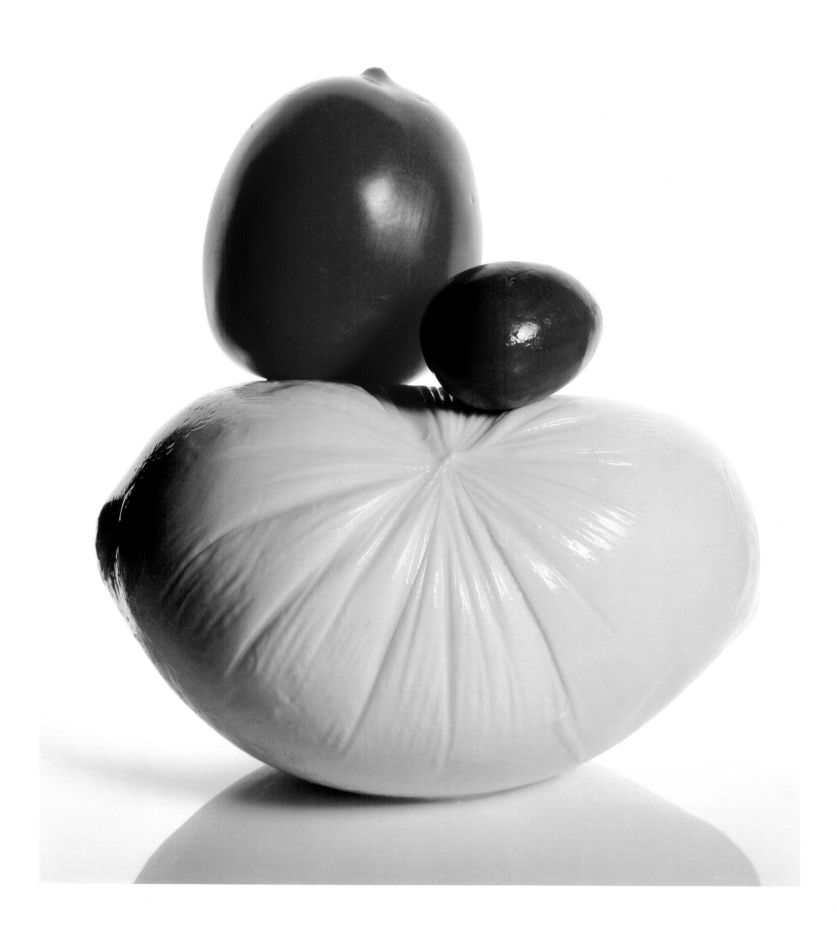

Italian Still Life, New York, 1981.

Gianni Versace, New York, 1981.

Italian Bottle and Cork, New York, 1981.

Milan Kundera, New York, 1981.

Croissant, New York, 1982.

Virgil Thomson, New York, 1982.

Bathing Suit, New York, 1982.

1983

Yves Saint Laurent, Dior's artistic heir, had come to our Paris studio in 1957 with his attendants, four severe women dressed in black. Many years later he came again to pose for Vogue, *still shy but somewhat more comfortable. By now he was the great Saint Laurent and we were not complete strangers. Our work lives had crossed many times. Still I sensed he was pleased to only peek out from behind a covering hand.*

Suzanne Farrell came to pose in February. I did not know her work as well as she might have wished, and she was somewhat prickly. Also, the costume she brought was strange to pose in. But as we worked together our difficulties solved themselves. The sitting was over too soon. A tender portrait of a beautiful person remains.

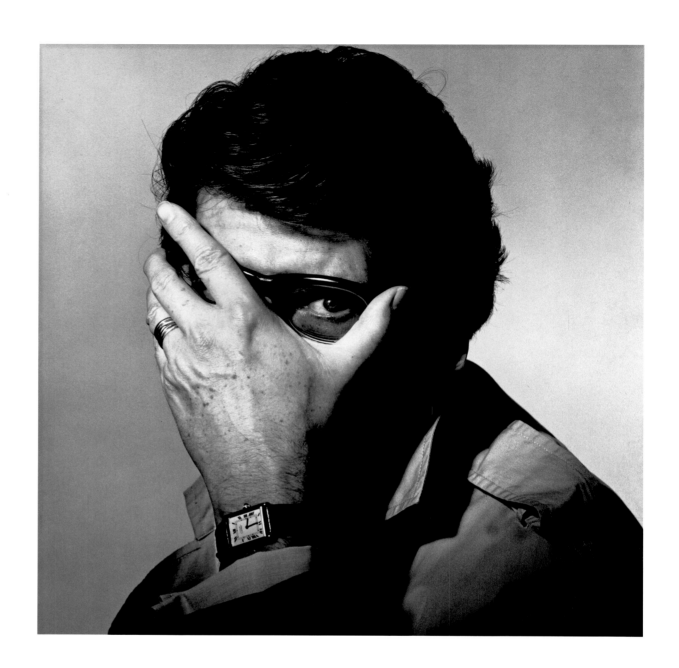

Yves Saint Laurent, Paris, 1983.

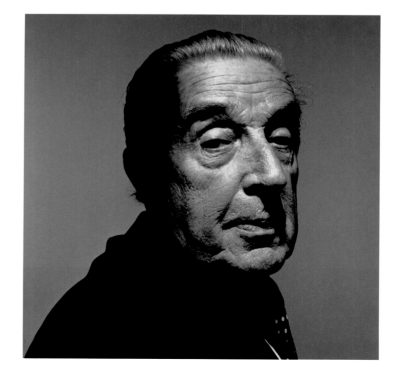

Sir Frederick Ashton, New York, 1983.

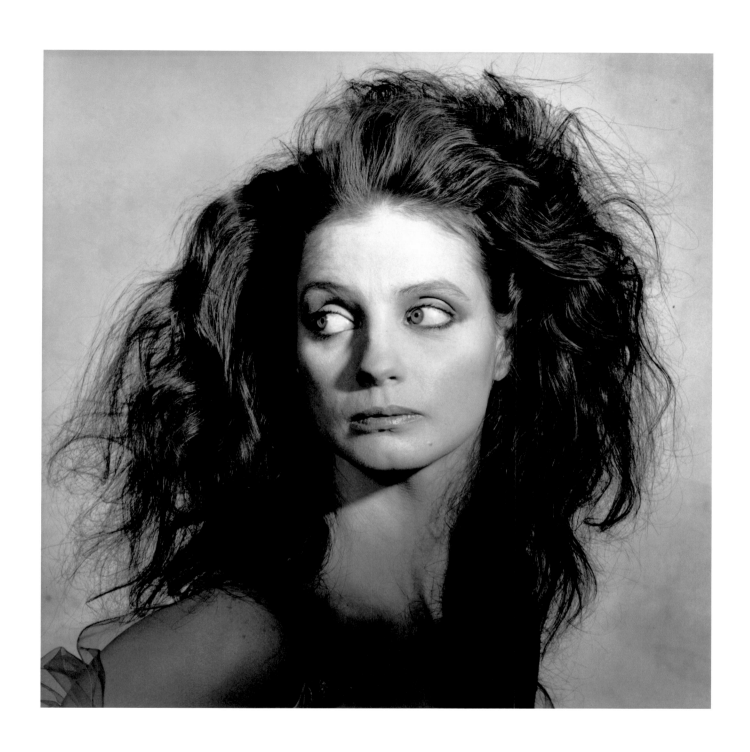

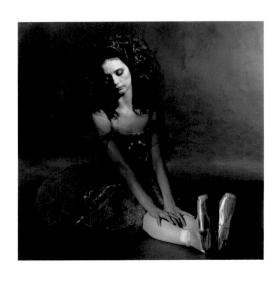

Suzanne Farrell, New York, 1983.

243

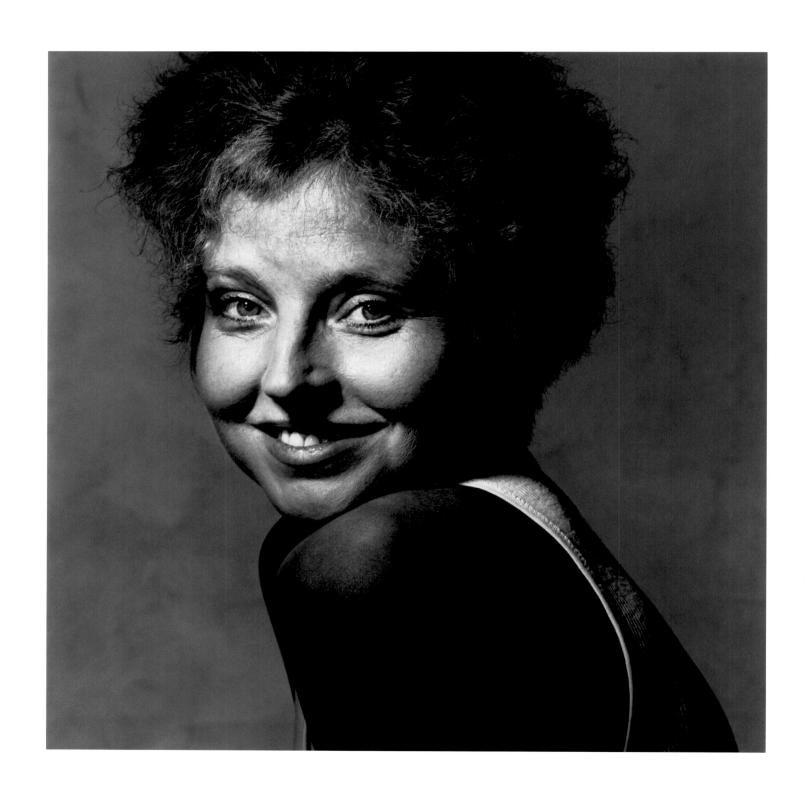

Hanna Schygulla, New York, 1983.

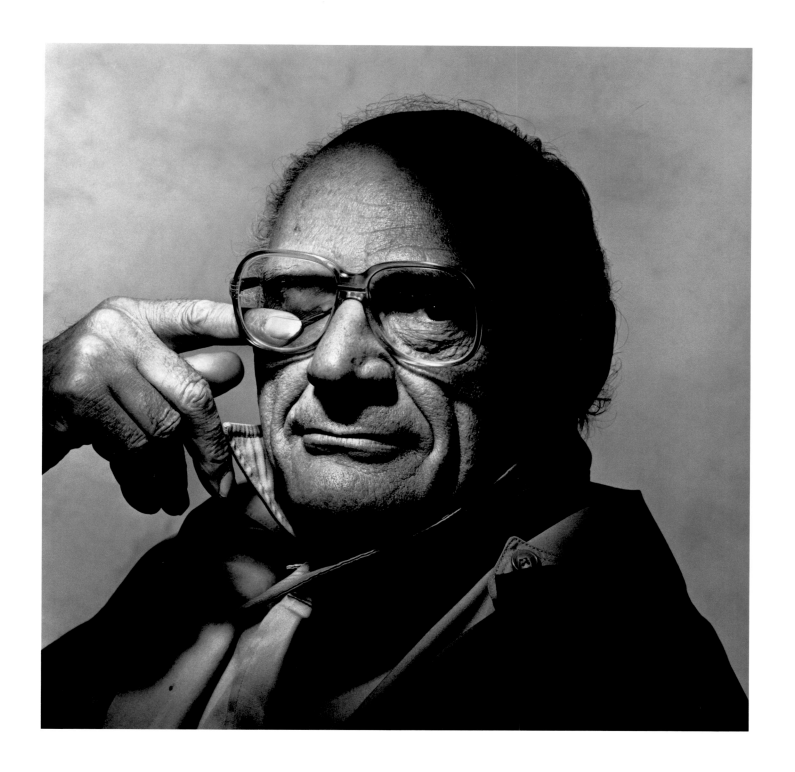

Arthur Miller, New York, 1983.

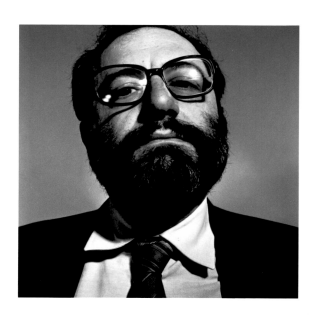

Umberto Eco, New York, 1983.

Vogue *Beauty Head* (Lauren Helm), New York, 1983.

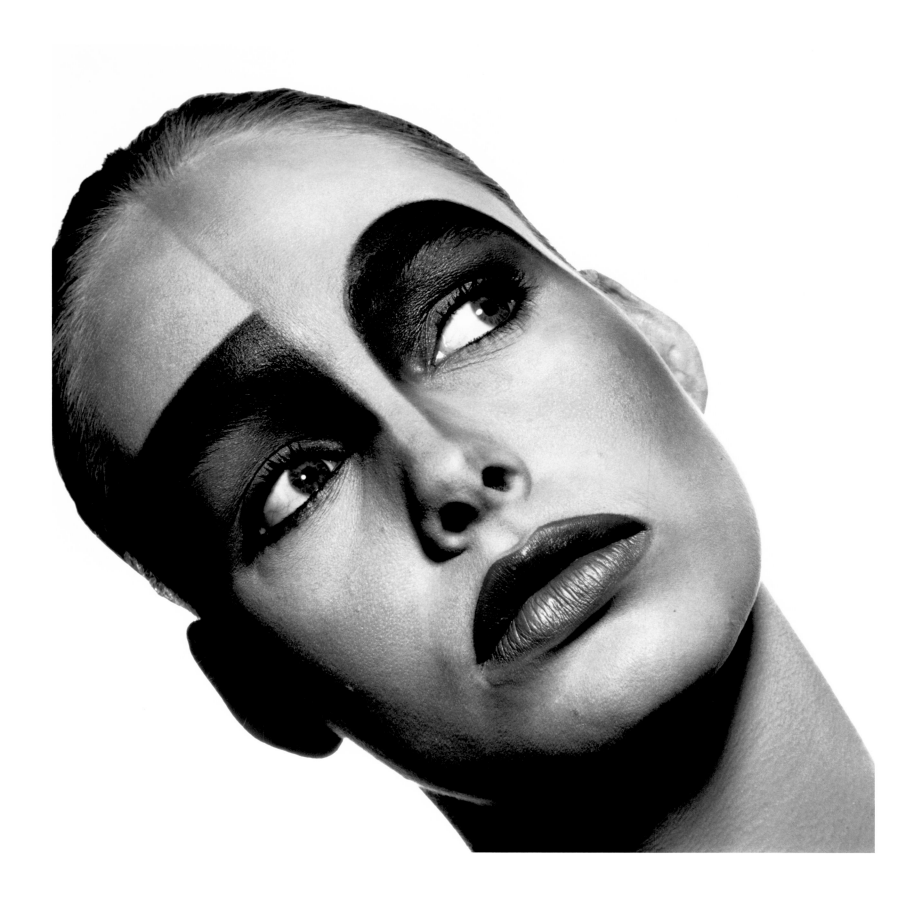

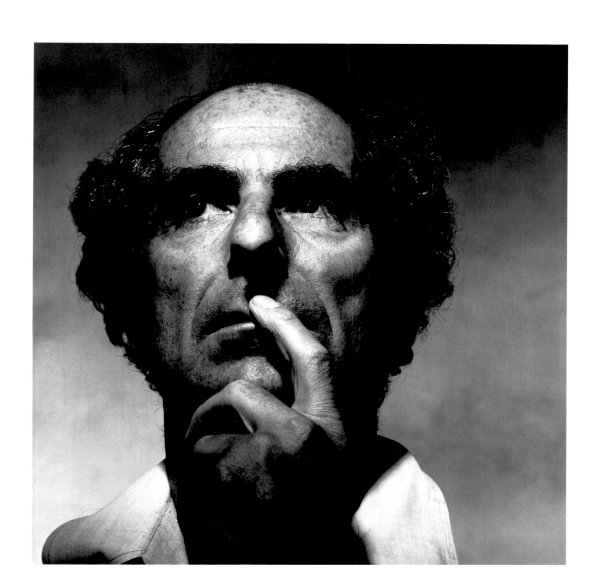

Philip Roth, New York, 1983.

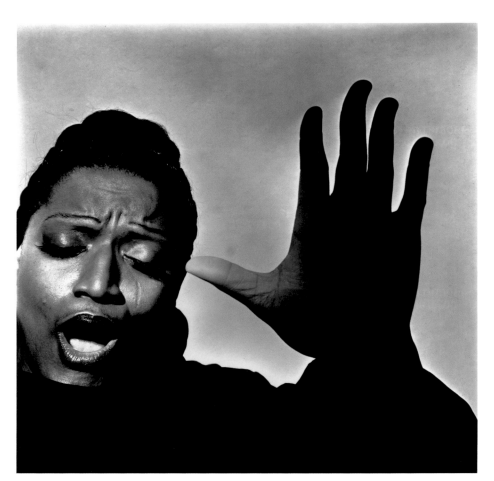

Jessye Norman, New York, 1983.

247

Italo Calvino, New York, 1983.

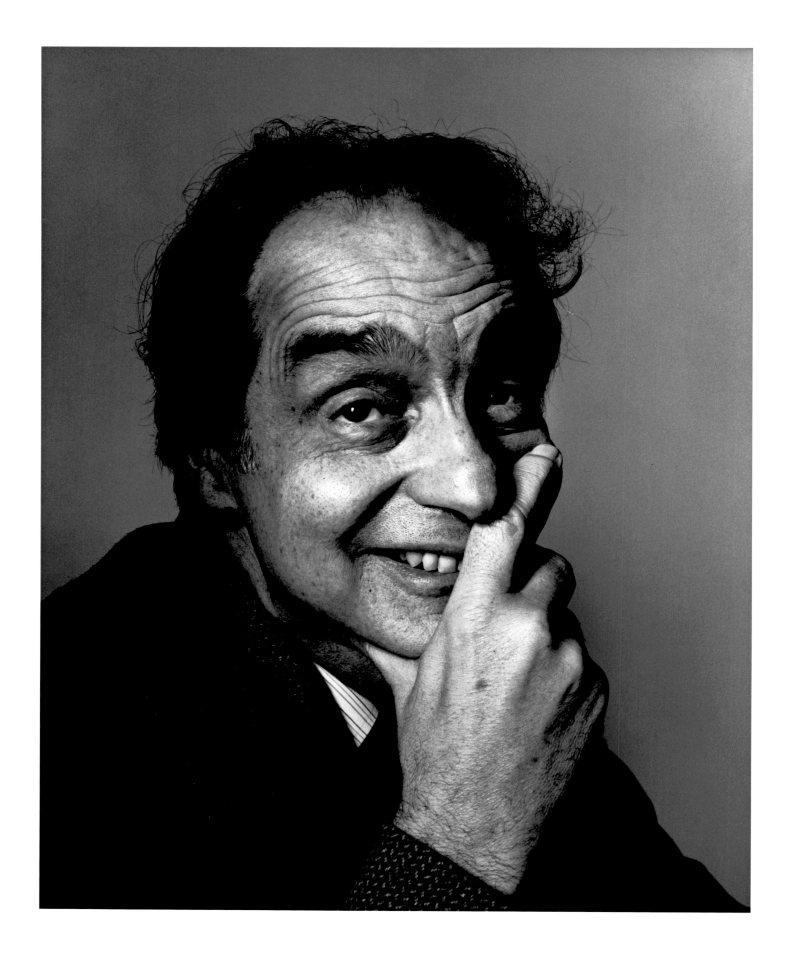

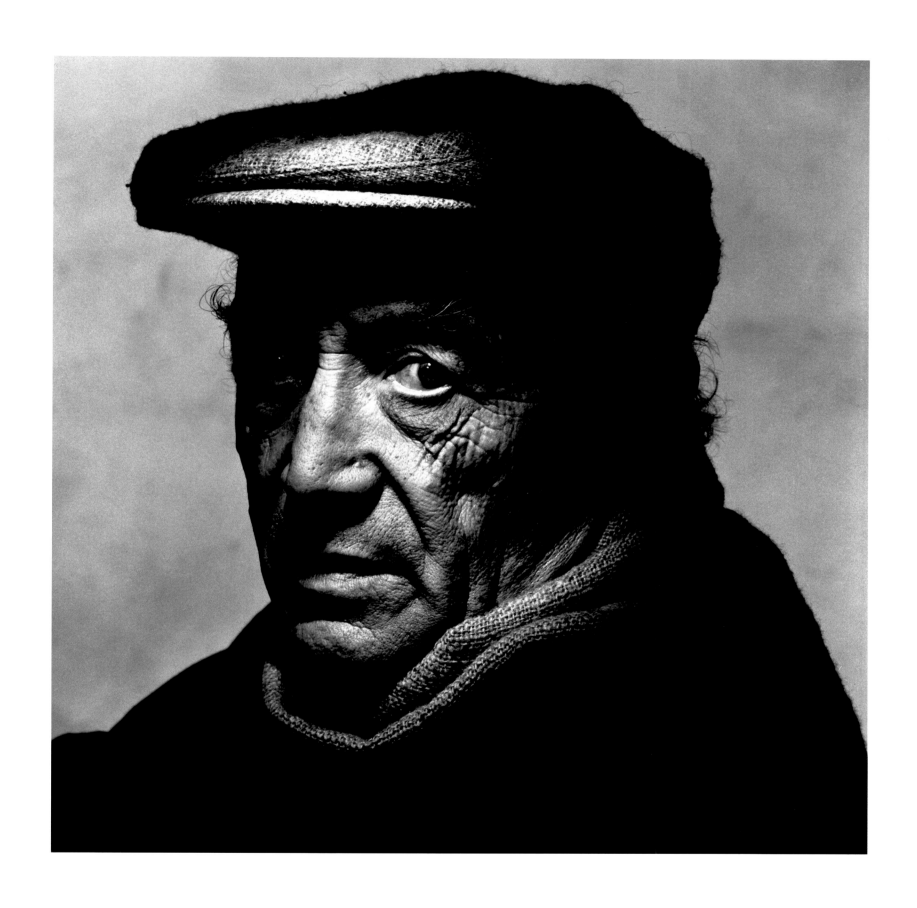

Isamu Noguchi, New York, 1983.

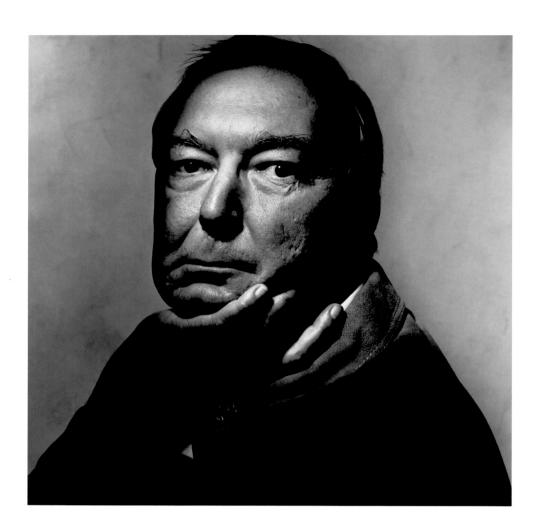

Jasper Johns, New York, 1983.

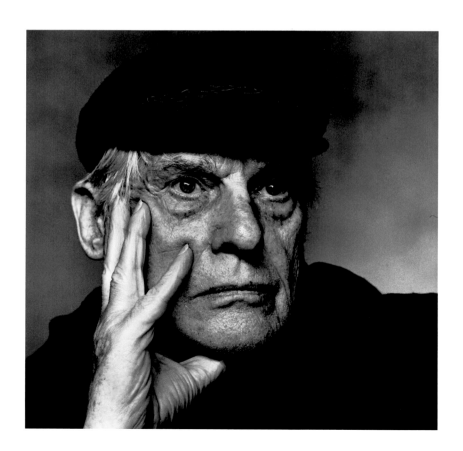

Willem de Kooning, Long Island, New York, 1983.

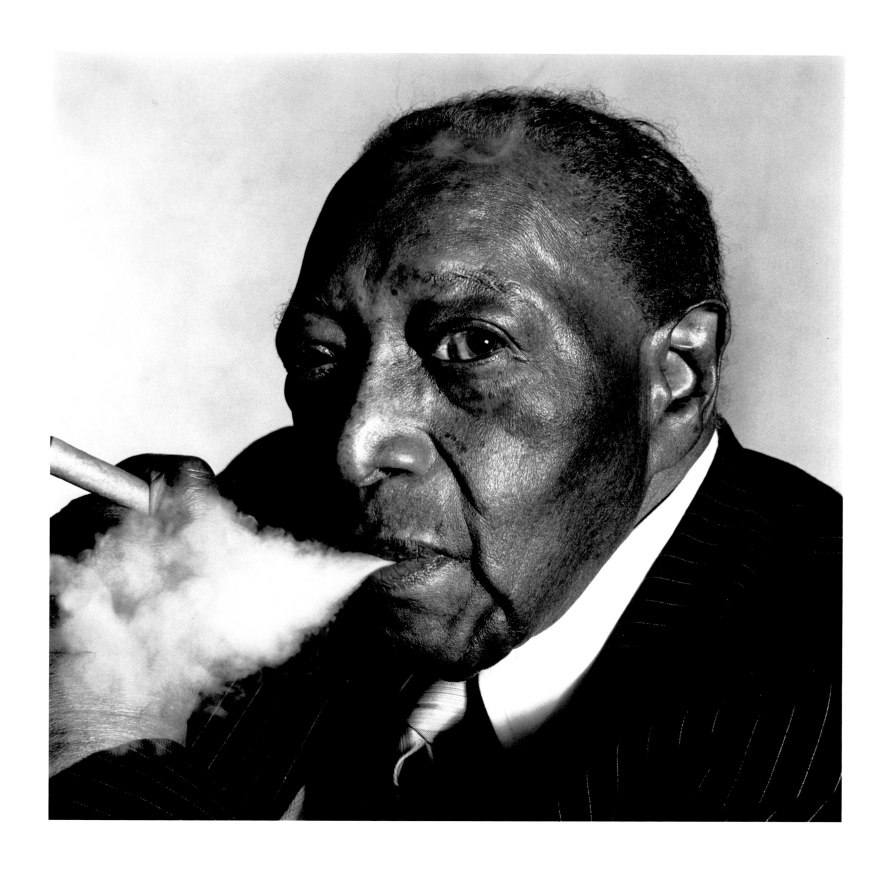

James Van Der Zee, New York, 1983.

Drawing, Sweden, 1984.

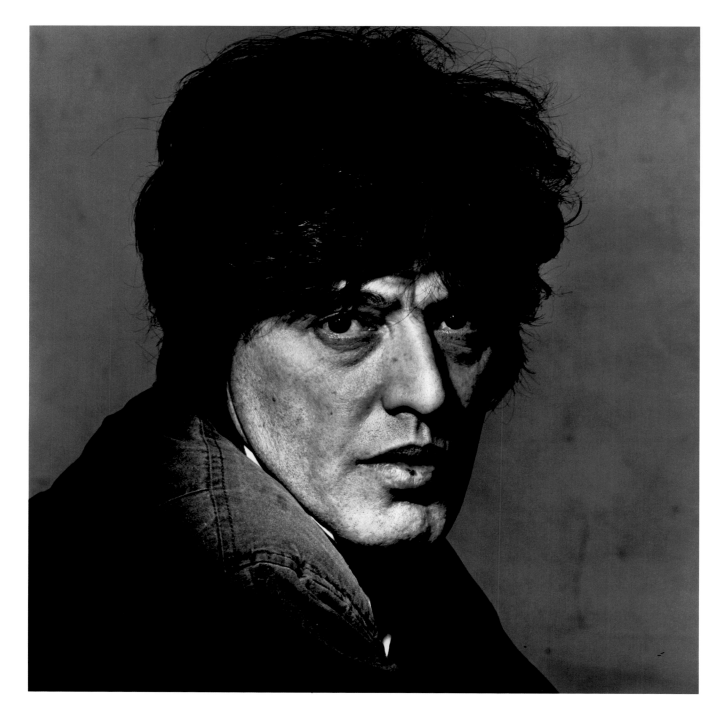

Tom Stoppard, New York, 1984.

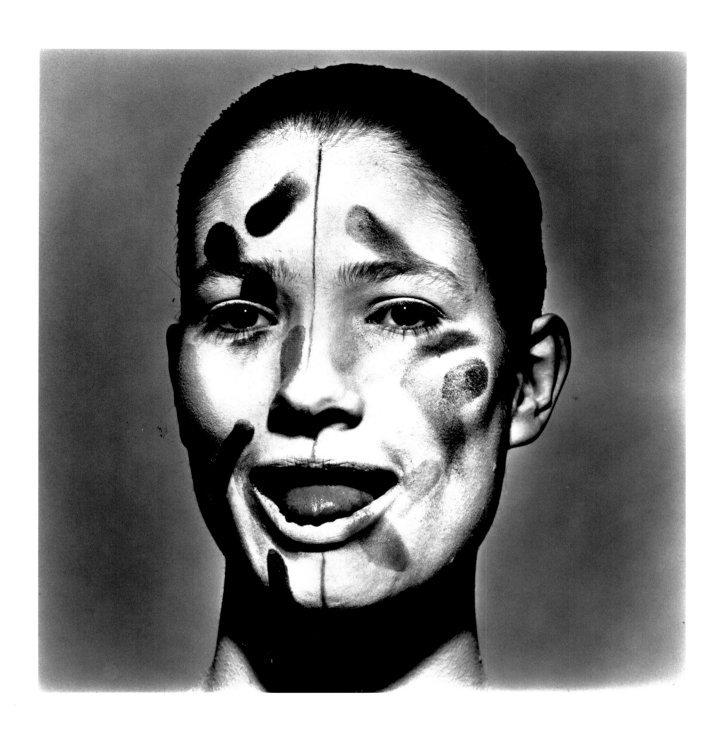

Vogue *Beauty Head* (Monique Van Heel), New York, 1984.

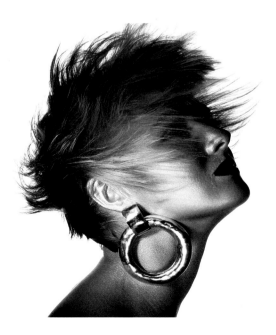

Vogue *Beauty, Gold Head*, New York, 1984.

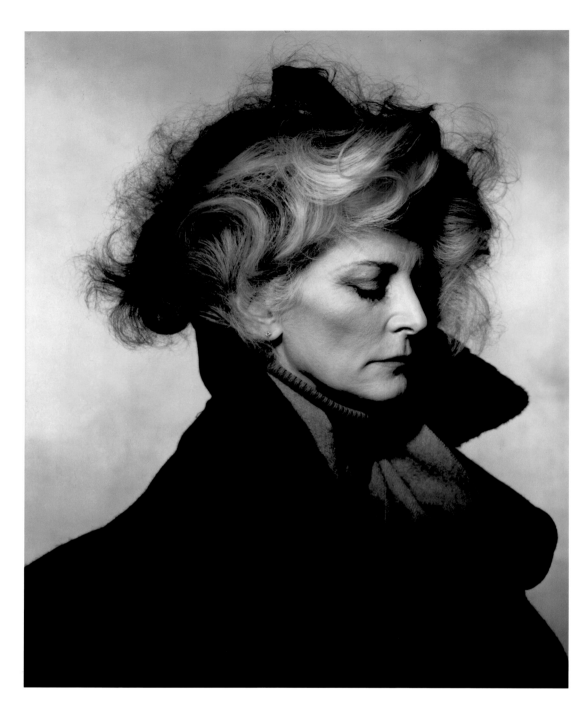

Carmen Dell'Orefice, New York, 1985.

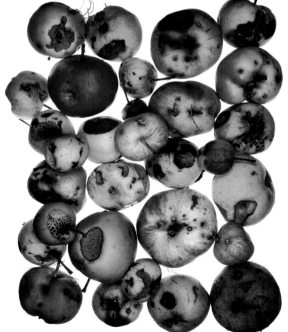

Red Apples, New York, 1985.

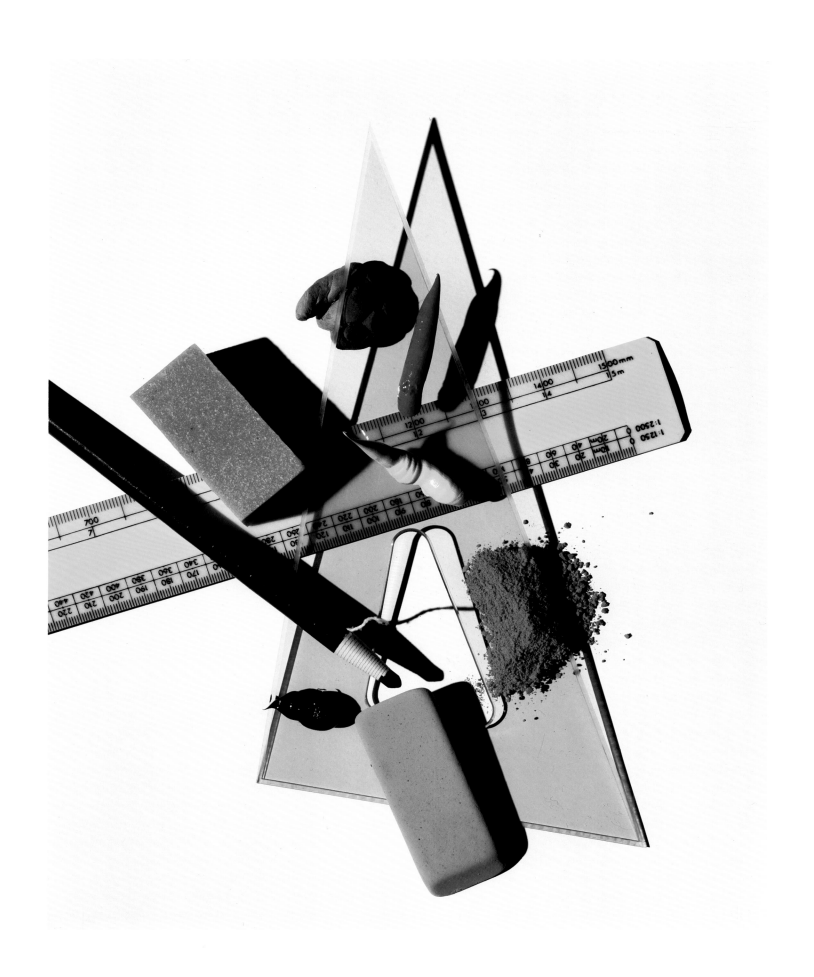

Still Life with Triangle and Red Eraser (advertising photograph for Fuji, Japan), New York, 1985.

Fernando Botero, New York, 1985.

Vanessa Redgrave, New York, 1985.

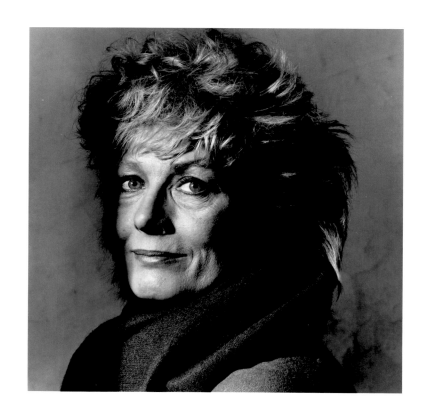

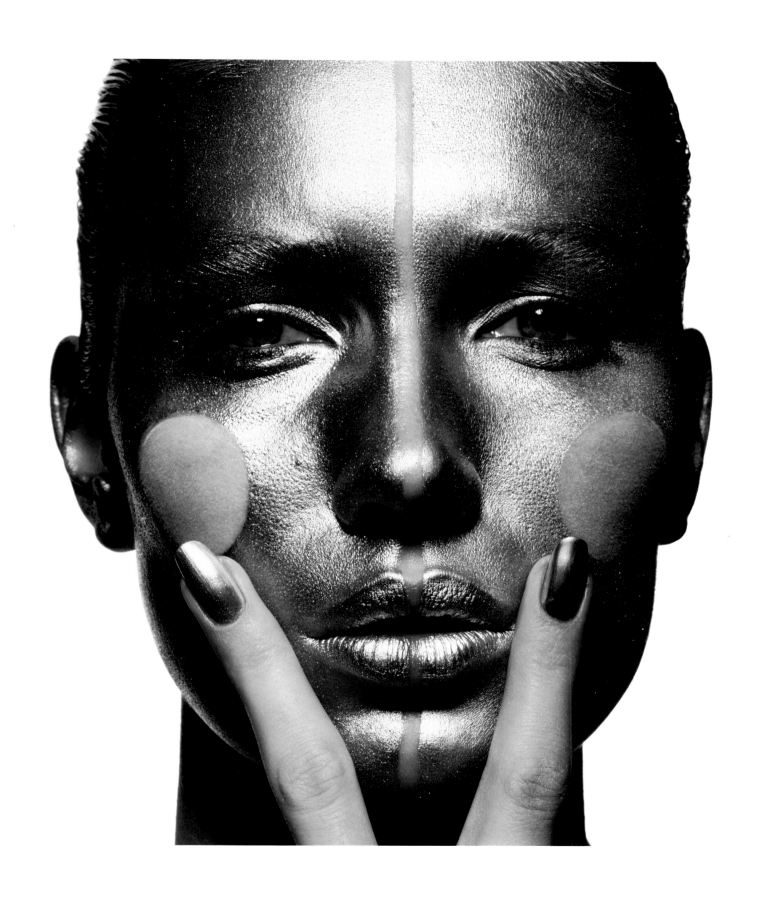

Vogue *Beauty, Gold and Silver Make-Up* (Renate Vackova), New York, 1985.

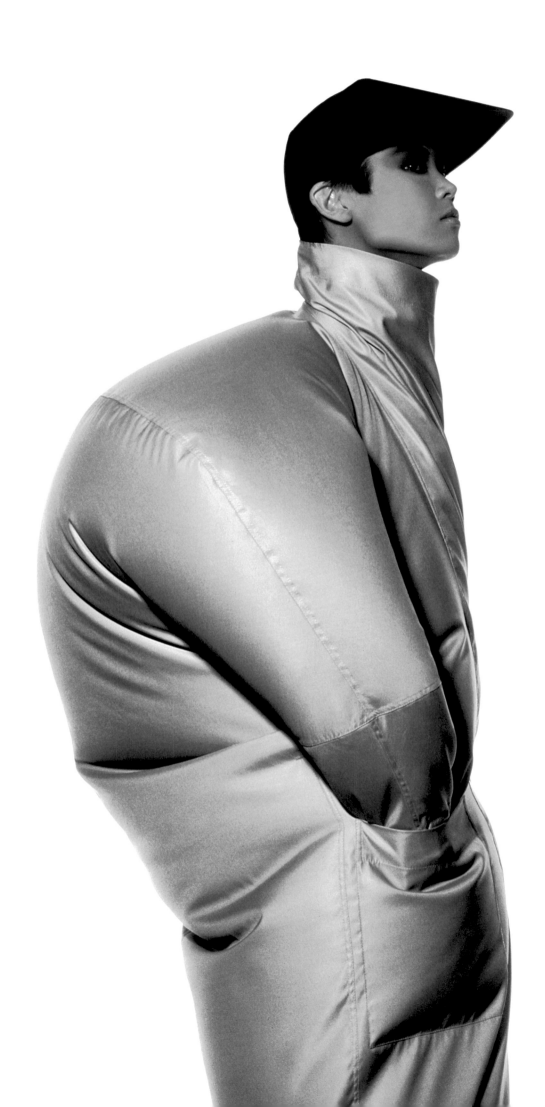

Issey Miyake Fashion (Jun Kano), New York, 1986.

The Hand of Miles Davis, New York, 1986.

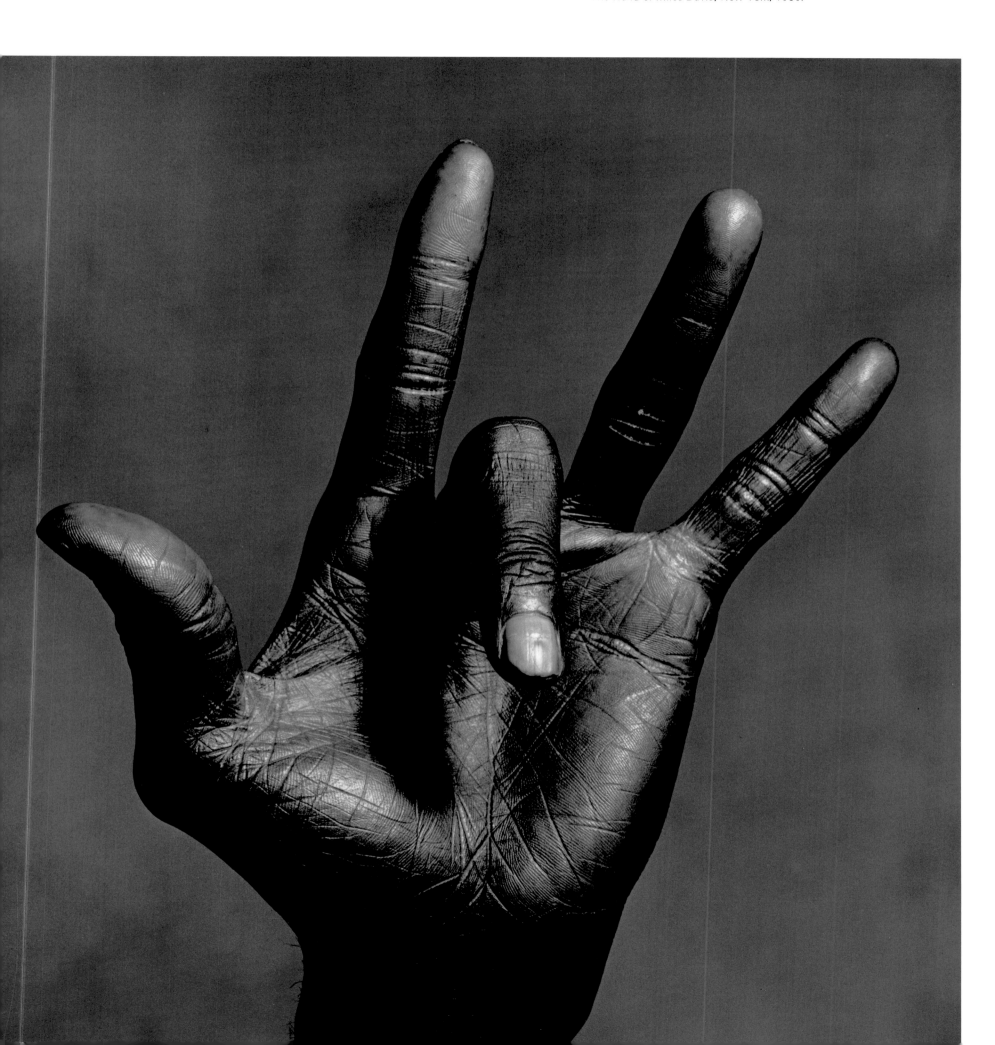

Rhinoceros Skull, Prague, 1986.

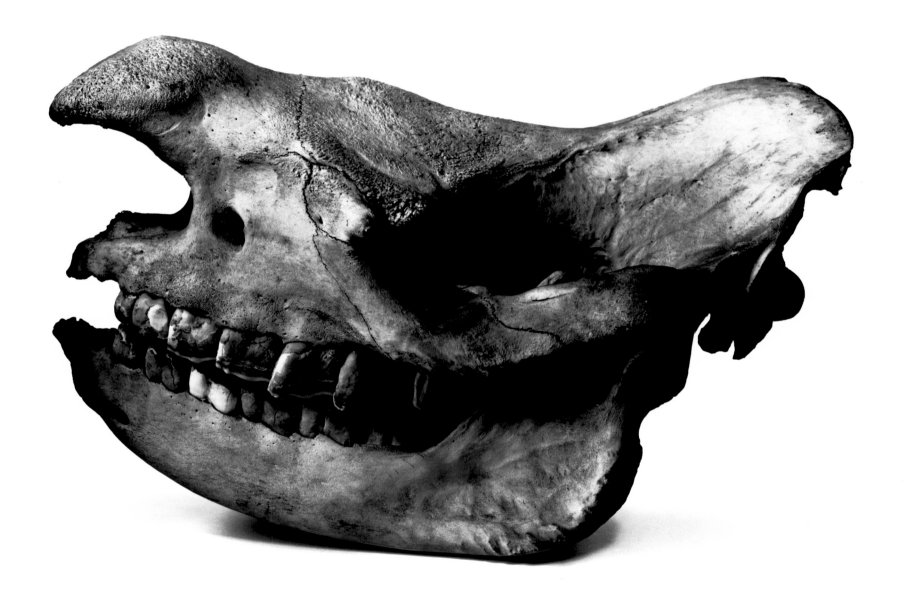

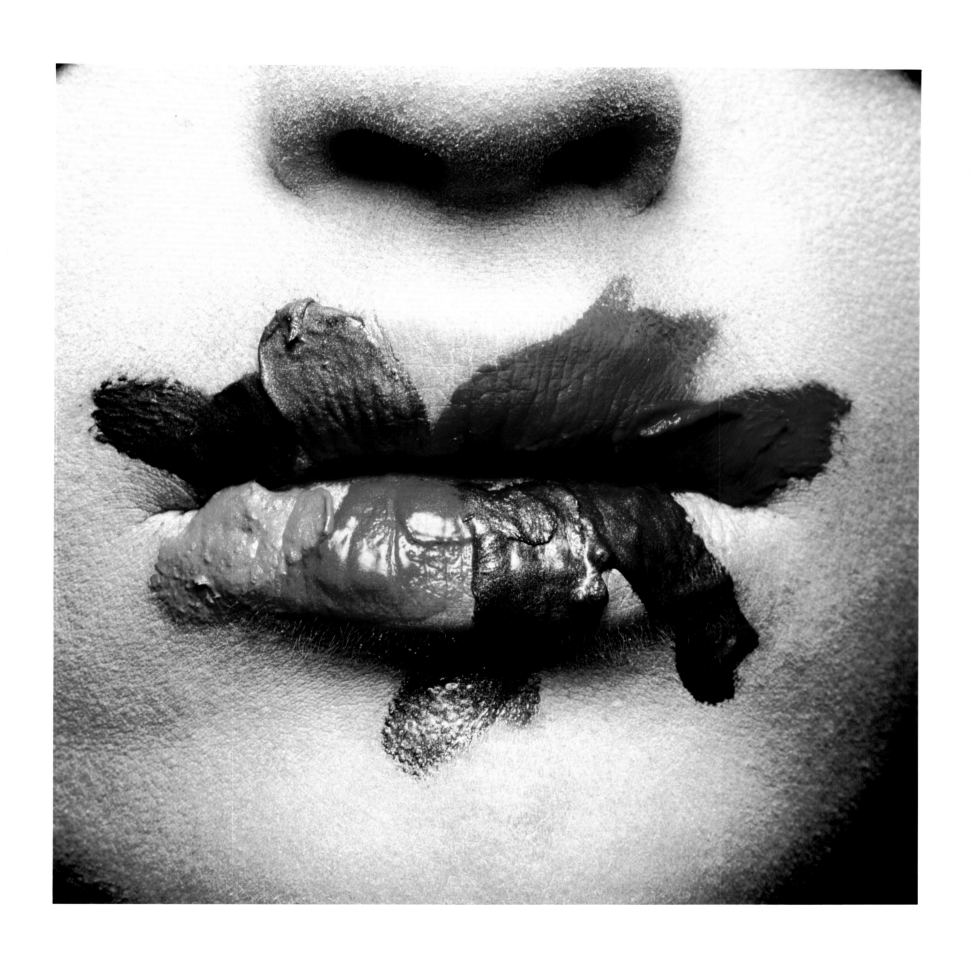

Mouth (for L'Oréal), New York, 1986.

Camel Skull, Prague, 1986.

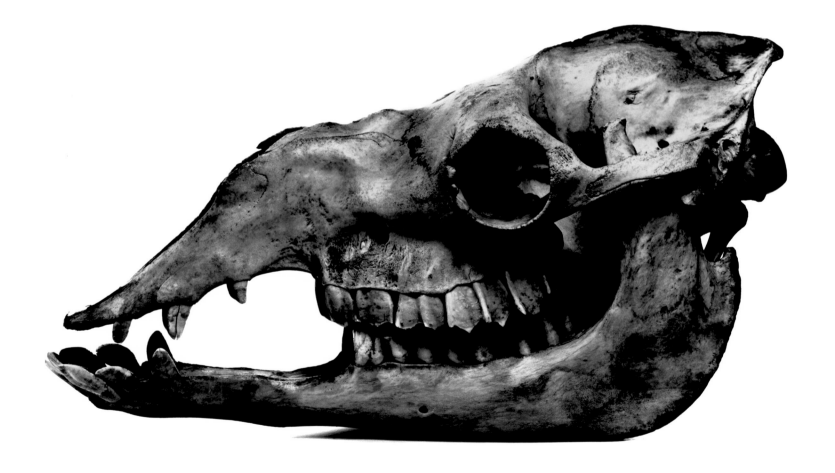

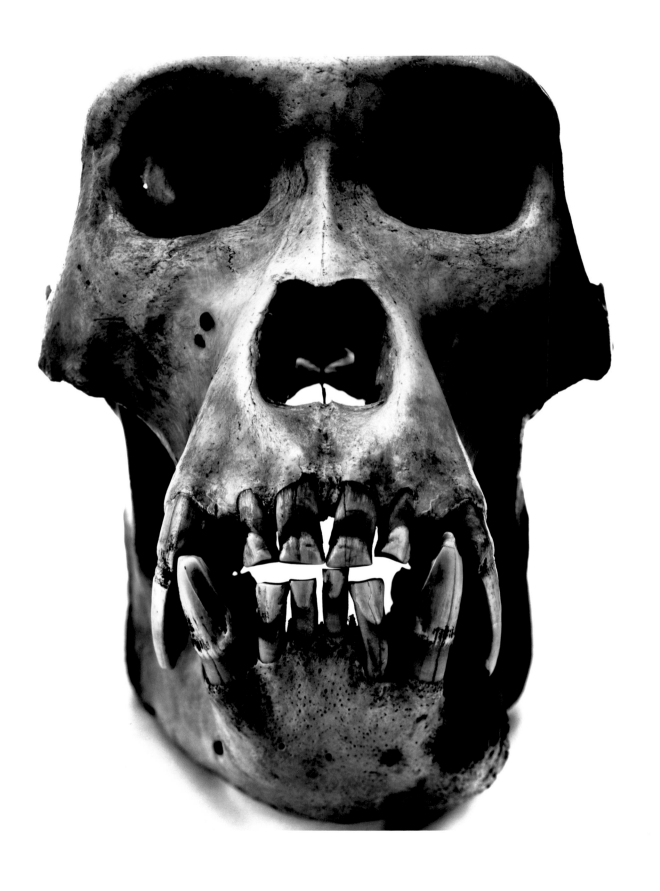

Gorilla Skull, Prague, 1986.

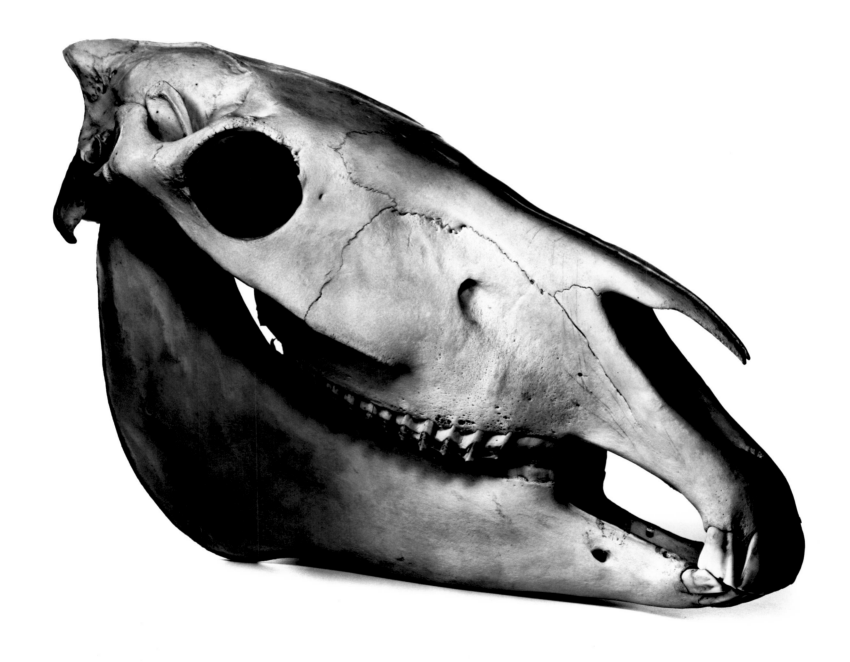

Zebra Skull, Prague, 1986.

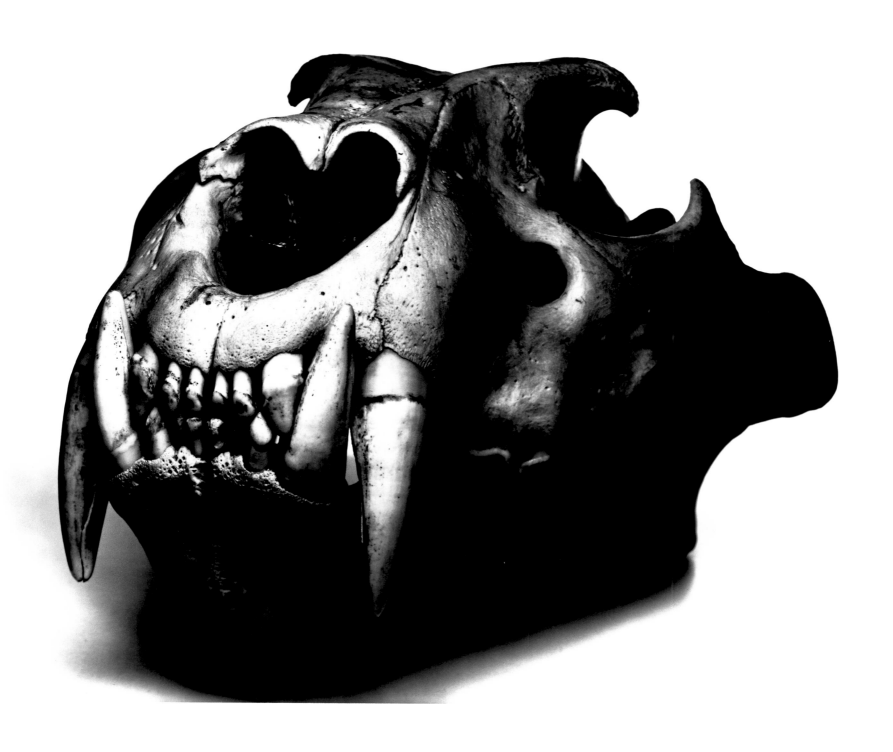

Lion Skull, Prague, 1986.

Issey Miyake Fashion (Jun Kano), New York, 1987.

Some time after a museum retrospective, feeling emptied, I began to draw, then to paint, tentatively picking up threads dropped forty-some years before. Pleased with the new freedom, I found inside myself accumulated forms, enjoyed arbitrary color, the touch of the brush, the flow of pigment, the slowness and privacy. I worked this way for two or three years of weekends and vacations.

It was inevitable that the pendulum would swing me back to the camera.

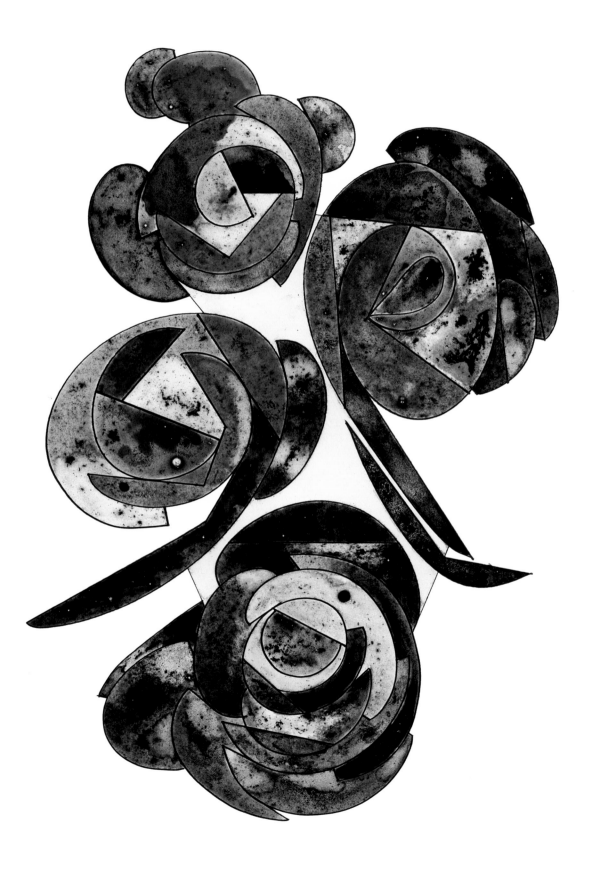

Drawing : *Four Japanese Ladies*, New York, 1987.

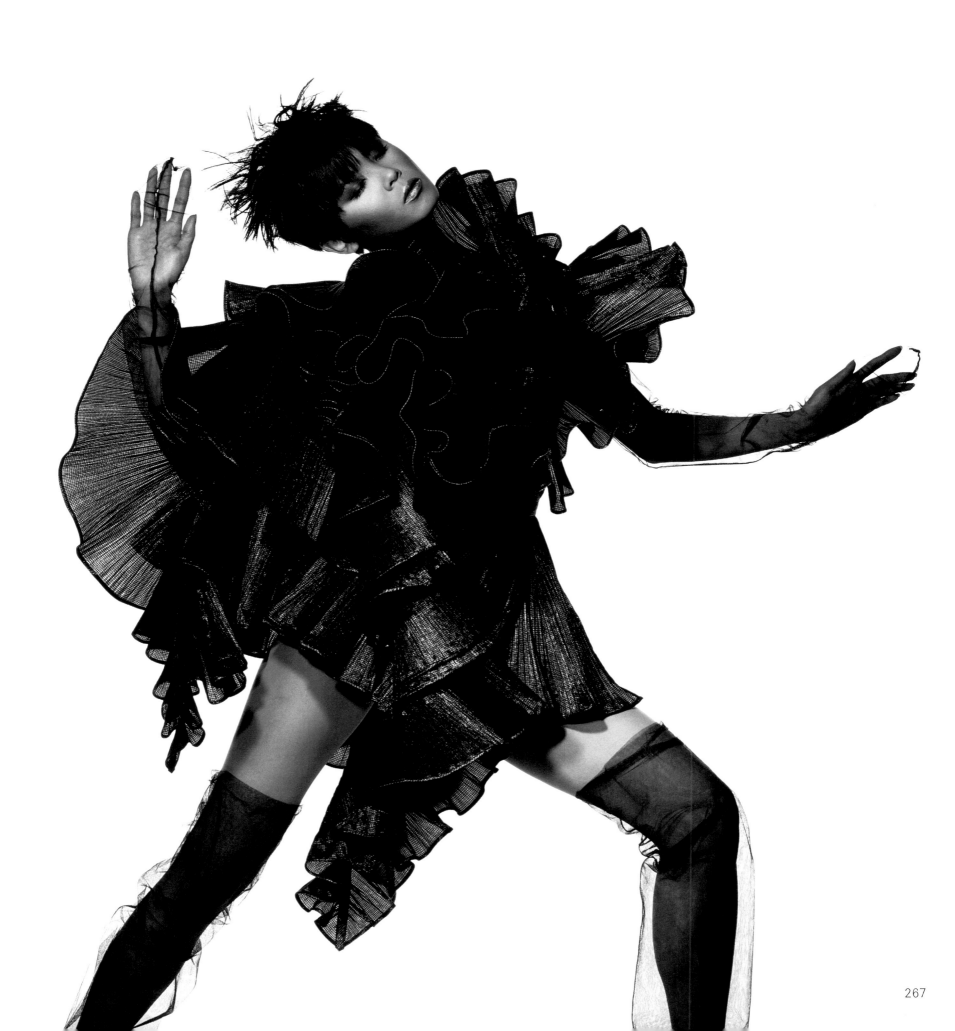

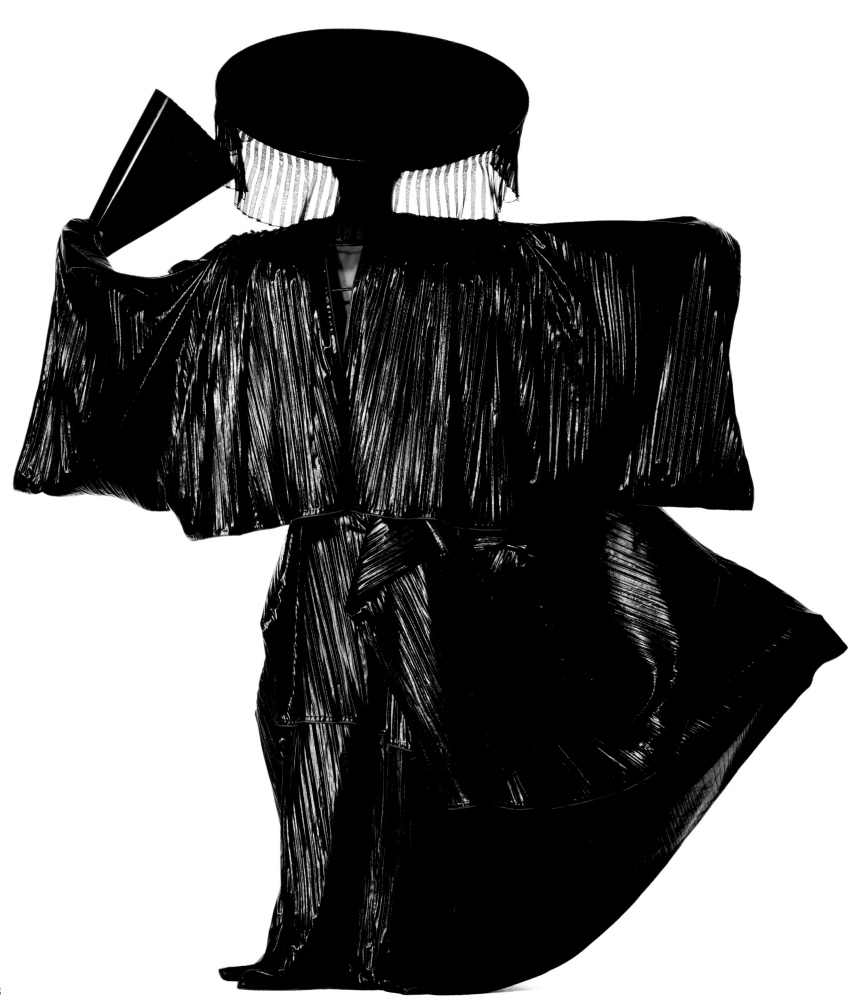

Two Issey Miyake Fashions (Jun Kano), New York, 1987.

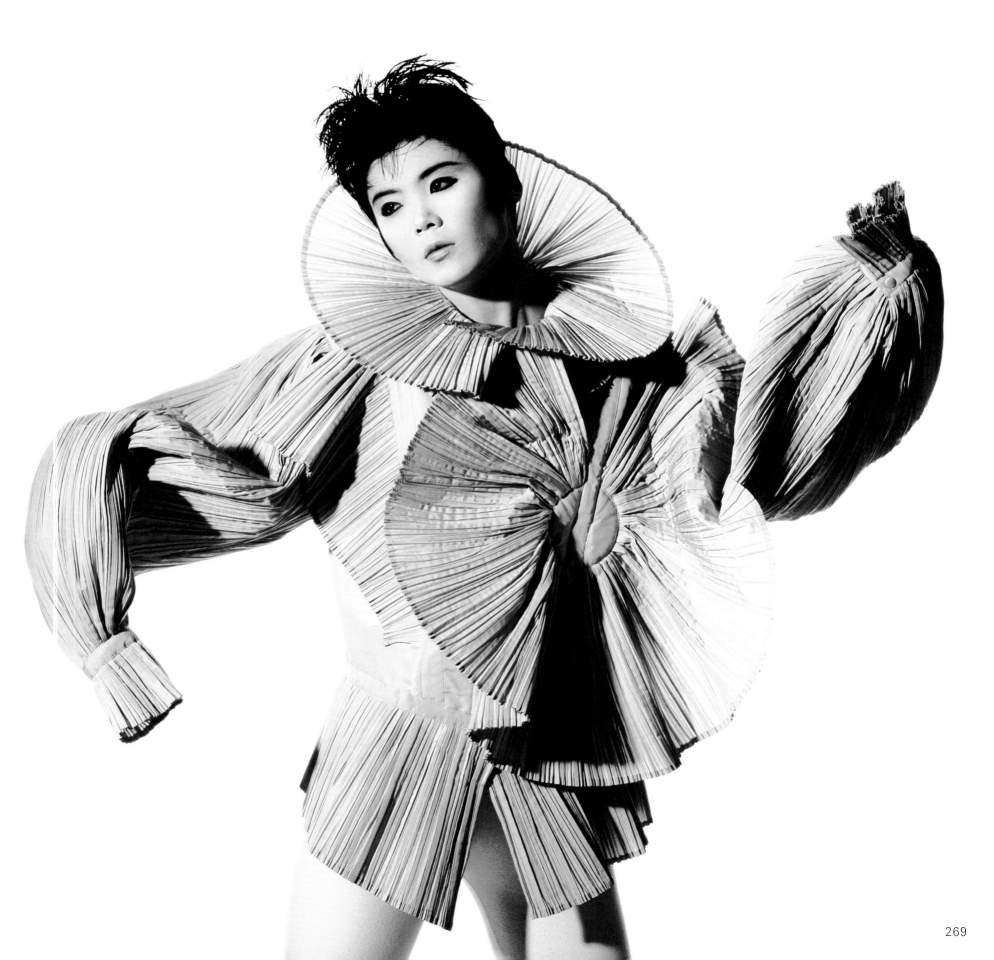

1987
1988

Josef Koudelka, New York, 1988.

Drawing: *Landscape with Mushrooms*, New York, 1988.

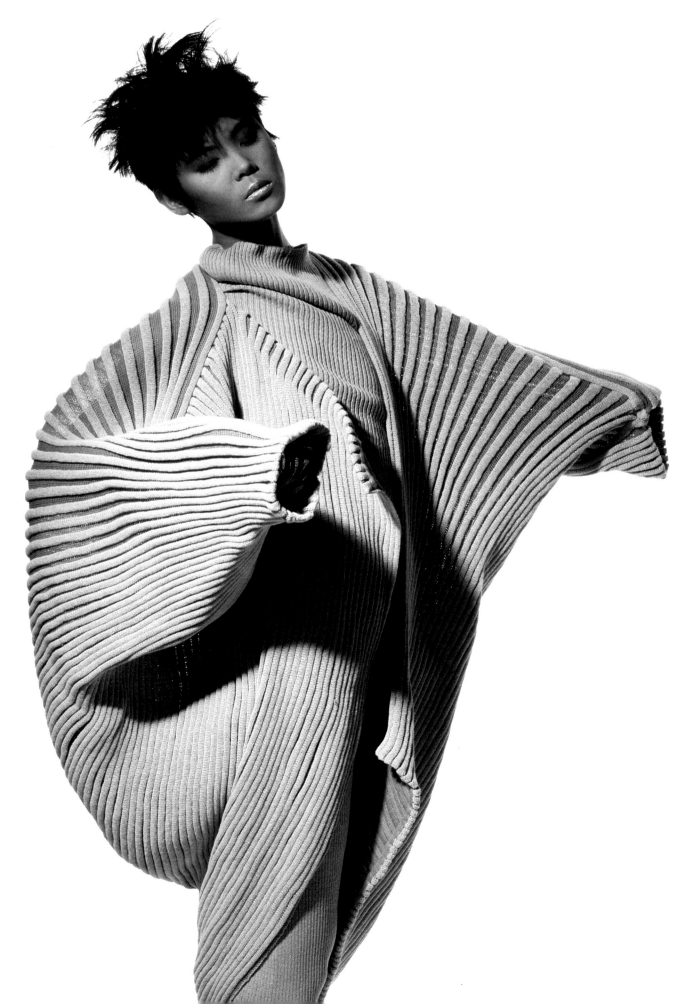

Three Drawings : *Untitled*, New York, 1987–88.

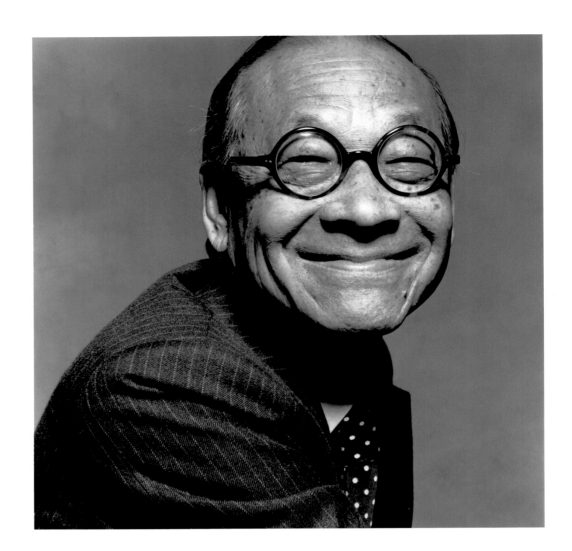

I. M. Pei, New York, 1988.

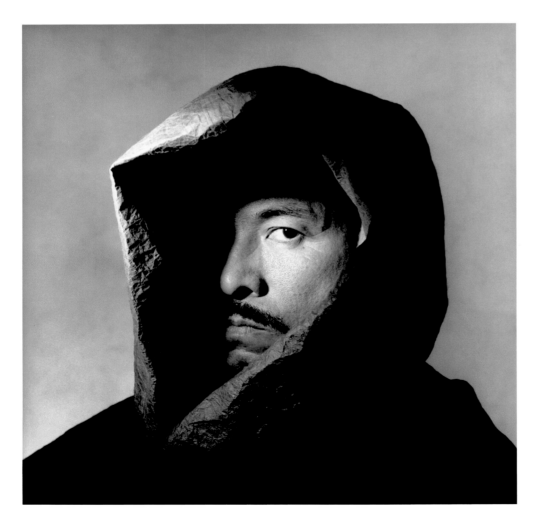

Issey Miyake, New York, 1988.

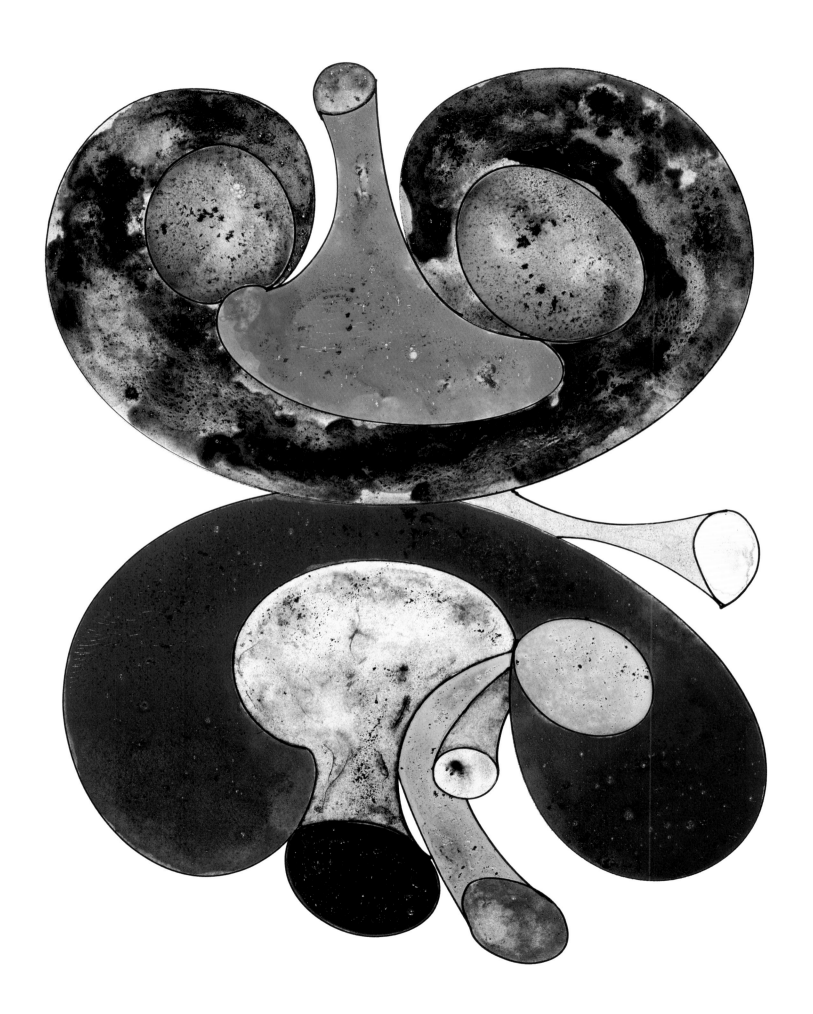

Drawing: *Two Mushrooms*, New York, 1988.

1988

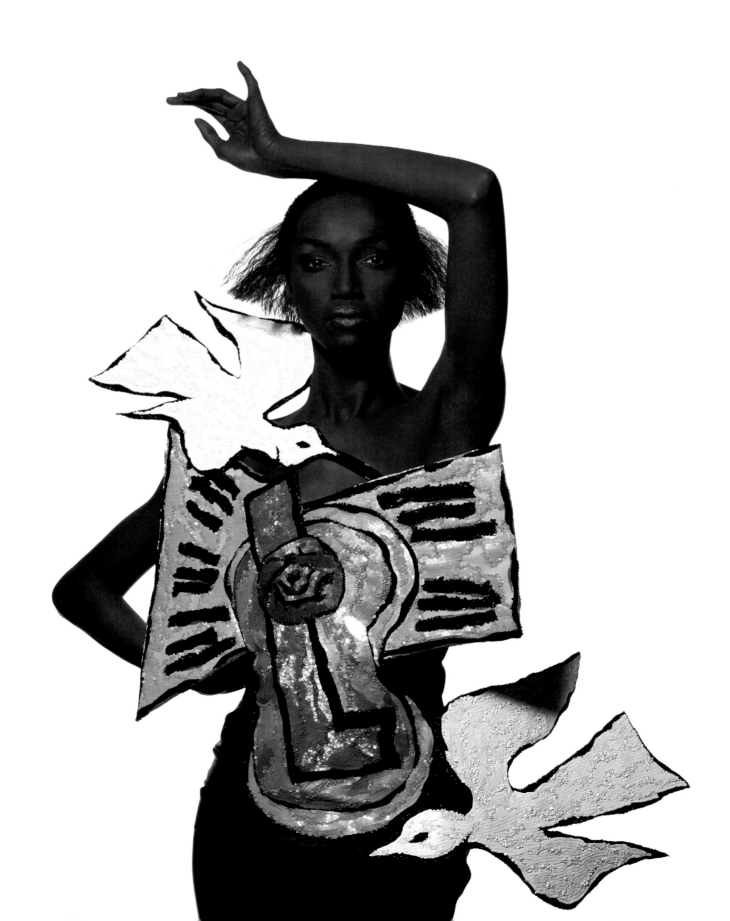

Drawing: *Untitled*, New York, 1988.

Jean-Paul Gaultier Fashion, New York, 1988.

Yves Saint Laurent Fashion (Katoucha), Paris, 1988.

Ungaro Fashion (Katoucha), Paris, 1988.

Vogue *Food Photograph*, New York, 1989.

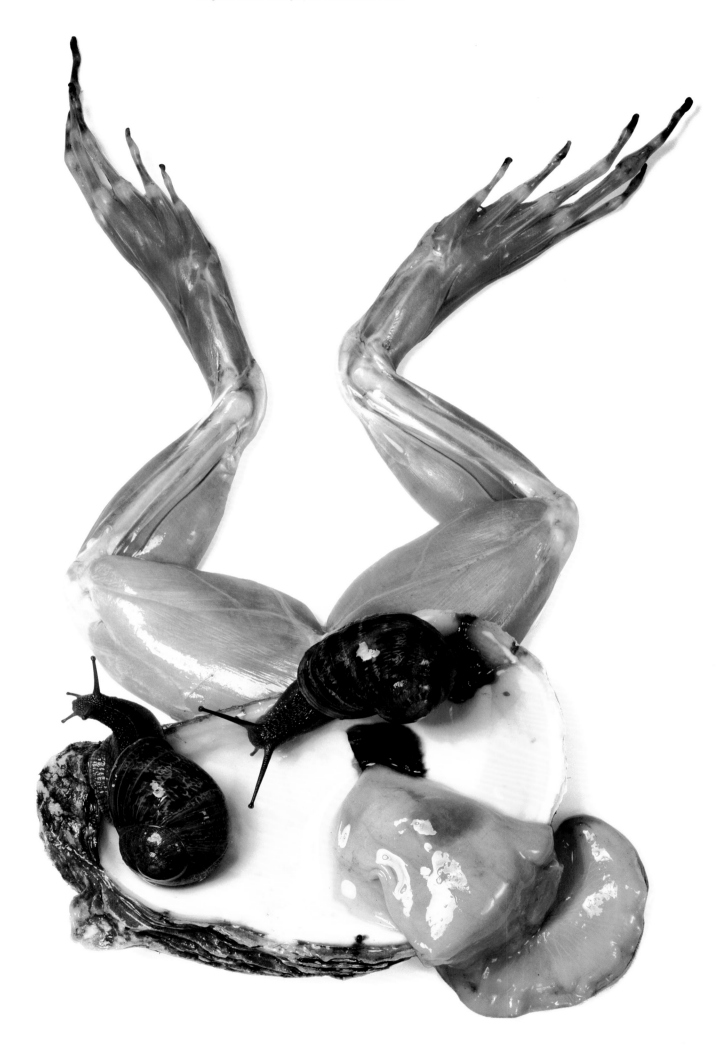

Lorenzo Mongiardino, New York, 1989.

Mikhail Baryshnikov in Kafka's Metamorphosis, New York, 1989.

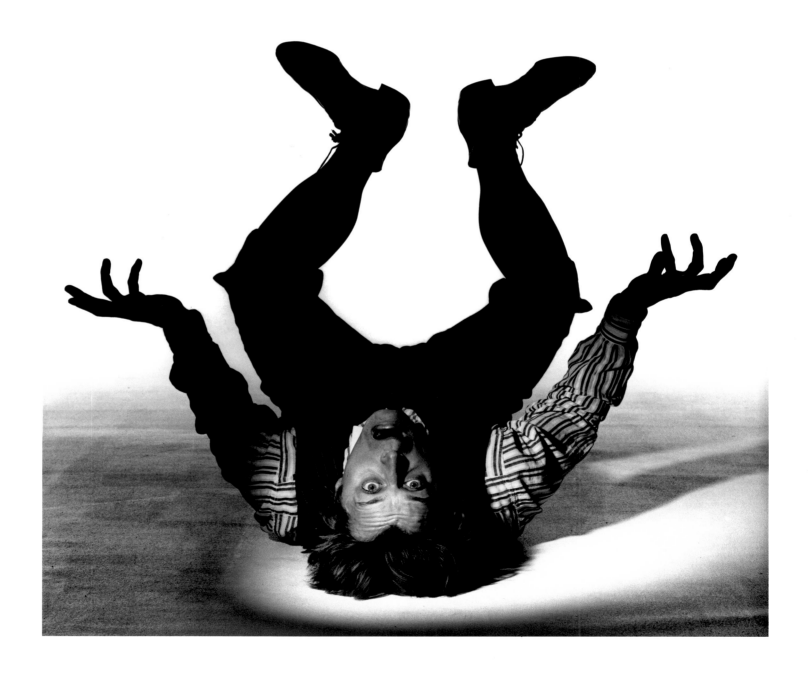

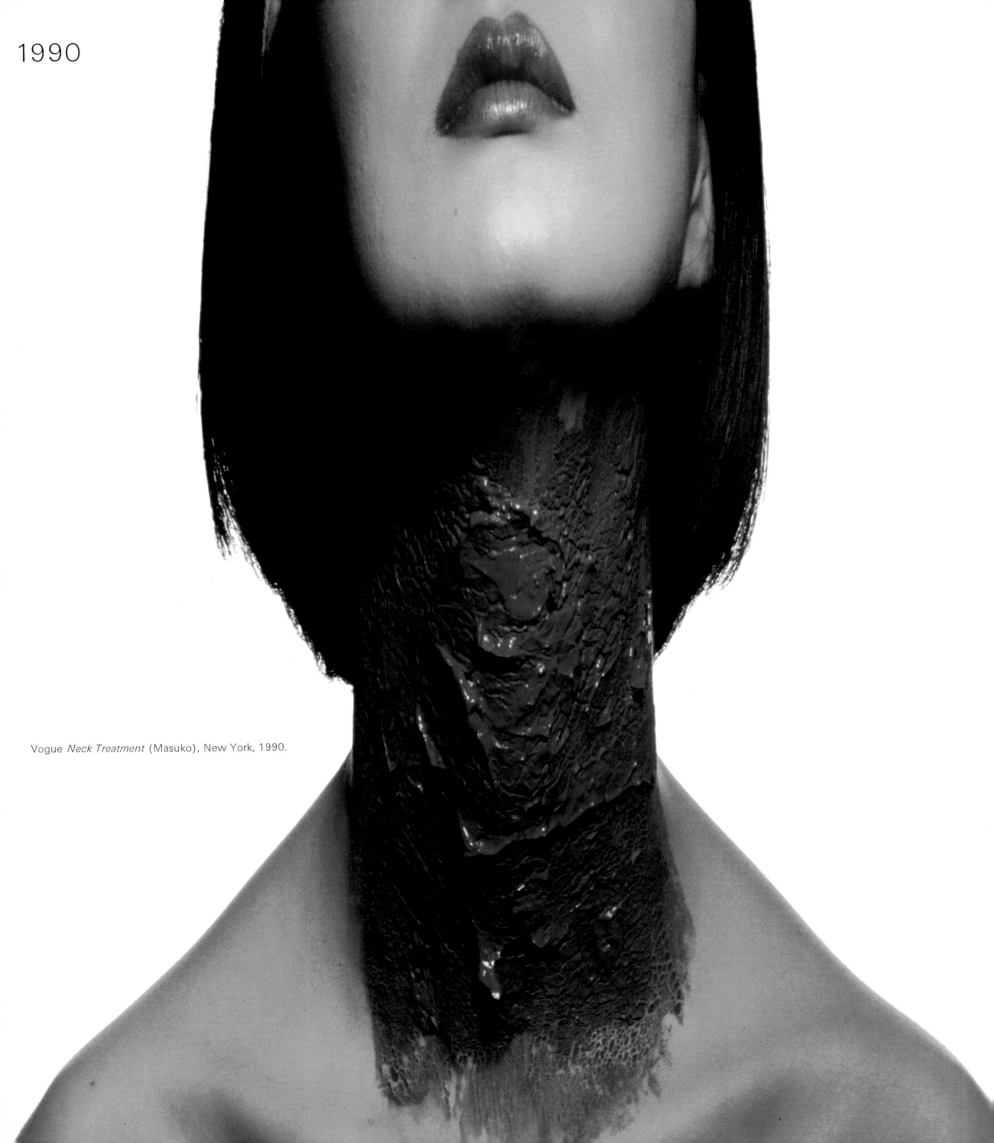

1990

Vogue *Neck Treatment* (Masuko), New York, 1990.

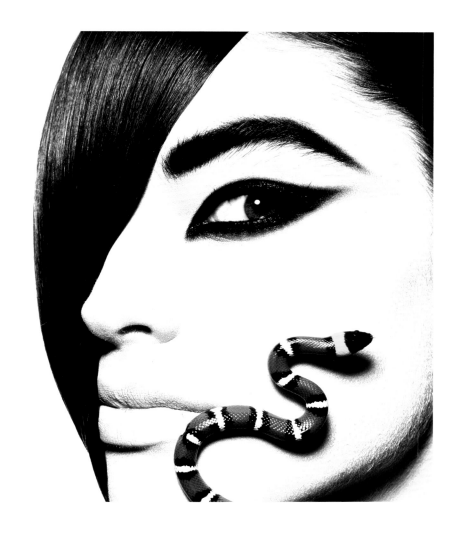

Vogue *Beauty*, *Cleopatra's Eye* (Kim Henderson), New York, 1990.

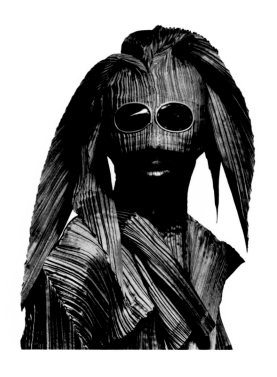

Issey Miyake Fashion (Yuki Fujii), New York, 1990.

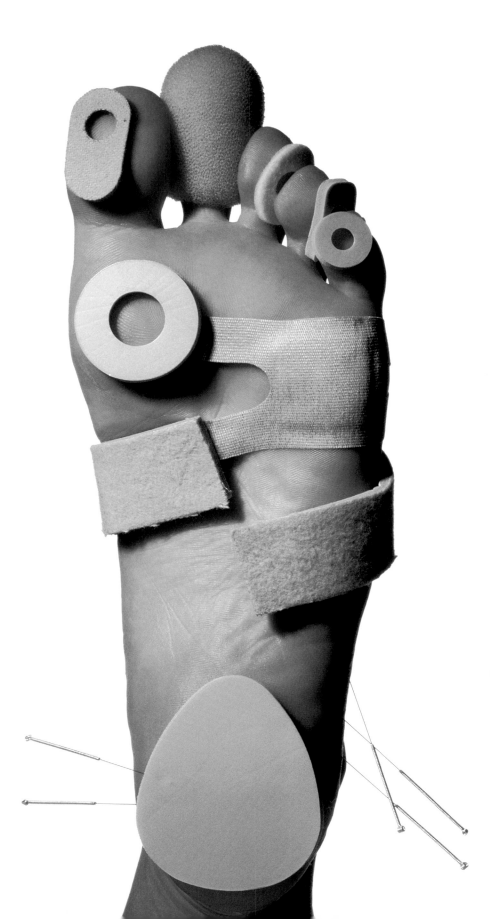

Vogue *Foot Care*, New York, 1990.

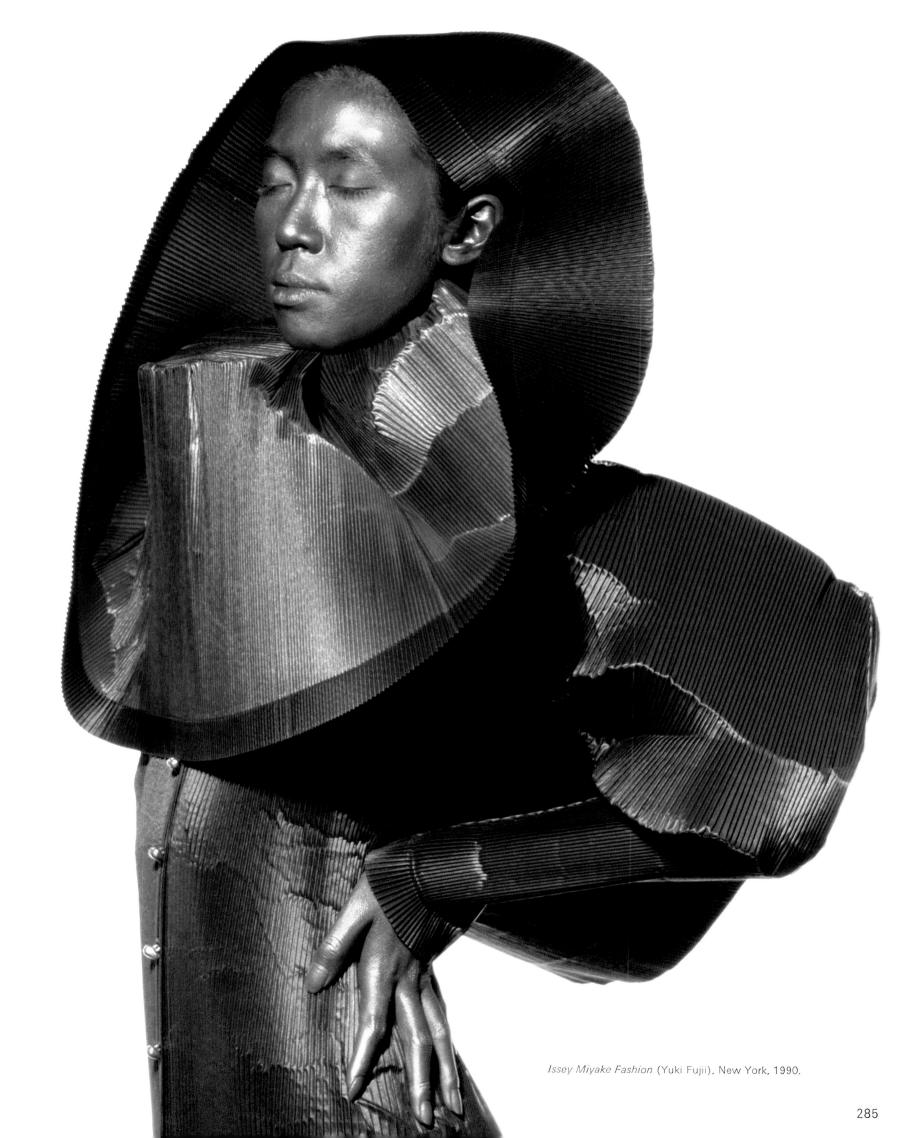

Issey Miyake Fashion (Yuki Fujii), New York, 1990.

285

1991

1991 marks the fiftieth year since Alexander Liberman and I met, and forty-eight years since we began our work together, a rich and fortunate relationship. He has been for me good friend, teacher, and inspirer. Some of the best work for Vogue, *although it may bear my signature, is in fact* ours, *the result of a special and close collaboration. The germ of an idea might come from him, perhaps only a thumbnail sketch. I would make a photograph. He would nurse it through the editorial process to the printed page.*

For complex and expensive projects he managed always to find the means. He knew, wisely, when to shield me from doubts and cold blasts that came from nervous editors. When I failed in an assignment I remember from him only understanding and sympathetic concern.

This book honors that relationship.

A Work Chronology in Detail

Compiled by Alexandra Arrowsmith

*Portraits marked with an asterisk are illustrated chronologically in the plate section.

Irving Penn, born Plainfield, N.J., 1917

1934–1938

Studied at Philadelphia Museum School of Industrial Art. Design classes with Alexey Brodovitch.

1938–1940

Worked as free-lance designer in New York. Made sketches for projected paintings.

1939

Photographs in New York streets, shop signs and façades.

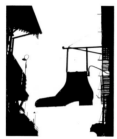

Shoe repair.

1940–1941

Advertising designer for a New York department store.

1941

Traveled to Mexico by train, in short trips across Southern states.

1942

Painted in a studio in Coyoacán, a suburb of Mexico City. At times traveled by streetcar or on foot to the more popular districts of the city, recording with camera shop façades, church interiors, signs, and lettering.

Dissatisfied with the painting results, destroyed the year's work before returning to New York.

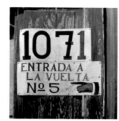

Street sign, Mexico.

1943

Hired by Alexander Liberman, art director of Vogue, *as his assistant, primarily to make suggestions for magazine covers to be photographed by others.*

At Liberman's suggestion, became a photographer. First cover was a still life. Eventually photographed 165 Vogue *covers.*

1944

Began a series of pictures of public figures surrounded by objects that called to mind aspects of their personalities and careers. Members of Vogue's *editorial staff contributed suggestions, making the pictures a group effort. The results were called "Portraits with Symbols."*

In New York, "Portraits with Symbols" for Vogue:

Fredric March
Dorothy Parker
Margaret Sullavan

Yves Tanguy and Kay Sage
James Thurber

First photographs of fashions for Vogue.

1944–45: Photographed war activities in Italy and India. Documented political wall inscriptions in Italy, Yugoslavia, and
**Austria. Photographed Giorgio de Chirico in Italy.*

1945

In New York, "Portraits with Symbols" for Vogue:

Alfred Lunt and Lynn Fontanne
Orson Welles

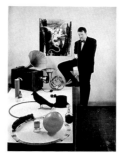

Orson Welles.

1946

In New York, began a series of photographs of dance and dancers for Vogue *and for ballet companies. The series continued through 1948. Subjects in 1946 included:*

Irina Baronova
Leon Danielian
*Alexandra Danilova and Frederic Franklin
Anton Dolin
Rosella Hightower
*Nora Kaye, André Eglevsky, and
 Alicia Alonso
Nathalie Krassovska
Nicholas Magallanes
Marie-Jeanne
*Alicia Markova
Léonide Massine
Maria Tallchief
Igor Youskevitch

Began an extended series of portraits of figures in the arts for Vogue. *This project, conceived by Alexander Liberman, which continued intermittently for three years, was planned as a body of work to be drawn on for future publication. Ruth Chapman was editor.*

Portraits for Vogue:

*The Angel (Maurice Tillet)
Milton Avery
Cecil Beaton
Ingrid Bergman ("Portrait with Symbols")
Eugene Berman
Paul Cadmus
*John Cage
Alexander Calder
Henri Cartier-Bresson and Ratna Mohini
Circus Acrobats
*Aaron Copland
Stuart Davis
Duke Ellington
Arshile Gorky and Wilfredo Lam
Helen Hayes ("Portrait with Symbols")
Danny Kaye ("Portrait with Symbols")
Emmett Kelly
Leonid
Ogden Nash
S. J. Perelman
Walter Piston
Kurt Seligmann
Pavel Tchelitchew
*Virgil Thomson

Group picture of Vogue photographers:

Serge Balkin
Cecil Beaton
Erwin Blumenfeld
Horst P. Horst
Constantin Joffé
Dorian Leigh (model)
George Platt Lynes
Irving Penn (with bulb)
John Rawlings

In New York, photographed "Fables Retold" for Vogue:

*"Cinderella":
Paula Laurence
Barbara Cushing Mortimer
Dorothy Parker
Carmen Dell'Orefice as Cinderella

"Red Riding Hood":
José Ferrer
Carmen Dell'Orefice as Red Riding Hood

*"Snow White and the Seven Dwarfs":
Constantin Alajálov
Ray Bolger
Eddy Duchin
Frank Fay
Hank Greenberg
John Kieran
Jack Kriendler
Carmen Dell'Orefice as Snow White

1947

Photographed a number of editorial still lifes for Vogue. These were pictures without commercial importance, published simply as surprises among the magazine's pages.

In New York, portraits for Vogue:

Judith Anderson
Brooks Atkinson
*W. H. Auden
Bettina Ballard
Samuel Barber
Alfred H. Barr, Jr.
Lucius Beebe
Dr. William Beebe
S. N. Behrman
Ludwig Bemelmans
William Rose Benét
Eugene Berman
Leonard Bernstein
Peter Blume
*Ray Bolger
John Mason Brown
Pearl S. Buck
Corrado Cagli
*Mrs. Amory S. Carhart, Jr.
*Marc Chagall
René Clair
Russel Crouse and Howard Lindsay
Frank Crowninshield and Edward Steichen
Eve Curie
*(Gala and) Salvador Dali
Adolph Dehn
John Dewey
*Christian Dior
Todd Duncan
Angna Enters
Carl Erickson (Eric)
*Max Ernst and Dorothea Tanning

Maurice Evans
James T. Farrell
Lyonel Feininger
Lion Feuchtwanger
Betty Field and Elmer Rice
Geraldine Fitzgerald
Esteban Francés
Peter and Dagmar Freuchen
Paul Gallico
Greer Garson
John Gielgud
Dizzy Gillespie
Dorothy Gish and John Patrick
John Gunther
Oscar Hammerstein II and
 Richard Rodgers
Judge Learned Hand
Roy Harris
Moss Hart
Stanley W. Hayter
Lillian Hellman
Wendy Hiller
*Alfred Hitchcock
Vladimir Horowitz
Langston Hughes
William Kapell
Ulysses Kay
Elia Kazan
Frederick Kiesler
Serge Koussevitzky
Frank Kovacs
Wanda Landowska
Charles Laughton
Jacob and Gwendolyn Lawrence
*Le Corbusier
Eva Le Gallienne
Carlo Levi
Jack Levine
Walter Lippmann
Archibald MacLeish
Fredric March and Florence Eldridge
*John Marin
Reginald Marsh
Mary Martin
Groucho Marx
Bill Mauldin
Lauritz Melchior
Darius Milhaud
Joan Miró
Ferenc Molnár
Carlos Montoya
Marianne Craig Moore
*George Jean Nathan and H. L. Mencken
Richard Neutra
Oscar Niemeyer
*Isamu Noguchi
Kenneth Patchen
Louis Paul
Abraham Rattner
Bill Robinson (Bojangles)
Carl Sandburg
Jimmy Savo
Rudolf Serkin
Eric Sevareid
Ben Shahn
Vincent Sheean
Robert E. Sherwood
*Oliver Smith, Jane Bowles, and
 Paul Bowles
*Stephen Spender
Jean Stafford
Harold Stassen
Vilhjalmur Stefansson
Edward Steichen
*Saul Steinberg (and Hedda Sterne)
James Stewart
Rex Stout
Frank Sullivan

Josef Szigeti
Rufino Tamayo
Allen Tate
Maggie Teyte
Dorothy Thompson
Gene Tierney
Gene Tunney
Louis Untermeyer
*Peter Ustinov
John Van Druten
Franklin Watkins
Max Weber
*Kurt Weill
E. B. White
Thornton Wilder
*Edmund Wilson
P. G. Wodehouse
Philip Wylie

Group picture of New Yorker artists:

Charles Addams
Constantin Alajálov
Perry Barlow
Whitney Darrow, Jr.
Chon Day
Robert J. Day
Richard Decker
Leonard Dove
Helen Hokinson
George Price
Mischa Richter
Carl Rose
Barbara Shermund
Otto Soglow
William Steig
Saul Steinberg
Richard Taylor
Barney Tobey

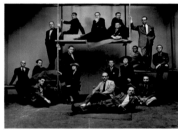

New Yorker artists.

Group picture of New York theatrical producers of the 1946–47 season:

Richard Aldrich
Kermit Bloomgarden
Cheryl Crawford
Jean Dalrymple
Alfred de Liagre, Jr.
Paul Feigay
Max Gordon
Oscar Hammerstein II
Leland Hayward
Theresa Helburn
Lawrence Langner
Herman Levin
Yolanda Mero-Irion
Brock Pemberton
Richard Rodgers
Lee Sabinson
Irene M. Selznick
Oscar Serlin
Oliver Smith
Robert Whitehead
John C. Wilson

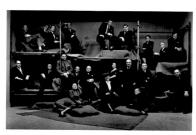

New York theatrical producers.

*Group picture of twelve of the most pho-
tographed fashion models of the period:*

Marilyn Ambrose
Helen Bennett
Lily Carlson
Lisa Fonssagrives
Elizabeth Gibbons
Kay Hernan
Dana Jenney
Andrea Johnson
Dorian Leigh
Muriel Maxwell
Betty McLauchlen
Meg Mundy

*In New York, photographs of three Vogue
fashion artists and their models:*

René Bouché and Elise Daniels
René Bouët-Willaumez and
 Barbara Tullgren
*Carl Erickson and Elise Daniels

*In New York, photographs of dancers for
Vogue continue:*

*George Balanchine and Maria Tallchief
Valerie Bettis
*Alexandra Danilova
Tanaquil Le Clercq
José Limón
Vera Zorina

Ballet Theatre group:

Alicia Alonso
Muriel Bentley
Lucia Chase
Max Goberman
Nora Kaye
John Kriza
Hugh Laing
Dimitri Romanoff
Oliver Smith
Antony Tudor
Igor Youskevitch

Ballet Society grouping:

George Balanchine
Leon Barzin
Todd Bolender
William Dollar
Esteban Francés
Joan Junyer
Rudi Revil
Kurt Seligmann
John Taras

Around-the-world flight for Vogue. *Made
photographic notes in London, Istanbul,
Karachi, Calcutta, and China.*

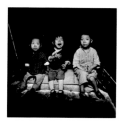

Children in China.

1948

In New York, portraits for Vogue:

Charles and Barbara Addams
Gilbert Adrian
Mrs. Lewis Amory and son
Marian Anderson
*Louis Armstrong
Claudio Arrau
Alexander Brailowsky
John J. Broderick
Louis Calhern
*Truman Capote
Hattie Carnegie
The Casadesus Family
Antonio Castillo
Maurice Chevalier
Bobby Clark
Padraic Colum
Noël Coward
Julio de Diego
*Marlene Dietrich
John Dos Passos
Paul Draper and Larry Adler
*Marcel Duchamp
*The Dusek Brothers
Duke Ellington
Mischa Elman
Mrs. André Embiricos
Georges Enesco
Jacques Fath
José Ferrer
Janet Flanner
Corey Ford
Lukas Foss
Wolcott Gibbs
Lillian and Dorothy Gish
Walter Gropius
*George Grosz
Jascha Heifetz
John Hersey
Charles James
Jennifer Jones
Dr. Alfred Kinsey
*Arthur Koestler
Fritz Kreisler
Maxwell Kriendler and John Perona
Gypsy Rose Lee
Beatrice Lillie
Howard Lindsay and Dorothy Stickney
*Joe Louis
Loren MacIver
Mainbocher
Gian Carlo Menotti
Yehudi Menuhin

Nathan Milstein
Edward Molyneux
Erica Morini
*John O'Hara
Georgia O'Keeffe
S. J. Perelman
Edith Piaf
Gregor Piatigorsky
Ezio Pinza
Francine du Plessix with Mr. and Mrs.
 Alexander Liberman
William Primrose
*Arthur Rubinstein
*Elsa Schiaparelli
Arthur Schlesinger, Jr.
Artur Schnabel
Irwin Shaw
*Charles Sheeler
*Mrs. William Rhinelander Stewart
*Igor Stravinsky
Rufino Tamayo
*Spencer Tracy
Helen Traubel
Mme. Valentina
Glenway Wescott
*E. B. White
*Duchess of Windsor
William Wyler

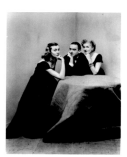

Francine du Plessix with Mr. and Mrs. Alexander Liberman.

Group picture of six songwriters:

Bob Hilliard
Burton Lane
Richard Lewine
Frederick Loewe
Hugh Martin
Carl Sigman

*In New York, photographs of dancers for
Vogue continue:*

Merce Cunningham
Agnes de Mille
Martha Graham
*Jerome Robbins

Ballet Society group picture: The Triumph
of Bacchus and Ariadne:

George Balanchine
Corrado Cagli
Tanaquil Le Clercq
Vittorio Rieti

In Milan, photographs of postwar Italian architects and designers for Vogue, including:

Franco Albini
Lodovico B. Belgiojoso
Fabrizio Clerici
Piero Fornasetti
Ignazio Gardella
Enrico Peressutti

Group picture of Italian architects in Milan:

Anna Castelli Ferrieri
Eugenio Gentili
Gabriele Mucchi
Giovanni Romano
Mario Tevarotto
Marco Zanuso

In Naples, photographs of people in the street and popular entertainers.

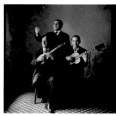
Street orchestra, Naples.

Elsewhere in Italy, portraits of figures in the arts. Edmonde Charles-Roux was editor for these and a number of other projects in Europe:

Massimo Campigli
Renato Castellani
Eduardo de Filippo and
 Mme. Titina Carloni
Renato Guttuso
Giacomo Manzù
Marino and Marina Marini
Gio Ponti
Vasco Pratolini
*Roberto Rossellini and Anna Magnani
*Luchino Visconti
*Elio Vittorini and Eugenio Montale

Group picture of artists and writers in Milan:

Renato Birolli
Beniamino Joppolo
Giuseppe Migneco
Ennio Morlotti
Vittorio Sereni

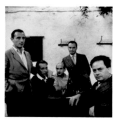
Artists and writers, Milan.

Group picture of Italian intellectuals in Rome's Caffè Greco:

Afro
Vitaliano Brancati
Pericle Fazzini
Ennio Flaiano
Carlo Levi
Libero de Libero
Mario Mafai
Mirko
Lea Padovani
Aldo Palazzeschi
Sandro Penna
Goffredo Petrassi
Orfeo Tamburi
Renzo Vespignani
Orson Welles

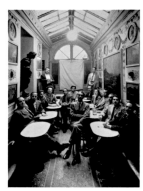
In Rome's Caffè Greco.

First trip to Paris for Vogue. Edmonde Charles-Roux was editor.

In France, portraits for Vogue:

Pierre Balmain
*Balthus
Jean-Louis Barrault
Christian Bérard
*Jean Cocteau
*Père Couturier
*André Derain
Roger Lacourière
*Dora Maar
Madeleine Renaud
Marcel Rochas
Jean and François Rostand

In Spain, photographic essay for Vogue: "Barcelona and Picasso." Inspired by A. Cirici Pellicer's Picasso antes de Picasso. Sebastià Junyer and Salvador Dalí advised.

*Visited the farm of Joan Miró in Tarragona, Spain. Made portraits of *Miró and his daughter, Dolores.*

Fashion assignment in Lima, Peru. A trip to Cuzco followed, resulting in the essay "Christmas at Cuzco."

1949

In New York, portraits for Vogue:

*Juliet Auchincloss
*Norman Parkinson
Ernesto N. Rogers

1949–50: A major project photographing the female nude. Experimentation in printmaking. The cultural climate of the time made it difficult to show these prints soon after they were made. They were first shown at Marlborough Gallery, New York, in 1980, as "Earthly Bodies."

Sent by Alexander Liberman to Paris for Vogue to see and study the couture collections, but not yet to photograph.

1950

In New York, portraits for Vogue:

Dr. René J. Dubos
Corey Ford
Cary and Betsy Drake Grant
Graham Greene
Aldous Huxley
Renée Jeanmaire
Sidney Kingsley
*Carson McCullers
*Mrs. Walter Denègre Sohier
Gloria Swanson
Dr. Selman A. Waksman

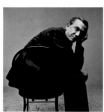
Graham Greene.

Program of work for Vogue in Europe. In Paris photographed the couture collections (the first of twenty-seven collections).
Made a comprehensive series of pictures of the "Small Trades," or "Petits Métiers," first in Paris, then in London and, the following year, in New York.

In Paris, portraits for Vogue:

Blaise and Raymone Cendrars
*Alberto Giacometti
Rhum, the Clown

In London, portraits in a daylight studio in Chelsea for Vogue. Siriol Hugh-Jones was editor:

*Cecil Beaton
Clive Brook
Peter Brook
Pamela Brown
*Richard Burton
Cecil Day Lewis
*T. S. Eliot
*Sir Jacob Epstein
Christopher Fry
Robert Hamer
Sir Alan P. Herbert
Eileen Herlie
*Henry Moore
Robert Morley
Eric Portman
J. B. Priestley
Claude Rains

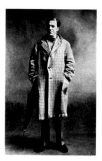

Cecil Day Lewis.

Sir Ralph Richardson
Margaret Rutherford
Victor de Sabata
Paul Scofield
*Sir Stanley Spencer
Graham Sutherland
Barbara Ward
Evelyn Waugh

Portraits of London children for Vogue.

In New York, a cover for the first time in black-and-white for Vogue.

April 1, 1950.

Unexplained appearance in Paris in 1986.

1951

In New York, portraits for Vogue:

Goodman Ace
Fred Allen
Jack Benny
Abe Burrows
Sid Caesar
Eddie Cantor
Joyce Cary
Bobby Clark
Mr. and Mrs. Angier Biddle Duke
Dr. Oliver St. John Gogarty
Martyn Green
Mr. and Mrs. John Gunther
*Louis Jouvet
Lee Konitz
Bert Lahr
Sam Levenson
William Marshall
Edward R. Murrow
Maureen Stapleton

*Rufino Tamayo
Lennie Tristano
*Tennessee Williams
Ed Wynn

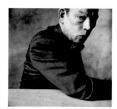

Fred Allen.

Continuation in New York of the "Small Trades" pictures begun in Paris and continued in London. The American series was published in Vogue *as "A Gallery of the Unarmed Forces."*

Built a point source enlarger based on the zirconium arc lamp. With eventual use of this enlarger in mind, photographed in France, Spain, and Morocco. The results were published as the essays "Sunday on the Seine" and "Morocco."

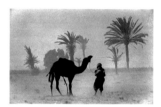

Sandstorm, Morocco.

In Morocco, portraits for Vogue:

General Augustin Guillaume
Hadji Thami el Mezouari el Glaoui
*Sultan Mohammed V, Ben Yussef

In France, portraits for Vogue:

Paul Claudel
Jean Gabin
Audrey Hepburn
Arthur Honegger
Serge Lifar
André Minaux
André Roussin
*Maurice de Vlaminck

Photographed Colette on her bed, at the window of her apartment in the Palais Royal.

Photographed more than eighty government, military, and society figures in a studio arranged by Vogue *at the Corcoran Gallery in Washington, D.C. Mary Van Rensselaer Thayer was editor:*

Stewart Alsop
Mrs. Hugh D. Auchincloss,
 Miss Janet Auchincloss, and
 Miss Jacqueline Bouvier
Mrs. Robert Low Bacon
U. E. Baughman
Leslie Biffle
Percy Blair
Frances P. Bolton

Ambassador and Mme. Henri Bonnet
Mrs. Morris Cafritz
Rachel L. Carson
General Clifton Cates
Oscar L. Chapman
Marquis Childs
Cyrus S. Ching
Georgia Neese Clark
General J. Lawton Collins
Senator Tom Connally
Mrs. Joseph E. Davies
Mrs. Dwight F. Davis and
 Mrs. Arthur A. Fowler
Michael V. DiSalle
Senator Paul H. Douglas
William O. Douglas
Senator James H. Duff
Ambassador Feridun C. Erkin
Dr. Luther H. Evans
Thomas K. Finletter
Doris Fleeson
William Chapman Foster
Senator J. William Fulbright
Mr. and Mrs. Philip L. Graham
Clark Griffith
*Dr. and Mrs. Gilbert H. Grosvenor
Colonel Mary A. Hallaren
Captain Joy B. Hancock
William Averell Harriman
Mary Haworth
Frieda Bright Hennock
Herblock (Herbert Block)
Mrs. Hiram Houghton
*Senator Hubert H. Humphrey
Eric A. Johnston
Ambassador Henrik de Kauffmann
Senator Estes Kefauver
Arthur Krock
Mr. and Mrs. Kenneth P. Landon
Dr. Alberto Lleras
Senator Henry Cabot Lodge, Jr.
Dr. William M. Mann
Joseph W. Martin, Jr.
Francis P. Matthews
Colonel Geraldine P. May
J. Howard McGrath
Senator Brien McMahon
Stanislaw Mikolajczyk
"Fishbait" Miller
Senator Blair Moody
Ambassador Munthe de Morgenstierne
Senator A. S. M. Moroney
Ambassador Mauricio Nabuco
Ferenc Nagy
Frank Pace, Jr.
Ambassador Vijaya Lakshmi Pandit
Drew Pearson
Philip B. Perlman
Duncan Phillips
Mrs. Anna M. Rosenberg
Mrs. Nellie Tayloe Ross
Dean Francis B. Sayre
Eric Sevareid
Mrs. Carolyn Hagner Shaw
Admiral Forrest P. Sherman
Senator Margaret Chase Smith
General Carl Spaatz
Lawrence E. Spivak and Martha Rountree
John R. Steelman
Senator Robert A. Taft
Colonel Katherine A. Towle
Professor Harold Clayton Urey
General Hoyt S. Vandenberg
Constantine Visoianu
André Visson
James E. Webb
Ambassador Hume Wrong

National Gallery of Art group picture:

Huntington Cairns
David E. Finley
Macgill James
Colonel Harry A. McBride
John Walker

1952

In New York, portraits for Vogue. *Allene Talmey was editor for these and most later portraits for* Vogue *in New York:*

Dave Brubeck
Wally Cox
Betty Furness
Stan Getz
Julie Harris
John LaPorta
Richard Lippold
Silvana Mangano
Vittorio Manunta
*Jimmy Savo
Phil Silvers
Smith and Dale
Saul Steinberg
Herman Wouk
*Lester Young and Charlie Parker

Began making advertising photographs for American and international clients. This work continues to the present.

1953

In New York, portraits for Vogue :

Peter Brook and Natasha Parry
Malcolm Muggeridge
Sophie Tucker

1954

In New York, portraits for Vogue :

Barbara Bel Geddes
Ava Gardner
Mrs. Winston Guest
*Grace Kelly
Gina Lollobrigida
*André Malraux
Willie Mays
Obernkirchen Choir Children
Mrs. William Paley
Arthur Penn
Roberta Peters
Seven Vintners from Bordeaux
Fred Zinnemann

1955

In New York, portraits for Vogue :

Rossano Brazzi
Gordon Bunshaft
Paddy Chayefsky
Duke Ellington and Louis Armstrong
Patricia Jessel
Herbert von Karajan

Viveca Lindfors
Igor Markevitch
*Ludwig Mies van der Rohe
 (and Philip Johnson)
Charlie Mingus
Eero Saarinen
Thornton Wilder
Shelley Winters

L. Fritz Gruber

1956

In New York, portraits for Vogue :

Maria Callas and Battista Meneghini
Jacques Yves Cousteau
Judy Holliday
Bert Lahr
Mary Martin and Richard Halliday
Siobhan McKenna
Ethel Merman
Vicomtesse de Ribes
Elisabeth Schwarzkopf
Dr. Hans Selye

*Alexander Liberman

1957

In New York, portraits for Vogue :

Mrs. Cleve Gray
Kay Kendall
New York Theatrical Producers
Ronald Searle
Pierre Soulages
Peter Ustinov

In France, portraits for Vogue :

Marcel Achard
Jean Anouilh
Marcel Aymé
*Simone de Beauvoir
Pierre Boulez
Maurice Druon
*Jean Giono (and Lucien Jacques)
Hubert de Givenchy
Joseph Kessel
François Mauriac
*Pablo Picasso
Man Ray
Germaine Richier
Françoise Sagan
*Yves Saint Laurent
Cécile Sorel

1958

In New York, portraits for Vogue :

Anne Bancroft, Anne Meacham, and
 Joan Plowright
Charles Eames
Jane Fonda
Roberto Iglesias
*Henry Kissinger
Marqués and Marquesa de Villaverde

In England, portraits for Vogue. *Penelope Gilliatt was editor:*

Kenneth Armitage
Hugh Beaumont
Reg Butler
Lynn Chadwick
Sir Kenneth Clark
*Ivy Compton-Burnett
Cyril Connolly
Julian Huxley
*Augustus John
David Low
*John Osborne
Philip and Arnold Toynbee
Kenneth Tynan
Arthur Waley
Rebecca West

1959

In New York, portraits for Vogue :

Friedrich Dürrenmatt
Henry and Jane Fonda
Cary Grant
Frederick Kiesler
*Sophia Loren
Shirley MacLaine
Yves Montand
Maya Plisetskaya
Cornelius Ryan
Simone Signoret
Edward Steichen

Group picture of eight American artists:

William Baziotes
James Brooks
Sam Francis
Philip Guston
Franz Kline
Barnett Newman
Theodoros Stamos
Jack Tworkov

1959–61: Series of beauty portraits for Vogue :

*Signora Giovanni Agnelli
Viscountess Astor
Princess Pierfrancesco Borghese
Gina Lollobrigida
Marchesa Alessandro di Montezemolo
Donna Maria di Niscemi
Mrs. Howard Oxenberg
Mrs. Giancarlo Uzielli

1960

Published Moments Preserved, *eight essays in photographs and words. Alexander Liberman wrote the introduction. Rosemary Blackmon collaborated on the text.*

Portraits for Vogue:

Cantinflas (Mario Moreno)
*John F. Kennedy
Gunnel Lindblom
Melina Mercouri
Piccolo Teatro di Milano
T. H. White

*Frederick Kiesler and Willem de Kooning
Alexander Liberman
Isaac Stern

Portraits for CBS Records:

Leonard Bernstein
Eugene Ormandy
George Szell
Bruno Walter

1961

In New York, portraits for Vogue:

Warren Beatty
Dick Gregory
The Hannon Sisters
Harold Pinter and Donald Pleasence
Leontyne Price
Lee Remick
Michael Rennie
Joan Sutherland
*Antonio Tàpies

In Paris, portraits for Vogue:

Hans Hartung
Eugène Ionesco
Elise and Marcel Jouhandeau
*Rudolf Nureyev

Mike Nichols and Elaine May for *America*

Began a series of yearly photographic essays for Look *magazine. Patricia Coffin was editor for six of these essays:*

1961 Provence
1962 Provincial Foods of France
1963 Portugal
1964 Sweden
1965 Paris
1966 London
1967 San Francisco

Douglas Cooper (in Provence)

1962

In New York, portraits for Vogue:

Edward Albee
Franco Corelli
Joseph Heller
Sol Hurok
Lorin Maazel
Marcello Mastroianni
Claude Mauriac and Emmanuelle Riva
*S. J. Perelman
Tony Richardson and Rita Tushingham

*Francis Bacon (in London)
Christopher Fry (in London)

Series of photographic people-essays for the short-lived Show *magazine:*

Robert Graves in Majorca
*(Sophia Loren with) Alberto Moravia, (Carlo Ponti, and Vittorio de Sica)
*W. Somerset Maugham in France
*Henry Moore in England

Some pictures of Moore's cabinets were published in Domus *(Milan) in December 1963.*

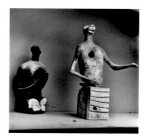

In a Henry Moore cabinet.

In England, portraits for Show *magazine:*

Shelagh Delaney
*Laurence Olivier
Harold Pinter
Peter Shaffer
William Turnbull
Arnold Wesker

Photographic essay on the provincial foods of France for Look *magazine.*

In New York, other portraits:

Mary Fullerton Faulconer
Yousuf Karsh
Robert Osborne

1963

Portraits for Vogue:

Anouk Aimée
Charlotte Ford
Max Frisch
Arthur Miller, Robert Whitehead, and Elia Kazan
Amanda Mortimer
Mrs. Alfred Gwynne Vanderbilt

In Austria, photographic essay for Show *magazine, including portraits of:*

Oskar Kokoschka
Fritz Wotruba

In Portugal, photographic essay for Look *magazine, including portraits of:*

Marquesa de Fayal with her son and father
Duque and Duquesa de Palmela
Amalia Rodrigues
King Umberto II of Italy

Began a series of photographic travel essays for Vogue:

1963 Scotland
1964 Crete
1964 Japan
1965 Gypsies of Estremadura

*The Ogilvy family (in Scotland)

The Museum of Modern Art, New York, circulated a small exhibition of work in the United States, but not in New York.

1964

Began printing in platinum metals. This work continues to the present.

In New York, portraits for Vogue:

*Josef Albers and Jasper Johns
Louis Armstrong
Josephine Baker
Benedetta Barzini
Saul Bellow
Helen Fedorenko
Audrey Hepburn
*Alan Hovhaness and Edgard Varèse
Robert Lowell and Edward Albee
*Yo-Yo Ma
Zero Mostel
George Segal
Barbra Streisand

Madame Grès (in Paris)
*David Smith (at Lake George)

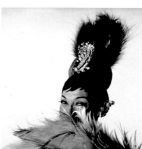

Josephine Baker.

In Sweden, photographic essay for Look *magazine, including portraits of:*

Harriet Andersson
*Ingmar Bergman
Albert Bonnier
Crown Prince Gustaf
King Gustaf VI, Adolf
Victor Hasselblad
Pär Lagerkvist
Birgit Nilsson
Hugo Theorell
Bo Widerberg

In Crete and Japan, photographic essays for Vogue.

1965

In New York, portraits for Vogue:

Mrs. S. Carter Burden
Michael Cacoyannis
*Truman Capote
Geraldine Chaplin
Julie Christie
Federico Fellini and Giulietta Masina
Ira Fürstenberg
Hans Hofmann
Jacques Lipchitz
*Rudolf Nureyev
Oskar Werner

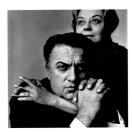

Federico Fellini and Giulietta Masina.

One hundredth Vogue *cover, January 1, 1965.*

In Spain, photographic essay on the Gypsies of Estremadura for Vogue.

Photographic essay on Paris for Look *magazine.*

1966

In New York, portraits for Vogue:

Clement Greenberg
Marshall McLuhan
James A. Michener
*Barnett Newman
Lee Radziwill
Ad Reinhardt
Leonard Rose
*Isaac Bashevis Singer
*Susan Sontag and David Sontag Rieff
Terry Southern
*Saul Steinberg
David Warner
Peter Weiss and
 Gunilla Palmstierna-Weiss
*Tom Wolfe

*The hands of Paul Bocuse (in Lyons)

In Northern Italy for Vogue, *photographs of Vladimir Nabokov chasing butterflies.*

Photographic essay on London for Look *magazine.*

Nelson Rockefeller

1967

In New York, portraits for Vogue:

Grace Bumbry
Arthur Penn and Warren Beatty

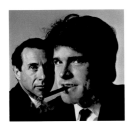

Arthur Penn and Warren Beatty.

Built a traveling photographic studio for a series of ethnographic essays for Vogue. *Mary Roblee Henry was editor for these essays:*

1967 Dahomey
1967 Nepal
1969 Cameroon
1970 New Guinea
1971 Morocco

Traveling studio, Nepal.

Much of this material was included in a book, Worlds in a Small Room, *published in 1974.*

Photographed first of seven yearly flower essays for Vogue *that were assembled and published as a book,* Flowers, *in 1980:*

1967 Tulips
1968 Poppies
1969 Peonies
1970 Orchids
1971 Roses
1972 Lilies
1973 Begonias

Photographic essay on San Francisco people for Look *magazine.*

1968

In New York, portraits for Vogue:

Arthur Ashe
Mia Farrow
*Coretta Scott King
Dr. Howard A. Rusk

L. Fritz Gruber

1969

Experimental color printing of photographs on porcelainized steel.

In New York, portraits for Vogue:

*Jorge Luis Borges
Shirley Chisholm
Leonard Cohen
Dr. Dorothy B. Ferebee
La MaMa Experimental Theatre Group
Elma Lewis
*Richard Lindner
Dr. Mildred Mitchell-Bateman
Pulsa Group
*Neil Simon
Topol

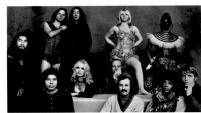

La MaMa Theatre group.

"The Imaginatives," a group of young art dealers:

Richard Bellamy
Paula Cooper
Michael Findlay
Arnold Glimcher
Ivan Karp
Klaus Kertess
Fred Mueller
David Whitney

In New York, photographed cast of The Boys in the Band *for* Look *magazine.*

In Cameroon, photographic essay for Vogue.

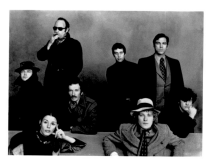

Young art dealers.

1970

In New York, portraits for Vogue:

Renata Adler
Busby Berkeley
Pete Hamill
Maureen Stapleton
John Updike
Gore Vidal

*Claude Lévi-Strauss (in Burgundy)

In New Guinea, photographic essay for Vogue.

1971

In New York, portraits for Vogue:

Alvin Ailey
*George Balanchine
Leonard and Felicia Bernstein
Pierre Boulez
Restaurateur Elaine and Her Friends
*Duke Ellington
Janet Flanner
Sir John Gielgud and
 Sir Ralph Richardson
Penelope Gilliatt
Germaine Greer
Caterine Milinaire
*Anaïs Nin
The King and Queen of Sikkim
Kathleen Tynan
*Andrei Voznesensky

*Tony Smith (in New Jersey)

In Morocco, photographic essay for Vogue.

1972

Over a period of some weeks, made a collection of cigarette butts of different shapes, sizes, and states of damage. It took about five days to make the camera negatives desired. Platinum prints took about fifteen months of work. Twelve of the prints were shown at the Museum of Modern Art, New York, in 1975.

In New York, portraits for Vogue:

Geoffrey Beene
*Bob Fosse
Burt Reynolds
Jacques Tati
Jon Voight
*Yevgeny Yevtushenko

*Pearl S. Buck (in Vermont)
Lee Krasner (in Springs, Long Island)

**Series of portraits for* Vogue *of Woody Allen enacting the look of legendary comedians Charlie Chaplin, Buster Keaton, Harold Lloyd, Groucho Marx, and Harpo Marx. Leo Lerman was editor.*

1973

Portraits for Vogue:

Oriana Fallaci
Ellsworth Kelly
Nicolas and Dominique Nabokov
Tatum O'Neal as Charlie Chaplin

1974

Portrait for Vogue:
I. M. Pei

Jerome Robbins (for *New York Times*)

Photographed Paris clothes from the early twentieth century exhibited at the Metropolitan Museum of Art, New York. These were published as a book in 1977.

Published Worlds in a Small Room.

1975

In New York, portrait for Vogue:
Elliott Carter

Series of photographs of street findings. These were exhibited in a show at the Metropolitan Museum of Art, New York, in 1977.

The Museum of Modern Art, New York, exhibited "Irving Penn: Recent Works, Photographs of Cigarettes" (platinum prints of photographs made in 1972).

The Galleria Civica d'Arte Moderna, Turin, exhibited "I Platini di Irving Penn: 25 Anni di Fotografia" (catalogue essays by Luigi Carluccio and Daniela Palazzoli).

1976

Joined Marlborough Gallery, New York.

Johnny Bench

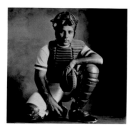

Johnny Bench.

1977

In New York, portraits for Vogue:

Leo Castelli
William Gibson, Anne Bancroft, and
 Arthur Penn
Philip Johnson
Leo Lerman
Dolly Parton
Arnold Schwarzenegger

*Alexander Liberman

Published Inventive Paris Clothes, 1909–1939: A Photographic Essay by Irving Penn, *with text by Diana Vreeland. Photographs had been made in 1974.*

The Metropolitan Museum of Art, New York, exhibited "Irving Penn: Street Material, Photographs in Platinum Metals."

Marlborough Gallery, New York, exhibited "Irving Penn: Photographs in Platinum Metals—Images 1947–1975." This show traveled to London in 1981, where the accompanying catalogue included an essay by Robert Hughes.

1978

In New York, portraits for Vogue:

Richard Avedon
David Halberstam
Diane Keaton
Miss Piggy
Pilobolus Dancers

*Merce Cunningham

Portraits for United Artists, including:

Albert R. Broccoli
Michael Cimino
Norman Jewison
Alan J. Pakula
David Puttnam
Sylvester Stallone

1979

In New York, portraits for Vogue :

Merrill Ashley
*Truman Capote
William S. Lieberman
Lucas Samaras
Lionel Tiger

Art dealers:

Leo Castelli
Xavier Fourcade
Sidney Janis
Lawrence Rubin, André Emmerich, and
 Arnold Glimcher

Alistair Cooke
Aaron Copland (for CBS Records)
Hiro

1979–80: Photographed a series of forty-two still lifes using a twelve-by-twenty-inch camera. Platinum prints of this material were exhibited at Marlborough Gallery, New York, in 1982.

1980

In New York, portraits for Vogue :

*Joseph Brodsky
Eduardo Chillida
Robert Hughes
Norman Mailer
William Maxwell
Luciano Pavarotti
Volker Schlöndorff and
 Margarethe von Trotta
Donald Sutherland
Hans-Jürgen Syberberg

John Huston

Published Flowers : Photographs by Irving Penn.

Marlborough Gallery, New York, exhibited "Earthly Bodies," nudes made in 1949–50 (catalogue essay by Rosalind Krauss).

1981

In New York, portraits for Vogue :

Pierre Cardin
*Milan Kundera
Gregor von Rezzori

Henry Geldzahler
*Gianni Versace

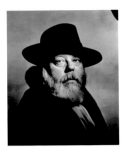

Henry Geldzahler.

1982

In New York, portraits for Vogue :

Julie Andrews
Oscar de la Renta
Christopher Plummer
Baron H. H. Thyssen-Bornemisza

Series of portraits for the new Vanity Fair, *including:*

Sherrill Milnes
James Rosenquist
Richard Stoltzman
*Virgil Thomson
Michael Walzer

Placido Domingo (for *Newsweek*)

Marlborough Gallery, New York, exhibited "Irving Penn: Recent Still Life: 1979–1980" (catalogue essay by Colin Eisler).

1983

Portraits for Vanity Fair *continue:*

John Ashbery
*Sir Frederick Ashton
 John Cage and Merce Cunningham
*Italo Calvino
*Willem de Kooning
 Edwin Denby
*Umberto Eco
*Suzanne Farrell
 Francine du Plessix Gray (in Paris)
 Seamus Heaney
 Dustin Hoffman
 Eugène Ionesco
*Jasper Johns
 André Kertész
*Arthur Miller
*Isamu Noguchi
*Jessye Norman
 Robert Rauschenberg
*Philip Roth
*Hanna Schygulla
 Susan Sontag (in Paris)
*James Van Der Zee

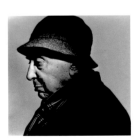

André Kertész.

Portraits for Vogue :

Harvey Fierstein
Richard Meier
*Yves Saint Laurent (in Paris)

Jesse Jackson (for *Newsweek*)
Nastassia Kinski (for *Time*)

1984

In New York, portraits for Vogue :

Hildegard Behrens
Jeremy Irons
Paloma Picasso
William Rubin
*Tom Stoppard

Portrait for Vanity Fair :

Norman Mailer

Rufino and Olga Tamayo

The Museum of Modern Art, New York, exhibited "Irving Penn," a retrospective of 168 photographs. The show was circulated to museums in the United States and abroad: Tokyo and Osaka; Paris; London; Madrid and Barcelona; Essen; Stockholm; Humlebaek (Copenhagen); Oslo; Helsinki; Lausanne; Tel Aviv; Milan and Rome.

A California billboard.

A book entitled Irving Penn, *by John Szarkowski, was published in conjunction with the exhibition.*

1985

First of three visits to Prague.

In New York, portraits for Vogue:

Richard Avedon
Mikhail Baryshnikov
Jacqueline Bisset
Richard Diebenkorn
Mia Farrow
Peter Jennings
*Vanessa Redgrave
Stephen Sprouse

Emanuel Ungaro (in Paris)

*Fernando Botero
*Carmen Dell'Orefice
Karl Lagerfeld

After an interruption of forty-three years, resumed drawing and painting.

1986

Returned to Prague to photograph a number of animal skulls at the Národní Muzeum.

Portrait for Vogue:

Robert Hughes

*Miles Davis
Takeo Kikuchi

1987

Portrait for Vogue:

Thomas P. "Tip" O'Neill

André Heller

Joined Pace/MacGill Gallery, New York.

Made photographs for a book on the work of fashion designer Issey Miyake.

1988

In New York, portraits for Vogue:

Tom Brokaw
Florence Griffith Joyner
Calvin and Kelly Klein
*Josef Koudelka
Natasha Richardson
Patricia Hearst Shaw

In New York, portrait for HG *magazine:*
*I. M. Pei

*Issey Miyake

Published:

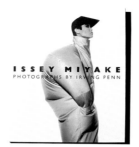

1989

In New York, portraits for Vogue:

Altynai Assylmuratova
*Mikhail Baryshnikov
Sting

In New York, portrait for HG *magazine:*
*Lorenzo Mongiardino

Pace/MacGill Gallery, New York, exhibited "Cranium Architecture," animal skulls photographed in 1986, with accompanying catalogue.

1990

In New York, portraits for Vogue:

Pedro Almodóvar
Jean-Paul Gaultier
Sylvie Guillem
Christian Lacroix
Louis Malle
Isaac Mizrahi
Rifat Ozbek
Gianni Versace

Jil Sander

Photographed twenty-seventh Paris couture collections for Vogue.

In Paris, portraits for Vogue:

Azzedine Alaïa
The de la Falaise Family
Grace Jones

The National Museum of American Art and the National Portrait Gallery, Washington, D.C., jointly exhibited "Irving Penn: Master Images" (catalogue essays by Merry A. Foresta and William F. Stapp).

Pace/MacGill Gallery, New York, exhibited "Other Ways of Being: 100 Photographs 1948–1971" (catalogue essay by Richard B. Woodward).

Center for Creative Photography, University of Arizona, exhibited "Irving Penn: Platinum Test Material."

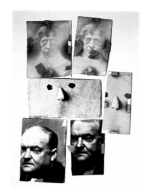

Platinum test material.

1991

In New York for Vogue, *photographs of Lincoln Kirstein and Peter Martins with dancers from the New York City Ballet in* The Sleeping Beauty.

The soloists, with Peter Martins:

Lauren Hauser
Margaret Tracey
Wendy Whelan
Diana White

The principal dancers, with Lincoln Kirstein:

Helene Alexopoulos
Merrill Ashley
Maria Calegari
Judith Fugate
Nichol Hlinka
Darci Kistler
Valentina Kozlova
Kyra Nichols

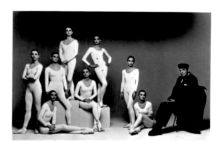

Lincoln Kirstein with dancers.

Acknowledgments

A number of years ago JoAnn Baker began to organize material for this book when it was no more than a vague speculation in my mind. I am grateful for her friendly persistence.

Alexandra Arrowsmith was diligent and precise in assembling the data that make up the book's detailed chronology, and in editing my writings. I have great admiration for her responsibility and standards.

Thomas Palmer worked closely with Richard Benson in making the black-and-white reproductions. True Sims was the book's dedicated production director, ably assisted by Toshiya Masuda and John McCormick. The international editions were coordinated by Natacha Vassilchikov.

Diana Edkins, curator of Condé Nast's photography archives, is always generous with her advice and in sharing her knowledge. She helped many times in tracking down elusive material that might have escaped us.

Michael Thompson, my studio chief, contributed his camera skills in preparing documents for reproduction. His work was invaluable. Nancy Parkinson, Cynthia Cathcart, Jane Bolster, and Robert Bear were each helpful in important ways.

Peter Schub and I have been associated professionally for many years. He has been ready with advice for this book and has contributed his good sense and experience in helping to present it both in America and abroad.

Nicola Majocchi was my right hand in putting the book together. I could not have managed without his strength, good judgment, and his ability to organize.

Patricia McCabe is the rock on which our studio stands. Among her many duties, a primary one has been as protector and caretaker of these photographs through the years. My professional decisions are made in consultation with her. She is the voice of our studio, its spirit and conscience.

I.P.

The book was printed in eleven impressions by Franklin Graphics of Providence, Rhode Island under the direction of Wayne Turner. The black-and-white plates were printed from 300-line-screen quadritone negatives made by Richard Benson and Thomas Palmer in Newport, Rhode Island. The color plates were printed in four colors from 300-line-screen separations made by Franklin Graphics. Black-and-white and color were over-printed with a spot varnish.

The type was set in Monotype Univers by Michael and Winifred Bixler. The typographer was Bert Clarke. The paper stock is 100 lb. Potlatch Quintessence text. The book was bound by the Riverside Group of Rochester, New York.

Grateful acknowledgment is made to the Condé Nast Publications Inc., for permission to reproduce the photographs listed below using the following abbreviations:

©	Copyright ©	l.	left
CNP	Condé Nast Publications	ctr.	center
ren.	Renewed	r.	right
(BrV)	originally reproduced in British *Vogue*		
(FrV)	originally reproduced in French *Vogue*		
(HG)	originally reproduced in *House & Garden*		
(VF)	originally reproduced in *Vanity Fair*		
(V)	originally reproduced in *Vogue*		

p. 18 (bottom) © 1943 ren. 1971 CNP, Inc. (V); p. 287 (top r.) © 1945 ren. 1973 CNP, Inc. (V); pp. 21 (bottom), 22 (bottom), 23, 24 (bottom), and 25 © 1946 ren. 1974 CNP, Inc. (V); pp. 20 (top and bottom l.), 22 (top), 26, 32, 34 (bottom), 39 (top and bottom), 43 (top), and 288 © 1947 ren. 1975 CNP, Inc. (V); p. 42 (top) © 1948 ren. 1976 CNP, Inc. (HG); pp. 13, 27, 28 (top and middle), 33 (bottom), 36 (middle and bottom), 37 (top), 40 (top), 41, 47 (top), 50 (bottom), 51, 52, 53 (bottom r.), 55 (bottom), 64 (top and bottom), and 289 (l.) © 1948 ren. 1976 CNP, Inc. (V); p. 53 (top l.) © 1948 ren. 1976 CNP, Ltd. (BrV); p. 72 © 1949 ren. 1977 CNP, Inc.; pp. 29, 45 (top and bottom r.), 47 (bottom), 48, 49 (top), 56 (bottom), 65 (top), 73 (top and bottom), 74, 76 (bottom), 79 (top), and 290 (ctr.) © 1949 ren. 1977 CNP, Inc. (V); pp. 55 (top), 76 (top), 78 (top), 80 (bottom), 81, 82 (top and bottom), 84 (top and bottom), 97 (bottom), 100 (top and bottom), 101 (top), and 291 (upper middle l.) © 1950 ren. 1978 CNP, Inc. (V); pp. 85 and 86 © 1950 ren. 1978 CNP, Inc. and Les Editions CN (V and FrV); pp. 83 (bottom), 87 (top), 101 (bottom), 102 (top), 107 (top and bottom), 110 (top), 112 (top and bottom), 113 (top and bottom), 114, 115 (top and bottom), 116 (top, middle, and bottom), 117, and 291 (top l.) © 1951 ren. 1979 CNP, Inc. (V); pp. 96 (bottom), 97, 98 (top and bottom), 99 (top, middle, and bottom), and 290 (r.) © 1951 ren. 1979 CNP, Ltd. (BrV); pp. 88 (top and bottom), 90 (top and bottom), 91, 92 (bottom), and 93 © 1951 ren. 1979 Les Editions CN; pp. 89 and 92 (top) © 1951 ren. 1979 Les Editions CN (FrV); pp. 102 (bottom), 103, 106 (bottom), 118, 119 (top and bottom l.), and 291 (top ctr.) © 1952 ren. 1980 CNP, Inc. (V); p. 110 (bottom) © 1952 ren. 1980 CNP, Ltd. (BrV); pp. 78 (bottom), 108 (top and bottom), and 109 © 1953 ren. 1981 CNP, Inc. (V); p. 94 © 1953 ren. 1981 CNP, Ltd. (BrV); p. 291 (bottom ctr.) © 1953 ren. 1981 Les Editions CN (FrV); pp. 119 (bottom r.) and 120 (bottom) © 1954 ren. 1982 CNP, Inc. (V); p. 111 © 1954 ren. 1982 CNP, Ltd. (BrV); pp. 120 (top) and 123 (top) © 1955 ren. 1983 CNP, Inc. (V); p. 42 (bottom) © 1958 ren. 1986 CNP, Ltd. (BrV); p. 95 (top) © 1958 ren. 1986 Les Editions CN (FrV); p. 127 (top) © 1959 ren. 1987 CNP, Inc.; p. 129 (top) © 1959 ren. 1987 CNP, Inc. (V); p. 61 © 1960 ren. 1988 CNP, Inc. (V); pp. 130, 131 (top), and 135 (bottom) © 1961 ren. 1989 CNP, Inc. (V); p. 135 (top r.) © 1961 ren. 1989 Les Editions CN (FrV); pp. 136, 140, 142 (top), and 143 © 1963 ren. 1991 CNP, Inc. (V); pp. 145, 151 (top and bottom), 152, 153, and 293 (r.) © 1964 CNP, Inc. (V); pp. 126 (bottom), 146, 147 (bottom), 150, 155 (bottom l. and r.), 156, 157, and 294 (l.) © 1965 CNP, Inc. (V); pp. 154, 158, 159 (top and bottom), 161 (top and bottom), and 162 (bottom) © 1966 CNP, Inc. (V); pp. 163, 164, 174 (top), and 294 (top ctr.) © 1967 CNP, Inc. (V); p. 177 (top) © 1968 CNP, Inc. (V); pp. 179 (bottom), 180 (bottom), 181, 294 (bottom r.), and 295 (l.) © 1969 CNP, Inc. (V); pp. 180 (top), 187, and 191 (bottom) © 1970 CNP, Inc. (V); pp. 192 (top), 194, 197 (middle), 198 (bottom), and 201 (top) © 1971 CNP, Inc. (V); pp. 196, 197 (bottom), 202 (bottom), and 209 (top and bottom ctr.) © 1972 CNP, Inc. (V); p. 220 (bottom) © 1976 CNP, Inc. (V); p. 222 © 1977 CNP, Inc. (V); p. 227 (bottom) © 1979 CNP, Inc. (V); p. 234 (top) © 1980 CNP, Inc. (V); p. 239 (middle r.) © 1981 CNP, Inc. (V); pp. 239 (bottom), 240, and 241 (bottom) © 1982 CNP, Inc. (V); p. 242 (top) © 1983 CNP, Inc. (V); pp. 241 (top), 243 (top and bottom), 244, 247 (top and bottom), 248, and 251 © 1983 CNP, Inc. (VF); p. 252 (bottom) © 1984 CNP, Inc. (V); p. 57 (top) and 250 (bottom) © 1984 CNP, Inc. (VF); pp. 253 (bottom), 256 (bottom), and 257 © 1985 CNP, Inc. (V); p. 296 (bottom ctr.) © 1985 CNP, Inc. (VF); p. 274 (top) © 1988 CNP, Inc. (HG); pp. 276, 278, and 279 (top and bottom) © 1988 CNP, Inc. (V); p. 281 (top) © 1989 CNP, Inc. (HG); pp. 280 and 281 (bottom) © 1989 CNP, Inc. (V); pp. 282, 283, and 284 (bottom l.) © 1990 CNP, Inc. (V); p. 297 (bottom r.) © 1991 CNP, Inc. (V).

The following photographs are copyright © Irving Penn courtesy of *Vogue* unless a different magazine is indicated: p. 21 (top) © 1946 ren. 1974; p. 289 (r.) © 1948 ren. 1976; p. 126 (top) © 1958 ren. 1986; pp. 28 (bottom), 34 (bottom), 36 (top), 38 (top), 40 (bottom r.), 46 (bottom), 49 (bottom), 54 (top), 60 (top), 68, 77, 80 (top), 83 (top), 95 (bottom), 104 (bottom), 124 (top and bottom l.), 125, 127 (bottom), and 290 (bottom l.) © 1960 ren. 1988; p. 174 (bottom) © 1967; pp. 188 (top) and 191 (top l.) © 1970; pp. 197 (top) and 198 (top) © 1971; pp. 144 (bottom), 147 (top), 170 (top and bottom), 171, 172 (top and bottom), 173, 175, 182 (bottom), 183, 184, 188 (bottom), 189, 190, 191 (top r.), 193, 199, 200, 201 (bottom), and 294 (middle ctr.) © 1974; pp. 66, 67, 69, 70, 71, 176, 177 (bottom), 178, 179 (top), 186, and 235 © 1980; p. 238 © 1981; pp. 31, 37 (bottom), 44, 53 (bottom l.), 75 (top), 106 (top), 134, 182 (top), and 192 (bottom) © 1983; p. 245 (bottom) © 1983 (courtesy VF); pp. 20 (bottom r.), 24 (top), 30 (top and bottom), 33 (top), 40 (bottom l.), 43 (bottom l. and r.), 45 (bottom l.), 46 (top), 50 (top), 53 (top r.), 54 (bottom), 56 (top), 57 (bottom), 59 (top, middle, and bottom), 75 (bottom), 87 (bottom), 96 (top), 104 (top), 122, 124 (bottom r.), 135 (top l.), 160, 162 (top), 185 (top), 195, 202 (top and bottom l.), 209 (bottom r.), and 290 (top l.) © 1984; pp. 245 (top), 249, and 250 (top) © 1984 (courtesy VF); pp. 58, 60 (bottom), 62, 63 (top and bottom), 65 (bottom), 79 (bottom), 105, 128, 129 (bottom), 132 (top and bottom), 133 (top and bottom), 144 (top), 155 (top), 165 (top, bottom l. and r.), 185 (bottom), 209 (bottom l.), 225, 230, 246, 253 (top), and 289 (ctr.) © 1985; p. 242 (bottom) © 1986 (courtesy VF); p. 270 (top) © 1988; p. 35 © 1990.

No photograph listed above may be reproduced without written permission of the Condé Nast Publications Inc., 350 Madison Avenue, New York, NY 10017.

The following images are copyright © Irving Penn: p. 11 © 1940 ren. 1968; pp. 16, 17 (bottom), and 287 (top ctr.) © 1942 ren. 1970; p. 19 (bottom) © 1945 ren. 1973; p. 19 (top and middle) © 1946 ren. 1974; p. 12 (bottom l.) © 1948 ren. 1976; pp. 18 (top), 131 (bottom), and 292 © 1960 ren. 1988; pp. 137, 138, 139, and 293 (ctr.) © 1962 ren. 1990; p. 141 © 1963 ren. 1991; p. 142 (bottom) © 1964; pp. 148 (top and bottom) and 149 © 1965; pp. 166 (top and bottom), 167, 168, and 169 © 1967; pp. 203, 204, 205, 206 (top and bottom), 207, 208, and 294 (bottom ctr.) © 1974; pp. 216 (top and bottom), 217, 218, 219, 220 (top), 221 (top), and 223 © 1975; pp. 212, 213, 214 (top and bottom), 215, 224 (top), and 295 (bottom r.) © 1977; p. 221 (bottom) © 1977 (courtesy Vivitar Corporation); p. 224 (bottom) © 1978; p. 295 (top r.) © 1978 (courtesy Time-Life Books Inc.); pp. 227 (top), 228 (top), and 231 (top) © 1979; pp. 226, 231 (bottom), 232 (bottom), 233, 234 (bottom), 237 (bottom), and 294 (top r.) © 1980; pp. 228 (bottom), 229, 232 (top), 236, 237 (top), 239 (top l.), and 296 (top ctr.) © 1981; p. 12 (top and bottom r.) © 1983; pp. 17 (top), 123 (bottom), and 252 (top) © 1984; pp. 14 (top and bottom), 15 (top and bottom), 254 (bottom), 256 (top), and 287 (l.) © 1985; pp. 254 (top) and 255 © 1985 (courtesy Fujinon); pp. 260, 262, 263, 264, and 265 © 1986; p. 259 © 1986 (courtesy Warner Brothers); p. 266 © 1987; pp. 272 and 273 (top and bottom) © 1987–88; pp. 270 (bottom), 274 (bottom), 275, and 277 © 1988; pp. 258, 267, 268, 269, and 271 © 1988 (courtesy Issey Miyake); p. 297 (top r.) © 1989; pp. 284 (top r.) and 285 © 1990 (courtesy Issey Miyake).

The following images are copyright © Clinique Laboratories, Inc.: p. 210 © 1986; p. 211 (top) © 1988 and 1982; p. 211 (bottom).

Page 261 copyright © 1987 Cosmair, Inc.

Page 121 copyright © 1954 ren. 1982 De Beers Consolidated Mines, Ltd.

Page 297 (ctr.) copyright © 1988 Miyake Design Studio and Callaway Editions, Inc.

Page 296 (bottom r.) copyright © 1984 The Museum of Modern Art, New York

Page 291 (lower middle l.) photograph courtesy Martin Harrison

Page 296 (top r.) photograph courtesy University Art Museum, University of California, Berkeley

No photograph listed above may be reproduced without written permission of the copyright holder.

Library of Congress Cataloging-in-Publication Data

Penn, Irving.
 Passage / Irving Penn with the collaboration of Alexandra Arrowsmith and Nicola Majocchi; introduction by Alexander Liberman; produced by Nicholas Callaway. — 1st ed.
 p. cm.
 ISBN 0-679-40491-0
 1. Photography, Artistic. 2. Fashion photography. 3. Penn, Irving. I. Arrowsmith, Alexandra. II. Majocchi, Nicola. III. Callaway, Nicholas. IV. Title.
TR654.P4513 1991 91-52709
779'.092 — dc20 CIP

Manufactured in the United States of America.

First edition.